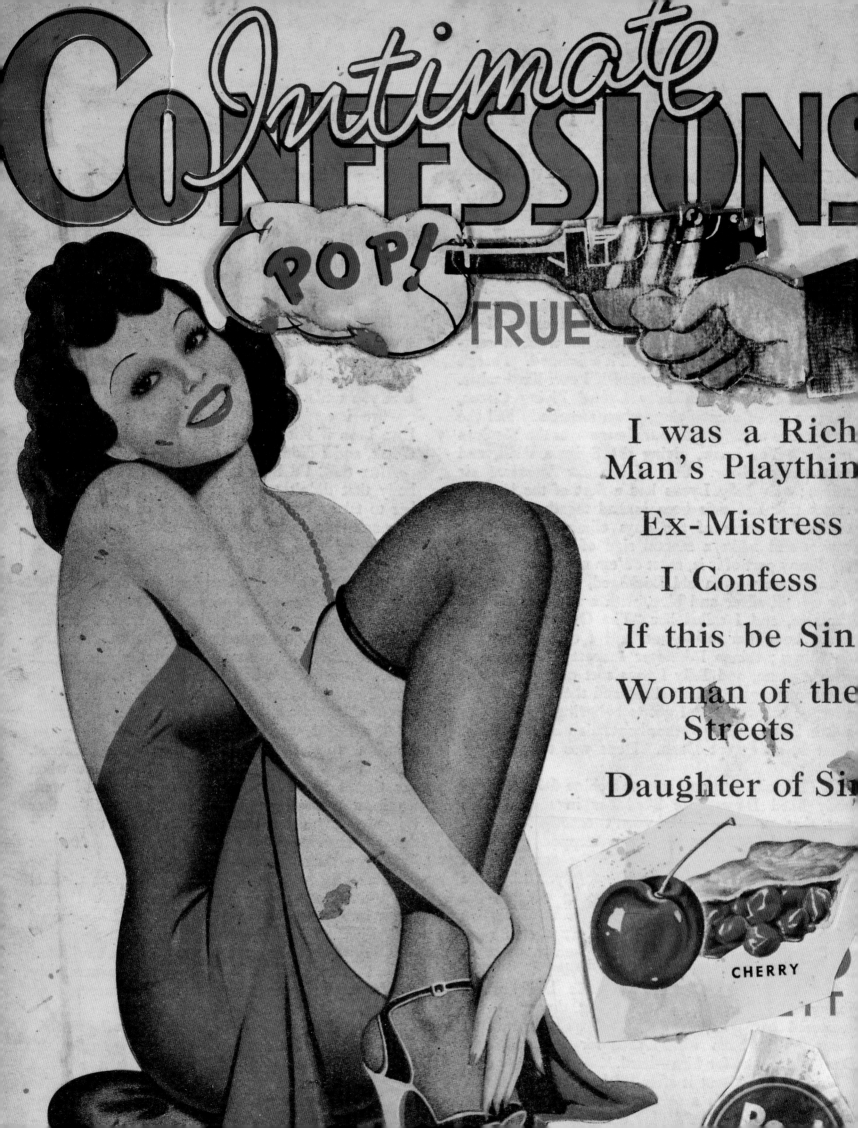

POP
TO
POPISM

edited by
Wayne Tunnicliffe
Anneke Jaspers

The NSW Government is proud to support *Pop to popism*, which is being exhibited exclusively at the Art Gallery of New South Wales as part of the Sydney International Art Series this summer.

Curated by the Art Gallery of New South Wales, *Pop to popism* is the most comprehensive pop art exhibition to be seen in Australia, and will fill an entire floor of the Gallery with artworks from the giants of the pop art genre.

Warhol, Lichtenstein, Koons, Haring and Hockney feature alongside Australian pop artists in this comprehensive survey, which explores the decisive role pop art played in bridging the gap between modern and postmodern art movements.

Securing outstanding exhibitions such as this through the NSW Government's tourism and major events agency, Destination NSW, not only enriches the cultural fabric of NSW, but also enhances our global city's reputation as Australia's cultural tourism hub.

It is with great pleasure that I welcome you to explore the evolution of pop art through *Pop to popism*.

Mike Baird
Premier of New South Wales

EY is proud to be the principal sponsor of the *Pop to popism* exhibition at the Art Gallery of New South Wales.

At EY we recognise the leading role the arts can have in contributing to a vibrant and diverse culture. Art inspires us, challenges us and rewards us. It makes our world better.

For over two decades, EY has proudly supported the visual and performing arts in Australia and New Zealand through our sponsorship program, providing pro bono professional services and connecting business leaders to art institutions. We do this to assist organisations in showcasing world-class exhibitions and performances, and to help make art accessible to everyone.

Pop to popism is the most extensive exhibition of pop art ever showcased in Australia and, as a long-term sponsor of the Art Gallery of New South Wales, EY is delighted to help bring this exhibition to Sydney.

Rob McLeod
Oceania CEO & Regional Managing Partner
EY

Pop art broke down the barriers between high art and popular culture forever when it began to be exhibited in the early 1960s. *Pop to popism* is the most comprehensive survey of pop art to be seen in Australia and reflects the decisive role played by pop in the development of contemporary art. For the first time this exhibition presents Australian pop artists alongside their international peers from the United States of America, the United Kingdom and Europe. It also extends beyond the period of classic pop art into the 1980s, giving audiences an insight into pop's enduring legacy both here and abroad.

Pop to popism is the fifth exhibition in our popular summer Sydney International Art Series and follows *America: painting a nation* (2013–14), *Francis Bacon: five decades* (2012–13), *Picasso: masterpieces from the Musée National Picasso* (2011–12) and *The First Emperor: China's entombed warriors* (2010–11). We acknowledge the support of the NSW Government through Destination NSW in enabling us to stage these ambitious international exhibitions in Sydney.

An essential part of my vision for the Gallery is to create closer alliances with cultural institutions around the world and this exhibition develops new relationships with several art museums in America and Europe we have not borrowed from previously. In addition we have drawn on the generous support of many international and Australian institutions we have worked with before, as well as borrowing from generous private collectors. We anticipate *Pop to popism* will provide further impetus for cultural exchange, and help the work of Australian artists become accepted as part of the international pop art canon.

I wish to thank Wayne Tunnicliffe, curator of *Pop to popism*, and Anneke Jaspers, assistant curator and research manager, for the dedication and scholarship they have brought to this exhibition and publication. I greatly appreciate the work and commitment of all the Gallery's staff, and in particular deputy director Anne Flanagan, director of collections Suhanya Raffel, and senior manager of exhibitions Charlotte Davy. Finally, to our principal sponsor EY, and our major sponsors Norton Rose Fulbright and the Terra Foundation for American Art, we express our gratitude for their generous support without which we could not have undertaken such an ambitious exhibition.

Michael Brand
Director
Art Gallery of New South Wales, Sydney

VALERIO ADAMI
HOWARD ARKLEY
EVELYNE AXELL
ENRICO BAJ
JEAN-MICHEL BASQUIAT
VIVIENNE BINNS
PETER BLAKE
DEREK BOSHIER
ROBERT BOYNES
KP BREHMER
MIKE BROWN
PATRICK CAULFIELD
ROSS CROTHALL
JUAN DAVILA
JIM DINE
ROSALYN DREXLER
RICHARD DUNN
ERRÓ
ÖYVIND FAHLSTRÖM
GILBERT & GEORGE
RICHARD HAMILTON
DUANE HANSON
KEITH HARING
DAVID HOCKNEY
KH HÖDICKE
ROBERT INDIANA
ALAIN JACQUET
JASPER JOHNS
ALLEN JONES
EDWARD KIENHOLZ
PETER KINGSTON
RB KITAJ
JEFF KOONS
MARIA KOZIC
BARBARA KRUGER
COLIN LANCELEY
RICHARD LARTER
TIM LEWIS
ROY LICHTENSTEIN
KONRAD LUEG
BRIDGID McLEAN
MARISOL
CLAES OLDENBURG
ALAN OLDFIELD
EDUARDO PAOLOZZI
PETER PHILLIPS
SIGMAR POLKE
PETER POWDITCH
RICHARD PRINCE
ROBERT RAUSCHENBERG
MARTIAL RAYSSE
KEN REINHARD
GERHARD RICHTER
ROBERT ROONEY
JAMES ROSENQUIST
MARTHA ROSLER
EDWARD RUSCHA
NIKI DE SAINT PHALLE
GARETH SANSOM
MARTIN SHARP
MICHAEL ALLEN SHAW
GARRY SHEAD
CINDY SHERMAN
WAYNE THIEBAUD
IMANTS TILLERS
JOE TILSON
TONY TUCKSON
PETER TYNDALL
WOLF VOSTELL
ANDY WARHOL
DICK WATKINS
JENNY WATSON
TOM WESSELMANN
BRETT WHITELEY

POP
TO
POPISM

Wayne Tunnicliffe

Pop is one of the defining art movements of the twentieth century; now instantly recognisable and widely understood, it is as much a part of popular culture as art history. Perhaps this was inevitable, as pop artists found their style and subjects in popular culture to begin with: from advertising, film, product design, packaging, television, pulp magazines and many other sources. When their works were first exhibited at the beginning of the 1960s, 'pop' was one of several names that were contenders including new realism, factualism and neo-dada. These other names suggest two important precursors: the tradition of realism in art from the mid nineteenth century onwards and the transgression of the dada movement in the early twentieth century. But 'pop' signalled a clear shift away from these earlier art movements and a bold new alignment with the burgeoning mass media and consumerism catalysed by the economic boom following World War II. The word 'pop' conveyed the exciting energy of this new art and, by the end of 1962, it was the name that was to stay.

Pop art was controversial from the outset for using a visual language derived from entertainment and consumerism. In 1957 the British artist Richard Hamilton wrote a now-famous letter in which he defined the characteristics of popular art as 'popular (designed for a mass audience), transient (short-term solution), expendable (easily forgotten), low cost, mass-produced, young (aimed at youth), witty, sexy, gimmicky, glamorous, big business'.[1] Hamilton was addressing the visual material flooding into people's homes, workplaces and the public sphere that pop artists subsequently drew on in opposition to both the lofty ideals of abstract art and the more anxious forms of mid-century figurative art which were dominant prior to pop's arrival. Pop artists aligned their art closely with its sources, sometimes directly by incorporating found objects and images, and often by simulating the forms and content of advertising and mass media.

For pop art's detractors, bringing soup cans and comic books into art galleries was a vulgar betrayal of long-held elite cultural values; for pop's many converts these works were radically relevant and even democratic, reflecting the world in which people actually lived. Describing pop art as a movement is convenient but not entirely accurate, however. Pop art did not have a manifesto or creed and the artists that were grouped under this name, while sharing an exploration of pop culture, often had divergent practices. Andy Warhol's screenprinted film stars, produced en masse, have little in common with Claes Oldenburg's outsize, handcrafted, soft sculptures of burgers and household appliances; likewise, Mike Brown's funky paintings that layer text and imagery are very different in appearance to Robert Boynes' super-smooth airbrushed paintings of cigarettes. The art of Warhol and Boynes seems impersonal and coolly distant, while that of Brown and Oldenburg is idiosyncratic and highly engaging.

While the characteristics of pop art vary greatly from artist to artist, some recurring features include a collage or pinboard-like accumulation of imagery, frontal compositions with compressed perspective, bright colours, a graphic sensibility, the use of text, and subjects that are immediately recognisable despite having often been translated across various mediums from their original source. The distinct categories of painting, sculpture, printmaking and photography became blurred during this time, with pop artists often conflating a range of techniques and mediums within a single work. While traditional art techniques were not necessarily used, pop art did not result in a deskilling but more a reskilling through the use of new techniques and materials derived from commercial rather than fine art traditions. As a consequence of pop art's close connection with the big business of commercial art and advertising, its status – as a celebration of consumer culture, a deadpan replication of its characteristics and methodologies, or a critique of capitalism – is still highly contested.

Versions of pop art arose in many art centres around the world and *Pop to popism* presents an Australian perspective on art's encounter with popular culture. It focuses on the international art that was known in Australia through magazines, catalogues and books; seen by Australian artists who travelled internationally or in exhibitions that toured to Australia; and occasionally purchased by private collectors and institutions. *Pop to popism* also contributes to a more nuanced and inclusive history of pop art internationally by situating Australian artists working in a pop mode in dialogue with some of their most prominent peers in Britain, the United States of America and Europe. It participates in the current reassessment of pop art by curators and art historians toward broadening the pop pantheon to represent the significant contribution of women artists; artists whose practice is more marginal to a mainstream definition of pop art; as well as artists working outside the usual art world centres.

Pop to popism is structured in seven sections that are broadly geographical and chronological. They reflect the emergence of individual practices in particular locations as well as pop's

development of a more international language by the late 1960s and the return to a pop idiom by a younger generation of practitioners in the 1980s. *Pop to popism* begins with pop art's origins after World War II in collage and assemblage practices. The artists included here introduced mass-media images and everyday references into their art through found photographs from magazines and newspapers, and found objects or pre-existing materials from the everyday world. The next section focuses on the generation of British artists who studied at London's Royal College of Art and exhiblted in the *Young contemporaries* exhibitions in London in 1961 and 1962. The more painterly approach of these diverse artists is often grounded in a collage aesthetic and was influential on Australian artists working in a pop idiom in the mid 1960s. The American section features artists that have become synonymous with pop, focusing on the 'big five' active in New York in the early 1960s; it also includes West Coast artists and more marginal figures associated with American pop art whose practice facilitates a broader perspective. In the European section that follows – which includes a focused selection of work from France, Italy, Scandinavia and Germany – many of the artists identified closely with American pop and exhibited or worked in New York in the 1960s. The section on Australian pop art looks at artists' responses to specific local influences and concerns, and to the same mass-media and entertainment culture that was increasingly global in the 1960s. *Pop to popism* presents the first survey of Australian pop art, situating Australian pop artists in a global framework.

The post-1968 period is the focus of the sixth section. By the end of the 1960s pop was a widely shared international language, but it was also subject to considerable pressure as the promise of material plenitude and social change at the beginning of the decade stalled and new art movements arose that challenged pop's alignment with consumerism. The popism section explores the return to a nuanced exploration of the language of popular culture and pop art at the end of the 1970s by a younger generation of artists. This return continues to resonate as many of these artists are still practising and developments first made in their work have been taken up by subsequent generations of artists.

As *Pop to popism* was conceived from an Australian perspective, exploring pop culture locally was important to this project from its genesis. Australian pop art's development, both independently and in dialogue with international pop art, follows a pattern typical of Australian modernism. From the 1950s onwards, Australia shared with much of the western world a booming postwar economy and an ambivalent fascination with American popular culture, while Australia's cultural gravitation towards Britain continued. The influence of British art is most evident in Australian work in the mid 1960s, but this was a two-way exchange and many Australian expatriates participated in shaping 'swinging London', as it was called in *Time* magazine in 1966. In the late 1950s the flat frontality of American pop painting became more evident in Australian art, though often in a hybrid style. Apart from the artists working in a purer pop idiom, many more were influenced by pop art and pop culture, and in the 1960s bright colours, graphic forms and topical mass-media subjects often appeared in their work. Inevitably pop art was discussed within the context of ongoing debates about regionalism versus internationalism, and the strength of Australian pop often lies in its unruly marriage of international idioms with local styles and subjects.

While art historians generally agree upon pop art's points of origin, the timing of its dissolution remains open to debate. Many survey exhibitions have chosen to finish between 1968 and 1972. The former year gave rise to an assassination attempt on Andy Warhol's life, momentous student and worker protests, the emergence of the counterculture movement, and a focus on American art – including pop – at the *Documenta IV* exhibition in Germany. By contrast, pop art was virtually absent from *Documenta V* in 1972. In the following years consumer capitalism was challenged by the oil crisis in 1973, the international stock market crash in 1974–75, and a decline in American manufacturing. Moreover, pop art was superseded by minimal, conceptual, land, body and other art practices in the large survey exhibitions that took the art world's temperature in the early 1970s. Nevertheless, both end dates for pop art are somewhat arbitrary. While some artists who had previously created pop works moved onto other styles at this time, many of its main protagonists continued evolving their pop practices. *Pop to popism* includes a selection of works from the 1970s that shows the ongoing use of a pop aesthetic and the emergence of forms of realism that demonstrate a debt to pop art.

Pop to popism extends the usual period of pop survey exhibitions into the 1980s in the popism section. Pop has been viewed as both a manifestation of late modernism and as ushering in

postmodernism. It did the latter through its use of appropriation and occasional irony, and the exploration of how mass media and popular culture shape subjectivity. Warhol's reworking of his 1960s imagery in his *Retrospective* and *Reversal* series in the late 1970s was postmodern in its self-reflexiveness and coincided with the emergence of a younger generation of artists whose work reflected a highly nuanced response to pop cultural imagery, appropriation, the legacy of pop art and emerging fields of postmodernist theory.

The 'popism' in *Pop to popism* refers to Andy Warhol's 1980 memoir of the 1960s, and also to this new generation of artists who began exhibiting in the late 1970s. The international artists in this section had a significant profile in Australia and most works in this section reside in Australian public and private collections. *Popism* was also the title of an exhibition curated in Melbourne in 1982 by Paul Taylor, the founding editor of *Art & Text* magazine who, in early 1987 in New York, conducted the last interview with Andy Warhol.[2] In *Popism*, Taylor profiled a group of Australian artists whose postmodern practices of appropriation updated pop art's engagement with mass media, announcing a new 'post-pop' art.

The longevity of pop art greatly surprised many of the critics who witnessed its arrival in the early 1960s and thought it was a flash in the pan. When pop lasted longer than they had anticipated, they declared it over by the end of the decade. Yet pop art's lasting legacy has transcended the art world, given its re-assimilation back into the popular culture from which it first took its subjects and styles over five decades ago. Popular culture is now taken for granted as another realm for contemporary artists to draw upon within a wide visual and conceptual vocabulary, and many artists also continue to refer to both pop art and the art associated with popism. This has occurred while the world that pop art was predicated on – and predicted for the future – has been fully realised: consumer capitalism is now dominant globally, and celebrity culture and momentary fame in mass and social media seems a Warholian world view come to life.

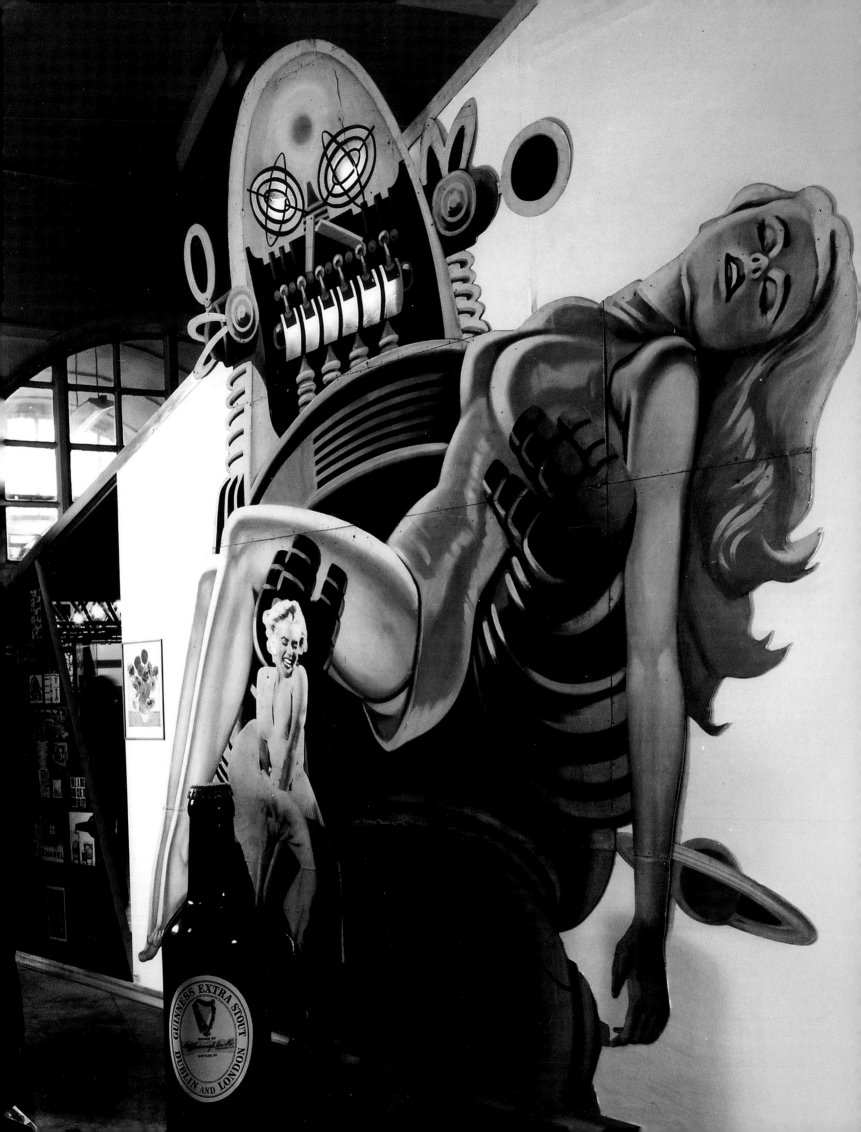

Wayne Tunnicliffe

THE FUTURE IS NOW
ORIGINS OF POP ART

Room created by Group 2 for the *This is tomorrow* exhibition, Whitechapel Art Gallery, London, 1956

Pop art arrived like a cartoon explosion at the beginning of the 1960s in many art centres around the world. Artists working with popular culture in diverse and even disparate ways were packaged into a new art movement and promoted by some of the great impresario dealers, critics and curators of the period. They were just as quickly reviled by those who saw pop art as a damaging affront to higher cultural values. While to many pop seemed to have appeared from nowhere, some artists had begun incorporating mass-media imagery and everyday objects into their art in a relatively unmediated way in the late 1940s and early 1950s.[2] Many of these artists drew on American popular culture, which was becoming increasingly global through the political and economic dominance of the United States of America after World War II, but those outside of the United States also drew on local popular cultures that at times diverged considerably from the American model. Early precursors to pop art engaged with the visual cultures of media and consumerism: film, television, glossy magazines, newspapers, billboards, product packaging, advertising, music, cartoons and comics. This was the increasingly insistent world of images and products that vied for people's attention and fuelled economies of desire, newly embedded in the everyday.

One of the most sustained investigations of popular culture in the early 1950s was undertaken by the Independent Group at the Institute of Contemporary Arts (ICA) in London, through a discussion program, exhibition activities, published texts and artworks. The latter have retrospectively come to be regarded as some of the earliest examples of pop art and are now amongst the most recognisable works using mass-media imagery made in that decade. The Independent Group was a loose and evolving association of mainly younger members of the ICA, and comprised artists such as Richard Hamilton, Nigel Henderson, John McHale and Eduardo Paolozzi; architects including Peter and Alison Smithson; and soon-to-be important writers and cultural theorists Lawrence Alloway and Reyner Banham.[3] The group ran an occasional series of lectures from 1952 to 1955, which reflected an inclusive and anti-elitist cultural view; topics explored were as diverse as advertising, architecture, aircraft and car design, science fiction, and fashion design and magazines. In an economically constrained Britain attempting to rebuild itself after the depression and World War II, American mass media offered what Alloway termed later in the decade 'the aesthetics of plenty'.[4] American popular culture was embraced by the Independent Group members as embodying desirable abundance and futuristic styling, offering a way forward from the traumas of the recent past. Popular culture seemed eminently more inclusive than traditional high culture, and the Independent Group participated in the greater social and class mobility that occurred in Britain in the postwar period.

Eduardo Paolozzi delivered the first Independent Group presentation in April 1952, in which he showed on an epidiascope (a form of overhead projector) with little commentary a series of collaged images from mostly American magazines and comic books to a small, invited audience and to a mixed critical reception.[5] Paolozzi had begun making collages in London in 1946 after seeing works by dada artist Kurt Schwitters and surrealist Max Ernst, as well as collages by some of the British surrealists. Schwitters had arrived in Britain as a refugee in 1940 after the Nazis declared his art degenerate, and lived there until he died in 1948. Some of his late collages incorporate advertising imagery and packaging materials in a direct way, with brand names and images appearing near intact.[6] Paolozzi has subsequently said he found collage a liberating way to incorporate in his art the images and materials of his upbringing in Edinburgh, as it was 'a happy return to my familiar Scottish street culture, to the cigarettes and film stars pasted in scrapbooks during my childhood'.[7] Paolozzi moved to Paris for two years in 1947, on the proceeds of a successful exhibition in London, where as part of a broader primarily sculptural practice he continued to make collages using magazines and comics as raw material, which were reputedly given to him by American ex-servicemen. While in Paris he met many of the city's leading avant-garde artists, including Alberto Giacometti, Tristan Tzara and Jean Dubuffet, and he viewed Mary Reynolds' extensive collection of works by Marcel Duchamp.

A few of Paolozzi's collages made in Paris and on his return to London involve multiple image sources, but many are juxtapositions of just two images or even single pages or magazine covers glued onto card.[8] Paolozzi made more overtly surrealist works through this period, but the group that later became known as the *Bunk* collages comprise relentlessly contemporary imagery of pin-ups, domestic appliances, comic characters and sci-fi robots appropriated from the immediate

consumer realm. One of the collages using multiple images, now known as *Bunk! Evadne in green dimension* 1952, shows Charles Atlas wearing leopard-print trunks from one of his famous muscle-building advertisements, hoisting aloft a big American family car, next to a slice of cherry pie and a diagram of the sexual functioning of male genitalia collaged with a pin-up girl. This combination of images conflates self-improvement, female glamour, male physical strength, desirable consumer goods, manufactured foodstuffs and sexual libido – suggesting their interdependence in the brave new world of mass-media communications and technology-driven consumerism.[9] The exclamation 'Bunk!' emblazoned across this collage was part of the original Charles Atlas ad and became the name of the entire group when Paolozzi later reproduced 45 of them as a print portfolio in 1972. Paolozzi included one of his collaged scrapbooks along with some of his more surrealist works in the ICA *Collages and objects* exhibition in October 1954, but it was not until the *Bunk* group were exhibited in his 1971 Tate retrospective and the print portfolio was subsequently released that they became widely known and positioned as essential pop art precursors.[10]

Richard Hamilton was one of the key Independent Group members, and he advocated for an expansive view of visual culture in the exhibitions he curated in the early 1950s, in his art practice and later in the decade in his published analytical texts on his own paintings. Hamilton's most well-known artwork from this period, the 1956 collage *Just what is it that makes today's homes so different, so appealing?* (Kunsthalle Tübingen, Germany) has become an icon of pop art and yet it was not displayed when it was made for the *This is tomorrow* exhibition, which opened in August 1956 at London's Whitechapel Art Gallery. The exhibition consisted of 12 collaborative projects, each devised by a group of three to four people intended to include a painter, sculptor and architect. It brought together neo-constructivist abstract artists and the Independent Group in a disparate but remarkable installation-based project that received over 20 000 visitors in the month it was on display.

Hamilton participated in Group 2, along with artist John McHale and architect John Voelcker, and with unacknowledged help from Magda Cordell and Terry Hamilton, to create the popular culture 'fun house' that remains the most celebrated part of the exhibition. The installation included a dazzling optical passageway; an oversized advertising prop Guinness bottle; a carpet that emitted strawberry scent when walked on; a jukebox playing hits; a large pinboard-type display of advertising images; a reproduction of van Gogh's *Sunflowers* 1888 (the National Gallery of London's most popular poster); a life-sized image of Marilyn Monroe with her skirt blowing up (from the movie *The seven year itch* of 1955); and a large promotional image for the newly released science-fiction film *Forbidden planet* (1956), showing Robby the Robot carrying the film's scantily clad heroine. The exhibition was opened by Robby the Robot – the robot suit was in London as part of the film promotions – although the man inside, reading the opening speech, was somewhat impeded by the suit fogging up. This remarkable assembling of materials and images from popular culture to create a complete environment anticipated much of what was to come in the 1960s. As Alloway prophetically wrote in the press release for the exhibition, '*This is tomorrow* gives a startling foretaste of the diversity and enormous range of the Art of the Future'.[11]

One significant 'future' that came after the Independent Group disbanded was the emergence of British pop art, which seemed to arrive suddenly in the *Young Contemporaries* exhibition of 1961 (held at the Royal Society of British Artists Galleries in London), but whose visual language was anticipated in works such as Hamilton's collage *Just what is it that makes today's homes so different, so appealing?*[12] This was made for the catalogue and one of the posters advertising the exhibition, but even in these low-resolution black-and-white reproductions it proved to be memorable. It was collaged from material gathered by Terry Hamilton and Magda Cordell, largely from John McHale's collection of magazines brought back from the United States, under categories specified by Hamilton: man, woman, food, history, newspapers, cinema, domestic appliances, cars, space, comics, TV, telephone, information.[13]

Even more than Paolozzi's collages, this work has come to be viewed as an index of what was to define pop art's encounter with popular culture: from the erotics of the burlesque pin-up and the muscle man holding the giant lolly with the word 'Pop' on it, to new technologies such as the television and reel-to-reel tape recorder, new domestic appliances like the vacuum cleaner, consumer goods like the television, the view out the window to a movie theatre, and the historical portrait hanging next to the framed romance comic book cover, which predates Roy Lichtenstein's first comic-book paintings by five years. The ceiling of the room has been replaced with a view of the moon, presciently signalling the escalation of the 'space race' between Cold War rivals the United States and Russia. The reproducible nature of this collage is emblematic of pop,

and as the original has seldom been exhibited its fame rests on its frequent appearances from the early 1960s onwards in articles and books, as well as in the restored colour reprints made by Hamilton using new digital technologies in 1992 and again in 2004.[14]

In the United States in the 1950s a number of artists were working with collage within a broader practice and were seeking a greater engagement between art and life in the postwar period. Key amongst these artists were Jasper Johns and Robert Rauschenberg, who in a generational shift reacted against abstract expressionist painting, which was in the ascendency in New York from the late 1940s. Championed by critics Clement Greenberg and Harold Rosenberg amongst others, abstract expressionism emphasised the communication of the artist's inner life through their unique painterly gestures on canvas, making art that was formal and self-referential. It was an art that avoided any connection with the United States' burgeoning popular culture, which Greenberg had famously earlier identified as 'kitsch', a form of debased art for the masses.[15] The abstract expressionist artists were in reality diverse practitioners, but were effectively promoted as a movement and achieved an international standing, which also designated the shift from Paris to New York as the new art world capital, with culture now joining the changed global political and economic world order.

Both Rauschenberg and Johns, in their distinctive ways, moved to incorporate the everyday and familiar into their practice. Rauschenberg often said that he aimed to bridge the gap between art and life, and Johns famously said that at the time he wanted to work with 'the things the mind already knows'.[16] They developed the most important innovations in their practice in the 1950s, when they were involved in an intimate personal and working relationship. Rauschenberg began making 'combines', incorporating aspects of both painting and sculpture, and using readymade materials in 1954–55, just as Johns began working on his first flag painting in 1954 after a unique inspiration: 'One night I dreamed that I painted a large American flag, and the next morning I got up and got the materials to begin it. And I did.'[17]

Rauschenberg 'combined' magazine pages, photographs, newspapers, and found objects from his studio, the streets or junk shops onto canvases and freestanding structures. He often brushed and smeared paint around and over the layered accretions, which can appear gestural but with none of the transcendent intentions of the abstract expressionists. His use of junk materials and deliberately fragmented, messy work could seem the antithesis of slick American postwar consumerism, and yet later in the decade he isolated the collaged mass-media images and devised a transferral process onto canvas. These works became more directly pop in the 1960s, when he moved to screenprinting after seeing Andy Warhol's use of this medium, which still retained a collage effect in juxtaposing diverse images, often on canvas with passages of paint similar to that on the combines.

Rauschenberg had met composer John Cage while studying at Black Mountain College, North Carolina, in 1953, and Cage had encouraged a looseness and engagement with chance in Rauschenberg's art, as well as advocating for the value of engaging with everyday life in cultural practice. Cage was friends with Marcel Duchamp, who lived in New York, and while Rauschenberg did not meet Duchamp until later in the decade, his influence is likely to have initially entered the work of both Rauschenberg and Johns through Cage. There is a literalness to their subject matter that recalls Duchamp's readymades in works such as Rauschenberg's combine painting Bed 1955 (Museum of Modern Art, New York), which incorporates a pillow, quilt and sheet onto a canvas. Rauschenberg's work differs from Duchamp's newly manufactured objects designated to be artworks, as Rauschenberg's second-hand materials always have evidence of their previous lives and the passing of time, of being modestly embedded in history. There is also a sense of readymade subjects in Jasper Johns' paintings of flags, targets, numbers and the alphabet in the 1950s, though Johns' works are resolutely hand painted rather than premade.[18] Johns' paintings famously confuse representation and function: the painted flag is a flag as well as its image, the targets could be used for target practice, the alphabets can be recited and the numbers can be counted.

Johns worked with encaustic, a fast-drying hot wax and pigment medium, which visibly preserved the artist's process of layering brushstrokes to build the surface, often over or incorporating collaged newspaper pages. The obvious materiality of these paintings draws attention to their being objects in the world as much as representations of what they depict, and their complex, layered surfaces also pull back from their apparent realism, heightening the intrinsic abstraction of their subjects: the stars and stripes of the flag, the concentric circles of the targets. The choice of the flag as one of the most loaded symbols in the United States inevitably added to the

perplexing nature of these works, which seemed neither patriotic nor unpatriotic, but both factual and somewhat mysterious. From the time they were first exhibited they sparked critical speculation on the nature of painting and representation; as critic Robert Rosenblum wrote of *Flag* 1954–55 (Museum of Modern Art, New York), it is 'easily described as an accurate painted replica of the American flag, but … as hard to explain in its unsettling power as the reasonable logicalities of a Duchamp readymade. Is it blasphemous or respectful, simple-minded or recondite? One suspects here a vital Neo-Dada spirit.'[19]

Like the alphabet paintings that he began in 1956, the first of Johns' number paintings, *White numbers* 1957, uses a tabular form in a system in which 0 to 9 appear in 11 rows of 11 numbers, preceded in the upper left with a blank square. Johns' choice of subject matter is everyday and even mundane, but his technique and use of this simple system of repetition invests both painting and subject with a surprising gravitas. The practical imperative to read or count the numbers seems at odds with the aesthetic and haptic pleasures of the thick, creamy-white encaustic from which the numbers at times barely emerge. The lusciously textured surface also recalls cake frosting, a more prosaic analogy. It is one of three works that New York's Museum of Modern Art director Alfred H Barr bought for the museum from Johns' striking first solo exhibition at the Leo Castelli Gallery in 1958, when the artist was virtually unknown.[20] This institutional endorsement and the widespread magazine coverage Johns' exhibition received marked the beginning of his international rise.[21]

Rauschenberg was invited to participate in an exhibition in 1962, titled *Dylaby: Dynamisch labyrint*, at the Stedelijk Museum, Amsterdam.[22] The artists involved – Martial Raysse, Niki de Saint Phalle, Daniel Spoerri, Jean Tinguely, Per Olof Ultvedt and Rauschenberg – created room installations to form the labyrinth, which could be entered by either of two doors. Rauschenberg's contribution was a form of cityscape, with a street painted on the floor between large cages of assemblages and a group of clocks running at different speeds. The two combines titled *Dylaby* that Rauschenberg retained as stand-alone works are made of found objects overlaid with passages of paint. The larger is comprised of a tarpaulin partially stretched on the wall as if it were a painting and partially hanging down to the floor like a soft sculpture, over which are collaged an ironing board, a battered Coca-Cola sign, and other objects on an area of white paint; the smaller work is made from a car tyre with part of a packing crate thrust through it, which is loosely painted white, with a black arrow pointing simultaneously in two directions.[23]

Rauschenberg was the only American artist included in *Dylaby: Dynamisch labyrint*, and all but one of the Europeans were members of the *nouveaux réalisme* (new realism) group that had been formed by critic Pierre Restany and artist Yves Klein in 1960. Although Restany rejected the association, the *nouveaux réalistes*' assembling of found, used materials and pursuit of a closer engagement in their art with life had strong affinities with what had become known as neo-dada. In the late 1950s and early 1960s this term was used to describe a range of practices using found materials, collage and even performative elements. While there are some similarities with aspects of dada, these later works did not have the destructive and disruptive spirit of the earlier movement. *The art of assemblage* exhibition at the Museum of Modern Art, New York, in 1961 had mapped the dada and surrealist lineage for contemporary assemblage and collage art, and included 13 works by Duchamp and a room of 30 collages by Schwitters, along with combines by Rauschenberg, works by many of the *nouveaux réalistes*, other Europeans such as Mimmo Rotella and Enrico Baj, and American artists who came to be associated with pop art, such as Marisol and Robert Indiana.

Johns and Rauschenberg had participated in Restany's *Le nouveaux réalisme à Paris et à New York* at the Galerie Rive Droite in Paris in 1961, and in November 1962, after *Dylaby: Dynamisch labyrint*, many of the *nouveaux réalistes* exhibited at the Sidney Janis Gallery in New York, in an exhibition titled *New realists*, which was conceived by Janis as a follow-on from *The art of assemblage*. While Johns and Rauschenberg were not included, Janis had invited a number of young American artists to participate, including Jim Dine, Roy Lichtenstein, Claes Oldenburg, James Rosenquist, Wayne Thiebaud, Warhol and Tom Wesselmann. Restany had thought this exhibition would consolidate the position of the European *nouveaux réalisme* movement in the United States, but instead attention was focused on the work of their American co-exhibitors. A direct engagement with mass media and consumer culture was both the subject and style of their work, a new visual language that made a dramatic debut in this exhibition and the solo exhibitions many of these artists had in 1962. The British term 'pop art' was endorsed for this new type of art in reviews of the *New realists* exhibition, and at a subsequent symposium at the Museum of Modern Art in December. What was to prove to be a global movement now had a name.

Eduardo Paolozzi

I was a rich man's plaything 1947
collage mounted on card
35.9 x 23.8 cm (support)
Tate. Presented by the artist 1971

(opposite)

(top from left)

Meet the people 1948
collage mounted on card
35.9 x 24.1 cm (support)
Tate. Presented by the artist 1971

**It's a psychological fact pleasure
helps your disposition** 1948
collage mounted on card
36.2 x 24.4 cm (support)
Tate. Presented by the artist 1971

(bottom from left)

**Was this metal monster master
– or slave?** 1952
collage mounted on card
36.2 x 24.8 cm (support)
Tate. Presented by the artist 1971

Man holds the key 1950
collage
36.4 x 25.4 cm
Victoria and Albert Collection. Given by the artist

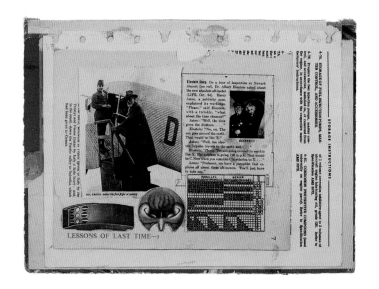

Eduardo Paolozzi

(above, clockwise from top left)

Lessons of last time 1947
collage mounted on card
22.9 x 31.1 cm (support)
Tate. Presented by the artist 1971

The ultimate planet 1952
collage mounted on card
25.1 x 38.1 cm (support)
Tate. Presented by the artist 1971

Windtunnel test 1950
collage mounted on card
24.8 x 36.5 cm (support)
Tate. Presented by the artist 1971

Headlines from horrors ville 1951
collage
25.3 x 39 cm
Victoria and Albert Collection.
Given by the artist

(opposite top from left)

You can't beat the real thing 1951
collage
35.7 x 24 cm
Victoria and Albert Collection.
Given by the artist

No one's sure how good it is 1952
collage
30.5 x 16.1 cm
Victoria and Albert Collection.
Given by the artist

Will man outgrow the Earth 1952
collage
36.3 x 25.7 cm
Victoria and Albert Collection.
Given by the artist

(opposite middle from left)

**You'll soon be
congratulating yourself** 1949
collage
30.5 x 23 cm
Victoria and Albert Collection.
Given by the artist

**Hazards include dust, hailstones
and bullets; Survival** 1950
collage
24.8 x 18.6 cm (each)
Victoria and Albert Collection.
Given by the artist

Sack-o-sauce 1948
collage mounted on card
35.6 x 26.4 cm (support)
Tate. Presented by the artist 1971

(opposite bottom from left)

Merry Xmas with T-1 space suits 1952
collage
38.2 x 28.5 cm
Victoria and Albert Collection.
Given by the artist

Real gold 1950
collage mounted on card
35.6 x 23.5 cm (support)
Tate. Presented by the artist 1971

Yours till the boys come home 1951
collage mounted on card
36.2 x 24.8 cm (support)
Tate. Presented by the artist 1971

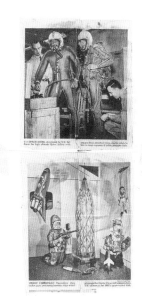

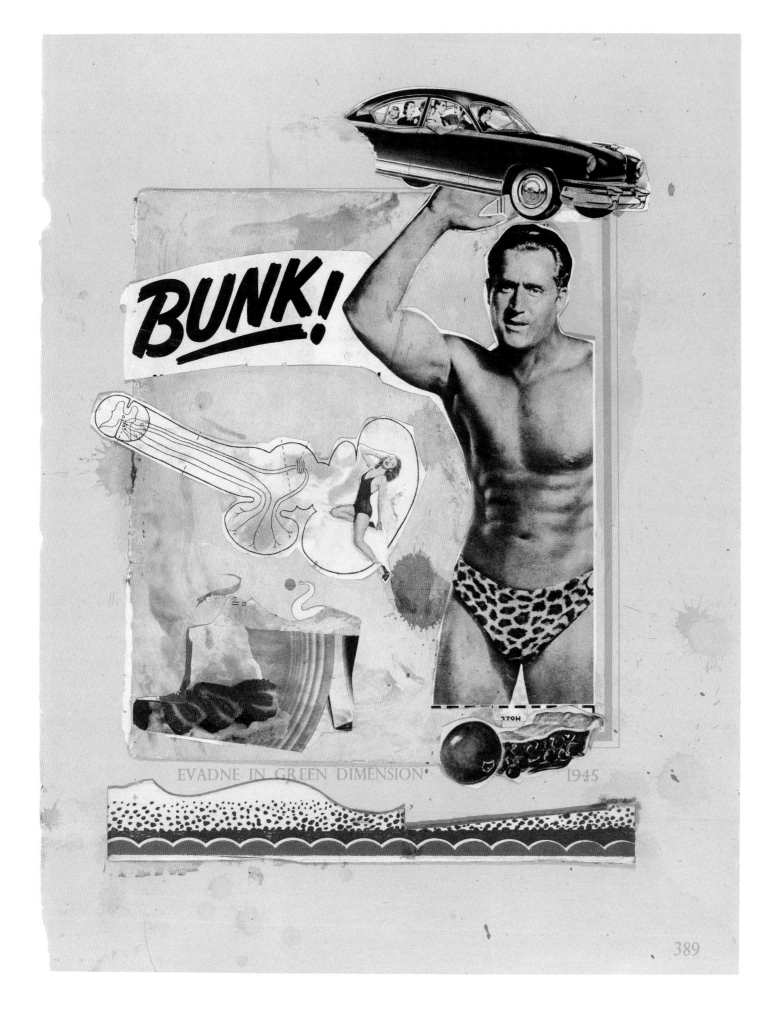

Eduardo Paolozzi
**Bunk! Evadne in green
dimension** 1952
collage, paper glue and string
56.7 x 41.5 cm
Victoria and Albert Collection.
Given by the Artist Copyright Trustees
of the Paolozzi Foundation

(opposite)

Richard Hamilton
Carapace 1954
oil on canvas
41 x 76.5 cm
Queensland Art Gallery, Brisbane.
Gift of Phyllis Whiteman and Josephine Whiteman
through the Queensland Art Gallery Foundation
2004. Donated through the Australian
Government's Cultural Gifts Program

**Just what was it that made yesterday's
homes so different, so appealing?**
Upgrade 2004 [original collage 1956]
Piezo pigment inkjet print
26 x 24.8 cm (image); 41.9 x 29.8 cm (sheet)
The Metropolitan Museum of Art, New York.
Gift of the artist, 2004

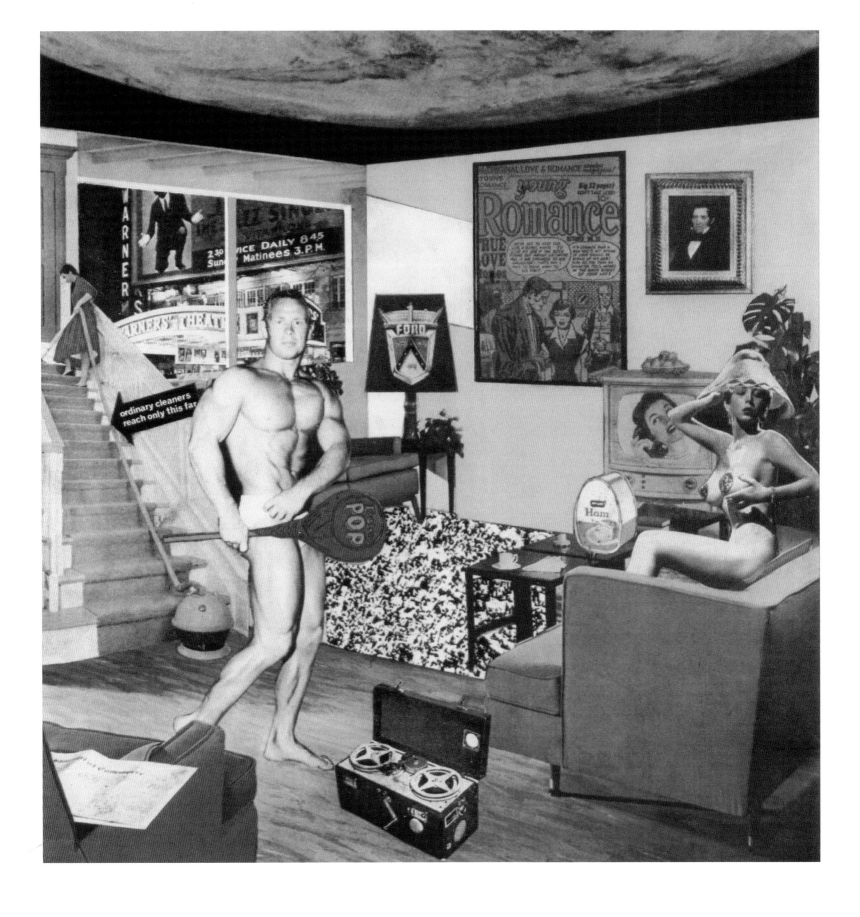

Jasper Johns
White numbers 1957
encaustic on canvas
86.5 x 71.3 cm
The Museum of Modern Art, New York.
Elizabeth Bliss Parkinson Fund 1958

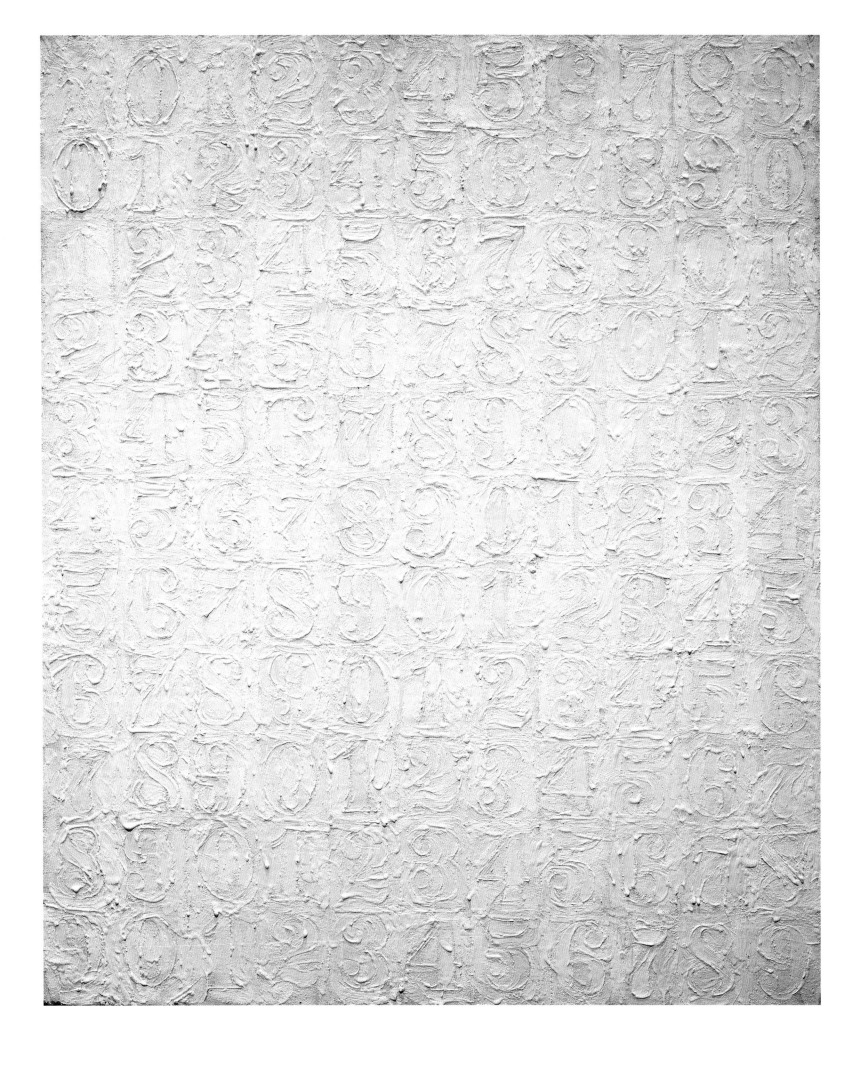

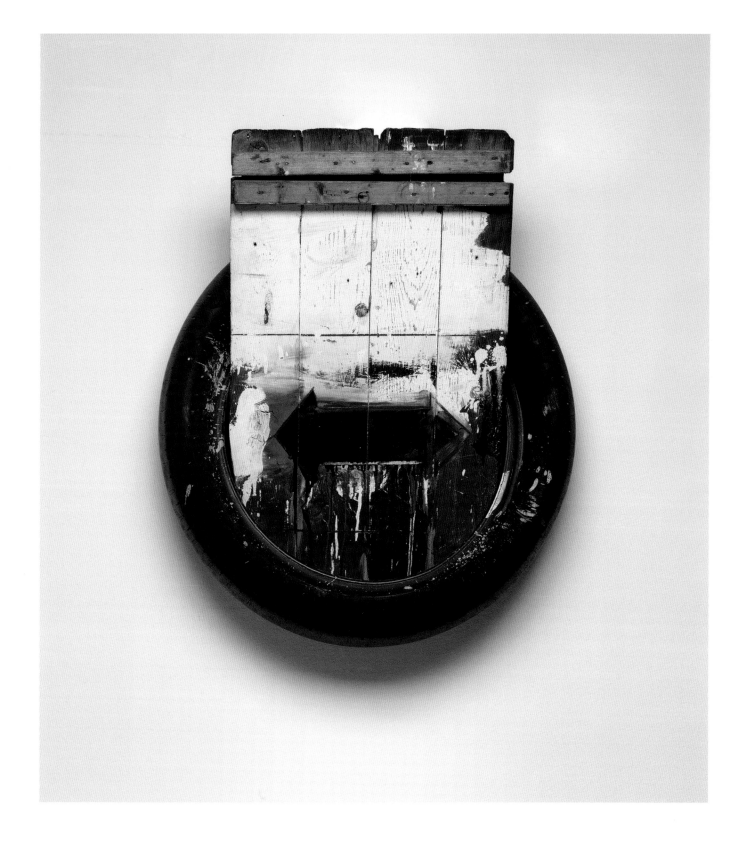

Robert Rauschenberg
Dylaby 1962
oil on rubber tyre and packing case timber
with iron nails
62.2 x 55.9 x 33 cm
Art Gallery of New South Wales, Sydney.
John Kaldor Family Collection

Robert Rauschenberg
Dylaby 1962
oil, metal objects, metal spring, metal
Coca-Cola sign, ironing board, and twine
on unstretched canvas tarp on wood support
278.1 x 221 x 38.1 cm
Robert Rauschenberg Foundation

(opposite)

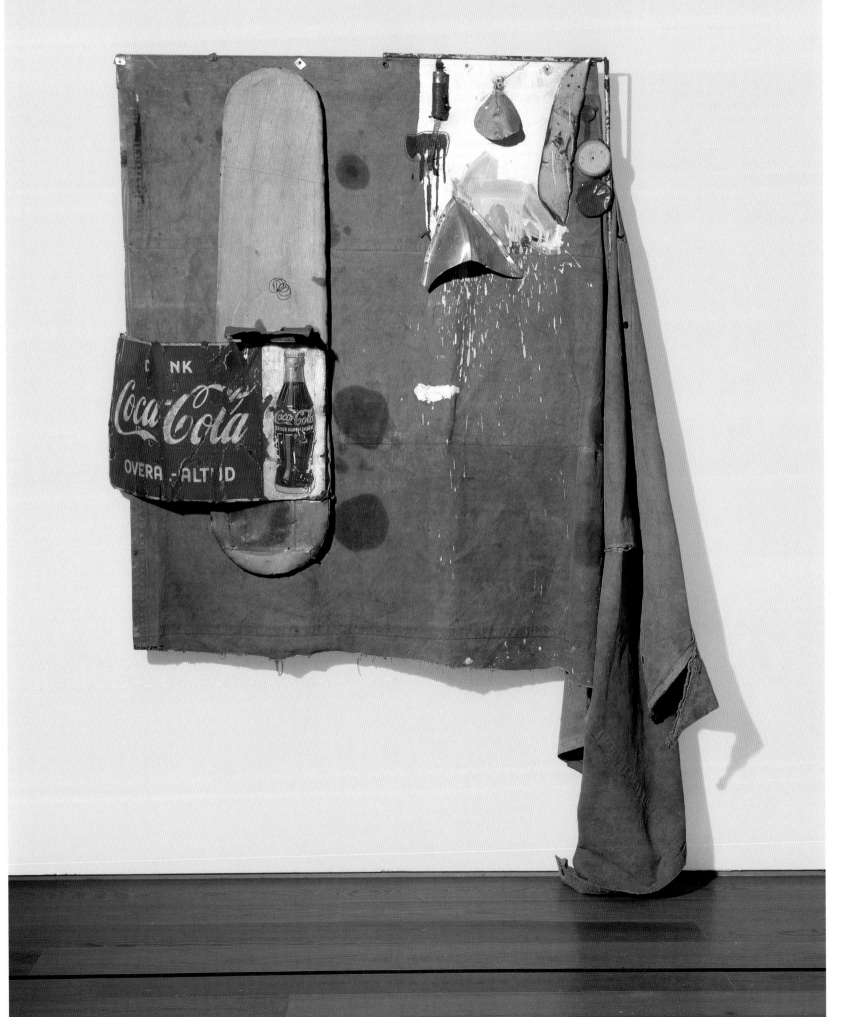

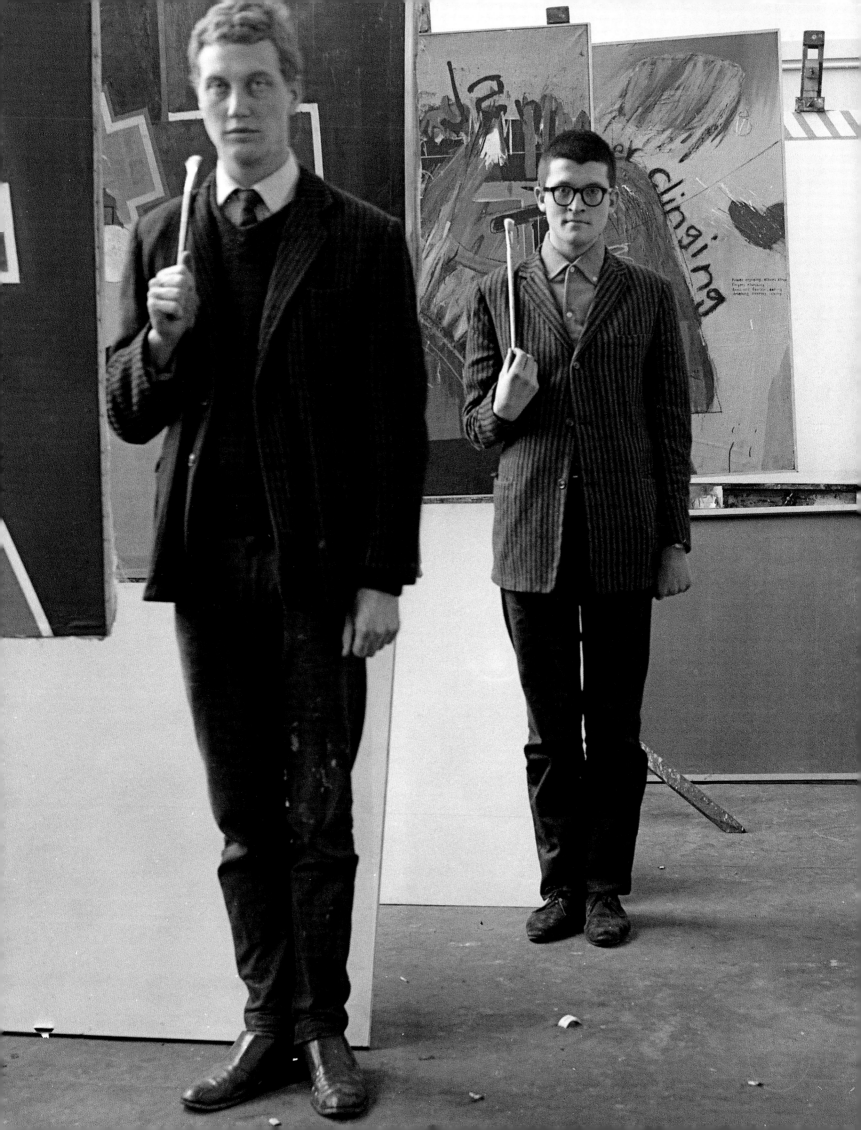

Michael Desmond

WHEN BRITAIN WENT POP

BRITISH POP ART

Derek Boshier (left) and David Hockney at the Royal College of Art, London, c1961

Pop art in Britain arrived with the *Young contemporaries* exhibition held in 1961 at the Royal Society of British Artists Galleries in London. This exhibition famously announced the coming of a new generation of British artists: Derek Boshier, Pauline Boty, David Hockney, Allen Jones, RB Kitaj, Patrick Caulfield and Peter Phillips, all students or former students at the Royal College of Art, London, who showed work that was attention grabbing and distinctively new. It was almost as if before 1961 Britain resembled an LS Lowry cityscape, bleak, grey and worried; and after 1961 it was Carnaby Street and the 'swinging sixtics'. In art, the Independent Group, founded in London in 1952, was an important precursor to this shift. The group fostered a multidisciplinary milieu that brought together painters, sculptors, architects and writers who believed that integrating elements of popular culture into fine art and architecture might enhance its appeal and relevancy in the postwar era. Their discussions prompted writer and critic Lawrence Alloway – a member of the Independent Group – to suggest that the 'definition of culture is being stretched beyond the fine art limit imposed on it by Renaissance theory, and refers now ... to the whole complex of human activities ... The new role for the fine arts is to be one of the possible forms of communication in an expanding framework that includes the mass arts.'[1]

Members of the Independent Group, like so many Britons, were fascinated by the crassness and glamour of American culture, and its impact on the United Kingdom. After years of privation, Britain was starting to recover from the effects of the war, and people were looking for luxury. A new generation responded to the return to prosperity with optimism and a desire for change. The direct contact with Americans during the war was part of this, providing an insight into an alternative society, but it was also a general loosening of ties with the past and dissatisfaction with restrictions of the class system. In the search for a way out of the romantic but stodgy conventions of the mainstream in Britain, American popular culture was perceived as 'more imaginative and more proficient ... more fully industrial', and as Alloway noted, 'This, and not nostalgia for another place, made it attractive'.[2] Novelists and playwrights – the 'angry young men' as they were named – expressed critical views of Britain in print, on stage and on television. Kingsley Amis' *Lucky Jim* (1954) and John Braine's *Room at the top* (1957) both reflect a popular desire to transcend the stuffiness of the past and negotiate a new future, which was also manifest in British new wave cinema.[3] The pill, first introduced in 1961, was a further instrument of change, with implications for traditional gender roles. It felt like a time of transition.

'It was as though everything was being invented,' said Peter Blake. 'It was only a little more than 10 years after the war, and everything was new – television was young, theatre was exciting, cinema was exciting. There were all the new immigrants and places like Portobello Road were springing up. It was vibrant, and to be there was marvellous.'[4] Eduardo Paolozzi, Richard Hamilton and the members of the Independent Group wanted art to reflect the present, and drew on the visual design of commercial art as more telling than the already historical imagery of fine art. In the 1950s Paolozzi moved from an expressionistic 'art brut' approach to sculpture, and began assembling his new works from the components found in his environment. *Markoni capital* 1962 is a disturbing example of this methodology. Individual components – found objects, such as pulley wheels, tool boxes, storage lockers – are stacked and cast in gunmetal and brass to form a single entity that reflects the industrial environment of twentieth-century culture. Paolozzi painted many of his sculptures in bright colours, but this work retains the brutal machine look in its uniform finish. There is a hint of factory smokestacks at the top of the form, which is architectural, yet the sculpture retains a menacing potential for animation, a robotic being with a questionable relationship to humanity. Paolozzi's machine anxiety has its roots in the atomic age of the 1950s, as does his use of assemblage as a means of constructing sculpture. Like the generation of younger pop artists that followed, he tries to make sense of a world made of fragmented parts that feel welded together rather than organically evolved.

Richard Hamilton also played off commercial design with fine art, and his collage *Just what is it that makes today's home so different, so appealing?* 1956 (Kunsthalle Tübingen, Germany) suggests that this marriage of high and low culture would be the appropriate direction for British art. In part this was to reflect the realities of the world as seen from a postwar perspective, but it was also in response to the high-art abstraction of the New York School, which was seen as the most progressive art in the 1950s. Major exhibitions of contemporary American art had been held at the Tate Gallery in 1956, including *Modern art in the United States: a selection from the collections of the Museum of Modern Art, New York*, and these were followed up in 1959 by *The new American painting*; both exhibitions were a showcase for the abstract expressionism work of the New York School. Hamilton was less interested in how American painting expressed

profound emotional states and more interested in the way American culture – the bombardment of colour and messages in film and television, magazines, music and advertising – impacted on the individual. His response was both as a fan and a critic.

In his collages and paintings, Hamilton arranged fragments of consumer culture to exploit the devices of marketing with a sly wit. *Adonis in Y fronts* 1963 celebrates the sophisticated design of advertising, while poking fun at its transparent flattery, in a work that couples the body beautiful with the purchase of a chest expander and a pair of underpants. His screenprint *My Marilyn* 1965, on the other hand, put a different twist on the marriage of body image and consumption, by adapting a series of photographs taken by George Barris that appeared in *Town* magazine in 1962, shortly after the tragic death of Marilyn Monroe. The composition consists of photos that Marilyn had either approved or crossed out, which he altered in colour and size to reveal how Marilyn herself was aware of her 'brand' and how it was sold. Images are in both positive and negative to make this point. The blue, pink and yellow colours are appropriately lurid and eye catching, but also refer to the palette used in Willem de Kooning's *Women* series of the early 1950s. There is an intimacy about colours that may be a reaction to Andy Warhol's searingly bright colourways and stock glamour image used in his Marilyns, made a few years earlier in 1962.

Hamilton's work was known to younger artists through the Independent Group, and his figurative practice was an example to the upcoming generation, which sought an alternative to abstraction and traditional romantic realism. Peter Blake was another exemplar, but less remote than Hamilton in age and seen as part of the new generation of painters, which included Peter Phillips, Derek Boshier, Pauline Boty, David Hockney, Barrie Bates (now known as Billy Apple), Allen Jones and RB Kitaj among others. The *Young contemporaries* exhibition was recognised as a vibrant change of pace in British art and a counter to non-representational image-making, then considered the most avant-garde contemporary style. This display was a breakthrough moment for most of the artists and it established them within the UK art scene. Though the term 'pop art' had been used in the 1950s in association with the work of Hamilton and Paolozzi, it now began to be applied to these artists.[5] However, the group was hardly uniform: indeed, it was an eclectic and highly individualistic fraternity. If they had one thing in common it was that despite transatlantic ambitions, the artists were consciously British at a time that Britain became the initiator of popular culture in music, film and fashion.

Peter Blake's paintings cannot be mistaken for American works; they are resolutely defined by local references. In *Self-portrait with badges* 1961 Blake uses American clothing and music to show his American allegiances, but it is the United States of America seen from afar. The Union Jack and other symbols of British culture appear frequently in his work, as in the work of the other Britons. His *The first real target* 1961 has American art, specifically the work of Jasper Johns and Kenneth Noland, as its target. Blake counters Noland's abstract and Johns' delicate, handcrafted 'target' paintings with a home-grown, store-bought target. British pop can be whimsical, and it flirts with neo-dada in its use of assemblage and the readymade object. Blake's work is almost always nostalgic, the quaintness and Victorian-music-hall feel finding full bloom in his design for the album cover for The Beatles' *Sgt Pepper's Lonely Hearts Club Band* in 1967.

In his work *Drinka pinta milka* 1962, Derek Boshier employs not only the Union Jack but also the catchy local slogan 'Drinka pinta milka day', which was written by the Milk Marketing Board and appeared in television ads, plastered over billboards, and on the sides of buses and milk bottles in the 1950s and early 1960s. The slogan is teamed with the Cadbury 'glass-and-a-half of full-cream milk' image for their brand of chocolate, and a few bars in the distinctive purple wrapper are also included. Boshier, while in National Service before entering art school, had read Marshall McLuhan's pioneering investigation of popular culture *The mechanical bride* (1951) and Vance Packard's *The hidden persuaders* (1957), and he was able to unravel the power of visual inducements in advertising. Joe Tilson – who was a student at the Royal College in the early 1950s with Peter Blake, Richard Smith and Bridget Riley – similarly exploited the language of advertising and graphic design, as his *Nine elements* 1963 demonstrates. He was influenced by American art during the mid 1950s but found his own voice when he drew on previous experience as a carpenter and joiner, making wooden reliefs in the early 1960s that incorporated bright colours with a strong sense of design to create what were unmistakably objects.

A great deal of the appeal of pop art was in its immediacy – the youthful artists were not painting for an elite and their works tended to be direct, the references local and contemporary, the style hip and immediate. Peter Phillips in particular identified with youth culture, using jukeboxes,

pin-ups, teen idols, pinball and board games, fast cars, and motorbikes as source material for his works, usually combined with abstract elements. With *Motorpsycho / Tiger* 1961–62 Phillips moved away from the tight compositional grids dictated by the board games he referenced and began to float larger images within looser compositions. In this painting a helmeted figure sits above a diagram of engine parts, specifically the coveted V-twin JAP engine used in cafe racers, and a menacing tiger emblem sits against a black leather jacket. Abstract shapes, decorative yet suggestive in their resemblance to the guardrails on tight bends, imply a narrative of speed and danger.

David Hockney made numerous changes in style during the 1960s but maintained a connection with pop art, at least in the mind of his admirers. In part this was due to his early celebrity as one of the 'young contemporaries', but equally his use of a fey figuration. His early works seemed to blend figurative elements of paintings by Francis Bacon and Jean Dubuffet with abstract-expressionist gestures and graffiti-like handwritten texts. The gay content of many of his early works was intended to shock at a time when homosexuality was outlawed, but outrage was diffused by a *faux-naïf* veneer and redeemed by his wit and mercurial visual intelligence. *We two boys together clinging* 1961 is an example of this, with its punning reference to a headline about two stranded youths clinging to a cliff all night at a time when Hockney was infatuated with Cliff Richard. The number '4.2' on the canvas is simple code for 'DB' or 'Doll Boy', a link to Richard's hit song 'Living doll'. The rhomboidal structure of Hockney's *The second marriage* 1963 makes a visual pun with the conventions of depicting depth, 'the illusionistic style' as he called it, while simultaneously affirming flatness, reflecting his innate sense of composition and scaffold of draftsmanship. He was immediately successful: his 1963 solo exhibition at the prestigious Kasmin Gallery sold out and he was already a regular in the social pages. Moving to California in January 1964 prompted a change from oils to acrylic paint, flat tones and mannered naturalism that attracted more patrons.

Allen Jones was at the Royal College with Hockney, Kitaj, Boshier and others later associated with the pop movement. Unlike the others, he was expelled – for 'excessive independence' – but still showed in the milestone 1961 *Young contemporaries* exhibition. Like his colleagues he used figurative material taken from urban streets and cities; for example, a series based on London buses. His subject matter was broadly interpreted to be near abstract, painted in vivid colours, often on shaped canvas. A suite of earlier paintings, including *Reflected man* 1963, show male and female figures entwined, expressing his interest in the ideas of Carl Jung and Friedrich Nietzsche, while interestingly paralleling the challenges to traditional gender roles in the 1960s, catalysed by the rise of women's liberation and, to some extent, gay rights. Taking these ideas further, Jones' later work drew on girlie magazines and fetish illustrations, making eroticised images of women that ended up antagonising a changed society. His women-as-furniture series, *Hatstand*, *Table* and *Chair* of 1969 (Ludwig Forum, Aachen) was attacked with stink bombs when shown at the Institute of Contemporary Arts, London, in 1978.

American-born RB Kitaj studied in Vienna and at Oxford before joining Hockney, Jones and Boshier at the Royal College of Art in London. His works, like those of other artists also associated with pop, were first seen as being against a fine art tradition, but Kitaj's work is steeped in history. For his paintings he borrows images found in magazines, but rarely those of advertising or glamorous film stars like his peers; Kitaj chose instead to select art-historical referents or thinkers and activists as his subjects. His work is often complex and has been seen by critics as more literary than visual. His loose brushwork, bright colours and fragmented compositions create narratives very unlike American pop. Kitaj didn't welcome the appellation 'pop' for his work, suggesting in 1976 an alternative in the 'School of London' that included Francis Bacon, Lucian Freud, Frank Auerbach, Leon Kossoff, himself and numerous others.

While Kitaj self-consciously grounded his work in art history, many artists questioned the authority of tradition and what painting or sculpture might be, as part of a broader spirit of change. Many artists were excited by the challenge of creating work to reflect society in a new way, producing zany, poignant, witty or brash works. Artists such as Gerald Laing, Patrick Caulfield, Antony Donaldson and Jann Haworth, also associated with British pop, made remarkable works. And the rise of the new generation sculpture, built around Anthony Caro, Phillip King and others coming out of St Martin's is another part of that story. Not all reputations last, however, and many artists, apparently important and influential at the time, are now all but forgotten.

Pauline Boty was, until recently, one such figure. Boty enrolled at the Royal College a year earlier than Boshier, Phillips and Hockney, and was also their friend. She appeared with Blake, Boshier

and Phillips in a 1962 BBC production *Pop goes the easel*, directed by Ken Russell, confirming the identification of the new art with the name 'pop' and as an emerging trend, as well as demonstrating its general media appeal. Beautiful, talented and clever, Boty played both 'dolly bird' and agent of social change, to all appearances the face of the new generation. Her paintings and collages reflected an awareness that this was a significant moment of change, and Boty described pop art as 'nostalgia for now'.[6] Her paintings featured film stars such as Marilyn Monroe, but also male heart-throbs including Jean-Paul Belmondo. Her work referred to contemporary events – Monroe's suicide, Kennedy's assassination, the Profumo affair. She appeared in film, plays, on television and was photographed by Lewis Morley and David Bailey. But in 1966, at the age of 28, with success on her doorstep, she died of leukaemia, just weeks after the birth of her daughter. Her work wasn't shown again until 1993, when its vitality and significance was recognised.

In the mid 1960s British pop splintered and the artists went their own ways. Britain had changed. No longer was it a place of war-time privation but a world cultural centre, and pop art had played a role in that evolution. Artists had moved away from portraiture and landscape, the twin pillars of British (and Australian) art, and while negotiating their own accord with abstract expressionism were impelled to take on brighter colours and popular imagery as part of a greater dialogue with American, rather than French, influences. Pop art was seemingly committed to exploring and blurring the boundaries of 'high' and 'low' culture, even as they were refashioned by advertising, film, television, fashion and rock music. Artists had embraced a mass-media society and responded in kind, using the tropes of a consumer society and playing them back to an increasingly sophisticated audience. Pop artists in Britain appropriated the popular clichés of film, television and advertising but noted, in a world flooded with commercial imagery, the impact on the individual imagination.

British pop did not endure as well as the American version. The individualism of those associated with the movement ensured that each artist took separate pathways. Lawrence Alloway has suggested that British pop was an oppositional response to an established aesthetic, always qualified by its relationship to painterly abstract art.[7] He further identified pop with a revitalising of figurative art in the United Kingdom but added that British artists had a tendency to adapt and moderate ideas: 'It may be due to this tendency of the British to modify ideas, to assimilate prudently, to balance forces, to postpone full commitment, that the English Pop Art does not possess the density and rigor of New York Pop Art. The English Pop artists were historically prompt ... but some fear of being simple ... seems to have blocked the full realisation of the style, diverse and rich as the area is.'[8] American critic Thomas Hess stated that British pop, 'in contrast to the vibrant openness of the US version, was not just "bookish" but actually "looking" as if made by librarians'.[9] British pop was nonetheless lively and witty. It both signalled and aligned with the changes that were happening in British society, encouraging a broader audience for art in its reflection of the everyday.

While not all of the lofty ambitions of the 1960s were realised, Britain remained the generator for popular culture for decades, taking a leading place in new trends in fashion, music, film and literature. New York may have stolen the art crown from Paris but the upsurge of creativity in London was the beginning of the decentralisation of cultural production. Many of the British pop artists went on to forge international careers, David Hockney being perhaps the best known. The impact of 'swinging London' was truly international, and the close connections between Britain and Australia ensured that this had great influence in this country.[10] As Robert Hughes noted at the end of the 1960s: '"The fact is", one painter said to me in 1966, "you can't begin to grow up until you've left the place".'[11] Many notable Australians 'grew up' in London.[12] The city offered great benefits as a testing ground for unproven Australian talent and the expatriates connected Australia with the source of emerging international trends.

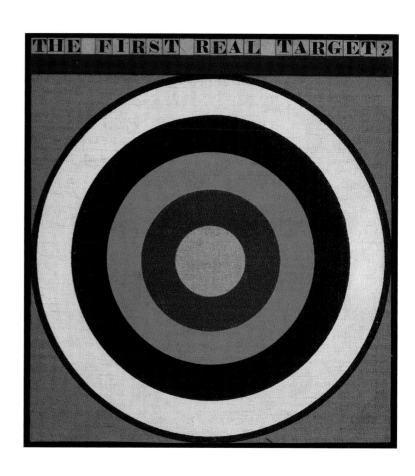

Peter Blake said that he became an artist by chance. While studying at the Gravesend Technical School in Kent he took a routine drawing examination, not realising that this made him eligible to spend half of his time in the school's art department and later at the Gravesend School of Art. It was a life-changing moment for the boy from a working-class background with little interest in art. 'My branch of Pop Art came out of my time there,' he recalled. 'During the day, you were being taught about ... Cezanne, then in the evening I was heading to the local jazz club, the wrestling, football on Saturdays. I was coming from one culture and learning another, but retaining my own.'[1] The sophisticated interweaving of these two cultures in his art – the high-art world of his studies and the popular one of everyday life – made Blake one of Britain's pioneering and most distinctive pop artists.

On the surface Blake's art seems a straight-forward and affectionate celebration of popular culture, an art that springs from boyhood enthusiasms, with the artist in the role of a fan. His early works have the quality of pop icons,

their subjects being entertainers, boxers and circus performers; there is a strong element of nostalgia in them. Yet these are deceptively simple images. Blake's reworking of popular culture is often coded and referential. 'Everything he makes is part of a larger commentary on the world as he sees it,' a friend noted, 'it is strategic, contextual, an art of positioning'.[2]

Self-portrait with badges 1961 is a fine example of this positioning. Blake was 29 when he painted it, but he looks older in the work. He had grown a beard to cover facial scars from a bicycle accident many years before. Blake was not confident about his appearance and this awkwardness is apparent in the work. This image is said to be one of the 'determined rebel ... flaunting his obsessive love of pop by clutching an Elvis fanzine'[3]; yet it is a painting full of irony. Blake made few self-portraits, and he took great pains with this one, working long hours on it between June and September 1961 in the studio he shared with Richard Smith in London. The composition was influenced by Watteau's melancholic figure of Pierrot, which Blake had seen in the Louvre.

Festooned with badges and clutching a fan magazine, a vulnerable and already aging Blake seems to pin his identity on the United States of America's vibrant youth culture, widely promoted at the time through cinema, music and fashion. Yet as he did with his painting *The first real target* 1961, alluding to Jasper Johns' early target paintings, Blake pays tribute to American culture while also positioning himself at variance to it. The broken fence and the sketchy, untidy elements of the landscape, along with the figure of Blake himself, evoke another tradition, the intimate one of British landscape art and portraiture, making this painting 'one of the most conceptually layered' of the artist's early works.[4] SM

Peter Blake
The first real target 1961
enamel on canvas and paper on board
53.7 x 49.3 cm
Tate, purchased 1982

Peter Blake
Self-portrait with badges 1961
oil paint on board
174.3 x 121.9 cm
Tate. Presented by the Moores Family
Charitable Foundation to celebrate the
John Moores Liverpool Exhibition 1979

(opposite)

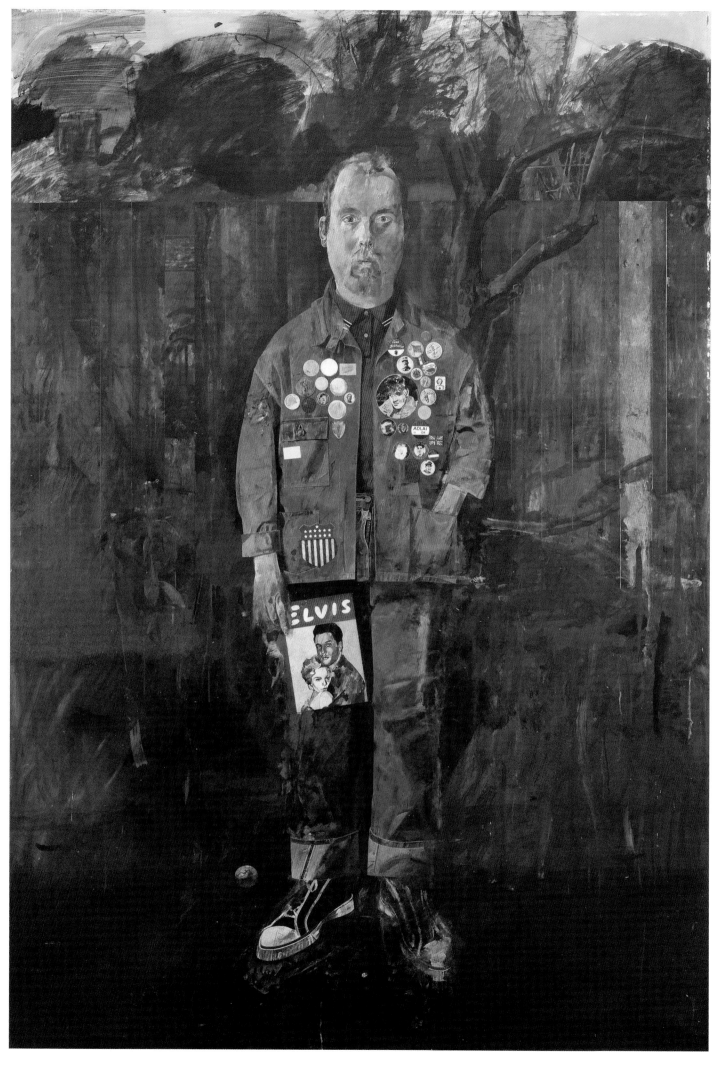

DEREK BOSHIER
Drinka pinta milka 1962

'Drinka pinta milka day' was a 1950s British advertising slogan for milk ('drink a pint of milk a day'). It became so popular that campaigns from the 1960s onwards have continued to use the invented term 'pinta' as a synonym for milk – 'She's a pinta girl' and 'A pinta only costs a shilling'. Like many of Derek Boshier's early 1960s paintings, *Drinka pinta milka* 1962 is a satire of Americanisation and advertising. In contrast to his contemporaries Boshier eschewed the glamour of popular culture for a cool critique of consumerism, citing journalist Vance Packard's groundbreaking book on the manipulative techniques of advertisers, *The hidden persuaders* (1957), as a seminal influence.[1] His 'identikit' men – the white, paper-doll-like figures that populate Boshier's paintings – refer to the dehumanised individual in consumer society.

In *Drinka pinta milka*, a gargantuan glass pours a waterfall of milk over half a dozen of these diminutive men, as well as a Union Jack flag and two bars of Cadbury Dairy Milk chocolate. A second stream of milk joins it, resembling the famous Cadbury 'glass-and-a-half' logo, and the resulting milky deluge threatens to sweep away everything in its path – men, products and flag tumble down and out of the lower edge of the canvas. To the left of this chaos, a tower of bodies, like an athletic human pyramid, perhaps alludes to the nutritious, energy-giving qualities of milk, as emphasised in the 'pinta' advertisements through the use of sportspeople and active 'everymen'. The red, white and blue colour scheme, which Boshier used in many of his works of this period, echoes the Union Jack, as well as the stars and stripes of the American flag. 'A lot of Pop artists embraced American culture,' he later reflected, 'but mine was a critique of it actually.'[2]

In the same year that he painted *Drinka pinta milka*, Boshier appeared in the British television documentary *Pop goes the easel*, alongside fellow students from the Royal College of Art, Peter Blake, Pauline Boty and Peter Phillips. In the film Boshier spoke at length about the insidious nature of advertising and Americanisation in Britain; however, the gentle sarcasm of his comments was lost in the film's stylish portrayal of the four artists as fashionable youth, enamoured of popular culture.[3] The final scene, for instance, shows all four painters joining in the twist at an art school dance party. JT

Derek Boshier
Drinka pinta milka 1962
oil on canvas
152.5 x 121 cm
Royal College of Art, London

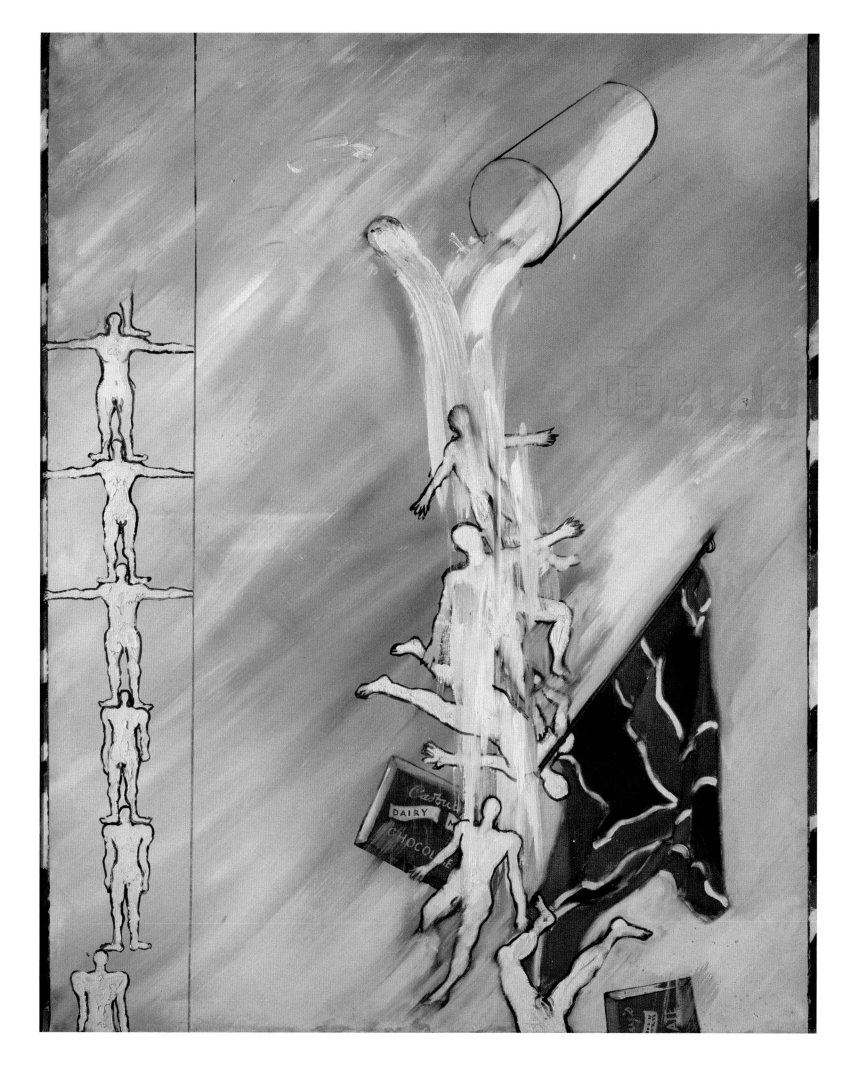

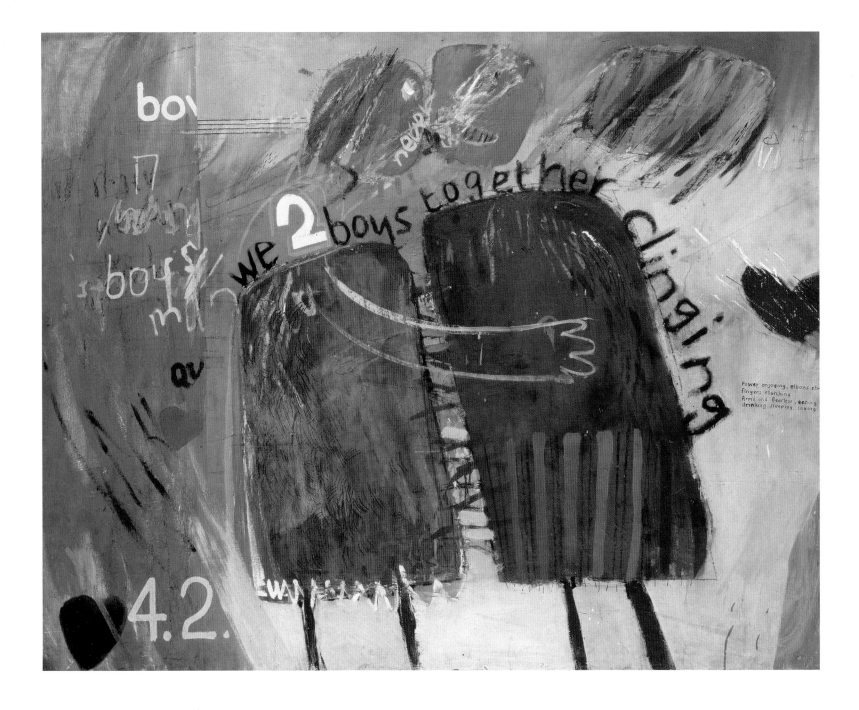

David Hockney
We two boys together clinging 1961
oil on board
121.9 x 152.4 cm
Arts Council Collection,
Southbank Centre, London

Peter Phillips
Motorpsycho / Tiger 1961–62
oil on canvas with lacquered wood panels
205.5 x 150.5 cm
Private collection

(opposite)

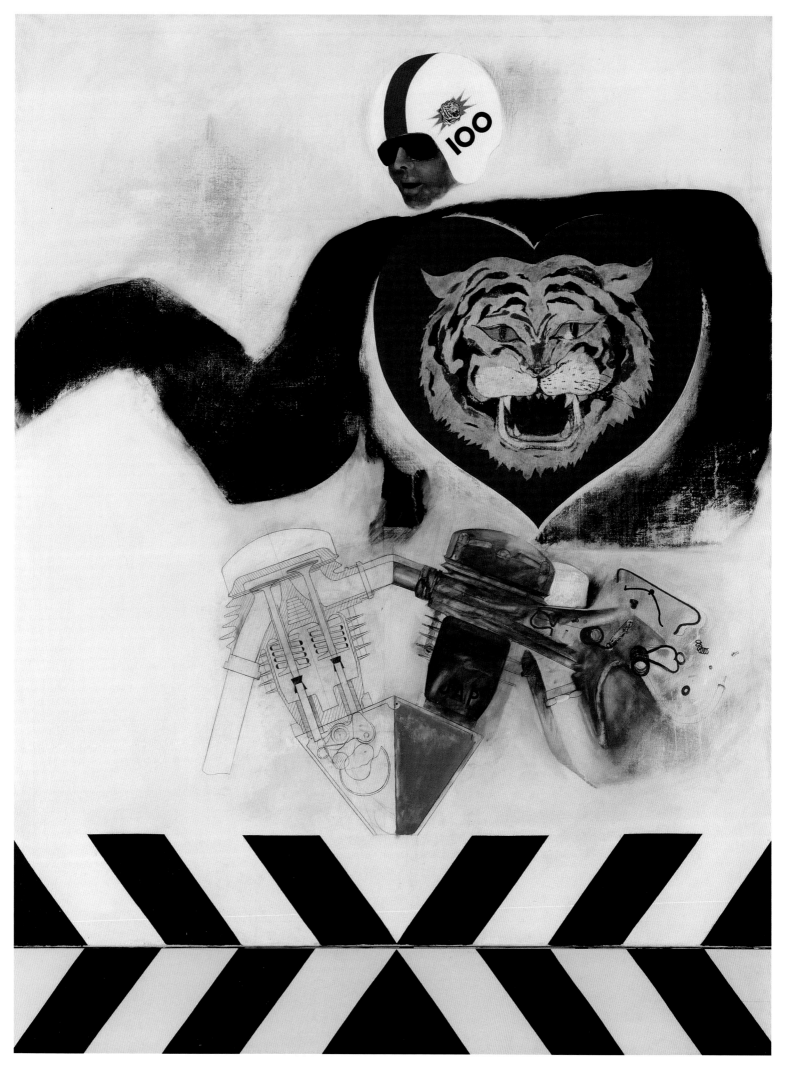

David Hockney
The second marriage 1963
oil, gouache and collage of torn wallpaper
on canvas
197.8 x 228.7 cm (irreg)
National Gallery of Victoria, Melbourne.
Presented by the Contemporary Art Society
of London, 1965

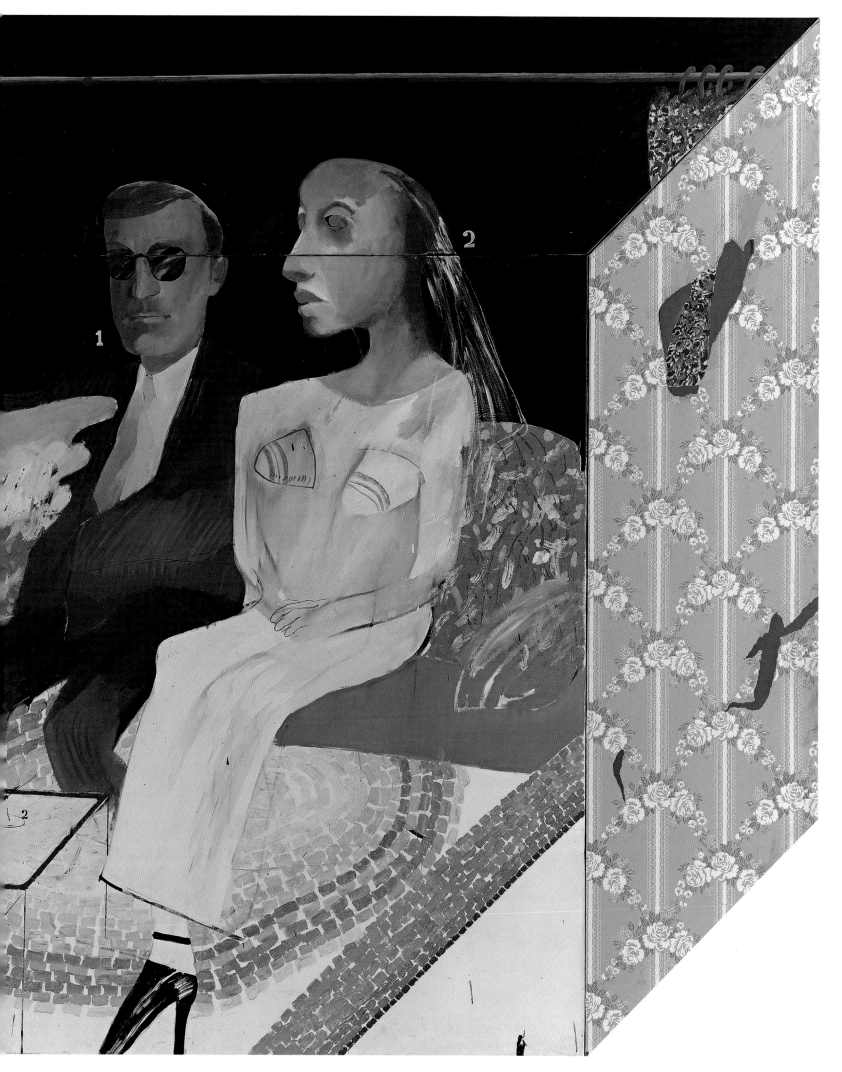

It is not my intention to create a picture consisting of merely literal references to things outside the area of the canvas.

Allen Jones, 1962[1]

Reflected man 1963 was shown at the Art Gallery of New South Wales (and other Australian galleries) in 1967, as part of the touring exhibition *Aspects of new British art*.[2] In the accompanying catalogue curator Jasia Reichardt detected 'a new attitude of vitality' in British art of the preceding decade. The three works by Jones included in the exhibition all dated from the early 1960s, when the artist was toying with the line between abstraction and figuration, or as Reichardt described it, 'a continuous process of metamorphosis between image and form'.[3] Influenced by abstract painters of the early twentieth century, including Robert Delaunay and Wassily Kandinsky, Jones developed a vocabulary of searing, vibrant colour in soft-edged patches to describe everyday objects and figures in an abstracted manner.

Reflected man seems to depict a figure in a domestic setting, reflected in a mirror. The prismatic effects of the mirror are suggested in the rainbow-like diagonal lines that run in a band down either side of the man. These lines provide an abstract foil for the figure within, which is itself enigmatic and elusive. Composed of a patchwork of colour, the man appears to dissolve into the background, or emerge from it, such that the viewer's eye constantly moves between the surface of the canvas and the illusion of the painted figure. On either side of the mirror a panelled wall is only half painted, and again our attention is drawn to the flatness of the painting, rather than the object represented therein.

This tension between surface and image, paint and subject, abstraction and representation was, according to Jones, a response to the challenge posed by abstract expressionism. In 2013 he recalled this early work: 'for me, at that time, I could see that the march in modernism was toward abstraction ... I could see this emptying out of content had a logic to it, how the pictures became about their own making, but I could not abandon the figurative reference, I just couldn't.'[4] Jones cited the works of American painter Larry Rivers, a pop precursor, as a catalyst for his solution to combining abstraction and the figure. Rivers' paintings alternate pictorial elements, often taken from magazines and other mass media, with passages of rough expressionistic brushwork. But in paintings like *Reflected man* Jones deconstructed the figure itself, such that it is never quite reunited on the canvas – the arm, for instance, floats in a disjointed manner, slightly away from the torso. Limbs and the spaces between them are confused, as are shadows and reflections, in an ever-moving puzzle of representation. JT

Allen Jones
Reflected man 1963
oil on canvas
152.4 x 182.9 cm
Arts Council Collection,
Southbank Centre, London

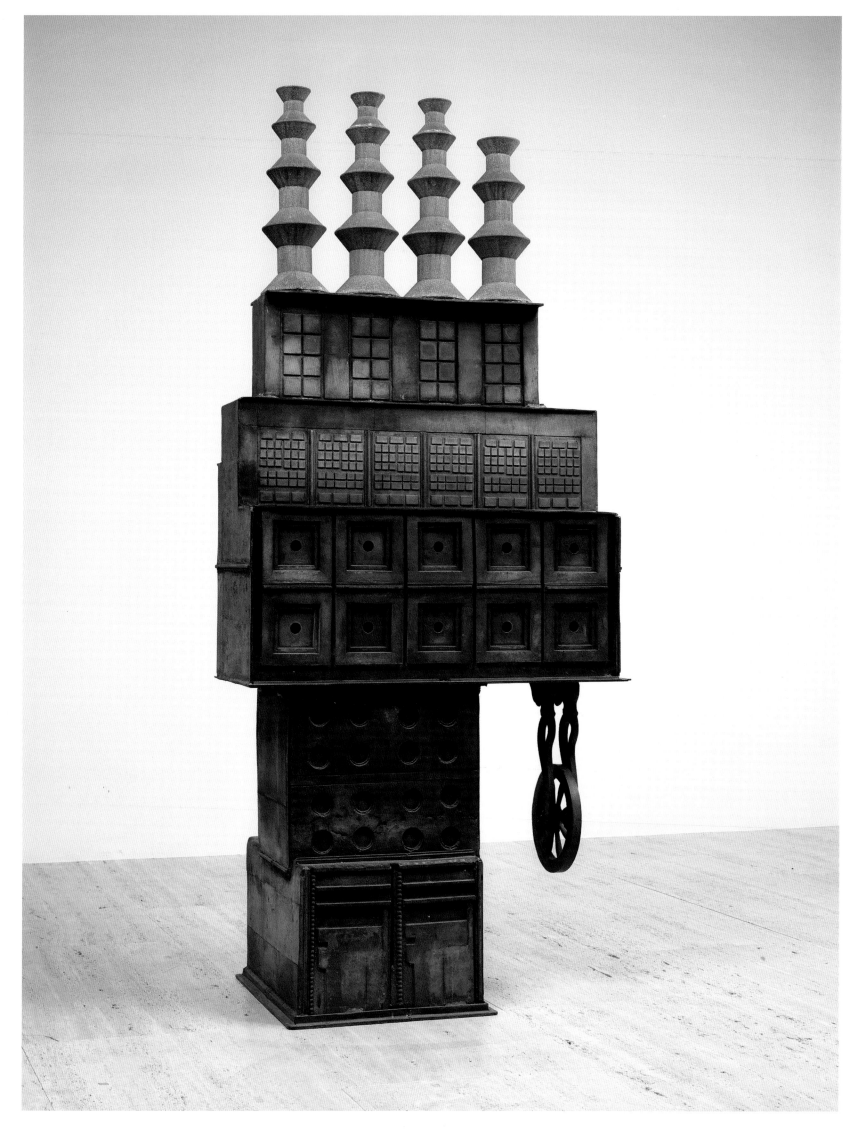

Eduardo Paolozzi
Markoni capital 1962
gunmetal and brass
226.7 x 98.5 x 67.3 cm
Art Gallery of New South Wales, Sydney.
Gift of Gabrielle Keiller 1985

(opposite)

Joe Tilson
Nine elements 1963
mixed media on wood relief
259 x 182.8 cm
Scottish National Gallery of Modern Art,
Edinburgh

Richard Hamilton
Adonis in Y fronts 1963
screenprint
69.2 x 84.8 cm
National Gallery of Australia, Canberra,
purchased 1982

(opposite above)

Richard Hamilton
My Marilyn 1965
screenprint
51.7 x 63.2 cm (image); 69 x 84.3 cm (sheet)
National Gallery of Australia, Canberra,
purchased 1974

(opposite)

As a young art student, David Hockney grappled with issues of identity, both artistic and personal. He had a natural talent as a draughtsman and was drawn to the figurative at a time when abstraction was fashionable. Gay and from a working-class provincial family, he feared that this also would set him apart. Fortunately he found support for his interest in the figure from Francis Bacon, a visiting tutor at the Royal College of Art. Poets he read at the time, as well as fellow art students, encouraged him to be more confident about his homosexuality, at a time when barriers of class and sexuality were gradually being eroded in England.

The works Hockney painted in the years from his enrolment at the Bradford School of Art in 1953 to his diploma show at the Royal College of Art in 1962 trace an artist in a period of self-discovery, not yet having found his voice. A group of paintings he exhibited under the title *Demonstrations of versatility* illustrates this, with subjects painted in diverse styles, showing influences from Jean Dubuffet to Picasso, and even Egyptian art. Some believed that Hockney would become primarily a pop artist, particularly after he received extensive publicity for one of his paintings based on a packet of Typhoo Tea.[1] Yet David Thompson, in a foreword to the influential exhibition *The new generation* at London's Whitechapel Art Gallery in 1964, claimed that while Hockney sourced images in the same eclectic way as pop artists, his aim was to explore 'problems of a pictorial nature, particularly conventions and ambiguities of space'.[2]

By 1964, the year in which he painted *Man in shower in Beverly Hills*, Hockney had developed his own immediately recognisable style, exchanging oils for acrylics and moving away from scratchy, expressionist surfaces to flatter ones, his subjects painted with greater realism in vibrant colours. The furtive or codified references to sexuality had also been replaced by images that were unambiguously homoerotic. Although Hockney moved to Los Angeles at the end of 1963, he had begun painting men in the shower before the move. 'For an artist the interest in showers is obvious,' he wrote, 'the whole body is always in view and in movement, usually gracefully, as the bather is caressing his own body.'[3]

Hockney sourced both the figure and tiled surface in this painting from a photograph in *Physique Pictorial*. Their incorporation into a painting threw up challenges[4]; he admitted to bending the plant in the foreground to cover the problematic feet of his bather. Some thought Hockney's approach to composition resembled graphic layout, but in this work he is clearly attempting more, experimenting with receding picture planes and the illusion of surfaces. This work shows Hockney engaging playfully as a gay artist with the long tradition of the painted nude, as well as finding a balance in his art between what he described as the perceptual and the conceptual.[5] SM

David Hockney
Man in shower in Beverly Hills 1964
acrylic paint on canvas
167.3 x 167 cm
Tate, purchased 1980

'For me, books are what trees are for the landscape painter', remarked RB Kitaj in 1965.[1] A self-confessed bibliophile, by this time Kitaj had established poetry, literature and illustrated journals as a broad inspiration and direct source for his painting practice, along with what he termed the 'surreal-dada-symbolist strain' within modern European art.[2] During the early 1960s, this manifested in intuitive, fragmented compositions that collaged together disparate imagery with textual elements signalling literary connections. Dense with allusions, Kitaj's citational approach was later augmented by his habit of penning didactic statements to accompany selected works.

In the years following his inaugural solo exhibition at London's Marlborough Fine Art in 1963, Kitaj pursued a more cohesive treatment of the pictorial field, though a dissonant juxtaposition of styles remained central to his aesthetic. In *Walter Lippmann* 1966 the effect is enigmatic and spatially disorienting. Vivid, hard-edge blocks of colour, passages of lyrical abstraction and areas of bare canvas are fused into narrative scenes sketched in the artist's distinctive graphic style. Reflecting the expanding nature of Kitaj's sources, a clear affinity with film is evident in the noir-inflected montage format, particularly the distant exchange between a dismayed young woman and a figure loitering in shadow. Kitaj also later recalled more direct cinematic references: *The constant nymph*, which was adapted for screen from Margaret Kennedy's 1924 novel, and the British film and stage actor Robert Donat, who inspired the man in the foreground wearing a military greatcoat and holding a drink.[3] The sinister ambience of the work is concentrated in this figure's sidelong, desirous stare fixated on the girl, as well as the slings that are unnervingly taut around each of their necks.

Walter Lippmann was among the earliest works for which Kitaj wrote a 'preface'; more of a parable than an explanation, this contextualises the small, truncated portrait of Lippmann that hovers to the far right of the canvas. A Pulitzer Prize-winning American journalist and political commentator, Lippmann is here – as he was in Kitaj's youth – 'the voyeur and explainer of complex events' that are otherwise disorderly and opaque.[4] Correspondingly, Kitaj himself refrained from elaborating any 'ultimate meanings' for the spectator, but noted in 1968 that the work was 'just about my favourite among the very few pictures I've made which I care for at all'.[5]

Kitaj's referencing and free association of all manner of readymade sources made him influential among fellow students at the Royal College of Art between 1959 and 1961, and aligned him with British pop art during the early 1960s. The flat, colourful surfaces of his paintings during this period, along with his experiments in collage and screenprinting, suggest Kitaj's alertness to pop's aesthetic possibilities, even if, as curator Richard Morphet has noted, 'his own trajectory lay in another direction'.[6] Indeed, Kitaj's concerns were primarily personal and historical, and when he turned explicitly to the question of identity in the mid 1970s, many of his earlier subjects – Lippmann included – revealed his longstanding engagement with the Jewish experience.[7] AJ

RB Kitaj
Walter Lippmann 1966
oil on canvas
182.9 x 213.4 cm
Collection Albright-Knox Art Gallery, Buffalo, New York. Gift of Seymour H Knox, Jr 1967

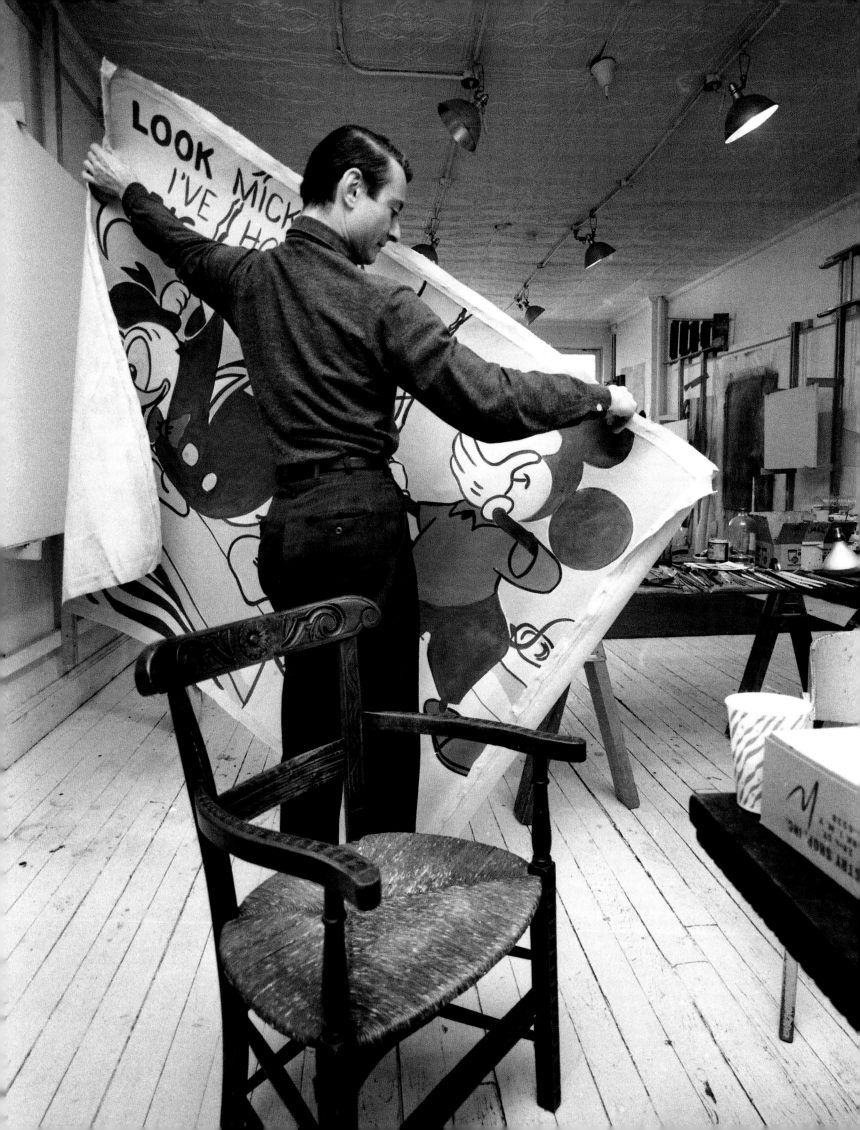

Chris McAuliffe

A BRAND NEW WORLD

AMERICAN POP ART

Roy Lichtenstein with *Look Mickey* 1961 in his studio at 36 West 26th Street, New York, 1964

In 1948 Claude Shannon, a mathematician working at the Bell Telephone Company research laboratories in New Jersey, published a technical paper on the transmission of units of information or 'bits'. Now, two generations later, bits fuel a globally networked information economy; some consider Shannon's paper to be second in importance only to Einstein's Theory of Relativity.[1] Outside the esoteric world of the laboratory, the United States of America was already awash with illustrated magazines, newspapers, billboards, movies and television sets. Americans were learning to live in what media theorist Marshall McLuhan called a 'worldpool of information fathered by electronic media'. McLuhan wrote: 'The medium, or process, of our time – electronic technology – is reshaping and restructuring patterns of social interdependence and every aspect of our personal life … It is forcing us to reconsider and re-evaluate practically every thought, every action, and every institution formerly taken for granted. Everything is changing …'[2]

Other commentators, less thrilled by the advent of McLuhan's 'Electronic Man'[3], were anxious about the social and moral impact of the media age. Media and information technologies presented a distinctive challenge, which historian Daniel Boorstin identified as 'The "Image" problem – the new-fangled puzzle of what is really real'. This problem was a technical consequence of media technology – images proliferated and were broadcast extensively – but it was also a categorical problem; reality was confused with, or superseded by concocted publicity images. It was a moral challenge: the integrity of American experience was threatened when a mass audience embraced media-generated fantasies. 'We have become so accustomed to our illusions that we mistake them for reality,' Boorstin warned. 'We demand them. And we demand that there be always more of them, bigger and better and more vivid.'[4] Consumers desired, took pleasure in and paid good money for the displacement of the real by the image. Worse still, according to McLuhan, Americans could not see that the foundations of their reality were shaking: 'They insist that the visual and the real are one. To question this is to undermine the American way of life.'[5]

The seemingly sudden emergence of American pop art at the beginning of the 1960s coincided with the social experience of McLuhan's 'worldpool' and Boorstin's '"Image" problem'. Inevitably, responses to an art that drew upon the imagery, languages and techniques of advertising and mass media were shaped by more general reactions to mass culture. Throughout the 1950s American intellectuals had pilloried mass culture as the antithesis of genuine culture. Historian Patrick Brantlinger later catalogued a suite of negative comparisons. Mass culture was mechanical, not organic; secular, not sacred; commercial, not free; vulgar, not aristocratic; ephemeral, not enduring; imitative, not original; indulgent, not high-minded; collective, not individual.[6] And yet here were artists, as Roy Lichtenstein admitted, embracing 'the most brazen and threatening characteristics of our culture'.[7] Critics reacted to artists' infatuation with Madison Avenue and Hollywood with horror. In one of the earliest reviews of pop art, Max Kozloff predicted that galleries would be 'invaded by the pin-headed and contemptible style of gum chewers, bobby soxers and worse, delinquents'.[8]

For many critics American pop art offered a pretext for airing their concern for the fate of high culture in the age of mass media. What was at issue was art's capacity to maintain its integrity; the sense of complex and profound cultural value arising from its separation from everyday, instrumental activity. The popularity of pop art – not simply its mass-media content but also its wide audience appeal and art market success – set off alarm bells. No longer a high-brow experience, art was caught up in a 'culture boom' that made it available to a large, aspirational 'middle-brow' audience.[9] By the early 1960s cultural commentator Dwight Macdonald complained, 'The market for cultural products has steadily broadened until by now practically everybody is a customer'.[10] Mass culture's 'respectful but undiscriminating' approach to art – features on old masters in *Life* magazine, fashion spreads shot in New York art galleries for *Vogue* – produced a middle-brow version of art. Macdonald dubbed this 'midcult'; a popular version of high culture that 'has it both ways; it pretends to respect the standards of High Culture while in fact it wears them down and vulgarises them'.[11]

Pop art's overt content – movie stars, automobiles, consumer goods, suburban décor – appeared to pander to this midcult sensibility. So, too, did pop art's style; boldly coloured, simply structured and patently illustrative, it seemed to abandon both technical and semantic complexity. Most troubling was pop's extensive museum, market and media exposure. It all reeked of the adoption of Madison Avenue advertising strategies by the art world. As a participant in a 1962 symposium on pop art at the Museum of Modern Art complained, the 'staggering proliferation' and 'overnight apotheosis' of pop art was reminiscent of 'a blitz

campaign in advertising, the object of which is to saturate the market with the name and presence ... of a commodity. The real artists in this affair ... are the promoters'.[12] Pop art had strayed so deeply into the territory of commodity culture that several speakers at the symposium refused to recognise it as art at all.

This was a surprising conclusion, given that American pop art remained largely entrenched in conventionally conceived art practices; easel painting, editioned prints and sculpture dominated the artists' output. Tom Wesselmann may have sourced materials direct from billboard manufacturers, but these were incorporated into the familiar, centuries-old compositional structures of the still life. Although Andy Warhol eventually branched out into what he dubbed 'business art' – a branded offering encompassing movies, plays, *Interview* magazine, a cable television talk show and promotional print portfolios – he continued to pursue such familiar genres as the portrait, the memento mori and flower painting. Others left art behind only because they had discovered forums that were more appropriate to their interests; Rosalyn Drexler, for example, pursued her explorations of archetype and melodrama in a successful career as a novelist and playwright.[13] It could even be said that pop artists restored to the studio what had been expelled in the heyday of the autonomous modernist artist. Warhol re-established the studio as an open, social and theatrical space. Returning to the strategies of the *fin-de-siècle*, he decorated The Factory as a holistic aesthetic environment in which the artist and his guests would perform a continuous bohemian *conversazione*. At the same time the pop artists' high-volume output and willingness to delegate the fabrication of artworks restored the studio to its pre-modern status as a workshop, managed by the master and staffed by apprentices.

What lay at the heart of accusations that pop was not art was the artists' apparent refusal to distance themselves from 'the supermarket that is our world', as poet Stanley Kunitz put it at the 1962 pop art symposium.[14] It seemed that the passive, undiscriminating mentality of midcult had now infected the art world. 'The recent pop artist,' complained critic Dore Ashton on the same occasion, 'is the first artist in history to let the world into his creative compound without protest'.[15] According to Kunitz, an authentic art, such as abstract expressionism, embodied 'courage and self-reliance ... self-awareness ... rich spontaneity of nervous energy ... a wild act of assertion combined with a metaphysical entrapment in the infrangible web of space-time'.[16]

Pop art seemed almost a parody of such high-minded ideals and was more inclined to look for infrangible webs of space-time in a sci-fi comic than in a painting. For Mel Ramos, courage and self-reliance were the stuff of comic book superheroes rather than art-world romanticism. His superheroes are often presented as a static archetype, not figures of nervous energy and wild assertion. In *Superman* 1962 (de Young Fine Arts Museum, San Francisco), for example, his face hints at consternation as much as heroic determination, Superman is an anxious, cut-out figure rather than a model of self-awareness; likewise Warhol's Hollywood icons, Drexler's movie gangsters, Roy Lichtenstein's romantic couples, James Rosenquist's anonymous housewives and Wesselmann's lounging nudes. All of them could be described in the same language that concerned intellectuals had used to characterise the wilderness of mass culture: 'sameness, interchangeable, dehumanised, deadened, bored, alienated, lonely, entrapped, anxious, manipulated'.[17]

Ironically, pop art's rapid success owed more to the abstract expressionist artists and their critical advocates than to PR machinations. As Robert Indiana astutely observed, the abstract expressionists had 'fought and won' the battle for public acceptance of American avant-garde art. But in creating an 'art-accepting public', they had initiated a relationship that was both 'advantageous and perilous'.[18] With an expanded audience now encountering the new art everywhere from newsstand magazines to art museums, the isolation of contemporary artists ended, and both reputational and material rewards followed. But the authority of traditional gatekeepers – such as critics, curators and museums – diminished when the values of midcult were substituted for more formal measures of artistic quality and cultural merit. Dwight Macdonald put it more bluntly: in a nation of culture consumers, 'everything becomes a commodity, to be mined for $$$$, used for something it is not'.[19] Although critics identified satirical and even critical positions towards consumer culture in pop art, the art-accepting public saw a brash, exhilarating celebration of the modern United States. 'Pop Art was not itself a product of the discothèque era', the critic Lucy Lippard observed wryly in 1970, 'but its reception was'.[20]

A further irony was that while antagonistic critics declared pop art a PR-driven fad, the artists themselves spoke repeatedly of their commitment to matters of art and aesthetics. The American pop artists anchored their work in art history, in an overt dialogue with abstract expressionism

and formal abstraction, and in a sustained exploration of modernist strategies, such as collage, the readymade, the mural and photo-mechanical reproduction. The fact that Rosenquist was working as a billboard painter when he began his early pop paintings, such as *Silver skies* 1962, deepened rather than diminished his interest in art. 'I'm not beating them at their game,' he later recalled. 'This is a painting.'[21] The task for Rosenquist, as it had been for the abstract expressionists and for many a modernist artist before them, was still to get a grip on what a painting could be, what painting could retain of its historical character in the face of competing forms of image making.

There was no denying the presence of mass culture, but artists did not identify this as a primary motivation or causal factor in their work. Robert Indiana acknowledged that his heraldic sign paintings related to roadside advertising but insisted that 'It is the formal aspect of my painting which fascinates me most … essentially I am a hard-edge formalist'.[22] His *The Demuth American dream no 5* 1963 paid tribute to the United States' urban, modernist traditions by repeating the primary motif of Charles Demuth's modernist icon *I saw the figure 5 in gold* 1928 (Metropolitan Museum of Art, New York), which in turn had alluded to a William Carlos Williams poem inspired by a passing fire engine. The sharply receding perspectival elements in Ed Ruscha's paintings were likewise based in the art museum as much as in street life; his repeated use of the device was rooted in his fascination with the oblique disposition of the drifting body of Ophelia in Sir John Everett Millais' 1851–52 pre-Raphaelite painting. The visual impact of mass culture could be powerful; 'it was literally staggering,' recalled Wesselmann, 'a woman's smile where the mouth is as big as your living room rug! Wow!' But as content it was downplayed by the artist: 'God knows, I drank more than my share of Coca-Cola when I was a kid … but it didn't mean a damned thing to me as an aesthetic matter.'[23]

What were the 'aesthetic matters' that preoccupied the American pop artists? Most immediate was the dominance of abstract expressionism. What had once been an avant-garde confined to downtown Manhattan had, by the end of the 1950s, come to represent the triumph of American painting and the establishment of New York as the world's art capital. Many pop artists honoured the masters of the New York School; Wesselmann spoke of 'a physical thrill, actually a thrill in my stomach' on seeing one of Robert Motherwell's *Elegy to the Spanish republic* paintings.[24] As students, they adopted the abstract expressionist idiom – 'everybody was trying to do it in one way or another', Wesselmann added – and drips, smears and erasures could still be seen in the hand-painted pop of the late 1950s and early 1960s. But pop artists had growing misgivings about the ways in which abstract expressionism defined art and its relationship with the world.

As Robert Rauschenberg put it, within abstract expressionism art was considered 'a personal expressionistic extension of the man'.[25] An artwork was seen as an articulation of the artist's inner life – the psyche, the emotions, the unconscious. Externalising this inner life in art was an act of self-assertion and self-realisation; the abstract expressionist was a latter-day version of Ralph Waldo Emerson's ideal of self-reliance, an innately creative, non-conformist individual in full possession of their material and creative resources.[26] Rauschenberg proposed instead an art premised on engagement with the world, in which 'the imagery and the material and the meanings of the painting would be not an illustration of my will but more like an unbiased documentation of my observations'. This suggested that what American art required was not wild acts of assertion but a kind of realism that registered the artist's responses to the everyday world of affluence and consumerism, media and technology. Rauschenberg charted these responses in layered arrays of found media imagery. Substituting roughly hewn maps of McLuhan's 'worldpool' for the heated outpourings of the psyche, he signaled a dramatic shift in the character of American art with a deft dismissal of abstract expressionism: 'I don't mess around with my subconscious,' he said, 'I mean, I try to keep wide awake.'[27]

Diverse as their approaches were, the American pop artists repeatedly demonstrated their determination to keep wide awake, to engage with the events and experiences of contemporary life. They had in common a fascination with the new icons and image-making processes of the mass media. In their paintings, prints and sculptures, totems of American consumerism – automobiles, domestic appliances, packaged foods, smiling housewives and sharply dressed 'organisation men' – echoed billboards, advertising catalogues and magazine spreads. The emerging social and political preoccupations of the 1960s – the space race, telegenic politicians, civil rights, gender roles, pop music – were also a shared interest. Even early efforts to give pop art a name emphasised the artists' involvement with the world; new realism, new social realism, new American dreamers, common object painting and commonism were some of the proposals.

But there was more to keeping wide awake than subject matter alone. Like the new pundits of the mass media and consumer society – the social scientists, information theorists, media gurus, semioticians and cultural studies theorists – the American pop artists sought to document and decode the conventions of popular imagery. For all its intensity of colour and simplicity of presentation, the American pop art image was consistently analytical, even conceptual, in its approach to mass culture, borrowing media images in order to parse their syntactical operations and semantic effects. Behind the superficial attractions of the movie theatre, supermarket and car yard, American pop art reveals a fundamentally schematic aesthetic. Pop's pictorial space is diagrammatic: flat, frontal and gridded, structured into distinctive, clearly bounded units whose connections to each other can then be plotted.

Pop art's propensity for repetition, usually regarded as an emulation of mechanical reproduction, is further evidence of this analytical bent. Repetition makes for sets, sequences and structures. This was embodied most obviously in the pop artists' use of numbers, the alphabet and primary geometric forms but also in the more subjectively ordered categories, such as automobiles, Hollywood stars, foodstuffs and appliances. Add to this pop's combinatory impulse – the tendency of artists to layer, interleave and thread together items from within sets – and the pop artists' interest in the grammar of mass cultural signs becomes apparent. The generic and totemic character of the pop aesthetic is not so much about the ubiquity of mass-media imagery as its abstract, schematic qualities. It is as if the vocabulary units of a modern-day primer were being laid out. Here is Man. Man plus tommy gun and double-breasted suit equals gangster. Man plus six-gun, plus dungarees equals cowboy. Here is leopard skin. What does it mean as a coat? And as upholstery fabric?

American pop artists approached visual language as a structured, social effect rather than a visceral, human phenomenon. The self-declaring, self-sustaining artwork, whether expressionist or abstract, was set aside as pop artists entered the functional territory of mass culture's new hieroglyphics. Units of public language, discovered in the social sphere, were stamped, stencilled and printed across surfaces. Sets, rules and relationships were identified. Sequences and layers of linked images pointed to the visual rhetoric of the contemporary American media; foodstuffs plus kitchen and car equals abundance, president plus aerospace technology equals Cold War brinkmanship. Of particular interest were effects suggesting the migration of modernist, avant-garde gestures into the realm of the popular. The radical simplification of language in the brand name, the headline, the caption and the speech bubble echoed the reductive language of modernist poetry. Matisse's still lifes and nudes were rediscovered in supermarket and homewares promotions. Collage was the new sport of channel-hopping television viewers; advertising was the legitimate heir to surrealism's celebration of desire and the unconscious; and the cryptic effects of Marcel Duchamp's readymade sculptures were rediscovered in hardware and whitegoods catalogues.

The American pop artists' particular form of realism – vested in the experience of the world and the symbolic systems of consumerism – introduced an additional aesthetic matter. Pop art's voice was cool and reticent; not the broadcast of heated transmissions from the psyche but an analytical reading of systemic operations. As Jasper Johns put it, 'I'm interested in things which suggest the world rather than suggest personality'.[28] An art that deployed found visual languages in order to dissect their semantic structures was unlikely to reveal much about its maker. Even more so if this art mimicked the procedures of mass culture itself, using photographic and mechanical reproduction, outsourcing production to commercial providers or delegating it to assistants, generating multiple items and seeking a 'factory finish' associated with industrial fabrication.

Contrary to the critical perception of pop art as an enthusiastic surrender to mass culture, the artists spoke of it from a distance. The cornucopia of consumerism – the riches offered by billboards, supermarket shelves and over-stuffed refrigerators – became a subject for Rosenquist only after he had become dissociated from it while living 'like a young bum' in New York City.[29] Lichtenstein instituted studio procedures that focused on the formal properties of his transposed comic books sources; a custom-designed easel allowed him to rotate canvases through 360 degrees, treating the painting as a purely structural exercise. Although many pop artists later revealed autobiographical resonances in their mass-cultural sources – Indiana's father operated a petrol station, Dine's a hardware store – they adopted an almost fatalistic attitude towards such content. Taking their lead from Marcel Duchamp and John Cage, they suggested that subject matter which emerged from their encounters with the world was found or simply arrived. Pop artists did not adopt the state of 'anaesthesia' that underpinned Duchamp's selection of

readymade sculpture but all adopted variants of his orchestrated randomness (or 'canned chance'), along with Cage's advocacy of non-hierarchical order.

This eager, yet aloof engagement with the contemporary world was especially apparent in the American pop artists' diligent, and occasionally obsessive, attention to matters of process and fabrication. A transfer of allegiance from action painting to Duchamp and Cage could reduce studio practice to a mute sequence of gestures – 'Take a canvas. Put a mark on it. Put another mark on it', wrote Johns in a sketchbook[30] – but most pop artists revealed a genuine enthusiasm for new techniques and materials. These ranged from inventive studio tinkering, in the case of Rauschenberg's use of lighter fluid to transfer newspaper images onto canvas; through inspired relocation, in the case of Warhol's adoption of the commercial screenprinting process; and detailed research and development collaborations with commercial suppliers, in the case of Lichtenstein's painstaking perfection of his Benday dot stencils. There was a clear preference for processes invoking the technologies of the mass media – photography and printing – and their distinctive effects, such as enlargement, repetition, degradation. Nevertheless, pop artists seemed to have a connoisseur's attachment to esoteric media; alongside the unsurprising allusions to the industrial age – metallic paints, foils, plastics, plexiglas, aluminium, Formica, neon light – were gunpowder, caviar, Pepto-Bismol, chocolate, cabbage, blood, urine and numerous other exotic, homemade pigments.

The pop artists' exploration of new materials and techniques, especially in intensive collaborations with remarkably adventurous print studios, emulated the research and development culture of contemporary industrial corporations. Writing of Rauschenberg, Cage had declared that 'Modern art has no need for technique. (We are in the glory of not knowing what we're doing.)'[31] In the case of American pop, it would be more accurate to say that the artists needed, indeed embraced, technique but approached it pragmatically. Technique was a case-by-case matter, the method appropriate to a desired end. Technical mastery, if it was required at all, was secured in collaboration with the appropriate experts. Likewise, while a pop artist might not know what they were doing (this could be delegated or discovered on the fly) they certainly knew where they were going; that is, pop could be improvisational but it was always tactical.

This fundamentally tactical character of American pop art was what Wesselmann had hinted at in his reference to aesthetic matters. Negotiating a position as the successor to abstract expressionism involved redefining the tenor of art (from hot to cool), repositioning art's relationship with the world (from autonomous to engaged) and declaring new modernist forebears (shifting allegiance from Picasso to Duchamp). Along the way it also involved subsidiary territorial manoeuvres, such as fending off the claims of colour field abstraction and forging loose alliances with emerging genres like underground film, happenings and experimental dance. It meant taking the conditions of contemporary mass-cultural experience seriously without surrendering art's capacity for serious reflection on experience. It meant embracing the languages and procedures of the industrial present without losing the advantages of reflective and analytical processes invested in the studio and art's genres. The very pace of the art world in the 1960s demanded tactical acuity; while pop art's success was rapid, so too was its normalisation and eventual redundancy. By the end of the 1960s, pop art appeared to be over, superseded in the art world by more radical post-studio practices, such as conceptual and performance art, and in the realm of popular culture by even more tactically astute figures like the Beatles and Twiggy.[32]

American pop art's most direct tactical achievement – the legacy that later generations continued to explore – was its forging of an art that grappled convincingly with McLuhan's 'brand new world of allatonceness'.[33] Political commentator Norman Mailer suggested that this was a world that had spawned a younger generation balanced 'on the jumps and cracks and leaps and breaks which every phenomenon from the media seemed to contain within it'.[34] Responding to it, artists like Rauschenberg produced work with the feel of 'many television sets working simultaneously all tuned differently', as John Cage put it.[35] But pop's more profound response was formal rather than giddying and kaleidoscopic. Pop art's visual field was erected on flat, schematic surfaces. These redefined the space of an artwork; it was not a window, mirror or world unto itself but a receptor. And the experience of this space was not one of illusion or transcendence, or even of the blunt affirmation of paint, it was the experience of data. Johns had heralded this space in the *Flag* paintings of the 1950s, works that oscillated between abstraction, representation and the thing itself. Critic Leo Steinberg recognised that Rauschenberg had perfected pop art's data-driven (and thoroughly frangible) version of space–time in his screenprinted paintings and transfer drawings of the 1960s:

the picture plane had to become a surface to which anything reachable–thinkable would adhere. It had to be whatever a billboard or dashboard is, and everything a projection screen is, with further affinities with anything that is flat and worked over – palimpsest, cancelled plate, printer's proof, trial blank, chart, map, aerial view. Any flat documentary surface that tabulates information is a relevant analogue, and it seemed at times that the surfaces of Rauschenberg's works stood for the mind itself – dump, reservoir, switching centre, abundant with concrete references freely associated as in an internal monologue – the outward symbol of the mind as a running transformer of the external world, constantly ingesting incoming unprocessed data to be mapped in an overcharged field.[36]

With the 'flatbed' space, Steinberg declared the advent of 'post-Modernism' – one of the earliest uses in art criticism of that now-common term.[37] Pop art's flatbed substituted the screen for the canvas, projection for representation, and data for content. And with this positioning of pop art as the terminus of modernism, aesthetic matters come to a head in a way that the pop artists, most of them still admirers of the modern masters, could not have envisaged. Philosopher and art critic Arthur Danto dates this terminus to April 1964, with Andy Warhol's first *Brillo box* exhibition at New York's Stable Gallery. Here, he suggested, purified categories ended; the perceptible difference between an art object and an item in a supermarket collapsed. Whereas earlier critics had seen this as evidence of pop's surrender to consumerism, Danto found a philosophical question in Warhol's stacked facsimiles: 'What makes the difference between an artwork [a *Brillo box*] and something which is not an artwork [a Brillo box] if in fact they look exactly alike?'[38] The difference between art and not-art could no longer be determined on visual grounds, in terms of what was real and what was representation. Danto concluded that pop art marked the end of a particular art historical narrative – modernism's attachment of the philosophical problem of art to the procedures and limits of representation. The American pop artists had made paintings, photographs, prints and sculptures, but they had also staged plays, made movies and television shows, joined rock bands, produced happenings, danced, published books and magazines, endorsed products, designed postage stamps, and sent artworks to the moon. Now that they, and Warhol in particular, had demonstrated that 'there was no special way a work of art had to be', art need no longer be preoccupied with its philosophical identity: 'artists were liberated to do whatever they wanted to do'.[39]

Jim Dine
An animal 1961
oil and pelt on canvas
183 x 153 cm
National Gallery of Australia, Canberra,
purchased 1980

ROY LICHTENSTEIN
Look Mickey 1961

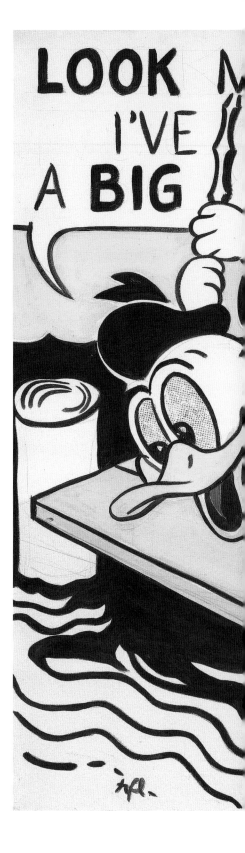

Look Mickey marks a watershed moment in both Roy Lichtenstein's career and the history of American art. Painted in June 1961, this is Lichtenstein's first pop work, signifying the very inception of the comic-based style that helped define an entire movement. Lichtenstein was 37 when he made the drastic decision to abandon painterly abstraction for brash, hard-edged imagery culled from popular culture, but the idea had been percolating in his mind for several years beforehand. After drawing a large Mickey Mouse on his son's bedroom wall in 1957, Lichtenstein began incorporating cartoon characters into his abstract expressionist-inspired paintings. Most of these experiments were destroyed, as he deemed the conjunction of sensitive brushwork and comics unsuccessful. It was after much thought and discussion that he finally resolved to paint his appropriated subjects in a way that fully acknowledged their origins. *Look Mickey* represents an irreversible turning point for the artist: 'I had this cartoon painting in my studio, and it was a little too formidable,' recalled Lichtenstein in 1966, 'I couldn't keep my eyes off it, and it sort of prevented me from painting any other way, and then I decided this stuff was really serious.'[1]

Look Mickey is based on an illustration from the children's book *Walt Disney's Donald Duck: lost and found* (1960); comparing the painting to the source reveals Lichtenstein's carefully considered process of transformation. Nuanced colour has been reduced to three primary hues on white canvas, extraneous details have been removed, a dialogue bubble inserted and the arrangement of forms altered to create a tightly unified composition. This is also the first instance of Lichtenstein's replication of Benday dots – the printing technique used to create

halftones – which are visible on the faces of Mickey and Donald. It was this self-conscious nod to methods of commercial image reproduction that underlined Lichtenstein's formalist concerns and helped claim comics as his personal territory.[2] Yet unlike the slick finish of his later works, *Look Mickey* appears freely drawn: draft pencil marks are deliberately left visible and the dots have a distinctive handmade quality, as they were applied with a plastic-bristle dog-grooming brush rather than a stencil.

The boldly graphic appearance of Lichtenstein's new work was perceived as an affront to the highly subjective and rarefied efforts of the dominant New York School painters. Indeed, the scenario of *Look Mickey* may be interpreted as satire, for Donald Duck peers into water that mimics the brushy fluidity of much abstract expressionist art, while his stance and proclamation of triumph seems to mock the genre's attendant narcissism. By enlisting such prosaic, mass-produced subject matter, Lichtenstein not only radically challenged existing hierarchies of visual art, but also opened up a field of aesthetics that compellingly engaged the contemporary social landscape. 'Pop art looks out into the world,' he stated, 'it appears to accept its environment, which is not good or bad, but different – another state of mind.'[3] FC

Roy Lichtenstein
Look Mickey 1961
oil on canvas
121.9 x 175.3 cm
National Gallery of Art, Washington, DC.
Gift of Roy and Dorothy Lichtenstein
in Honour of the 50th Anniversary of
the National Gallery of Art, 1990.41.1

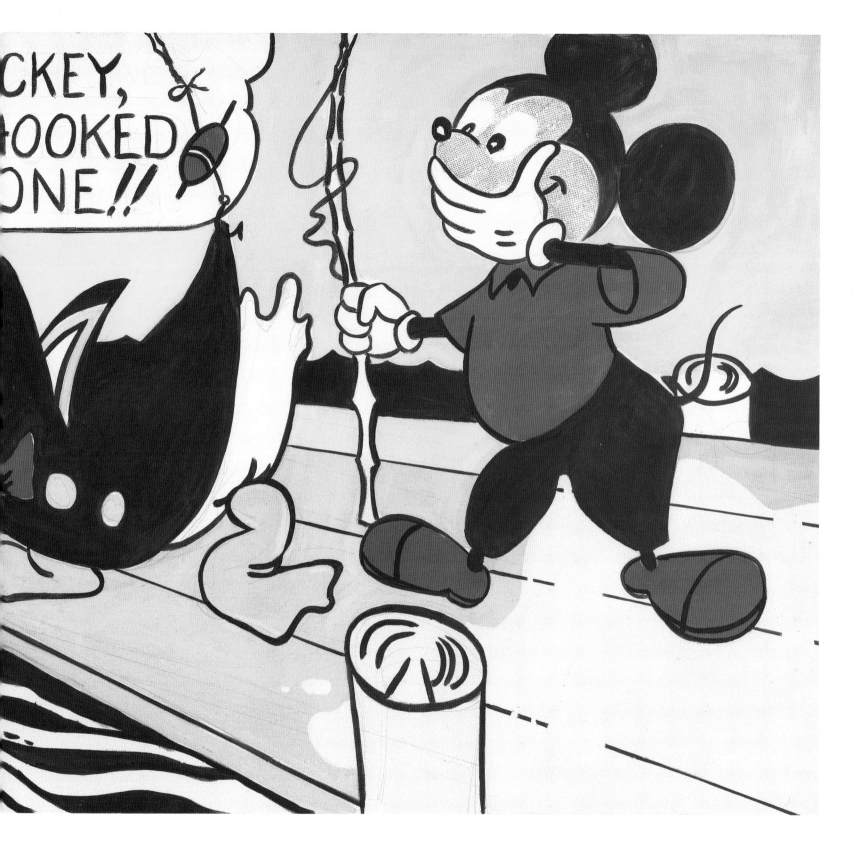

Roy Lichtenstein
Kitchen range 1961–62
oil on canvas
173 x 173 cm
National Gallery of Australia, Canberra,
purchased 1978

Roy Lichtenstein
Woman in bath 1963
oil and magna on canvas
173.3 x 173.3 cm
Museo Thyssen-Bornemisza, Madrid

Wayne Thiebaud
Delicatessen counter 1962
oil on canvas
76.8 x 92.1 cm
The Menil Collection, Houston

JAMES ROSENQUIST
Silver skies 1962

The lustrous title of James Rosenquist's *Silver skies* 1962 evokes an American dream embodied in the gleaming pressed metal of a new automobile and the glamour of transatlantic flight. It conjures images of sky-scraping billboards advertising tyres and cola with the promise of a new life.

However, the irony of Rosenquist's early paintings is that although their visual language is derived from billboards, by fragmenting familiar images the artist divests them of meaning. In *Silver skies* the neck of a soda bottle becomes a study in grey; a woman's face beams at an unseeable object of desire; a seagull's head cranes awkwardly against an inverted sky. The title, in fact, has an equally

banal origin in a man Rosenquist saw painting an apartment hallway silver.

Silver skies was one of 12 paintings exhibited at Rosenquist's first solo exhibition at the Green Gallery in New York in 1962. It was shown again later that year at the important *New realists* exhibition at Sidney Janis Gallery. His works certainly had an immediate impact; art critic GR Swenson wrote at the time that 'the viewer's experience is less a sense of disproportion ... than a sense of violence at seeing fragments of a billboard environment in actual, full-size proportions'.[1]

Rosenquist employed this monumental scale to encourage viewers to see beyond the pop-cultural images he used. 'I believe it is

possible to bring something so close that you can see through it,' he said, 'so it comes to you right off the wall.'[2] What ultimately mattered were the formal relationships between the image fragments, which he arrived at by collaging material sourced from magazines. Arranging and manipulating disparate images allowed Rosenquist to experiment with colour, scale and composition. The source images for *Silver skies* were never compositionally fixed, though some were ruled with grids – an armature borrowed from billboard painting.

Unlike his contemporaries Andy Warhol, Robert Indiana and Roy Lichtenstein, Rosenquist also modelled form. The grey and red monochromes of *Silver skies* may

be reminiscent of duotone magazine printing, but they also recall the *grisaille* technique used in painterly imitation of marble sculpture by Renaissance masters. However, it is Rosenquist's mode of delivery, rather than the objects themselves, that speaks most profoundly to his experience of modern life, with its barrage of images and mass media saturation. When the collector Robert Scull – an early patron of Rosenquist's – visited the artist's studio in 1962, he asked why the objects were not centred on the canvases. Rosenquist's reply reinforced that the medium truly was the message: 'man, this is our new religion – the cathode-ray tube – and the painting *is* the explanation'.[3] AY

James Rosenquist
Silver skies 1962
oil on canvas
199.4 x 502.9 cm
Chrysler Museum of Art, Norfolk.
Gift of Walter P Chrysler, Jr, 1971

By the early 1960s Ed Ruscha had shrugged off the abstract expressionist leanings of his art-school years and embraced his love of the written word. His early discovery of the work of Jasper Johns and Robert Rauschenberg – and their lineage to Marcel Duchamp – informed his approach, giving him licence to transform language into art. *Noise, pencil, broken pencil, cheap Western* 1963 is an early example of Ruscha's pared-back style and features an incongruous arrangement of *trompe l'oeil* objects and a description of sound. The artist considers the painting his personal best, and has often stated his regret in parting ways with it.

Ruscha was 26 when he completed this work and was already gaining significant public attention for his art – he was included in the seminal pop exhibitions *New painting of common objects* at the Pasadena Art Museum in 1962 and *Pop art USA* at the Oakland Art Museum in 1963. The present work was included in his first solo show at the Ferus Gallery in Los Angeles in May 1963. Moving from the Midwest to Los Angeles in 1956, Ruscha's subsequent work was inevitably conditioned by his love for this environment, and he frequently found inspiration in the landscape and vernacular of America's west. The present painting is no exception: it features a life-sized image of a Western comic book, its sheriff-versus-outlaws cover reflecting a mythology deeply embedded in every American's psyche. The comic dates from 1946, suggesting a sort of boyhood nostalgia on Ruscha's part as well as signifying the archetypes perpetuated in popular culture.

The comic's role in this enigmatic composition – as an image within an image – is deliberately unclear. The viewer is left to make their own narrative assumptions about the relationship between the items depicted, as Ruscha prefers to remain ambiguous, stating: 'I've always had a deep respect for things that are odd, for things which cannot be explained. Explanations seem to me to sort of finish things off.'[1]

Set against a deep blue void, the eponymous objects float outwards to the canvas edges, seemingly pointing out that this pictorial space is an illusion. The word 'noise' is another illusory element – Ruscha uses the visual to evoke the aural and, in doing so, underscores the muteness of his medium. This synesthetic jumble is further complicated by the word's oblique angle, which tricks our spatial cognition into thinking that it has three-dimensional form. Having worked as a commercial artist and typesetter Ruscha understands the psychological impact of written words and uses typography to manipulate our understanding of the message conveyed. 'Noise' ostensibly relates to the broken (or breaking) pencil, but the unspecific noun lets our minds fill in the blanks. This presents a kind of philosophical conundrum, inspiring questions about the relationship between ideas and images, truth and fiction. By isolating an artefact of pulp fiction, a semantic abstraction and the humble pencil – a tool for both writing and drawing – Ruscha ultimately draws our attention to the way language and images shape our interpretation of reality. FC

Edward Ruscha
**Noise, pencil, broken pencil,
cheap Western** 1963
oil and wax on canvas
180.3 x 170.2 cm
Virginia Museum of Fine Arts, Richmond.
Gift of Sydney and Frances Lewis

'Americans have always regarded the cowboy as a national symbol and the movies have made him so all around the world.'[1] So begins the *Life* magazine article on 'the Western hero', for which this sculpture was made. The special issue was a tribute to the film industry and showcased the Western as one its most distinctive genres. It also provided Marisol with the opportunity to create a contemporary interpretation of the theme. John Wayne was an obvious choice of subject; he is, after all, a man typecast as the mythological hero in countless renditions of America's favourite morality play.

Wayne is but one of many well-known personalities Marisol has portrayed over the course of her lengthy career. These portraits, as well as her depictions of ordinary people, help situate her work in the realm of pop art. Yet where her peers often touched on the commercial, formulated quality of celebrities, Marisol brings a humanist approach to her sculpted portraits. The artist created *John Wayne* in 1963, the same year that her close friend Andy Warhol represented Elvis Presley as a cowboy. Unlike his serialised paintings, Marisol's work is decidedly handcrafted and seems to caricature rather than celebrate the man concerned. She has commandeered an emblem of masculinity to satirise a social cliché, just as many male pop artists borrowed feminine imagery. Wayne sits astride a carousel-style horse painted in the patriotic colours of red, white and blue. It is an effigy that relates to the tradition of militaristic equestrian statues and the stallion's anatomy, the phallic saddle horn and the upraised pistol underline the super-macho nature of this theme.

Marisol carved the majority of the sculpture from wood and has applied plaster casts of her own hands, adding an extra appendage to indicate the cowboy's fast draw. Her wit and quirkiness is clearly evident in the figure, but she also presents us with a complexity and pathos that reveals her serious intent. This is especially apparent in the various faces that have been drawn or collaged onto Wayne's blockhead, which suggests simultaneity and changing personae.

Marisol's use of disparate materials and techniques were informed by the theories on visual 'push and pull' propounded by her teacher Hans Hofmann. When she moved from painting to sculpture in the mid 1950s Marisol melded this abstract expressionist training with the influence of American folk art, pre-Columbian statuary and found objects. By 1963 she had produced two successful solo exhibitions and participated in several pivotal group shows. These included *The art of assemblage* at the Museum of Modern Art in 1961, which charted the amorphous neo-dada origins of pop art with works by Duchamp, Picasso, Schwitters and Rauschenberg, amongst others. As the only prominent female artist in New York's pop scene, Marisol's early critical reception often focused on her beauty, while relating her totemic figures to oversized dolls. But she skilfully used this publicity, and welcomed commissions like *John Wayne* to attract the broadest possible audience to her art.[2] FC

Marisol
John Wayne 1963
wood, mixed media
264.2 x 243.8 x 38.1 cm
Colorado Springs Fine Art Center.
Julianne Kemper Purchase Fund,
Debutante Ball Purchase Fund

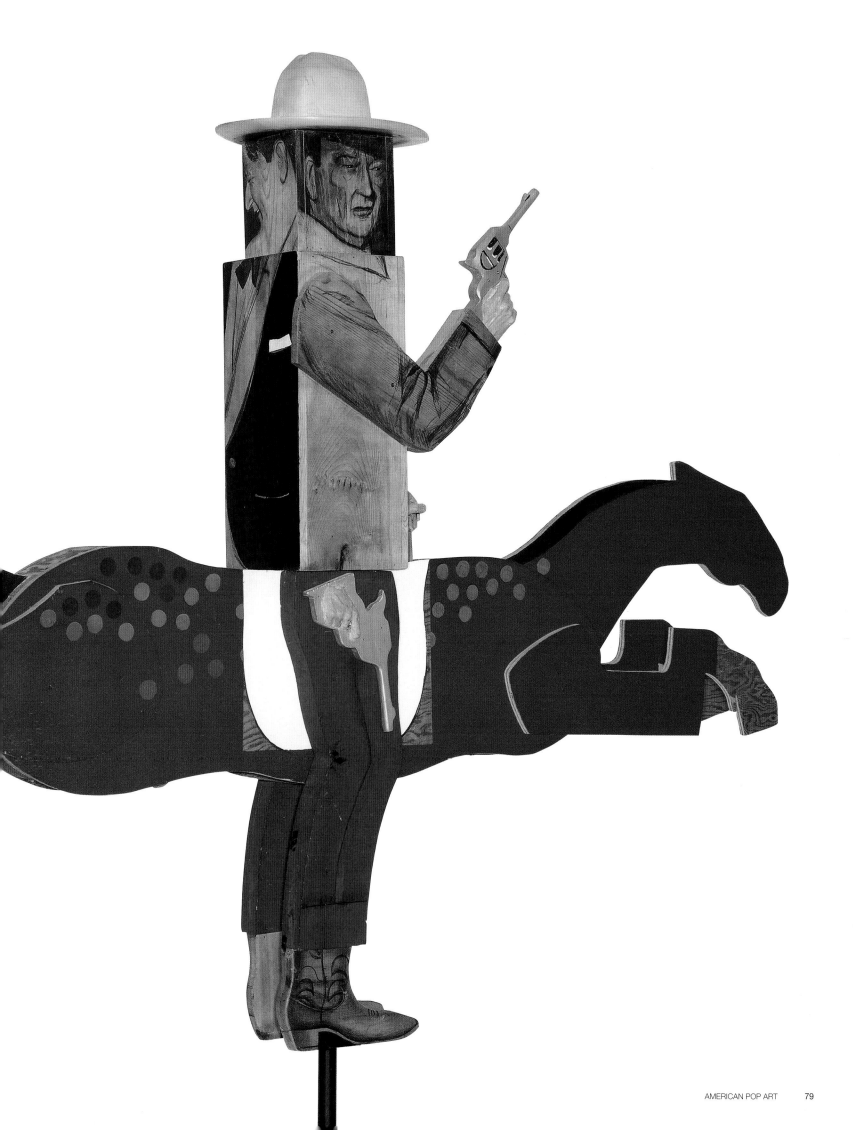

In the summer of 1963 Andy Warhol travelled westwards for the opening of his second solo exhibition in Los Angeles. The previous year he had presented the West Coast art world with his *Campbell's soup can* paintings, the shockingly commercial subject matter of which firmly established him as one of the most important artists associated with America's new pop art movement. For his second show Warhol tailored his work specifically for the context in which it would be displayed, using the serial quality of his art to reflect on the manufactured nature of celebrity and Hollywood's most ingrained stereotypes. *Triple Elvis* 1963 was produced especially for this occasion. Before his arrival Warhol instructed the Ferus Gallery to line their front room with his silver Elvis paintings and the back room with portraits of Elizabeth Taylor. This choreographed arrangement of celebrity royalty – Elvis Presley being the king of rock'n'roll and Taylor the recent star of the hit film *Cleopatra* – seemed to acknowledge the kind of clichéd gender binaries being simultaneously explored in the comic paintings of Roy Lichtenstein, where men and women are represented within the formulaic realms of action and romance.

Warhol had held an almost obsessive fascination for the glittering allure of Hollywood since boyhood, but he was acutely aware of its manipulations and distortions. Like his Marilyn Monroe paintings before it, *Triple Elvis* uses visual repetition to comment upon the way the entertainment industry promotes people as products, and how the public at large consumes them. The strobe-like effect of the multiplied figure – produced using Warhol's signature screenprinting technique – works to evaporate the presence and meaning of Presley's persona. It also calls forth associations with cinematic motion, the metallic background being a direct reference to the silver screen.

Aside from depicting a mainstream idol, *Triple Elvis* aptly takes as its subject an American mythology that has long been the fodder for Hollywood fantasy: the Western. This is not Elvis the hip-shaking musician but Elvis the actor, assuming the familiar stance of cowboy masculinity and aiming a gun at the heads of viewers. The slightly larger than life-sized portrait was appropriated from a publicity still for the movie *Flaming star* of 1960, in which Presley plays a sensitive singing cowboy, far removed from the rugged, tough talkers routinely played by the likes of John Wayne. Warhol's choice of image makes it abundantly clear that Elvis is a camp approximation of a cowboy, made faintly ridiculous by the obvious artifice of his performance. The artist would continue to honour and parody cowboys throughout his career, for he saw them as cyphers charged with underlying meaning.[1]

During his road trip to LA, Warhol contemplated how few people had yet to 'tune in' to the glorious kitschiness of popular culture, concluding: 'Once you "got" Pop you could never see a sign the same way again. And once you thought Pop you could never see America the same way again.'[2] FC

Andy Warhol
Triple Elvis 1963
screenprint ink, silver paint and
spray paint on linen
208.3 x 180.3 cm
Virginia Museum of Fine Arts, Richmond.
Gift of Sydney and Frances Lewis

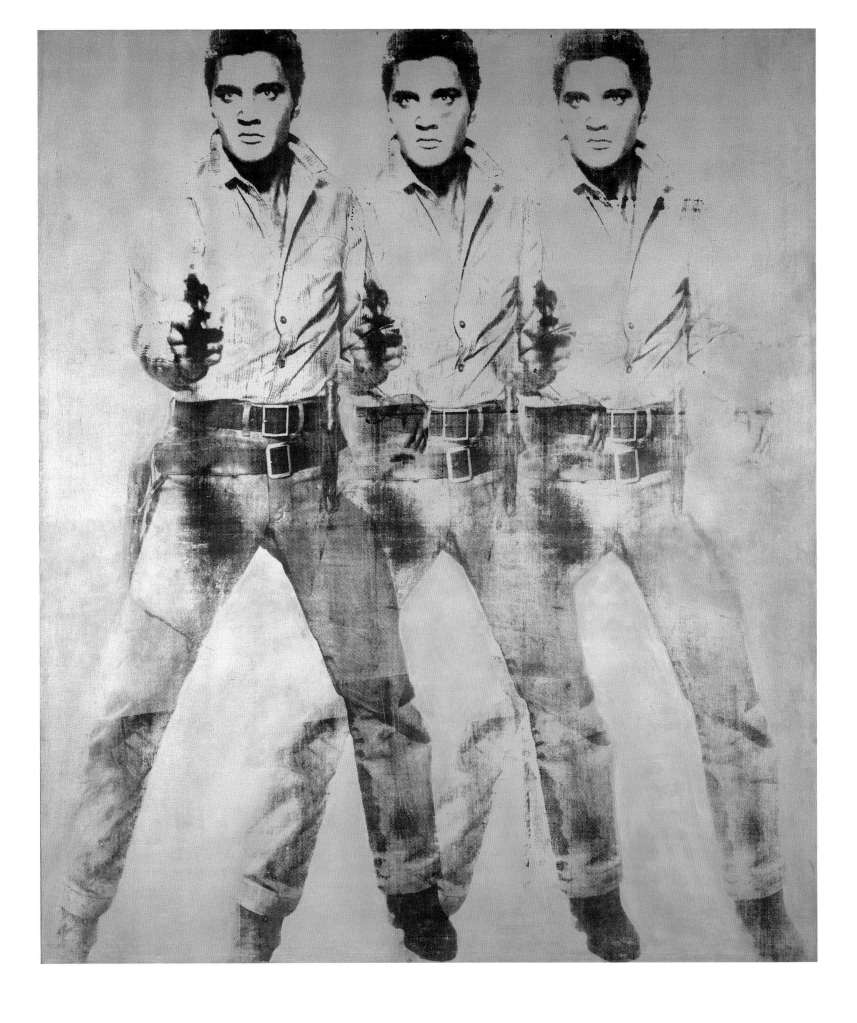

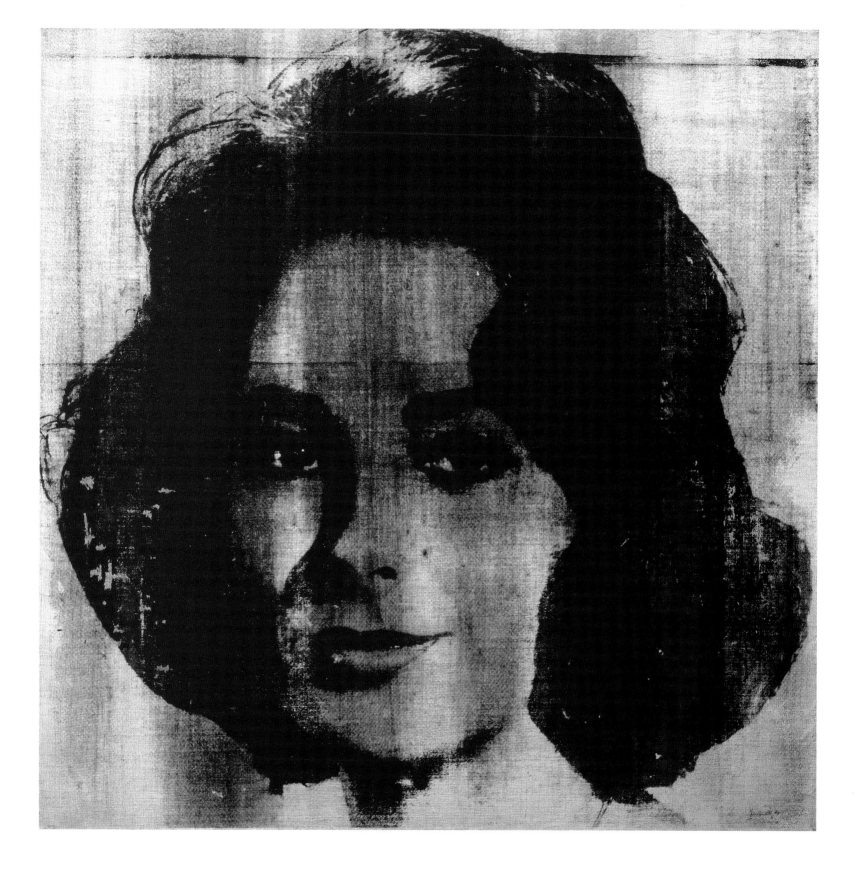

Andy Warhol
Silver Liz [Studio type] 1963
silkscreen ink and silver spray paint
on linen canvas
101.6 x 101.6 cm
The Eyles Family Collection

Andy Warhol
Jackie 1964
acrylic and silkscreen ink on linen
4 works: 50.8 x 40.6 cm (each)
The Andy Warhol Museum, Pittsburgh.
Founding Collection, Contribution The Andy
Warhol Foundation for the Visual Arts Inc

(opposite)

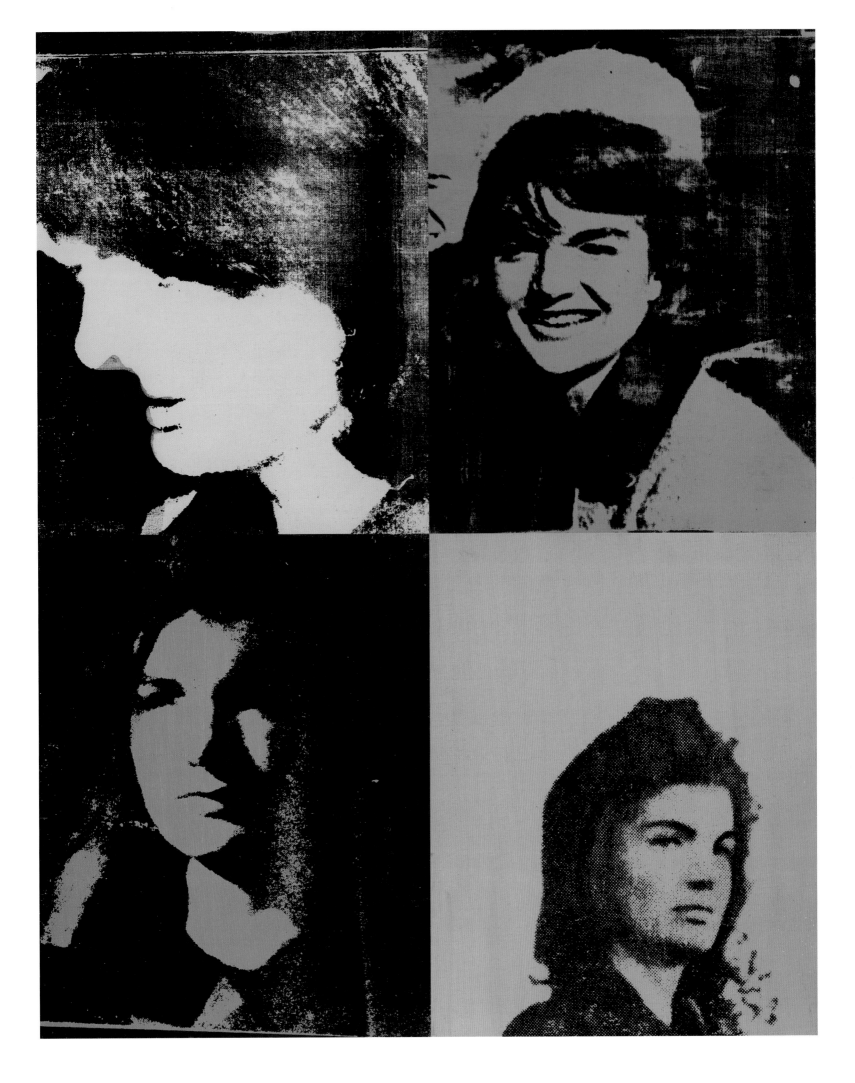

Robert Rauschenberg's *Quote* 1964 is multi-directional: president John F Kennedy points us upwards, the parachuting astronauts lead us downwards and a stop sign arrests our attention. These directional indicators prompt the viewer to scan the canvas in much the same way we might skim a newspaper or watch television. They also reinforce the effects of gesture and movement embedded in the work; Rauschenberg himself claimed to want 'to make a surface which invited a constant change of focus and an examination of detail'.[1]

Quote is among a series of 79 screenprinted paintings that Rauschenberg produced between 1962 and 1964. By this time he was well known for his combines (see *Dylaby* 1962, pp 32–33) and had been experimenting with a solvent-based manual transfer process since 1958 as a means of integrating popular and mass-produced imagery with the two-dimensional picture surface.[2] Rauschenberg wrote that he began the screenprinted paintings 'to escape familiarity of objects and collage'[3], but the shift to a commercial reproduction technique also aligned him more closely with pop art. He was inspired by Andy Warhol's turn to screenprinting two months earlier, which extended on the precedents of his own earlier transfer works.[4]

Rauschenberg exploited the fact that images came with – or quoted, as the title would suggest – cultural and personal associations, which when taken out of context could generate new meanings. The image of the parachuting astronaut, for instance, has been compared to an angel or heavenly messenger.[5] Falling under the distinctly authoritative image of Kennedy, we are also reminded of the great space race of the 1960s. This particular image of Kennedy can be seen in eight of Rauschenberg's screenprints and is the only one to consistently stand on its own. He had commissioned the screenprint of Kennedy before the president's assassination, and afterwards deliberated whether or not to use it, as it had become even more loaded with meaning and emotion.[6] As Rauschenberg noted, the inclusion of the green dot and open cube in *Quote* 'heighten the viewer's intellectual awareness' and act as reminders of the illusory nature of the photograph.[7]

Unlike Warhol's screenprints, *Quote* and Rauschenberg's screenprinted canvases remain painterly, poetic, multidirectional and engaged. They share American pop's flatness, reproductive processes and popular content, but not it's cool disengagement, hard edges and mass-produced effect. These shared qualities have produced a variety of critical responses, from claims that they are a reflection of the multiplicity of contemporary life, to Brian O'Doherty's belief that they are an example of 'the city dweller's rapid and disinterested scan'.[8] The critic Max Kozloff referred to them as 'midway between Titian and colour television'.[9] AG

Robert Rauschenberg
Quote 1964
oil and silkscreen ink on canvas
243.8 x 182.9 cm
Kunstsammlung Nordrhein-Westfalen,
Düsseldorf

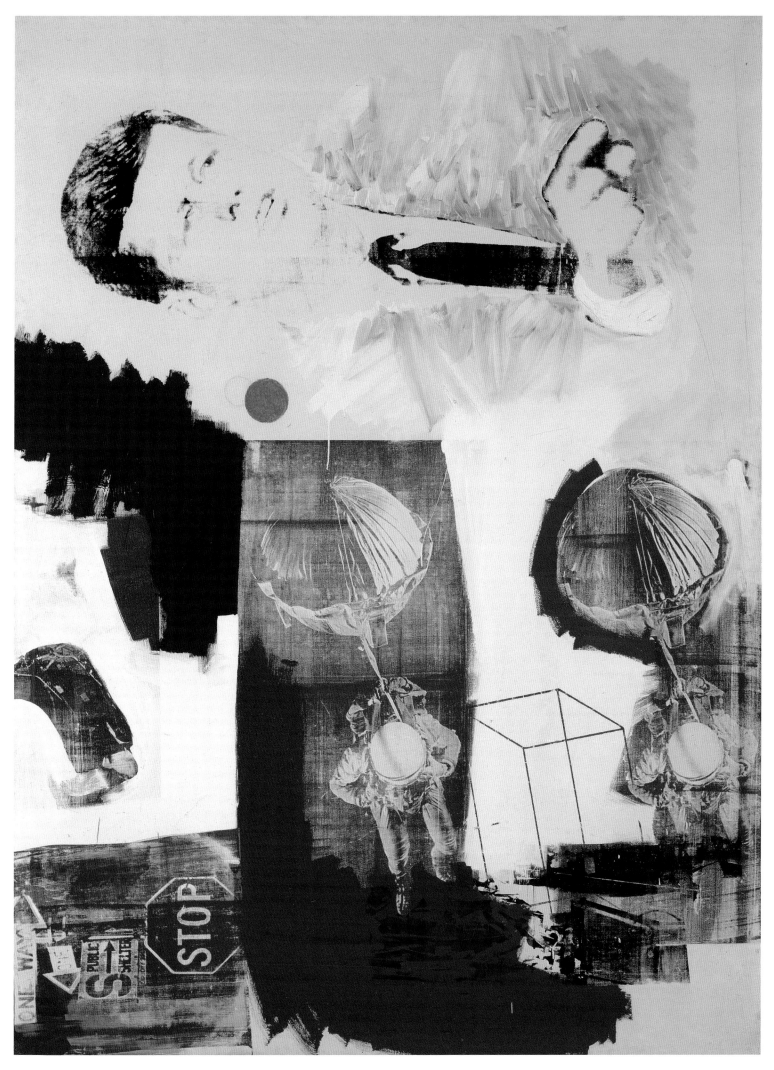

Roy Lichtenstein
In the car 1963
oil and magna on canvas
172 x 203.5 cm
Scottish National Gallery of Modern Art,
Edinburgh

Tom Wesselmann burst onto the New York art scene in 1961 with his series *Great American nude*. His subject matter was a staple of the Western canon, but his approach was not. Legs akimbo and breasts bared under the gaze of George Washington or the stars of the American flag, his nudes brought to life 1960s American sexual taboos and caught their viewers *in flagrante delicto*.

In spite of his provocative subjects Wesselmann considered himself chiefly a formalist, 'less concerned about the image and more concerned about how it is formed'.[1] In a book he penned under the *nom de plume* Slim Stealingworth, he wrote that his nudes were inspired by a dream about the relationship between the colours 'red, white and blue'.[2]

Wesselmann's grand still-life paintings, such as *Still life #29* 1963, reveal him as a master of formal innovation. As critic Brian O'Doherty put it, their subject matter is 'the petty coinage of our daily lives … forms of transposed banality'.[3] *Still life #29* replicates domestic objects on a grand scale: fruit on a stand accompanies a saltshaker on a kitchen table; a Volkswagen Beetle hovers in the background.

Like his pop contemporaries, Wesselmann was interested in the visual language of advertising and he sourced much of his collage material directly from billboard manufacturers. Collage allowed him to create a dynamism within his images. 'A painted pack of cigarettes next to a painted apple wasn't enough for me,' he said, 'but if one is from a cigarette ad and the other a painted apple, they are two different realities and they trade on each other'.[4] This is evident in *Still life #29*. The collaged apple not only provides a point of textural difference

to the shaker rendered in oil, but it also draws attention to Wesselmann's reduction of the fruit stand to near abstraction in order to create negative space. The ambiguity of the Volkswagen brings foreground and background onto a single plane in a parody of art historical conventions.[5]

Though he used advertising images, Wesselmann did not engage in a cultural critique through them. Indeed, he objected to labelling his work pop art 'primarily because it causes many art historians, curators and critics to focus excessively on subject matter and assumed sociological commentary'.[6]

Interestingly it was Wesselmann's still lifes (#17 and #22), rather than his nudes, that were included in the *New realists* exhibition at Sidney Janis Gallery in 1962. Yet, in spite of his innovative practice, he has been relatively ignored by art historians.[7] Nor did he receive a retrospective by North American institutions until 2012.[8] No doubt this rankled with the artist, but there is truth to what his alter ego Stealingworth wrote: 'many critics have described Tom Wesselmann as the most underrated painter of the Pop Art Generation that revolutionised the American Art world of the 1960s'.[9] AY

Tom Wesselmann
Still life #29 1963
oil and collage on canvas
264.2 x 365.8 cm
Claire Wesselmann

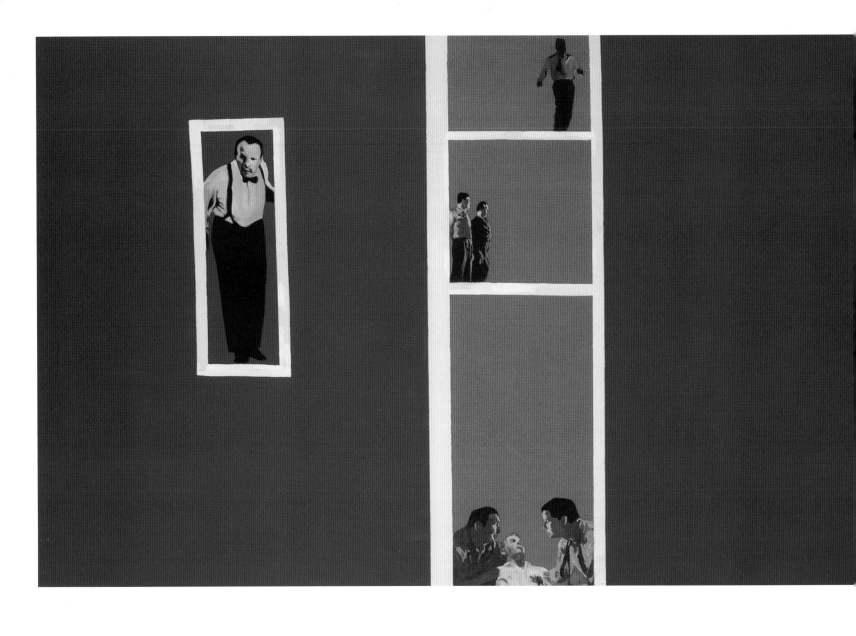

ROSALYN DREXLER
Home movies 1963

Rounding the edge of the canvas, a pistol-packing gangster aims his tommy gun directly at the viewer, making us complicit in Rosalyn Drexler's whodunit. All the characters and intrigue of a 1940s film noir are present: the chase, the trench-coat-clad gangster, the shot victim and the witness peering through the door. The viewer takes the role of private eye. Fashion, body types and actions heighten these cinematic associations, from the dramatic fall of the victim to the hitman's luminous white shirt that was identified by criminologists as the 'uniform of criminals' in the 1950s.[1] Drexler takes as her subject, not capitalist consumerism like many of her fellow pop artists, but the most American of all spectacles: cinema.

With its flat, clean surface and use of mass-media imagery, *Home movies* 1963 is one of Drexler's largest canvases and sits firmly within pop art's tradition. Her characters sit in empty fields of colour, just like 1960s advertisements in which products were placed on empty backgrounds to maintain uninterrupted visual

impact.[2] Like many of her pop contemporaries, Drexler also employs collage and reproductive processes. Underneath what appear to be painted figures are photocopied and enlarged cutouts from movie posters, newspapers and magazines; occasionally the halftone dots of the reproductions peek through. Hiding the process in this way, *Home movies* is neither a painting nor a collage – it has been called one of Drexler's 'faux' paintings.[3]

Although Drexler's images are always found, their placement and composition is not haphazard. Unlike the grids and singular images of Andy Warhol or the cubist-like arrangements of Tom Wesselmann, Drexler's compositions employ a certain staging. Each image is spatially confined to a floating cell, defined by orange or blue colour fields and boarded off by thin white bands.[4] The effect is much like a filmstrip or a storyboard for a comic. Even the colours, which are 'warm' by pop standards, evoke either shadows or a brightly lit corridor. In this way Drexler – who was also a playwright, novelist

and pro-wrestler – employs a form of storytelling and reinserts narrative at a time when it was confined to Roy Lichtenstein's speech bubbles.

Violence, specifically male violence, is an overarching theme in *Home movies*. The cliché of the gangster, firmly inserted into the popular American mythology through film, is here part of a broader social commentary. Where Warhol depicted the United States of America's most famous criminals, Drexler's gangsters and victims could be anyone. They are a reminder that violence is not only a thing of filmic fiction, but also an everyday phenomenon. It exists not just in dark alleyways but also, as the title suggests, in the private sphere of the home. Through the layering of 'already consumed images of failed role-playing', Drexler makes violence in the United States public.[5] She herself has said 'everything that happens is somebody's home movie (whether filmed or not)'.[6] AG

Rosalyn Drexler
Home movies 1963
oil and synthetic polymer with
photomechanical reproductions on canvas
122.1 x 244.2 cm
Hirshhorn Museum and Sculpture Garden,
Smithsonian Institution, Washington, DC.
Gift of Joseph H Hirshhorn, 1966

(above left)

Rosalyn Drexler
Race for time 1964
acrylic and photomechanical
reproduction on canvas
152.7 x 127.6 cm
Hirshhorn Museum and Sculpture Garden,
Smithsonian Institution, Washington, DC.
Gift of Joseph H Hirshhorn, 1966

Robert Indiana described himself as 'an American painter of signs charting the course'.[1] By 'signs' he meant the subject matter of many of his paintings – the profusion of highway symbols that forest the American landscape. However, it could also be said that Indiana's works describe an American psyche coming to terms with its cultural and political heritage; they are a sign of their times.

The Demuth American dream no 5 1963 describes the banal cycle of human life that upholds the façade of the American dream: 'EAT', 'HUG', 'ERR' and 'DIE'. This irony may be read as social commentary; although Indiana's *Confederacy* series, begun in 1965, would establish him as an artist of political conviction, earlier works such as *French atomic bomb* 1960 (Museum of Modern Art, New York) had reflected the political zeitgeist.

Beneath the hard-edged formality of the painting's geometry lie personal meanings and references to art history. *The Demuth American dream no 5* was made in response to American modernist Charles Demuth's *I saw the figure 5 in gold* 1928 (Metropolitan Museum of Art, New York), which visualised the experience of writer William Carlos Williams, who heard 'a great clatter of bells and the roar of a fire engine passing the end of the street', inspiring him to poetry.[2]

The central panel – with its yellow text and intricate grey background – most closely recalls Demuth's painting, while the addition of the external panels distances it from the form of the original. Though Indiana often employed numbers for their formal qualities, 'freed from their context and role to inform', here he toys with numerical associations.[3] The figures in this work refer to the date of Demuth's original and Indiana's year of birth, 1928, and the year of Williams' death and of the creation of Indiana's work, 1963. 'I did my painting in 1963,' Indiana noted in 1968, 'which when subtracted by 1928 leaves 35 – a number suggested by the succession of three fives (5 5 5) describing the sudden progression of the firetruck in the poet's experience'.[4]

Other personal references are captured in the text. 'EAT' refers to the roadhouse signs of his mother's workplace and evokes the last word she spoke to Indiana before she died. The bleak human cycle might be read auto-biographically, as an ascent to the American dream from Indiana's broken childhood. To a contemporary American viewer, Indiana's cultural references certainly inspired a process of introspection. In 1965 art critic Mario Amaya wrote that 'the words transmit a psychological and emotional jolt and the artist appears to want them to gnaw into the subconscious and come to terms with the associations, past and present'.[5]

Indiana compared the cruciform shape of the painting to Cimabue's *Crucifix* 1287–88 (Museo dell'Opera di Santa Croce, Florence), though the horizontality of the work is reminiscent of Indiana's earlier allegorical painting *Stavrosis* 1958 (collection of the artist). Perhaps the Christian analogy was not a casual one. When the artist was offered his first exhibition in 1958, as Robert Clark, he began a process of autogenesis, changing his name to that of his home state in the tradition of great Renaissance masters. Clark was reborn Indiana and his American dream had begun. AY

Robert Indiana
The Demuth American dream no 5 1963
oil on canvas
5 panels: 121.9 x 121.9 cm (each)
Art Gallery of Ontario, Toronto.
Gift from the Women's Committee Fund 1964

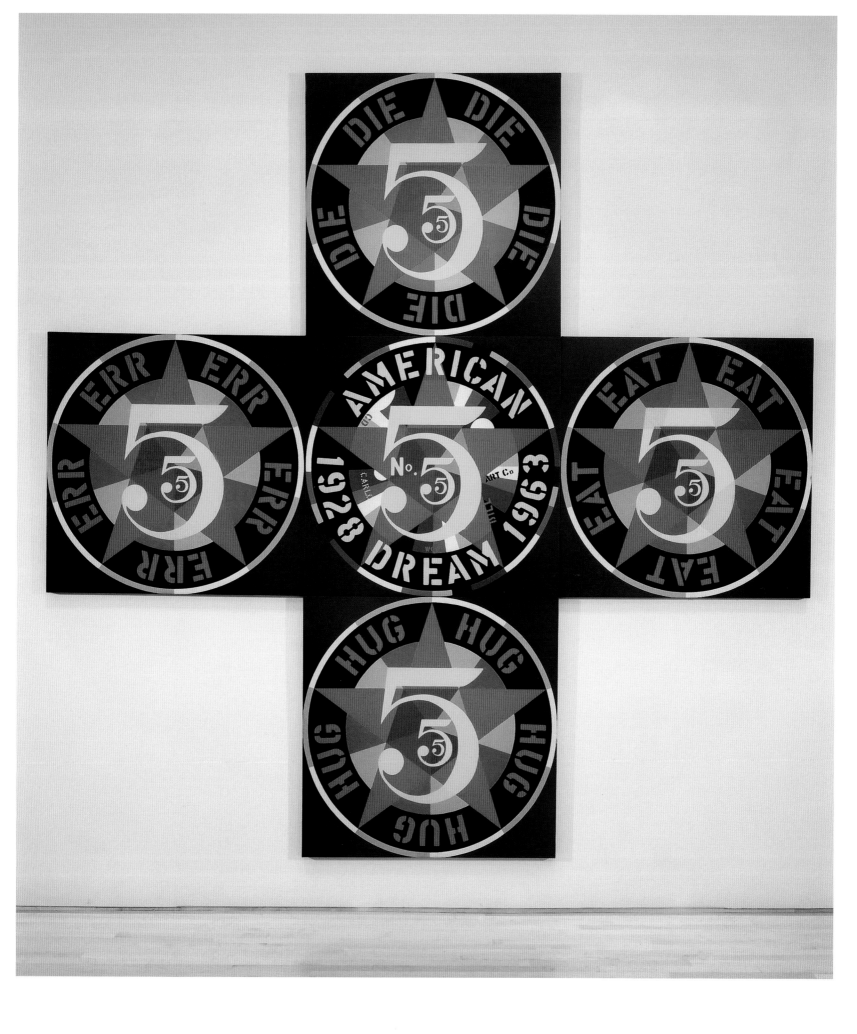

Claes Oldenburg
Leopard chair 1963
vinyl, wood, foam rubber and metal
83.9 x 177 x 93.7 cm
National Gallery of Australia, Canberra,
purchased 1978

Andy Warhol
Heinz Tomato Ketchup boxes 1964
silkscreen ink and house paint on plywood
21.6 x 39.4 x 26.7 cm (each)
The Andy Warhol Museum, Pittsburgh.
Founding Collection, Contribution The Andy
Warhol Foundation for the Visual Arts Inc

Andy Warhol
Campbell's soup 1 1968
portfolio of 10 screenprints on paper
published by Factory Additions, New York
88.9 x 58.4 cm (each)
Kerry Stokes Collection, Perth

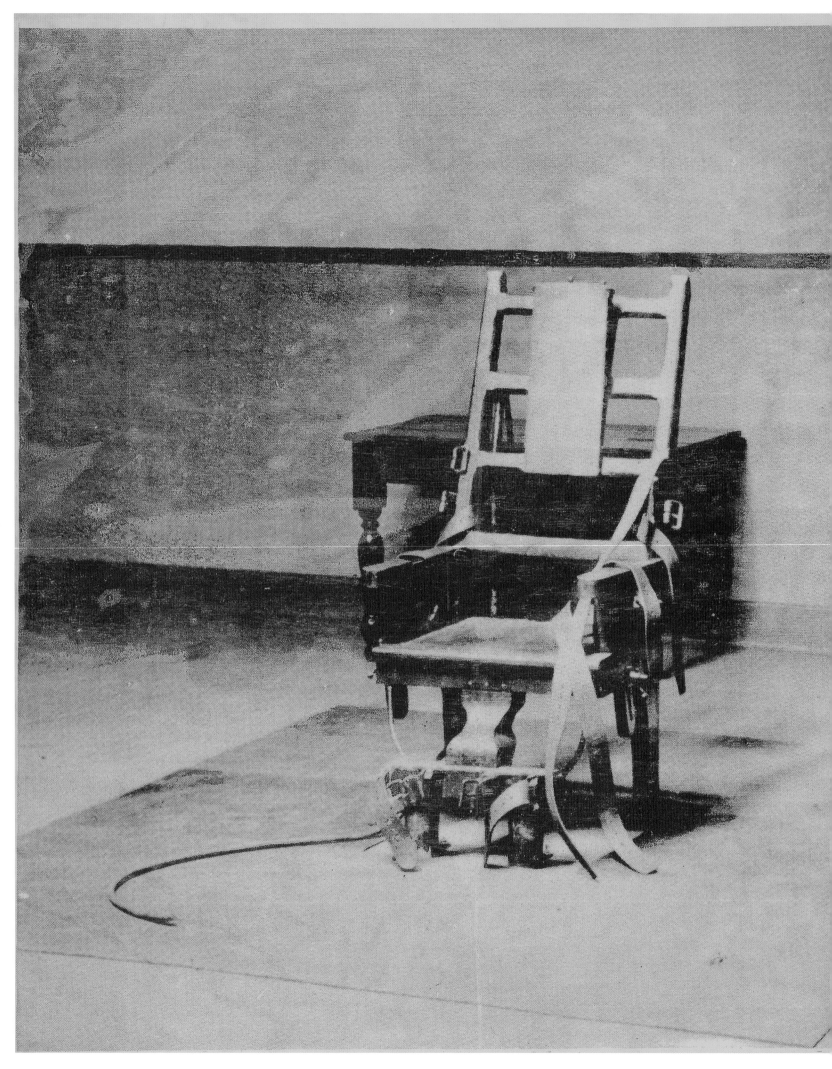

Andy Warhol
Electric chair 1967
synthetic polymer paint screenprinted
on canvas
137.2 x 185.1 cm
National Gallery of Australia, Canberra,
purchased 1977

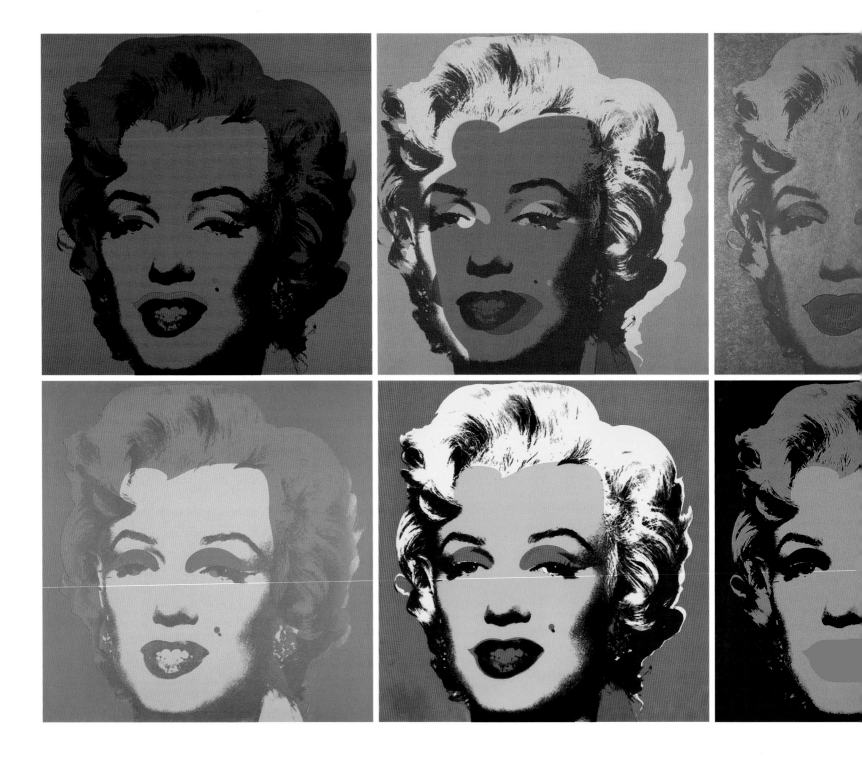

Andy Warhol
Marilyn Monroe 1967
silkscreen on paper
suite of 10: 91.5 x 91.5 cm (each)
Frederick R Weisman Art Foundation,
Los Angeles

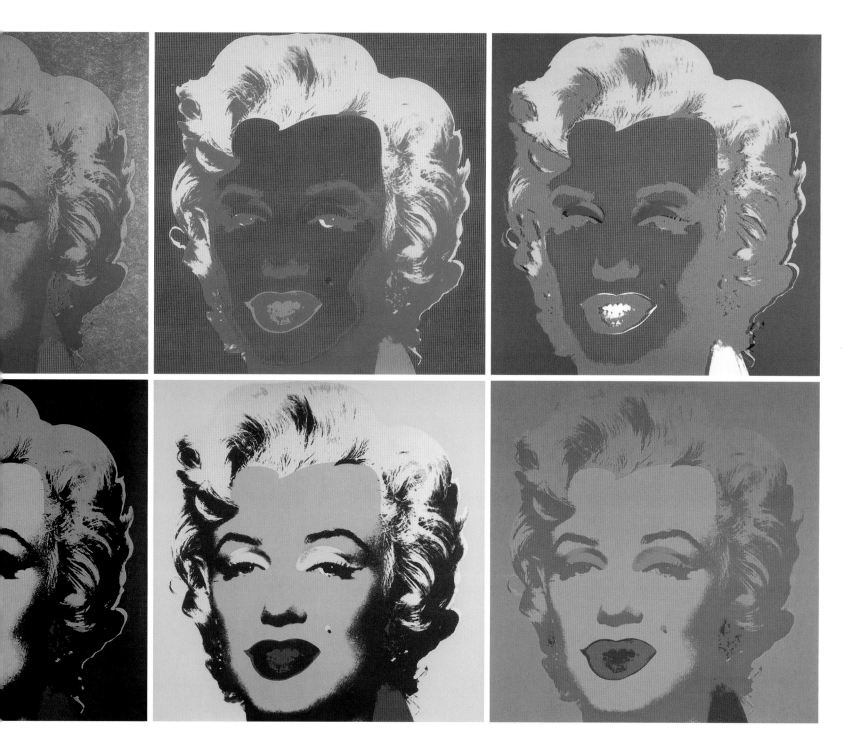

Andy Warhol
Screen tests 1965–66
16 mm film transferred to digital file
black-and-white, silent
The Andy Warhol Museum, Pittsburgh.
Contribution The Andy Warhol Foundation
for the Visual Arts Inc

(above from top)
Screen test:
Edie Sedgwick ST308 1965
4:36 min at 16 frames per sec

Screen test:
Lou Reed ST263 1966
4:18 min at 16 frames per sec

(opposite from top)
Screen test:
Bob Dylan ST82 1966
4:36 min at 16 frames per sec

Screen test:
Marcel Duchamp ST80 1966
4:24 min at 16 frames per sec

TWENTYSIX

GASOLINE

STATIONS

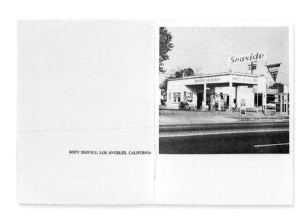

BOB'S SERVICE, LOS ANGELES, CALIFORNIA

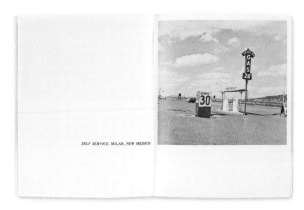

SELF SERVICE, MILAN, NEW MEXICO

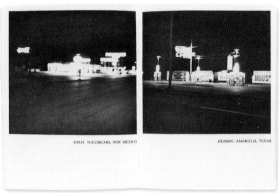

ENCO, TUCUMCARI, NEW MEXICO HUDSON, AMARILLO, TEXAS

KNOX LESS, OKLAHOMA CITY, OKLAHOMA

NINE

SWIMMING

POOLS

Edward Ruscha
Twentysix gasoline stations 1963
(printed 1969)
48 pages, 26 black-and-white
photographic illustrations; glassine dust jacket
17.9 x 14.1 cm (book closed)

(top)

Nine swimming pools and
a broken glass 1968 (printed 1976)
62 pages, 10 colour photographic illustrations
17.7 x 14.1 cm (book closed)

Art Gallery of New South Wales, Sydney.
Purchased with funds provided by the
Photography Collection Benefactors Program 2008

104

Edward Ruscha
Every building on the Sunset Strip 1966
54 pages (folded), black-and-white photographic
illustrations; accordion fold; original slipcase,
silver paper over boards; white paper belly band
18 x 14.2 cm (book closed);
18 x 750 cm (book open, pages extended)
Art Gallery of New South Wales, Sydney,
purchased with funds provided by the
Photography Collection Benefactors Program 2008

Hanging limply from the ceiling with sagging blades and tangled cords, Claes Oldenburg's *Giant soft fan – ghost version* 1967 is shaped not by the deliberate hand of the artist, but by gravity. The fan's soft canvas and larger-than-life size help to amplify the impact of these natural forces. 'On a large scale,' Oldenburg noted, 'gravity wins out completely.'[1] By relying on what he called his 'favourite form creator', the premeditated artistic processes that traditionally go into creating three-dimensional art objects are essentially left up to chance. With such a radical rethinking of sculpture, Oldenburg has been referred to as the only pop artist to have added significantly to the history of form.[2]

Giant soft fan – ghost version is one of Oldenburg's soft sculptures, a term he coined to refer to his oversized sewn and stuffed sculptures of everyday objects. Their origin lies in the giant stuffed props he made for the Ray Gun Theatre, a series of happenings he produced in 1962 in New York.[3] It is perhaps no surprise then that Oldenburg's colossal fan takes on a kind of theatrical presence. With its oversized scale, lumps, bumps and crevices, the sculpture takes on an anthropomorphic guise and reminds us of the not-so flattering parts of our bodies. Its droopy limpness gives it a feeling of being tired or bored. Even its name, 'ghost version', conjures popular images of spooks and their swaying formlessness.

Preparatory drawings reveal that Oldenburg first envisioned the giant fan as an outdoor monument for Staten Island in New York. Later, he saw it as a replacement for the Statue of Liberty, as he thought it shared visual qualities with the statue's spiked crown and would 'guarantee the workers of Lower Manhattan a steady breeze'.[4] *Giant soft fan – ghost version* and a companion work in black vinyl, *Giant soft fan* 1966–67 (Museum of Modern Art, New York), are large-scale models of this proposal.[5] 'I have a shiny black fan and a dry white fan,' Oldenburg wrote, 'like two angels, those winged victories that walk beside you, the white angel and the black angel.'[6]

The treatment of common consumer objects in pop art is typically deadpan, ironic, shiny and new. Oldenburg's electric desk fan, however, is quite the opposite. In it there is a subtle sense of nostalgia; the design of this fan was old-fashioned even in the late 1960s. Oldenburg preferred outmoded objects for their form, stating, 'an electric fan has more form than a television set or an air conditioner'.[7] The comical transformation of a mass-produced metal object into something that is soft and handmade suggests an approachable art for the everyday consumer. By making us pay attention to these familiar objects in such unexpected ways, Oldenburg's art is more an acceptance of the everyday world than a critique of consumer society. AG

Claes Oldenburg
Giant 3-way plug scale B 1970
wood
147.3 x 99.1 x 74.9 cm
Tate, purchased 1971

Claes Oldenburg
Giant soft fan – ghost version 1967
canvas, wood and polyurethane foam
304.8 x 149.9 x 162.6 cm
The Museum of Fine Arts, Houston.
Gift of D and J de Menil

(opposite)

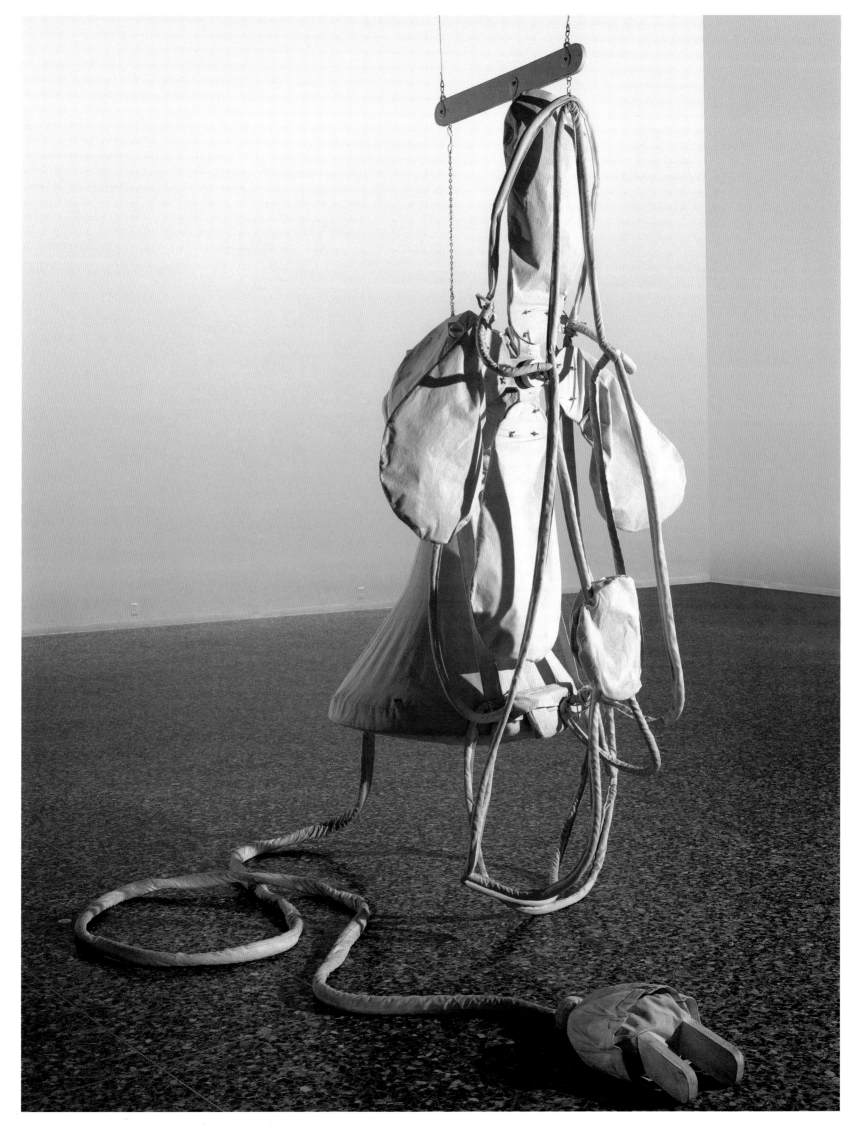

Robert Indiana
Love cross 1968
oil on canvas, five panels
457.2 x 457.2 cm (irreg)
The Menil Collection, Houston

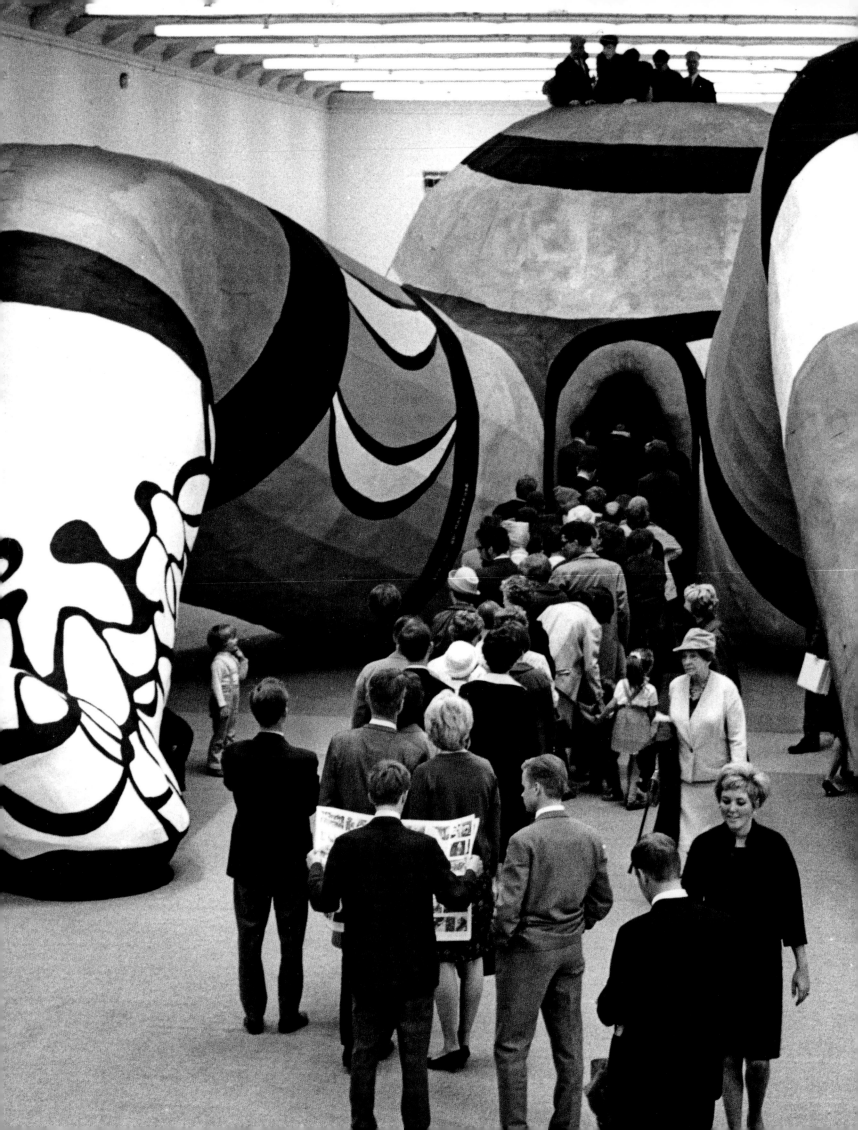

Ann Stephen

WHAT WAS EURO POP?
EUROPEAN POP ART

She: a cathedral by Niki de Saint Phalle, Jean Tinguely and Per Olof Ultvedt at the Moderna Museet, Stockholm, 1966

IMPERIALISTISCHER REALISMUS? COMMON OBJECT PAINTING? NATURALISMUS? POP-ART?

Nouveau-Realisme? Pop-Around? Know-Nothing-Genre? Imperialistischer Realismus? Common Object Painting? Naturalismus? Pop-Art? Neo Dada? Volkskunst? Kapitalistischer Realismus? Junk Culture? New Vulgarismus? Gegenständlichkeit? Antikunst? [1]

The quandary facing European artists in the face of American pop art is dramatised by the possible 'isms' that framed an exhibition invitation in 1963. The four young German artists who drew up the list – Manfred Kuttner, Konrad Lueg, Sigmar Polke and Gerhard Richter – declared themselves *Kapitalistischen Realisten* (Capitalist Realists) as they launched their own pop vernacular on the frontline of the Cold War. Others, like Valerio Adami, Erró, Öyvind Fahlström, Alain Jacquet and Niki de Saint Phalle, so identified with North American culture that by the 1960s they were working in New York, the undisputed capital of pop. The glamour, power and apparent cynicism of American pop would bring to the surface deep anxieties as the United States of America rolled out its Marshall Plan for economic recovery through Western Europe. Some older European avant-gardists expressed very mixed feelings about American pop art, including the Belgian Marcel Broodthaers, who wrote that it 'hurls a curse and calls down insult and contempt upon itself in return'.[2] Others feared that the 'know-nothing-genre' based on comics and mass media would undermine the culture of the museum in the still austere climate of reconstruction in a divided Europe.

POP ART? NEO DADA? NOUVEAU-REALISME?

Me? A savage? She has finally found an answer that a woman in a man's civilisation is like a black in a white civilisation. Niki de Saint Phalle[3]

When Niki de Saint Phalle identified as a savage, she was a lone female voice within the *nouveaux réalistes* (new realists) out of which she and several other French pop artists like Alain Jacquet and Martial Raysse had sprung. The Paris-based group had sought to bridge the gap between art and life through neo-dada practices and performances, as in Klein's use of female nudes as paintbrushes.[4] In 1962 Raysse and Saint Phalle exhibited with Robert Rauschenberg, among others, at the Stedelijk Museum in Amsterdam.[5] Her installation was described as being like 'a shooting gallery', as targeted bags of paint exploded onto a large white relief of monsters when shot, 'as if in a fairground game'.[6] Compared to the mass culture that fuelled American pop art, the French artists rarely strayed beyond the walls of the museum for their source material, giving their work an artfulness and at times even a defensive role in maintaining European painting.

For instance, Alain Jacquet's two 1964 printed canvases included in *Pop to popism – Déjeuner sur l'herbe (diptych)* and *Portrait d'homme (Portrait of a man)* – are part of an extended print project produced over 1964, based on Manet's *Le déjeuner sur l'herbe* (*Luncheon on the grass*) 1863 (Musée d'Orsay, Paris). His diptych, of a female nude with two fully dressed male companions glancing provocatively towards the viewer, restages the original river scene poolside. All three of the figures in Jacquet's reenactment were players in the Parisian avant-garde: the nude, gallerist Jeannine de Goldschmidt, then wife of art critic Pierre Restany; Restany, who coined the term *nouveaux réalistes*, lounging on the right in hat and tie; and the artist Mario Schifano, seated between them. The original photograph was ingeniously 'signed' using a readymade item of food packaging, with the brand name 'Pain Jacquet', placed on the rug, though all such details were concealed by the photographic dot screen that abstracts the triangular composition against a series of horizontal bands. Jacquet adopted the commercial printing technique using four inks, known as process colour (or CMYK, an acronym for cyan, magenta, yellow and black). The camouflaging effects of the dots intensified in the subsequent series, with selective parts of the image magnified by off-register screening in two- and three-colour runs. For instance, in *Portrait d'homme*, the reversed head of the central seated male figure is singled out and scaled up, as one of over 250 sheets that would constitute an entire sequence. While the staging of this *déjeuner* is unmistakably Parisian, the model for an artist using industrial methods of production was Andy Warhol's Factory in midtown Manhattan.

Martial Raysse also used photomechanical effects of mass reproduction, such as the dot screen, combining it with reproductions from French masters like Ingres. However, his painting *Rear view*

mirror 1962 is sourced from a fashion plate, a blow-up of synthetic glamour, the close-cropped face overpainted with garish, flat and unnatural colors in an extended landscape format. The eyes – made-up and framed by blue 'hair' – fix the viewer, yet the twist introduced by the title places the image as a reflex view. The art historian Sarah Wilson argues that 'there is a political dimension accompanying the 1960s *vanitas* in Raysse (his Louvre parodies elide here with contemporary images) which contrasts with Warholian anesthesia'.[7] Whether it was a political reaction, the double-take of a rear view suggests a more furtive game of voyeurism and seduction distinct from the full frontal *Marilyn* pictures that Warhol created the same year, which Raysse would have seen during his first exhibition in New York.

Niki de Saint Phalle, who was raised in New York and then moved back to Paris in the 1950s, became a crucial transatlantic intermediary for the *nouveaux réalistes*. After her *Tirs* series of shooting paintings, Saint Phalle began to create a race of giant Amazonian figures known as the *Nana* series in 1965. These are no femme fatales, but a proto-feminist response to the machismo culture of her French contemporaries and popular culture. Over the following decade, her *Nana* series would morph into pleasure playgrounds and erotic palaces; some even offer vaginal entry. Her friend, the art critic Barbara Rose, explains its meaning in French: 'Nana was Zola's *demimonde* prostitute and in current French argot the word corresponded to broad or chick. A nana was the opposite of a well brought up "nice" girl in other words.'[8] A work from the *Nana* series, *Black beauty* 1968, is a transatlantic celebration of woman and negritude – complete with psychedelic dress, heels and handbag – one that links Fernand Léger's earlier celebration of American youth to a future sisterhood.

VOLKSKUNST? NOUVEAU-REALISME? KAPITALISTISCHER REALISMUS?

Pop art has rendered conventional painting – with all its sterility, its isolation, its artificiality, its taboos and its rules – entirely obsolete … Pop art is not an American invention, and we do not regard it as an import … This art is pursuing its own organic and autonomous growth in this country.[9]

With this declaration, Düsseldorf Academy students Manfred Kuttner, Konrad Lueg, Sigmar Polke and Gerhard Richter launched themselves in 1963 as pop artists. Aside from Lueg, they were not born in American-occupied West Germany but were refugees from the German Democratic Republic: Polke left as a child in 1953, Kuttner in 1960 and Richter in 1961, aged 29, just as the Berlin Wall was erected. Their experience of the east–west divide – both the differences and similarities between 'big business' capitalism and 'big brother' socialism – was an essential ingredient in all their work. For instance, compare the *Leben mit pop, eine demonstration für den Kapitalistischen Realismus* (*Living with pop,* sometimes referred to as *Life with pop: a demonstration for Capitalist Realism*) performance in 1963 by Richter and Lueg with Andy Warhol's display in Bonwit Teller's department store. In 1961 Warhol had placed five of his paintings in a shop window with fashion mannequins, while he was still working as a designer in New York. His deadpan mix of art and commerce was an ironic celebration of the artificial surfaces of modernity. Two years later in October 1963, when Richter and Lueg staged guided tours and dancing in Berges furniture store in Düsseldorf, they included exhibition rooms on several floors, with the artists themselves presented as brand commodities, entitled 'Couch with cushions and artist', amongst other retail commodities, such as 'Floor lamp with foot switch'. Richter and Lueg sat on display, dressed in business suits on a white pedestal, alongside a television screening *The era of Adenauer* on the departing West German leader, who, like Australian prime minister Robert Menzies, had been chancellor since 1949 until leaving office in the same month in 1963. Their occupation of the retail site, subtitled 'a demonstration for Capitalist Realism', inverted the didactic language of the eastern bloc for the west, recasting pop art as a dark satire on commodity fetishism.

Amongst the works on display in the 'demonstration' was Richter's small painting *Mund* (*Mouth*) 1963 (Art Institute of Chicago), based on a photograph of Brigitte Bardot's open lips. The soft, out-of-focus image, taken from a media shot, indicates the future direction of his painting. Richter was drawn, with a certain fascinated horror, to that genre of salacious tabloid which drags the personal snapshot into the chilling glare of media after a tragedy. While media death was the stock-in-trade of Warhol's found imagery, Richter sought different narratives from such media: 'When Warhol painted the killers, I painted the victims ...'[10] As he explained in an interview with the art historian Benjamin Buchloh:

I looked for photos that showed my actuality, that related to me. And I selected black-and-white photos because I noticed that they depicted that more forcefully than colour photos, more directly, with less artistry, and therefore more believably. That's also the reason why I preferred those amateur family photos, those banal objects and snapshots.[11]

His painting *Helga Matura with her fiancé* 1966 transforms the family snap of a murdered prostitute from newsprint column to a larger-than-life canvas. Richter is not so much after verisimilitude but distance with his blurred black-and-white images, made by dragging a dry brush across wet paint. The effect is hallucinatory as the woman, leaning forward and dressed like a model in a fashion plate with heels poised, shimmers luminously, dwarfing her fiancé. Her smile towards the camera is made all the more chilling because it is her *memento mori*, inextricably linking her sex appeal with her murder.

One of Richter's sparring partners in the Düsseldorf Academy, Polke was not included in the 'demonstration', though all of his work ripped into the provincial heartland of West German consumerism. At the time he was making fabric paintings out of the kitsch material of cheap manufactured cloth. For instance, Polke's *Untitled (Vase II)* 1965 has a printed pattern of dots, out of which he worked a folksy still life by adding enlarged Benday dots. The German art historian Walter Grasskamp argues that Polke's 'serious silliness' was deceptive, for its 'witty tone of apparent amateurishness and parapsychological heteronomy ... made him the founder of "petit bourgeois realism" ... and soured the glamour with which American Pop art dazzled its West German viewers'.[12] In 1967 Polke, Lueg and Richter contributed a print for the *Grafik des Kapitalistischen Realismus* (Graphics of Capitalist Realism), satirising the aspirations of the West German 'economic miracle'. The exception was Richter's print *Hotel Diana* 1967, which shows him and Polke asleep in separate beds. By then they had begun to move on from pop: Richter was already working with abstraction, and Lueg had become the dealer Konrad Fischer and opened his gallery with an exhibition by Carl Andre.

NEW VULGARISMUS? VULGARISMUS?

Consider art as a way of experiencing a fusion of 'pleasure' and 'insight' ... It is time to incorporate advances in technology to create mass-produced works of art, obtainable by rich or not rich. Öyvind Fahlström[13]

So begins the 1966 manifesto *Take care of the world*, written by the artist Öyvind Fahlström when he was based in New York. It proposes a reparative role for art, calling for consciousness-expanding new drugs, unilateral disarmament, and free basic food, transportation and housing paid through taxes. The following year, 1967, Fahlström made an edition of plastic signs, *ESSO-LSD*, in which he appropriated a corporate logo for 'the ecstatic society'.[14] His diptych of these two irreconcilable acronyms lends legitimacy to the psychedelic, while equating the petroleum corporation with an illicit drug. His art, whether recycling comics or logos, was one that collided global realities, like his nomadic life that had spanned a childhood in Brazil, Sweden, and later in Rome and Paris before he landed in the midst of New York's avant-garde in the 1960s. Yet, as the artist Mike Kelley observed, he never quite fitted: 'Fahlström's tactics have more in common with the ambitions of the Conceptualists than those of the Pop artists with whom he is generally grouped ... but his use of popular imagery is inconsistent with most Conceptualist practice.'[15]

Erró, the Icelandic artist who had also arrived in New York, via Paris, in the late 1960s, was dubbed one of pop's 'social commentators' for his overabundant world of excess, created out of comic books.[16] For *Pop's history* 1967, a painting based on a small collage, he assembles a teeming multitude of Russian peasants contesting the Americans' claim to be the inventors of pop art, as if it were a site of super power struggle. In a twist of fate, his paintings have become mired with accusations of plagiarism by comic book artists.

The idea of a politically engaged art was still crucial to certain Europeans who identified more with British pop and popular culture than the cool aesthetic of the Americans. The Milanese artist Enrico Baj had a long involvement in socially engaged art, from the *Movimento d'Arte Nucleare* group in the 1950s to the *Great antifascist collective painting* in 1960, against French military involvement in Algeria. His anti-militarist *Le Baron Robert Olive de Plassey, Gouverneur de Bengale* (The Baron Robert Olive de Plassey, Governor of Bengal) 1966 is a parody of the eighteenth-century British colonial ruler of India, collaged from felt, braid, badges and brocade,

with the 'eyes' made out of The Beatles fan badges. By contrast, the figurative forms of his fellow Milanese artist, Valerio Adami, are highly refined studies in sexual fetishism, heighted by the flat, astringent enamel paint, outlined in black, with an occasional drop shadow, like the British artist Patrick Caulfield. The painting *F Lensky all'International Dance Studio* (*F Lensky at the International Dance Studio*) 1968, framed by doubled mirrors, feet and bars of the dance studio, portrays a renowned male dancer of Carnegie Hall fame. The pointed limbs of this frozen dance are sliced into cubist arcs and resemble tightly bound energy, as a contemporary legacy of futurism.

POP ART POST-MORTEM? POP-AROUND?

In June 1968, when *Documenta IV* opened in Kassel, West Germany, American art dominated the survey. While amongst the German artists selected there were no pop artists, nor *Kapitalistischen Realisten*, *Documenta IV* curator Arnold Bode did include *nouveaux réalistes* Arman, Jacquet and Raysse, alongside Jim Dine, Claes Oldenburg, Robert Rauschenberg, James Rosenquist, Andy Warhol, Tom Wesselmann, Joe Tilson, David Hockney and Eduardo Paolozzi. The preeminence of American art in the exhibition provoked much criticism and demonstrations. The American military intervention in Southeast Asia, combined with two decades of dependency orchestrated through the Marshall Plan, fuelled this opposition. As art historian Thomas Crow argues, 'in a volatile and internationalised art economy' there was much resentment, as 'America remained largely closed to imports from the Continent'.[17]

In spite of the protests *Documenta IV* proved a bonanza for the newly appointed director of the Power Institute at the University of Sydney, Professor Bernard Smith, then touring Western Europe acquiring for the Power collection. His selection of 19 purchases in Kassel was almost entirely European, including several prints by Arman, Ramon and Jacquet. He had previously purchased the Adami and Baj's *Le Baron Robert Olive de Plassey, Gouverneur de Bengale* in Italy, revealing a preference for socially engaged and crafted work. Along with the work of British artists Allen Jones and Tilson, these examples of European pop from the Power collection were regularly exhibited in Australia over the following decade.[18] In 1969, when the National Gallery of Victoria (NGV) hosted the national touring exhibition *Three trends in contemporary French art*, one of Niki de Saint Phalle's *Nana* figures was the 'cover girl' on the catalogue of its eclectic survey, spanning kinetic art and tachisme alongside Erró, Arman and Marcel Duchamp. The acting director of the NGV, Gordon Thomson, claimed against all odds that 'France continues to act as the conscience and register of the art world, retaining her position of centrality despite the forceful challenges of modern times'.[19] While *Nana* added colour and flair to the occasion, nothing could disguise the rout of French art, particularly in the wake of the extraordinarily successful Australian tour of *Two decades of American painting* two years earlier.

It is hard to speak of the reception of European pop art in Australia, as it was so partial, with only occasional glimpses of a fractured, atomised movement that was primarily defined in terms of American pop. Even the most coherent group, the *Kapitalistischen Realisten*, would remain largely unknown and unseen here until the 1980s; then they tended to be confused or conflated with German neo-expressionists. Yet their dark anxieties, particularly their fears about being consigned to provincialism by the era of American expansion, would have resonated with many Australian artists.

Elegant, impersonal, large in scale, both timeless and reflective of its time, *Rear view mirror* 1962 reveals Martial Raysse's singular visual language, more intellectual and satirical than the American approach to pop art. As he turned to painting in the early 1960s, Raysse stood out for taking a radical new approach to representation, which he defined as the 'hygiene of vision'.[1]

The artist chose not to draw his subject, preferring to use a photograph of an anonymous young woman, exploiting the flattening of reality that is characteristic of mechanical reproduction. Amputated from the lower half of her uncluttered face, the rest of the subject's visage is left intact and enhanced by dazzling colours. Out of an irresistible urge to beautify the world, Raysse persistently advocated artifice and illusion in his practice. Cropped to a rectangle, which unambiguously evokes a rear-vision mirror – the reliance on the readymade was finally unnecessary and instead mingled with the subject – the painting plunges the spectator into the space of the reflection of the feminine face, which in return gazes out at them. Raysse appropriates the tradition of illusion in painting, in which, according to Michel Foucault, 'the neutral furrow of the gaze piercing at a right angle through the canvas, subject and object, the spectator and the model, reverse their roles to infinity'.[2]

At the time of *Rear view mirror* Raysse was also making his debut on the international art stage, moving from New York to Los Angeles in 1963, where he would remain until 1968, his work gradually becoming infused with American popular culture. The painting was exhibited in January 1963 in the Dwan Gallery in Los Angeles

for his second American solo exhibition, *Mirrors and portraits*, after the presentation of his environment *Raysse beach* in New York in 1962.

In the early 1960s the female face appeared obsessively throughout Raysse's works, and his portraits echo the processes used by major figures in pop art who were working with the female image at the same time. However, unlike Warhol's portraits, his women were almost always anonymous, deliberately beautiful, and conceived as archetypes of a feminine ideal commonly seen in advertisements and magazines. A few years later, and with the same audacious and unique virtuosity, Raysse revisited the Old Masters, including Cranach and Ingres, with a small group of images in which he appropriated and adapted famous paintings, mainly featuring female nudes, giving them bold and vivid makeovers. Raysse's works offer a glowing palette of hyper-saturated colours, brimful of the thrilling visual intensity and sensuality of his native South of France, reinvigorated in Los Angeles, where the bright light, good weather and beach life all reminded him of the Riviera. That heightened sense of colour was crucial to Raysse, as he had come into an art world in Europe that was still emerging from the inheritance of World War II. His vibrant use of colour dispersed those dark shadows. AGA

Martial Raysse
Rear view mirror 1962
photomechanical reproduction and
paint on paper mounted on fiberboard
76.5 x 152 cm
Hirshhorn Museum and Sculpture Garden,
Smithsonian Institution, Washington, DC.
The Joseph H Hirshhorn Bequest 1981

Alain Jacquet
**Portrait d'homme
(Portrait of a man)** 1964
screenprint on canvas
163 x 115 cm
JW Power Collection, University of Sydney,
managed by Museum of Contemporary Art,
purchased 1968

Déjeuner sur l'herbe (diptych) 1964
photo screenprint on canvas, two panels
173 x 96.5 cm (each)
National Gallery of Australia, Canberra,
purchased 1983

Voluptuous and voluminous, *Black beauty* 1968 of Niki de Saint Phalle's *Nana* series presents the female form as radically assertive, liberated and joyous. Its great physical presence forms a bold visual statement about the status and representation of women: a monument to what the artist later perceived as a new matriarchal age.[1] The work stands at odds with conventional depictions of the female figure by predominantly male pop artists; a canon of iconography synonymous with the objectification of women. Purposefully breaking with 1960s beauty ideals propagated by advertising, *Black beauty* does not merely subvert such pictorial customs, but disregards them completely in its overt declaration of independence.

Painted in bright colours, the figure's dress reflects a psychedelic aesthetic aligned with 1960s fashion and culture. Her naïve appearance, but forthright, proud stance, exudes a sense of honesty and openness. With exaggerated and irregular proportions, *Black beauty* appears like a contemporary representation of the prehistoric mother goddess.[2]

The *Nana* sculptures – first exhibited at Galerie Alexandre Iolas, Paris, in 1965 – mark a point of resolve in Saint Phalle's work following the chaos and destruction that is characteristic of her shooting paintings and distressed assemblages. Formed of wire structures, papier-mâché, fabrics and yarn, these early *Nana*s constitute an abstract ornamentation reminiscent of patchwork, validating notions of feminine materials and decorativeness.[3] As the series developed, Saint Phalle produced *Nana*s from innovative, durable materials on a scale that could command large public spaces. These sculptures, often placed outdoors, appear free and exuberant in their active poses. The series title, *Nana* – a French term used to refer to women, at times pejoratively – is ennobled by Saint Phalle in her celebration of femininity.[4]

Saint Phalle's work is underscored by elements of feminist and sociopolitical activism, evinced particularly by her *Nana* series. Her work resonates with the African-American civil rights movement in terms of its sense of advocacy for equality, an aspect that was highlighted by the Whitney Museum of American Art's acquisition of Saint Phalle's *Black Venus* in 1968.[5] Further, the artist exhibited her largest and most controversial *Nana*, entitled *Hon (She)* 1966, at the Moderna Museet, Stockholm.[6] This collaborative, all-encompassing installation – filling the entire exhibition hall – presented a 'woman-cathedral': a pregnant woman of vast proportions lying on the ground with splayed legs, through which gallery visitors could enter. This groundbreaking work demonstrates Saint Phalle's role in challenging the establishment through her practice. The sheer scale of the project is a testament to her standing as an artist – as the only female member of the *nouveaux réalistes* group in Paris and her strong connections to the New York art scene – at a time when female artists were largely overlooked. JW

Niki de Saint Phalle
Black beauty 1968
from the series **Nana**
resins with synthetic polymer paint
237.4 x 145 x 60 cm
State Art Collection, Art Gallery of
Western Australia, purchased 1982

Sigmar Polke
Untitled (Vase II) 1965
oil on beaver bed sheet
89 x 75.5 cm
Stiftung Museum Kunstpalast,
Düsseldorf

Konrad Lueg
Football players 1963
tempera on canvas
135 x 170 cm
Deutsche Bank Collection at
the Städel Museum, Städel Museum,
Frankfurt am Main

In 1962 Gerhard Richter began making paintings from photographs. This turn to readymade pictorial content was spurred by the cultural circumstances in which he was newly embedded, having fled Dresden for Düsseldorf the year prior. At the time photographic production was proliferating 'almost hysterically' in West Germany as a vehicle for fuelling consumption, and Richter was exposed to a volume and variety of imagery from which he had been hitherto isolated in the communist East.[1] Meanwhile, his pursuit of a radically new approach to painting by way of photography – a medium implicitly linked to the past – unfolded against a backdrop of collective repression regarding Germany's recent history, lending a heightened tension to his works engaged with wartime themes or broader notions of death, trauma and loss.

Richter's interest in personal snapshots and the equally spontaneous, uncomposed character of mass-media photography developed alongside his early appreciation of American pop art. His first contact with the movement was in reproduction in 1963, when Konrad Lueg showed him a picture of a stove painted by Roy Lichtenstein; soon after, they travelled together to Ileana Sonnabend's Paris gallery where they saw his work firsthand, and declared themselves to be 'German Pop Artists'.[2] Richter later recalled the appeal of Lichtenstein and Andy Warhol's 'astonishing simplification' and anti-aesthetic treatment of their subjects, though ultimately his approach remained distinct from their classically pop idiom.[3]

Helga Matura with her fiancé 1966 comes from the period of intense studio production that followed. Rendered in Richter's signature *grisaille* style and heavily blurred, it skilfully conveys both the facture and evanescence intrinsic to its photographic source. The work is one of two portraits depicting the prostitute Matura that Richter painted in 1966, based on tabloid reproductions published after her murder in January that year.[4] The first shows her as a younger woman, seated in grass, smiling and unguarded, with her name inscribed beneath. In the latter painting Matura appears in a glamorous social setting, posing with her oddly adolescent-looking fiancé, whom she towers over. Despite this awkwardness, their touching feet add a sentimental edge to the scene, which emphasises the ambiguous status of the source image, caught between private and public realms.

By reproducing a photograph so overtly contaminated with the meaning of subsequent events, *Helga Matura with her fiancé* foregrounds Richter's interest in the way images become socially coded and emotionally charged. Though he initially claimed his photo paintings were demonstrations of indifference, he later abandoned this position, confessing: 'I painted things that mattered to me personally – the tragic types, the murderers and suicides, the failures, and so on.'[5] Richter's works dealing with these subjects share an affinity with Warhol's 'Death and Disaster' series, which similarly echoes the mass media's morbid fascination with mortality and misfortune. But where Warhol underlined the media's anaesthetising effect, Richter sought to galvanise the affective potential of such imagery from within the discipline of painting.[6] AJ

Gerhard Richter
Helga Matura with her fiancé 1966
oil on canvas
199.5 x 99 cm
Stiftung Museum Kunstpalast,
Düsseldorf

Samstag,14.Okt.1967, zwischen 11 u. 12 Uhr (Antwerpen, Hotel Diana, rechts Polke, links Richter)

Grafik des Kapitalistischen Realismus
(Graphics of Capitalist Realism)
print portfolio
published by Stolpeverlag, Berlin, 1968
Art Gallery of New South Wales,
purchased 1991

(above, clockwise from top left)

Gerhard Richter
Hotel Diana 1967
colour photo lithograph
29.5 x 40.2 cm (image); 59.6 x 84 cm (sheet)

KH Hödicke
Magic window cleaner II 1967
colour screenprint on transparent synthetic
polymer resin (plexiglas)
82.9 x 58.6 cm (image/sheet)

Sigmar Polke
Weekend-home 1967
colour screenprint
52.2 x 84 cm (image, irreg); 59.6 x 84 cm (sheet)

(opposite, clockwise from top left)

Wolf Vostell
Starfighter 1967
photo screenprint, glitter
53.5 x 81.8 cm (image/sheet)

KP Brehmer
The sensuality between fingertips 1968
offset colour photo lithograph, four seed
packets on cloth-covered cardboard
69.5 x 49.8 cm (image/sheet)

Konrad Lueg
Babies 1967
offset lithograph in duotone
59.6 x 84 cm (image/sheet)

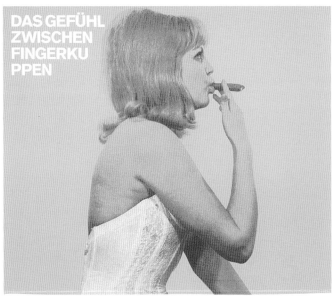

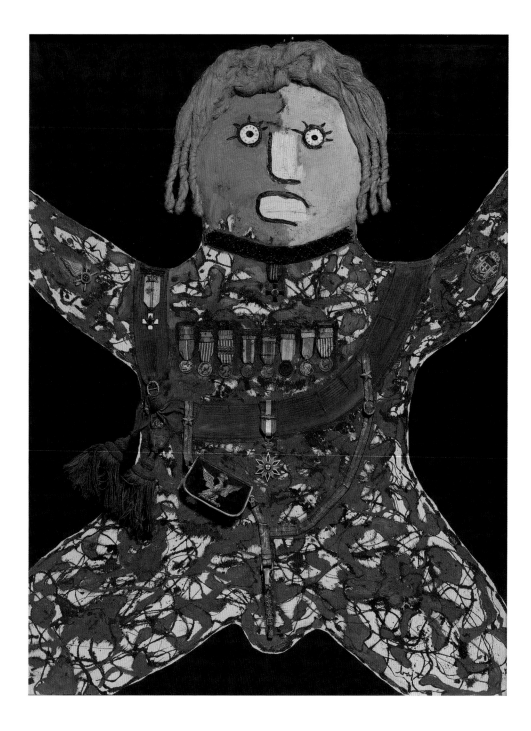

Enrico Baj has been described as 'a moralist with a penchant to ridicule human behaviour'.[1] In 1969 Baj visited Australia at the invitation of the Power Institute of Fine Arts, University of Sydney, which was pioneering a collection engaged with progressive international developments and had recently purchased a work by the artist. In a lecture given at the university, Baj noted that his creative agenda was not explicitly political, but had long been engaged in debunking 'official stupidity'.[2] In his work of the 1950s, this was primarily an aesthetic pursuit, marked initially by a revolt against 'the glacial geometry of abstraction', and later by a broader disavowal of 'cliché ridden convention' as an exponent of so-called anti-style.[3] Nevertheless, in 1959 Baj began a series of paintings that repeated the figural motif of the military general, turning his critique toward the socio-political arena.

Between 1959 and 1961 Baj produced nearly 40 generals: primarily frontal, cropped portraits with comically naïve anatomy, arms splayed or occasionally raised in salute. *General*

1961 is amongst the last works executed as part of the series, though Baj continued to depict venerated public figures for years to come. General Charles de Gaulle was an inspiration for a number of these personages, though Baj was unequivocal that his work invoked a type, rather than an individual: an emblem of power and 'stupid authority', invested with 'a false prestige, a very ridiculous prestige', in the wake of the horrors of World War II.[4] Baj's portraits register his cynicism and distaste for the glory bestowed upon perpetrators of violence – and the attendant social desire for decoration and honour – by rendering them grotesque. The puerile expression, squat physique and bulging groin of the figure in *General* are archetypal features of his caricatures, along with the rendering of military garb as vulgar spectacle.

Baj's derisive humour is partly expressed through his approach to materials. In *General*, a glut of medals is affixed to the figure's chest, their symbolic allure dulled by excessive repetition; a sash with ostentatiously tasselled

ends is also draped across his shoulders, supporting further embellishments. Most amusingly, the general's hair is a mass of twisted thread, unceremoniously pasted atop his head and sullied with paint. Though Baj had been incorporating readymade ephemera into his paintings since the mid 1950s – from textiles and braiding to glass and 'junk' – his generals signalled a greater convergence in this regard between form and content, and foreshadowed his use of more overtly consumerist materials like children's Lego and buttons bearing popular slogans. By 1966, his assemblage-based aesthetic and popular subjects had prompted many Italians to claim him as 'the father of Pop art', according to Lucy Lippard's early scholarly synopsis of the movement.[5] However, perhaps the most 'pop' of all his gestures was to follow in 1969 when, jaded by the enduring demand for his decorated figures, Baj decided to make the last of his generals available as a mass-editioned ceramic plate 'within the reach of all', to be offered 'like two fried eggs'.[6] AJ

Enrico Baj
General 1961
oil with collage of sisal, silk, wool, glass,
cotton, enamel, wood and various metals
146 x 110.1 cm
National Gallery of Australia, Canberra,
purchased 1978

(opposite)

Enrico Baj
**Le Baron Robert Olive de Plassey,
Gouverneur de Bengale
(The Baron Robert Olive de Plassey,
Governor of Bengal)** 1966
collage with felt, braid, brocade
and badges on canvas
146.4 x 114.6 cm
JW Power Collection, University of Sydney,
managed by Museum of Contemporary Art,
purchased 1968

Erró's work reveals his voracious appetite for images gleaned from newspapers, magazines and books. Cut-outs of figures, objects and scenes are accumulated by the artist in vast quantities from various visual spheres, including advertisements, comics, photographs, postcards and artwork reproductions. He then combines and manipulates these diverse fragments to produce complex compositions underpinned by coruscating wit. His large-scale works have an overt physical presence, comprising a dizzying array of pictorial elements so densely composed that they cannot be perceived in a single moment. In this sense Erró's work encapsulates the effect of photomechanical reproduction and the proliferation of images across the world in the twentieth century.

The principles of collage are fundamental to Erró's practice. The artist feverishly assembled cut-out images in a kind of rapid, automated process, which is evident in his prolific output.[1] Some collages evolved into paintings, initially being transferred freehand on to canvas by the artist, and later through use of a projector.[2] While *Pop's history* 1967 is not a collage per se, its method of production emulates that of Erró's cut-out works: the artist projected found images onto the canvas one after another, outlining the cast images to create the final work. This technique served to relegate *Pop's history* to a form of reproduction: a copy of the various projected images, which in turn were published reproductions. In this context, painting is 'degraded' to the status of a mechanically reproduced image. This method also enabled Erró to remove the artist's hand from the work and achieve a crisp finish, synonymous with the characteristics of commercial imagery and pop art more broadly.

Pop's history adopts the format of a cartoon, based on an image Erró appropriated from an American magazine.[3] The farcical sporting event is annotated by a banner entitled 'Pop's history', which is contextualised by a range of pictures appropriated from American pop art. Underscored by a sense of irony, the totemic Russian bear imagines a Tom Wesselmann nude, while other figures picture works by artists including Andy Warhol, Roy Lichtenstein, James Rosenquist and Claes Oldenburg. In this spirit the iconic works of pop art depicted in *Pop's history* are given equal visual weight to that of the cartoon figures, epitomising the democratising effect of the mass media and the breakdown of cultural distinctions intrinsic to pop art itself.

Erró's work examines the socio-cultural climate of postwar Europe, visually cataloguing the new consumer society, gender constructs, the media and politics. His powerful combination of images points to a world where minds are manipulated by the image, where propaganda and commercial branding infiltrate daily life.[4] In this vein Erró stands as a radical pop artist, playing on political irony derived from Cold War animosity. In *Pop's history* he works within a western framework – adopting images from American sources – yet he problematises American propaganda against the Soviets, and in turn Soviet strategies of indoctrination. While Erró's work has a patent political aspect, the artist himself did not propagate a particular ideology, rather working to critique Cold War tensions. JW

Erró
Pop's history 1967
glycerophtalic paint on canvas
145 x 205.2 cm
Reykjavik Art Museum

The emblematic concision of *ESSO-LSD* 1967 is characteristic of iconic pop art of the period, yet it is distinguished by artist Öyvind Fahlström's spirit of activism.[1] The work is distinct in Fahlström's oeuvre – particularly in his overt imitation of the visual language and subject matter of advertising – but it remains consistent with the philosophies central to his practice. Produced in synthetic materials as an edition of five, it harnessed technological advances to move toward the idea of mass-produced works of art, obtainable by all in society.

ESSO-LSD presents a pair of vacuum-formed plastic signs. The component to the left replicates the logo of the American-founded international petroleum company Esso, a subsidiary of Exxon Mobil. Stemming from Marcel Duchamp's idea of the readymade, the corporate brand has been appropriated into the work and isolated from its functional context. Yet, unlike a true ready-made, it is a manufactured, three-dimensional reproduction, rather than the object itself. By re-presenting this trademark, the work points to the propagation of American culture and commercialism in the postwar period. It signifies a commodity fundamental to economic growth in the twentieth century: powering cities, transportation and industry, and enabling the production of consumer goods.[2]

By contrast, the corresponding panel on the right presents the acronym for the psychoactive, hallucinogenic drug lysergic acid diethylamide, synonymous with 1960s counterculture and its anti-establishment sentiments. It references Fahlström's first experience with LSD in 1967 and his notion of an 'ecstatic society', where art and consciousness-expanding drugs are harnessed to incite creative living and pleasure.[3]

The format of the LSD acronym – the red text encircled by a blue oval – mimics that of the corporate petroleum brand. Aligned with Fahlström's earlier work with concrete poetry, its typographical arrangement is as important as the acronym itself in conveying meaning and achieving the intended effect of the work.

This visual device and the connection between the two panels enables new meaning to emerge, while simultaneously diffusing it revealing Fahlström's interest in the liquidity of meaning and how images are defined by their context.[4] It signals the aesthetic of interactivity and 'game structure' developed more overtly in Fahlström's 'variable' and 'game' paintings, where the viewer is integral to animating or 'playing' the work.

ESSO-LSD visually exemplifies Fahlström's ideas on art, society, politics and economics

expounded in his 1966 manifesto *Take care of the world*, underpinned by socialist principles and advocation for international disarmament. Such views are arguably at odds with the profit-driven motives of Esso, particularly in light of its role as a major defence contractor during World War II and within the socio-historical context of the Vietnam War.[5] Interestingly, however, Esso was active in the American civil rights movement, supporting African-American drivers as welcome customers at its chain of petrol stations at a time of rampant discrimination.[6] This aspect of the company's vision perhaps has greater affiliations with the ideas of social equality and free love epitomised by Fahlström's LSD sign. JW

Öyvind Fahlström
ESSO-LSD 1967
plastic in three colours, two pieces
88 x 119.5 x 7 cm (each)
IVAM Valencian Institute of Modern Art,
Generalitat

Wayne Tunnicliffe

'THE EASEL DID NOT GO POP: IT WENT BANG!' AUSTRALIAN POP ART

More than any other Australian art movement of the 1960s, pop responded to external stimulus: the advertising, mass media, consumer and popular culture experienced through much of the western world after World War II. Australia shared the political stability and economic growth enjoyed by many nations in the 1950s and 1960s, and participated in the new connectivity that media theorist Marshall McLuhan famously termed 'the global village' in 1962.[1] New consumer goods were widely available, and an increasingly sophisticated advertising industry developed in which some artists worked. Pictorial magazines, newspapers, comics, mass-market books and films were highly popular entertainment, and television was introduced in 1956. Major international music acts performed in Australia – from Bill Haley and His Comets in 1957, to The Beatles and The Beach Boys in 1964, The Rolling Stones in 1965, and Bob Dylan in 1966 – coinciding with a new local pop-music scene and the emergence of teen culture as a social and market force that became a more rebellious youth culture later in the 1960s.

At the beginning of the decade Australia had a conservative and long-standing government under prime minister Robert Menzies, a white Australia migration policy, a repressive censorship regime, no citizenship for Indigenous peoples, and abortion was illegal. The Cold War between the United States of America and Russia led to anxieties about nuclear destruction and the spread of communism, and Australia supported the American war in Vietnam from 1962. As with much of the developed world, however, radical social, cultural and political shifts took place over the decade, which irrevocably changed how Australians lived; some artists participated directly in making change occur. Australia also shared the ambivalent desire for all things American, felt by much of the non-American world, while fearing 'coca-colonisation' and retaining strong cultural allegiances to Britain and Europe. Australian art's encounter with pop culture arrived independently of international pop art, but responded to overseas developments as they became known during the 1960s, eventually becoming defined and even confined by critical definitions of pop art from the United States and Britain. And yet Australian pop artists were often highly individual practitioners rather than part of a programmatic movement, informed by their specific Australian context and local artistic peers as well as global developments.

Australian art at the beginning of the decade has often been drawn into battle lines between painterly abstraction in Sydney, led by the charismatic figure of John Olsen, and the expressive figurative paintings of the artists, called the Antipodeans, that art historian Bernard Smith had rallied around a manifesto and an exhibition in Melbourne in 1959. While these were two prominent art movements, the reality was more complex, with the continuing success of the romantic figurative school of Paris painters known as the 'Sydney charm school', abstraction in Melbourne practised by artists such as Roger Kemp and Leonard French, and representational artists whose work did not fit the Antipodean group mould, such as the increasingly austere realism of Jeffrey Smart or the gently satirical urban and suburban subjects of signed-up Antipodean member John Brack.[2] As pop emerged from a younger generation of artists there was already a tradition of vernacular and city subjects which aided its reception, including the street scenes of social realist artists in the 1930s and 1940s, Sidney Nolan's St Kilda and Luna Park paintings in the 1940s, and the 1950s urban subjects of Brack and other Antipodeans Charles Blackman and Robert Dickerson.

The first sustained use of mass-media imagery and found everyday materials was revealed in the exhilarating and chaotic 1962 exhibitions by the young, Sydney-based artists Mike Brown, Ross Crothall and Colin Lanceley, as the Annandale Imitation Realists (AIR) at the Museum of Modern Art of Australia in Melbourne, and as the Subterranean Imitation Realists (formerly of Annandale) at the Rudy Komon Gallery in Sydney.[3] The term 'Imitation Realism' was a provocation in itself, to both abstract and figurative artists alike, and the AIR works are a remarkably anarchic combining of discarded objects from Sydney streets with collaged photographs from magazine and newspaper pages and deliberately crudely painted text and images.[4] Despite the occasional use of collage or assemblage prior to this in Australia, there is no local precedent for these works or for their presentation in Melbourne, stacked up on hastily made temporary structures as a complete environment.[5] Critic and curator Daniel Thomas suggested a context in recent international neo-dada and assemblage art that was profiled in *The art of assemblage* exhibition at the Museum of Modern Art in New York in 1961, and with British pop art, but also identifies popular culture sources that are equally local and international:

> Besides art they like nude women and food; often in combination. There are several collages or pin-ups drowning in spaghetti or rice. They know which magazines, comic strips, TV stars, advertisements, hit tunes, have the widest popular currency in Australia. Their intention is to

extract from this large area of life some sort of poetry, both literary and visual, by using the very same tawdry magazines and the very same glittering or gaudy objects that furnish this world intellectually and physically.[6]

A desire to both contextualise and differentiate the AIR exhibitions from international developments catalysed Australia's first in-depth article on pop art, Elwyn Lynn's 'Pop goes the easel' in the November 1963 edition of *Art and Australia*.[7] Lynn discusses approaches to popular culture occurring simultaneously in London, New York and Sydney, and shows considerable knowledge of the artists already associated with the movement internationally.[8] He charts differences between each approach, but identifies global connectors such as an interest in sexualised advertising images and an 'attempt to redeem the products of mass-media and mass production by using the means of mass culture'; he goes on to say that the artists 'know millions come to life when they hear the pop singers, enter Woolworths or Coles, or read the alluring advertisement'.[9] In discussing British pop Lynn cites the Independent Group and the *This is tomorrow* exhibition at the Whitechapel Art Gallery in 1956, and he has clearly read Richard Hamilton's 1957 definition of popular art when he characterises 'mid-twentieth century urban art':

> They are not worried about the transient, short-term solutions in their art; they use what is expendable and easily forgotten; the cleverness of other people's gimmicks fascinates them; they are more anti-art than anti-big business whose irrational glamour intrigues them. They do not aim at the usual art market, but at youth.[10]

While Lynn acknowledges that the AIR shared these elements with both British and American pop, he also recognises their own rich inventiveness and distinctive visual language, and finishes by declaring, 'The past and present work of Crothall, Brown and Lanceley was not created in a vacuum of course: it was created by individual and highly personal artists; its debut was dramatic and the applause can still be heard. The easel did not go Pop: it went Bang!'[11]

The AIR use of collage, assemblage and painting, often within the one work, was to become a characteristic of Australian pop art.[12] One of the most pop of the AIR works was Mike Brown's *Mary Lou* 1962, particularly in its second incarnation as *Mary Lou as Miss Universe* 1962–63 (destroyed), which became infamous when Brown removed it from display at the Art Gallery of New South Wales (AGNSW) in December 1963. Named after Ricky Nelson's 1961 hit song 'Hello Mary Lou', it was exhibited in the Melbourne and Sydney AIR exhibitions in its first version, a large-scale painted woman with ukuleles for legs, a doll's arms, plastic bathtub ducks for breasts, a crushed red paint tin lid for a vagina and painted hair that radiated across the upper part of the painting, comprised of both tribal patterning and painted text. Brown reworked *Mary Lou* after the AIR exhibitions and it became dramatically colonised by collaged pin-up girls cut from men's magazines. It was selected by curator Laurie Thomas for the exhibition *Australian painting today: a survey of the past ten years* (1963–64) that was to tour Australia and then Europe, but when the exhibition was displayed at the AGNSW Thomas advised Brown that his painting would not be going overseas, as *Mary Lou as Miss Universe* no longer had artistic merit.[13] From surviving photographs the reworked *Mary Lou* clearly does have considerable merit, but the reduction of the artist's process to the cut and paste of collage, and the use of images from pin-up and 'girly' magazines viewed as 'vulgar' was a step too far for officially sanctioned culture.[14]

The rejection of *Mary Lou as Miss Universe* occurred just as a new generation of artists engaging with popular culture were achieving public recognition in Sydney and Melbourne. The *Young contemporaries exhibition* held at Farmer's Blaxland Gallery, Sydney, in April 1964 included Mike Brown and Ross Crothall, but also other artists with a pop subject and style, including Michael Allen Shaw, Martin Sharp, Ken Reinhard and Dick Watkins. In 1964 Reinhard also won the Sulman Art Prize with his satirical pop painting *The public private preview* 1964 (collection of the artist), and Watkins, Shaw, Richard Larter, Reinhard, Gareth Sansom and Robert Rooney all had solo exhibitions in commercial galleries. Daniel Thomas's review of the *Young contemporaries exhibition* was titled 'Pop art and "ad" men' and singled out pop as 'really proliferating. It is undeniably pop art, clearly acknowledging its source material from popular culture in signs, trademarks, advertisements, comic strips.' Thomas goes on to write that it can be completely abstract, as in Crothall's work, or completely figurative, as in Shaw's paintings, and saliently observes 'In both cases there is a claim to inherit the main tradition of realism, for the subject matter is taken from the widely-shared everyday experience of ordinary men and women in an era when the advertising jingle has become the real folk music'.[15] James Gleeson was more dismissive, considering some of the same artists in 'favour of the latest fashions from America'.[16] These two critical positions marked a divide that was to characterise

the response to pop art in Australia through the decade: the view of it as a manifestation of an increasingly global culture versus a fashionable copying of international art movements.[17]

In 1964 The Beatles toured Australia to rapturous crowds and youth culture went mainstream as a widely discussed phenomena. Ken Reinhard included a portrait of The Beatles in his first solo exhibition at the Macquarie Galleries in September, after he had won the Sulman Prize, and critics identified his work as a form of pop satire. Critic Wallace Thornton wrote: 'His social comment embraces the suburban wedding, strippers, Beatle fans, beauty contest entrants, the topless fashions of 1964 and subjects like canned entertainment.'[18] The works themselves combined drawing, painting, Letraset text, and collaged magazine and newspaper images, and text amongst other elements on a clean, white ground, which gave them a cooler and much less expressive appearance than that of many of his contemporaries. Reinhard's work soon evolved into the style he was to continue with through the decade, which left satire behind and became a hybrid of hard-edge abstract and figurative elements, and embraced commercial design.

Dick Watkins, Richard Larter and Michael Allen Shaw were firsthand witnesses to early British pop. Watkins had spent three years in London from 1959 and returned to Australia via New York in 1961. The effect of this trip on Watkins' work was immediate, and in 1963–64 the influence of Robert Rauschenberg's combines, RB Kitaj's figurative painting and Kenneth Noland's hard-edge abstraction are clearly visible.[19] Larter and Shaw were both British artists; Larter migrated to Australia permanently in 1962 and Shaw was resident in Sydney from 1963 to 1966. They had witnessed the emerging British pop scene and worked with both figurative and abstract elements in their paintings, a characteristic of British pop as it evolved in the paintings of Derek Boshier and Allen Jones amongst others.[20]

Shaw was given the second-ever solo exhibition to be held at the newly established Watters Gallery in Sydney in December 1964, and at this time his figurative paintings were typically dominated by flat areas of colour interspersed with patterning formed by stripes, dots and other shapes. Wallace Thornton observed the connection with recent forms of abstraction: 'The imagery of pop art is adjusted with the attitude of the hard-edged school in these works.'[21] One of Shaw's series was based on the lurid covers of popular Larry Kent pulp detective novels, and another was titled *Elke* after the then high-profile actress, sex symbol and centrefold Elke Sommer. Shaw's most impressive Australian period work is the 1965 *Lawrence diptych*, portraying Lawrence of Arabia on the left panel against a strong red ground, and a cluster of horsemen on the right panel.[22] Elwyn Lynn wrote that this work, 'done like a photo negative in fierce colours, deals with past heroism and despair by using the unswerving immediacy of the poster: it is the best and least didactic of local pop yet seen'.[23]

From the mid 1950s Larter was drawn to contemporary urban life in the streets, cafes, pubs and strip clubs of London. He cites Kitchen Sink School artist John Bratby as an influence, and particularly his technique of painting multiple viewpoints in one painting.[24] Larter saw the seminal *This is tomorrow* exhibition at Whitechapel Art Gallery in 1956, and admired the work of David Hockney and RB Kitaj in particular at the *Young contemporaries* exhibitions in London. The collage aesthetic on display in *This is tomorrow* and in the accompanying catalogue, and Eduardo Paolozzi's earlier collages made from glossy American magazines, which began to be displayed from the mid 1950s, were a precedent for Larter's own extensively practiced collaging.[25] Larter's liberated attitude towards sexual expression had full reign from the early 1960s, and freed from the formal limitations of his idiosyncratic application of paint through syringes when they became hard to get after 1965, Larter developed a more overtly pop, flat, frontal style in which clamorous multiple painted images are connected through areas of abstract patterning.

The uneasy relationship between some mid 1960s Australian pop and repressive censorship laws came to a head in a series of high-profile prosecutions. Gallery owner Max Hutchison and Mike Brown were charged with obscenity after Brown's November 1965 *Paintin' a-go-go* exhibition at Gallery A in Sydney's Paddington. Hutchison pleaded guilty and was fined, while Brown was found guilty in November 1966 and sentenced to three months' hard labour, the maximum penalty available. The severe sentence was shocking and many in the arts community rallied to support Brown; while his sentence was eventually reduced to a fine of $20, his conviction was upheld. This court case came hot on the heels of the prosecution of the editors of *Oz* magazine in 1964, which had published the work of artists and cartoonists Martin Sharp and Garry Shead. The two had met while they were students at the National Art School in East Sydney, and in 1962 initiated the production of the student newspaper *The Arty Wild Oat*, which lasted for two issues. Through this they met Richard Walsh, who edited *Honi Soit* at the

University of Sydney, and Richard Neville, editor of *Tharunka* at the University of New South Wales. Walsh, Neville and cadet journalist Peter Grose launched *Oz* magazine on April Fool's Day in 1963. It was immediately controversial, as it challenged the conservative establishment on multiple fronts. Articles on abortion and chastity belts in the first issue led to obscenity charges being laid against the editors, and then a second series of charges were brought against them, the printer and Sharp in 1964 for seemingly contentious content, including Sharp's satirical cartoons. This time the defendants were sentenced to jail with hard labour, later reduced on appeal to a conviction and fine.[26]

While the appeal process dragged on Sharp's first solo exhibition, *Art for Mart's sake*, opened on 8 December 1965 at the Clune Galleries in Potts Point. The exhibition title was an obvious pun on 'art for art's sake', with the 'art's' substituted with an abbreviation of 'Martin', and further punning suggesting both the art market and a supermarket, a pop trope from the United States. The exhibition's presentation was orthodox, with framed works on paper and collage paintings on the wall, and free-standing sculptures, but the works themselves continued the punning, satirical and surreal vein of Sharp's work as a cartoonist. The influence of the Annandale Imitation Realists can be discerned in some works, and Sharp had earlier befriended Lanceley, who had written an article on the AIR for the second issue of *The Arty Wild Oat*.[27] Sharp's surreally biomorphic forms and bright organic patterning in this exhibition were all precursors for the more psychedelic designs that were to follow after he moved to London. The exhibition was commercially successful and, after the drawn out appeal process for their earlier obscenity convictions concluded, on the proceeds Sharp and Neville set off early in 1966 for London, via Southeast Asia.

In September 1966 Clune Galleries subsequently hosted the *Oz supa art market*, an Australian response to the 1964 exhibition *The American supermarket* at the Bianchini Gallery in New York, in which Billy Apple, Andy Warhol, Roy Lichtenstein, Claes Oldenburg, Tom Wesselmann and others had recreated a supermarket with art that emulated store goods. The Sydney version also copied supermarket displays stocked with art, and the organisers were architecture students and artists John Allen, Michael Glasheen and Peter Kingston, with contributions by Garry Shead and drawings sent from London by Martin Sharp.[28] While Ben Davie in *The Sun* declared 'Sydney's first Pop Art show has opened to reveal "a new visual experience ..."', a more informed Craig McGregor in *The Sydney Morning Herald* began with 'Pop strikes again' and continued by saying that Sharp's drawings were the least pop part of the exhibition, but 'Not so the work of the other three [*sic*], which are as wildly extravagant and zany as any Oldenburg could wish and transform Clune's into a sort of nightmare amalgam of a Woolworth's Foodarama and the Tempe tip'. While McGregor, an important commentator on popular culture, criticises the Clune show as being only partially successful, he also points out that pop content did not just transform art but that perceptions of the familiar were also changed: 'By rediscovering form, pattern, vitality in our everyday environment pop has helped to re-create it, transform it into art.'[29]

Sharp joined the remarkable Australian diaspora in London in the 1960s, which built on the prominence gained by Australian artists through a series of exhibitions in the late 1950s and early 1960s. While dominated by an older generation, the success of charismatic young painter Brett Whiteley was galvanising, and his flat and studio in Ladbroke Grove became a focus for many of the younger visiting and relocating Australian artists. The roster of expatriates contributing to 'swinging London' as it was named by *Time* magazine in 1966 was remarkable: Barry Humphries, Robert Hughes, Clive James, Germaine Greer to name but a few who became high-profile cultural commentators.[30] Neville and Sharp set up a London edition of *Oz* in 1967, which after a shaky start became one of the most important counterculture magazines of the period. *Oz* published Sharp's work, which extended from cartooning to cover and poster designs that were remarkably original and prescient counterculture images, and which anticipated and then participated in the psychedelic art movement. Sharp exemplified the disciplinary crossovers that occurred in pop culture in the late 1960s, co-writing with his room-mate Eric Clapton one of Cream's most popular songs, 'Tales of brave Ulysses', and designing covers and posters for the band's *Disraeli gears* and *Wheels of fire* albums.

Brett Whiteley's high public profile and persona during the 1960s was pop in itself. After establishing his reputation in London in the early 1960s through expressive, richly toned, abstract paintings based on the landscape, he moved to a mixed abstract-figurative art, initially through a series depicting his wife Wendy in the bathtub at their new Pembridge Crescent flat, influenced by Francis Bacon and Pierre Bonnard.[31] He subsequently explored the notorious

murders by serial killer John Christie, and his increasingly hybrid paintings assimilated collage and the bright, flat colours associated with pop and hard-edge style, particularly on returning to Sydney in 1965 and staying at Whale Beach, when he moved further towards a pop-expressive idiom. It is in a hyped-up version of this style that he undertook *The American Dream* 1968–69, one of the most ambitious works by an Australian artist in this period. In the work Whiteley explores the disparity between hopes and realities in encountering American culture firsthand after moving to New York in 1967 and taking up residence in the Chelsea Hotel. This massive painting emulates the scale of Rosenquist's *F-111* 1964–65 (Museum of Modern Art, New York) and is an acidic, dystopian response to the fissures in American society: the wars, racism and poverty that were the underbelly to the gloss and glamour of consumer life.[32]

While American and British popular culture were everywhere in music, fashion and film, the main source of information on international pop art remained magazines, including the American publications *Art International* and *Art News*, and from 1964 the British *Studio International*. Copies of *Ark*, the Royal College of Art's magazine that had included the young British pop artists, were also available at the State Library of Victoria and at the University of Sydney library.[33] Pop art also had mainstream coverage, with the typically dismissive articles appearing in *Time* and *Life* magazines in 1963 and 1964 replaced with more accepting articles soon after, including in local fashion magazines such as *Vogue Australia*.[34] Major international exhibitions featuring pop art, such as the 1964 Venice Biennale and *Documenta IV* in Kassel in 1968, were reviewed and discussed in Australian art publications, including *Art and Australia* and the Contemporary Art Society, NSW Branch's *CASNSW Broadsheet*. The mid 1960s also saw a boom in pop-art book publishing, and Mario Amaya's *Pop as art* (1965) and John Rublowsky's *Pop art* (1965) were reviewed with the salient observation that both books had 'no hint of the mass of criticism that has met Pop-art'.[35] The luxurious, large-format 1965 publication *Private view: the lively world of British art* included younger pop artists such as Hockney, Boshier and Peter Blake, as well as establishment figures, and the Australians Nolan and Whiteley.[36]

Only a very few international pop works could be seen firsthand in Australia, however. In 1963 the Contemporary Art Society exhibited David Hockney's *I saw in Louisana a live-oak growing* 1963 (Art Gallery of Ontario, Canada), though as an example of pop art it was somewhat perplexing to local critics. Hockney's *Two friends* 1963 (collection unknown) was owned by Frank McDonald, director of the Clune Galleries in Sydney, and was reproduced in Elwyn Lynn's article 'Pop goes the easel' and displayed publicly in the *Young British painters* exhibition at the AGNSW in 1964, which also included two wooden constructions by Joe Tilson on loan from the Calouste Gulbenkian Foundation.[37] *Contemporary American painting, selected from the James A Michener Foundation collection* toured in 1964 and included Jim Dine's *Four coats* 1961 – a major example of his collage paintings – and Larry Rivers' *Dead veteran* 1961 (both Blanton Museum of Art, University of Texas, Austin), but these two works were not like the American direct popular image works known by 1964, and Lynn remarked that the 'impact on younger painters would have been more marked had more assemblage and pop art been included'.[38] In 1965 the Contemporary Art Society of London presented the National Gallery of Victoria (NGV) with the important Hockney painting *The second marriage* 1963, which directly influenced some Melbourne artists. In Sydney, John Kaldor had begun collecting American pop art in 1964 and by the end of the decade would have works by many of the leading artists. Kaldor had read the dismissive article on pop art in *Time* magazine in 1963, but the works had excited him, and when in Paris on a business trip in 1964 he visited the Ileana Sonnabend Gallery and bought a small Roy Lichtenstein, *Peanut butter cup* 1962.[39] He later acquired Robert Rauschenberg's combine *Dylaby* 1962, Claes Oldenburg's *Soft hot and cold taps* 1965 (collection unknown), Tom Wesselmann's *Great American nude no 17* 1961 (private collection), as well as a maquette for Jasper Johns' *Green target* 1955 (Louisiana Museum of Modern Art, Denmark) and a small painting from Andy Warhol's *Flowers* series (collection unknown).[40]

Melbourne artist Gareth Sansom cites the British pop artists he read about in *Ark* and the Hockney when it arrived at the NGV as being influential on his highly individual figurative style.[41] Sansom's fragmentary painted and collaged images are linked through areas of flat, abstract patterning and worked surfaces using enamel house paint in conjunction with oil, pencil and oil crayon, and which could involve 'blow torch, PVA and scraping'.[42] In the mid 1960s Sansom worked through the influence of Francis Bacon and Jean Dubuffet in his expressive, meaty figures; the British pop artists in the strong colours and patterns of heart shapes, stripes, diamonds and circles; and even experimented with image transfers similar to those used by Rauschenberg. Sansom's energetic hybridity and formal arrangement of multiple elements is entirely his own, however,

opposite, from left: Daniel Thomas, Dick Watkins and Michael Allen Shaw, Elizabeth Bay, Sydney, 1965. The photographer Robert Walker is reflected in the mirror and the large painting is by Shaw.

and by 1968 he was collaging even more found images onto some of his most impressive works, such as *The great democracy*, which he described in a contemporary interview as 'aesthetic photo albums'.[43]

In Sydney, *Oz* magazine cartoonist Garry Shead also painted in an expressive figurative style, which shows the influence of Bacon and Whiteley's mid-1960s paintings, and in his solo exhibitions at Watters Gallery from 1966 Shead confronted sexual hypocrisy in keeping with a counterculture desire to expose double standards. Shead's most direct pop works were exhibited in *Oh what a beaut view and other paintings* in 1968; included was *Bondi* 1968. These works share the eroticism common to later 1960s pop art internationally, and they remain confronting. Critic and artist Noel Hutchison wrote of this exhibition:

> Shead paints with the attitude of that onlooker who is always around in parks and public places. Looking to see the obscene, Shead finds, and celebrates it. He is a moralist, and yet salivates over the joys of human exposure. 'Bondi' [encourages] an attitude of shocked love for lewdness. The prudish are confronted and decimated by their own guilt complexes.[44]

The founding of the Central Street Gallery in Sydney in 1966 brought focus to the new forms of abstraction in Australia that from the mid 1960s were known as hard edge or colour field, and which also became known as the Central Street style. While Central Street lasted only four years, its programmatic promotion of artists and endorsement by critics and curators as a new internationalism in Australian art achieved a high profile. This culminated in the 16 artists who had exhibited at Central Street being selected for *The field* exhibition of 1968 that opened the new NGV and was subsequently shown at the AGNSW. The demise of this movement is as well documented as its rise, with many of *The field* artists moving away from hard-edge abstraction by the early 1970s. Central Street's association with a pure, hard-edge style was by no means established from the beginning, however, and the opening exhibition in April 1966 was of American pop art prints that Paul McGillick had brought back with him from the Leo Castelli Gallery in New York, including works by Jasper Johns, Andy Warhol, James Rosenquist, Roy Lichtenstein, Frank Stella and Robert Rauschenberg.[45] A second exhibition of American prints and posters in July 1967 included further pop artworks within a broader selection of work.[46]

Key Central Street artists Dick Watkins and Alan Oldfield painted energetic pop–hard-edge hybrids that show a more diverse approach to internationalism than is often associated with late 1960s Australian abstraction. After his first pop-informed works of the early 1960s Watkins returned to a more resolved pop–abstract idiom in a group of works from 1967 and 1968. *The fall no 1* and *The fall no 2*, both 1968, are amongst the finest of this group and show two of Watkins' divergent approaches. Both were worked up from collage maquettes made from cut-up pages of comic books, with the figurative elements fragmented to the point of abstraction.[47] *The fall no 1* is closer to its source material, with flat sweeps of strong colour that retain the dynamic sense of movement in the original comics. *The fall no 2* shows Watkins working through a cubist, constructivist and Fernand Léger-inspired abstraction, part of an international resurgence of interest in the art of the 1920s and 1930s, and in art deco design, explored concurrently by Lichtenstein.[48] While appearing hard edge from a distance, on closer viewing the hand-painted quality of these works is obvious, with areas that are deliberately brushy, schematic and even unfinished looking, as typically Watkins steps back from any programmatic art movement into his own individual approach.

Alan Oldfield moved from a typical mid-1960s expressive figurative art influenced by Bacon and Whiteley in his first exhibition in 1966 at Watters Gallery, to a more full-blown pop art in the group of paintings of women he exhibited in 1967.[49] These works, with titles such as *Smile*, *Metermaid* and *Lucy in the sky with diamonds*, only survive in faded colour slides but show the influence of both Tom Wesselmann and Allen Jones in their flat, strong coloured areas and partially abstracted figures.[50] Oldfield's solo exhibition at Central Street in 1969, titled *The great nostalgia show*, merged figurative pop and hard-edge abstraction as Oldfield ran through the styles he identified with each decade of the twentieth century up to the current moment. The work *Cliché* c1968, in the 'Sixties' section, features the text 'Made in Australia' and has a hard-edge, comic-book lightning bolt overlaying a seeming superhero figure who reaches around to hold a phallic extrusion. The title *Cliché* and the text in the work may refer to the ongoing tussle between those who thought Australian art should have Australian subjects and those who argued for an internationalism that both pop and hard edge represented late in the decade.

Both Watkins and Oldfield exhibited in *The field*, as did Melbourne artist Robert Rooney, with his hard-edge pop abstract *Kind-hearted kitchen garden IV* 1968 (Ian Potter Museum of Art, University of Melbourne). Rooney's interest in beat culture in the late 1950s and imagery culled from magazines such as *Life* and *Time* is well documented, and he exhibited collages in the 1950s as well as composing them for private use as source material and as a satirical exchange between friends in the early 1960s.[51] Rooney, like Sansom, read copies of *Ark*, which he had begun ordering in 1962, and became interested in pop art and American abstraction in the mid 1960s. After seeing the watershed exhibition *Two decades of American painting* in 1967 and responding to the wave of Australian interest in hard-edge abstraction, he developed his series of irreverent hard-edge pop paintings, which utilised repeated shapes varied in complex patterns across works, with stencils cut from Kellogg's cereal packets in the *Kind-hearted kitchen garden*, *Cereal bird beaks*, *Canine Capers* and *Slippery seals* series. The final series before Rooney gave up painting for over a decade were the *Superknit* works derived from knitting patterns, which he painted from 1969 to 1970.

Two decades of American painting, toured by the International Council of the Museum of Modern Art, came to the NGV and AGNSW in 1967.[52] This exhibition included exceptional abstract expressionist, hard-edge and colour-field painting, and both pop precursor and classic pop works. Some of the most important included Jasper Johns' *White flag* 1955 (Metropolitan Museum of Art, New York) and *Map* 1961 (Museum of Modern Art, New York), Robert Rauschenberg's combine *Allegory* 1959–60 (Museum Ludwig, Cologne), and Larry Rivers' *The pool* 1956 (collection unknown). Classic 1960s pop included Allan D'Arcangelo's *US Highway 1 No 4* 1963 (collection unkown); Roy Lichtenstein's *Femme d'Alger* 1963 (The Eli and Edythe L Broad Collection, Los Angeles) and *M-Maybe* 1965 (Museum Ludwig, Cologne); James Rosenquist's *I love you with my Ford* 1961 (Moderna Museet, Stockholm); and Andy Warhol's *Electric chairs* 1964, *Jackies* 1964 and *Campbell's soup* 1965.[53] The exhibition polarised avant-garde and conservative artists and the public, but was widely discussed and viewed, with 115 000 visitors recorded in Sydney and the catalogues selling out at both venues.[54] While the critics concentrated on the abstract works that formed the majority of the exhibition, the pop paintings were positively reviewed, with comments on their unexpected complexity. Patrick McCaughey described them as 'a revelation', and said of the Rosenquists and Warhols: 'In the flesh, these are disturbing paintings and wipe the smile off the face. Of all the paintings in the exhibition these seem to point most directly to an experience of anxiety.'[55] Wallace Thornton wrote that Lichtenstein's 'high technical achievement assists an impressive artistic statement', and James Gleeson that 'The vitality of the ideas behind all these varied [pop] paintings will not come as a surprise to those who have followed the developments in smaller exhibitions, prints, books and journals – but the sensitivity of so much of it is unexpected.'[56] Critics hoped that Australian artists would respond to the ambition and quality of the works, but another significant effect was that the exhibition showed most Australian pop did not look like American pop art.[57]

In the same year, 1967, Vivienne Binns' first solo exhibition at the Watters Gallery in February shocked and appalled both the conservative establishment and many of the more liberal art critics. The 23 works on display were materially and stylistically diverse, and recalled the free-flowing anarchism of the Annandale Imitation Realists and Mike Brown's exhibitions earlier in the decade.[58] Many of the paintings have a pop-funk style and strong, distinctive, off-key colours that participate in the psychedelic and counterculture art that was just beginning to emerge internationally. Particularly provocative to the critics were the assemblage *Yipes! ... What a mess* 1967 (destroyed) – the chaotic and dirty appearance of which seemed 'unfeminine' – and the even more confronting erotic genital works: the erect flower-spouting penis of *Phallic monument* 1966, the *vagina dentata* of *Vag dens* 1967, and the kinetic pulsing clitoral *Suggon* 1966. The artist's gender and the explicit sexuality of these works inflamed the negative response, from the outraged and dismissive to the patronisingly sexist. By the mid 1970s Binns' 1967 exhibition was viewed as proto-feminist and a precursor to the core imagery that later emerged internationally in the work of artists such as Judy Chicago. The critic and curator Lucy Lippard responded to Binns' work in an interview with Ann Stephen, when she visited Australia in 1975, describing it as 'that mind-blowing show of Vivienne Binns' in Sydney in 1967, which was way ahead of its time, and must have been a shocker'.[59]

Binns' raw, assertive sexuality contrasts with the work of male contemporaries, such as the nudes and partially clad women featured in Peter Powditch's 'sunorama of bleached sands, bikinied brown maidens and blue-blue waters'.[60] However, what may appear to be celebrations of sensuality and hedonism were sometimes held to be harsh rather than idealised due to their

painted expressions and fragmented forms.[61] While the beach was strongly associated with Australian identity from the early twentieth century onwards, and often appeared in newspapers and magazines, cinema newsreels, painted pub signs and tourism posters, it had only appeared occasionally in art. American surf culture was a global export in music and film from the late 1950s, and was an easy overlay with an already existing and sometimes rebellious surf culture in Australia, bringing a renewed focus to our beaches. From mid 1969 and into the mid 1970s, Powditch came closest in Australia to a Warholian serial production, in his *Sun torso* series, which developed from experimental prints he made in the Gallery A print workshops. The *Sun torso* images involved Powditch spray painting over geometric and more figurative templates, which could be recombined in numerous ways, as indicated by the fact that the AGNSW's example is number 140. These were popular works that were exhibited widely and won several art prizes in the early 1970s.

Adelaide-trained artist Robert Boynes was producing highly accomplished, minimal pop paintings with some of the smoothest surfaces in Australian art in the late 1960s. He had painted in the pop-inflected figurative style, with its debt to Bacon and British pop artists that was common to many of his contemporaries in the mid 1960s, until travelling to Britain in 1967 for two years. There he responded to Peter Phillips' paintings in his *Factory image* series, with defined, modular forms partially overlaying the nudes, before turning to the airbrushed, reduced and frontal cool impersonalism in works such as *Premonition* 1969. The frontality of these images and their immaculate execution – and the choice of the ultimate marketed consumer product and emblem of sophistication, the cigarette – rivals the most direct of late-1960s American pop. In 1973–74 Boynes utilised this style with imagery from newspapers in politically loaded works such as *Playboy club news* 1974, in which mass-media images and text are manipulated to expose how they function in creating meaning, a move which pre-figures the critical–analytical mode of postmodern art.

Ken Reinhard also fused aspects of art and commercial design in his practice, and was the closest artist in Australia to a pop impresario, as he was adept at organising exhibitions as events and generating publicity. His exhibitions in the 1960s included art machines that lit up, played music and sprayed perfume; women modelling Reinhard-designed dresses; and chromed female mannequin sculptures wearing brightly coloured crash helmets. Exhibited in his last major solo exhibition at the Bonython Gallery in 1972, *EK* 1972 features a life-sized, photo-mechanically reproduced female nude, hard-edge abstract 'racing' stripes, a chromed logo and an exhaust pipe protruding somewhat phallically from the surface. This exhibition was Reinhard's ultimate exploration of art and commercial design, and extended to including a Honda 750 and Alfa Romeo cars as part of the display. Reinhard declared, 'The Alfa Romeo is as valid an aesthetic experience as the Mona Lisa'.[62]

Another artist who might have agreed with this statement was Bridgid McLean. From 1968 to 1974 she produced strong-coloured pop paintings of racing cars and racing car drivers, which merge man and machine through an emphasis on design and graphic treatment that conflates organic and machine forms. It is refreshing to find amongst all the men painting pin-up girls, a woman painting the testosterone-fuelled world of competitive racing. McLean's meticulously painted images were well received and James Gleeson, who had previously often been reserved about Australian pop art, described her first exhibition at Watters as 'a spectacular debut' and continuing 'both theme and treatment can be traced back to American pop art. Nevertheless McLean's paintings are pop art with a difference. She does not regard the automobile as a symbol of our time but as an object of aesthetic beauty. She admires a racing car in much the same way as Poussin admired the ruins of the Roman Campagna.'[63] Gleeson's attempt to trace classicism in McLean's work does not do justice to her extremely contemporary treatment of an equally contemporary subject matter, painted in true pop style as a fan of Formula 1 and Australian driver Jack Brabham.

Australian artists working in a pop idiom were producing some of their most resolved work in the late 1960s and early 1970s, yet in a series of books published from 1969 to 1971 the critical and art historical tide had retreated from the enthusiasm some had shown for pop art in the mid 1960s.[64] While the lavish *Australian art and artists in the making* (1969) included pop as a significant 1960s art practice, *Present day art in Australia* (1969) included many of the same artists and the statement from Daniel Thomas in his introduction: 'Real Pop Art scarcely started.'[65] This was echoed in James Gleeson's *Modern painters 1931–1970* (1971) – in which he wrote: 'Pop-Art was the only significant post-war movement that failed to attract an appreciable following in Australia' – and Bernard Smith wrote in the 1971 second edition of *Australian painting*

1788–1970 that 'Pop art did not make ground readily in Australia'.[66] Robert Hughes' revised 1970 edition of *The art of Australia* does not mention pop art at all.[67]

Gleeson and Hughes had not been very responsive to pop art during the 1960s, but Smith had defended the artistic value of Mike Brown's paintings in court and purchased Allen Jones' *Come in* 1967, amongst other works, for the Power collection at the University of Sydney, while Thomas had been an enthusiastic advocate for a developing local pop art scene in the mid 1960s. As an indication of where critical allegiances now lay, the front and back covers of *Present day art in Australia* featured colour reproductions of hard-edge works by Tony McGillick and Sydney Ball, and with the widespread adoption and curatorial ascendency of hard edge and the perception that Australian artists were participating simultaneously in an international art movement, figurative art – even with a pop content or form – was temporarily eclipsed. By this time many of the critics as well as artists had travelled internationally, and witnessed the prime examples of American pop in *Two decades of American painting*. In his introduction to *Present day art in Australia* Thomas, who had travelled previously to the United States in 1966, identified attributes of American pop as defining pop art. In discussing the Annandale Imitation Realists he acknowledged their work as urban art but differentiated their practice from pop, as they 'had none of the cool, dead-pan aestheticism of Pop Art; it was not a crypto-"art about art" like Pop'. His observation of the desire to identify local examples of international movements is salient, however: 'When it appeared it was called Pop Art, for that movement had only recently been named, and Australian examples were being sought'.[68]

Bernard Smith's more sustained analysis identifies three key reasons pop did not take in Australia: that our culture is suburban rather than urban; that Australia already had a prominent figurative art style (the Antipodean group) and so pop art did not have the singular dominance of abstract expressionism to react against; and that Australians viewed art as a 'highly serious activity and on no account to be mocked'. While it is beyond the scope of this essay to look at these arguments in depth, none really hold up, except perhaps the latter, which is reflected in slow sales for some of the pop artists in the 1960s.[69] Most Australian artists were living in an urban environment in the 1960s, and many smaller European cities that engendered their own versions of pop art were no more urbanised than Sydney or Melbourne. And while there was a strong abstract art movement in Britain in the 1950s, there were also prominent figurative alternatives, with Francis Bacon and the Kitchen Sink School amongst others. While Smith goes on to discuss in some detail the artists who did respond to pop and rightfully identifies the melding of abstract and pop impulses in Australian art, he identifies pop with the irony, coolness and detachment of international pop, which would seem also to mean American pop art. Smith identifies pop's impact on Australian art as not insignificant, but suggests it was not 'taken up, as hard-edge painting was' and 'never developed into a programmatic, evangelising style'. The consequences of the equally rapid abandonment of hard-edge by many practitioners as a stylistic dead end were not apparent when his analysis was written.

Smith's analysis is considered and valuable, but in aligning pop art with American pop he diminishes the engagement with popular culture that occurred locally, which is a hybrid, energetic variant of the regional pop styles that emerged around the world in the 1960s, and is more closely aligned to the diffuse influence of pop culture in British art during this period. Australian artists continued their exploration of pop culture into the 1970s, and one significant later manifestation was the free-wheeling counterculture experiment that was the Yellow House in Sydney, conceived by Martin Sharp and realised through a loose and changing collective of artists, filmmakers, performers and Sydney's demi-monde. Some of the most individual practitioners of the 1960s, such as Richard Larter, Mike Brown, Martin Sharp and Gareth Sansom, continued to make works using a pop language that developed from their earlier practice. At the end of the decade, with a return to painting by a younger generation of artists, and the assumption that photography, video, performance and music were all viable mediums, Australia had a new wave of art addressing popular culture, given focus by Paul Taylor's *Popism* exhibition at the NGV in 1982. Pop returned as a salient visual language that addressed both popular culture and art practice, the upbeat visual style of which could provide immediately accessible imagery but also questioned how meaning was produced and manipulated through mass culture and visual coding. This new wave called on the history and legacy of 1960s pop artists, and celebrated, participated in and critiqued pop culture while seeking a complex understanding of how it shapes our lives.

**MIKE BROWN
ROSS CROTHALL
COLIN LANCELEY**
Byzantium 1961–62

Conceived by Mike Brown, Ross Crothall and Colin Lanceley, *Byzantium* 1961–62 is the only collaborative work created by all three protagonists of the short-lived, Sydney-based group known as the Annandale Imitation Realists (AIR), and subsequently as the Subterranean Imitation Realists (formerly of Annandale).[1] *Byzantium* encapsulated the verbal and visual battle its members were waging against Australia's conformist postwar art scene, which was entrenched in the figurative–abstract debate of the 1950s.

Byzantium stood defiantly at the end of the group's inaugural show, held at Melbourne's Museum of Modern Art of Australia in February 1962. Balanced on concrete-block 'legs' with cardboard cut-out arms attached along its edges, the almost 2-metre-high panel was topped by a flattened kerosene-drum 'head' with over-painted features; the words 'HERE IN BYZANTIUM' were writ large across an adjacent wall.[2] The largest of 212 works in what was Australia's first art installation, the proto-pop assemblage *Byzantium* was an all-encompassing vision that brought the diverse histories, beliefs and cultures of the artists' collective experiences into creative relation with each other, thereby eschewing the prevailing western veneration of the heroic artist-genius as an individual creator.

This otherworldly figure – with its frenetic surface encrusted with ruined fragments of twentieth-century consumerism – discloses the AIR's enactment of dadaist principles, incorporating techniques of bricolage and collage, and a fascination for the fetishist creations of tribal cultures, prefiguring pop art's deliberate irreverence for 'high art'. Every nook and cranny is crowded with energetically painted figures whose idiosyncratic forms and intricately patterned visages are borrowed from Maori, Balinese and New Guinea Sepik carving. Throughout *Byzantium*, as in many AIR works, language is used freely, incorporating handwritten elements as formal modes of expression. There is a wilful obscurity in the disparate range of references, including slang and military jargon; however, the title *Byzantium* specifically references WB Yeats' poem of the same name, notable itself for its highly ambiguous imagery and intention.[3]

Byzantium's ostensibly unedited, spontaneous outpouring is also suggestive of the stream-of-consciousness prose by the 'father' of the United States of America's beat generation, Jack Kerouac, whose novel *On the road* (1957) was read by a generation of disaffected Australian baby boomers.[4] Kerouac espoused 'composing wild, undisciplined,

pure, coming in from under, crazier the better'[5], and was informed by surrealist automatic writing. His *The subterraneans* (1958) portrayed San Francisco's bohemian counterculture, the so-called 'beatnik' artists, writers and musicians who fused art, literature, jazz and ritual.[6] Kerouac's subversive novel was quickly subsumed by the mainstream through the sanitised celluloid adaptation seen in Australian cinemas in 1960.[7]

Simultaneously instilled with optimism and disillusionment, beat vernacular was in accord with AIR creative ethics: in the significance of art to life. The AIR transition to 'Subterranean' in their second and last exhibition at Sydney's Rudy Komon Gallery in May 1962 suggests the spirit of beat culture had entered the group's creative maelstrom, however fleeting. By the show's conclusion, the group had disbanded: Brown and Crothall were dissatisfied that the AIR initiative had not exacted the radical disruption they had hoped for, instead receiving 'soft pedalling approval' from the critics.[8] NW

Mike Brown, Ross Crothall
Sailing to Byzantium 1961
enamel, pencil and oil crayon on
composition board
98 x 151.3 cm
National Gallery of Australia, Canberra,
purchased 1981

(opposite)

Mike Brown, Ross Crothall,
Colin Lanceley
Byzantium 1961–62
oil, synthetic polymer paint and collage
of found objects on plywood
183 x 122 cm
National Gallery of Australia, Canberra,
purchased 1988

After the Annandale Imitation Realists went their separate ways at the end of 1962, Colin Lanceley continued to make exceptional collage and assemblage works, including *Love me stripper* 1963 and *The dry salvages* 1963–64 (Art Gallery of New South Wales). While Lanceley was also making freestanding and wall relief sculptures, both of these works accumulate found materials onto an ultimately painterly form. *Love me stripper* is more figurative and represents the scantily clad strippers Lanceley saw as they walked from club to club to perform in Sydney's Kings Cross. Lanceley lived locally and was witness to the trade in flesh and titillation that had been widely reported in the media since the first strip club, the Pink Pussycat, opened in Darlinghurst Road in 1958. The title of this work is poignant, as it suggests the strippers' desire to be loved, but also the punters' desire for the strippers and to be loved in turn by the object of their desire.[1]

Love me stripper is adorned with lace, beads, brooches and other materials that convey a sense of sexual fetish and of the working girls dressed up for the night; the figures appear next to a row of coloured hearts in the lower right symbolically, and perhaps futilely, connecting love and desire. The pink flesh of the strippers is accentuated by the bright blue ground, and the crescent-shaped forms of their heads recall the prostitutes in Albert Tucker's *Images of modern evil* series from World War II and Willem De Kooning's early 1950s paintings of women derived from magazine images.

Love me stripper was owned by Robert Hughes and was reproduced in Elwyn Lynn's early article on pop art, 'Pop goes the easel', in *Art and Australia* in 1963.[2] Lynn traces a context for the Annandale Imitation Realist works within international pop art, while also remarking on their originality. Hughes' article on irrational imagery in Australian art in the same issue specifically differentiates between the work of Lanceley and American pop: 'What distinguishes Lanceley's work from Oldenburg's, Rosenquist's or Lichtenstein's is its emphasis on irrational poetic content. He is not producing deadpan objects whose existence is passively self-contained, and the popsters are.'[3]

Lanceley's assemblage paintings and sculptures are precursors to pop art, like the work of many other assemblage and collage artists working at this time internationally. Their emphasis on mixed media, everyday found materials and popular-culture subjects freed up art categories for the pop work that was to come. While Lanceley's work does not look like American pop art, it does touch on pop subjects, and when Lanceley controversially won the Helena Rubinstein Travelling Art Scholarship in 1964 one critic wrote of his work: 'They remind one of the battlefield littered with the corpses of commerce, both sides having suffered total defeat.'[4] WT

TONY TUCKSON
Pyjamas and Herald 1963

While Tony Tuckson's painting practice was a largely private pursuit until his first solo exhibition in 1970, he had, for over a decade, been producing some of this country's most sophisticated abstractions. Tuckson's work was the outcome of a secluded creation, but he would often declare: 'you can't paint in a vacuum'.[1] Tuckson's paintings of the 1950s and 1960s reflect his great capacity for engaging with current-day art movements; considering and interpreting a range of conceptual and aesthetic models as a means of advancing his own individual expression. In this context, by 1963, with pop recently established as a major cultural phenomena in the United States of America and Britain, Tuckson had responded to a new system of thinking: to the 'deepening inroads of art into non-art'[2], as he considered how the very 'things' of ordinary life could be fused with his highly personalised act of painting.

Tuckson's *Pyjamas and Herald* 1963 has clear affinities with Robert Rauschenberg's combines, the hybrid form of painting and sculpture that Rauschenberg produced from around 1955. Tuckson had perhaps derived the bold, gestural palette of blacks, whites and reds that he employed in the early 1960s from Rauschenberg's phases of similarly coloured expressionism. But Tuckson's *Pyjamas and Herald* is more directly charged with a Rauschenbergian sense of emotionally mapping the world through cultural refuse – discarded newspapers, pyjama pants and printed hessian bags are all in Tuckson's compositional mix. Rauschenberg had initially incorporated news-papers, photographs and an increasing array of debris in his canvases as autobiographical elements in his works. Tuckson may also have

intended a personal narrative through his collaged objects, yet of greater significance was his use of the canvas as an experimental ground for investing the painted gestures of abstract expressionism with the impact of real-life objects. The canvas acts as a seeming magnetic force, amassing a range of daily detritus to appear, as the critic Leo Steinberg so astutely articulated in terms of Rauschenberg's work, an image of the mind itself; of a modern consciousness as it is 'constantly ingesting incoming unprocessed data' of the external world.[3]

Tuckson saw his art as intrinsically connected to the notion of human gesture, yet in *Pyjamas and Herald* we see this sense of personal expressionism reconciling with materialistic impositions. Like Rauschenberg, Tuckson suggests a slippery identity of the modern self as one intercepted by mass-produced forms and forces. So, too, is the aesthetic guise of the artist moving between the realms of abstract expressionism and the narrative signals of pop art. Rauschenberg may have provided Tuckson's conceptual and aesthetic groundwork, but *Pyjamas and Herald* is irrevocably made the artist's own through his exceptional synthesis of object and painted gesture; his compositional command of pigment, litter and personal coding results in a highly evocative whole. DM

Tony Tuckson
Pyjamas and Herald 1963
synthetic polymer paint, tempera, and collage of newsprint, hessian and cotton on composition board
121.9 x 182.8 cm
National Gallery of Australia, Canberra, purchased 1979

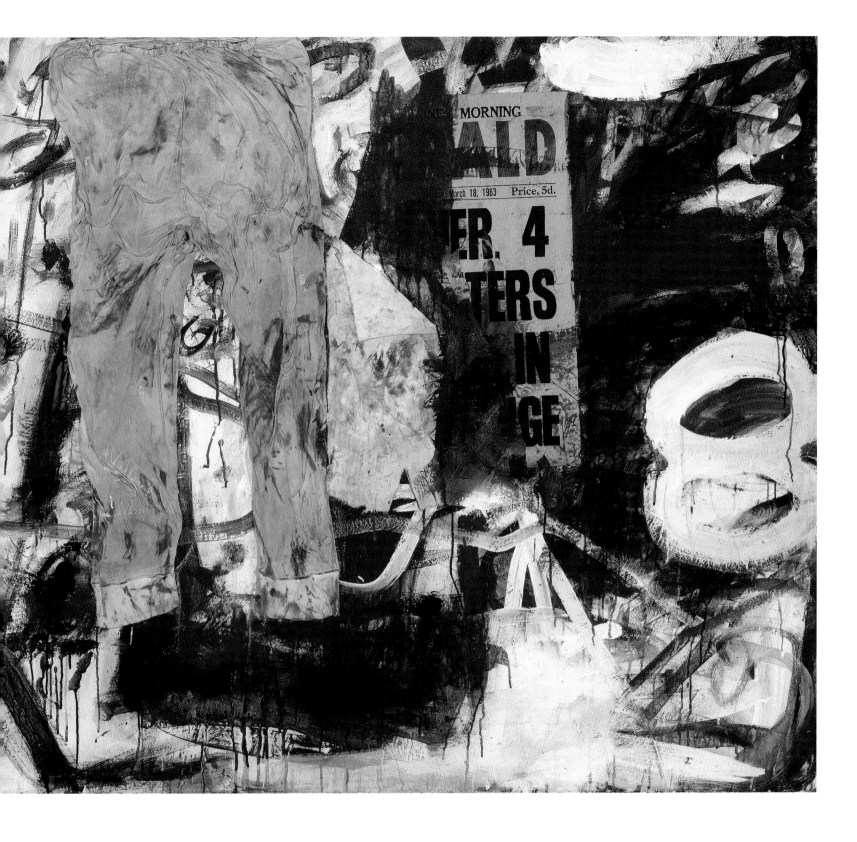

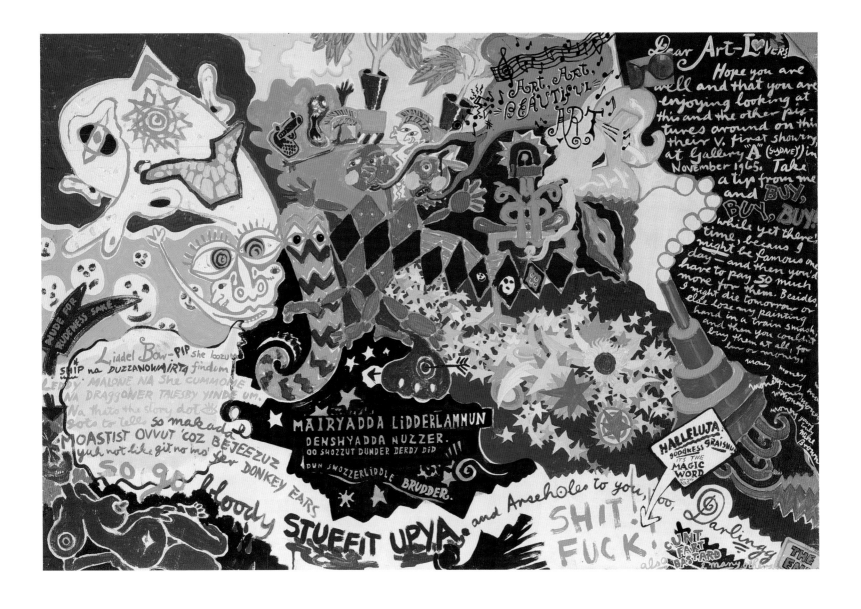

MIKE BROWN
Hallelujah! 1965

Mike Brown's *Hallelujah!* 1965 (also known as 'Art beautiful art') is a satirical and provocative address to the art establishment and so-called 'art lovers' of Sydney during the 1960s. The Australian art market had boomed from the late 1950s onwards, with postwar affluence and a growing appreciation for local art. Catering to this demand and replacing the artist's societies of yesteryear were commercial galleries, some of whom capitalised on this trend by spruiking art as a status symbol and as social/financial investment.[1] This was further encouraged by the staging and promotion of shows featuring well-known names of the abstractionist orthodoxy. Pandering to prescribed tastes had alienated Brown, whose innovative pop art assemblage *Mary Lou as Miss Universe* 1962–63 (destroyed) was excluded, uncontested, on aesthetic and moral grounds from the touring exhibition *Australian painting today: a survey of the past ten years* (1963–64). What had ensued was a scene perceived by Brown – and elucidated hilariously in his painting *Hallelujah!*

– to be a shameless network of profiteering dealers, sell-out artists, collaborative critics, traditionalist institutions and a complacent public.

Hallelujah! presents a clutter of doodled text and image, melded into a confounding pop-art-style painting.[2] It also encompasses elements of outsider art, tribal art, urban art, mass media and kitsch. Brown's carnivalesque depiction of clownish, odd-bod figures, harlequin-chequered diamond patterning, and shooting stars or fireworks are allegorical of the Sydney art scene as a circus. Elsewhere, nonsensical phrasing is reminiscent of radio jingles and rock'n'roll music. Four-letter swear words and genitalia elicit the graffiti and advertising of seedy Darlinghurst and Kings Cross, particularly in its promise of fun, money, sex and violence. After gaining our attention, Brown encourages us to 'BUY, BUY, BUY' his painting in a sarcastic passage of script scrawled upper-right. The 'famous' artist unpretentiously signs off with 'so go bloody STUFFIT UPYA, and Arseholes to you too, Darlingg. THE END'.

Hallelujah! was featured in Brown's infamous third solo exhibition *Paintin' a-go-go!* at Max Hutchison's Gallery A in Sydney, 1965. Despite favourable reviews[3] and *Hallelujah!* being purchased, the display was shut down by the Sydney Police Department Vice Squad over public complaints of indecency. In 1966 Brown was convicted under the *Obscene and Indecent Publications Act* of 1901 and sentenced to three months' imprisonment. Magistrate GS Locke, failing to recognise the artist's commitment to the spiritual act of creation in his rejection of circumscribed and self-aggrandised late modernism, denounced the show as an 'orgy of obscenity'. Brown was acquitted after an appeal and the penalty was reduced to a $20 fine with $15 costs. The trial highlighted the difficult reception of pop art in Australia, as well as the contradictory nature of a society that was exposed to popular culture and consumerism, yet morally conservative and self-censoring. NY

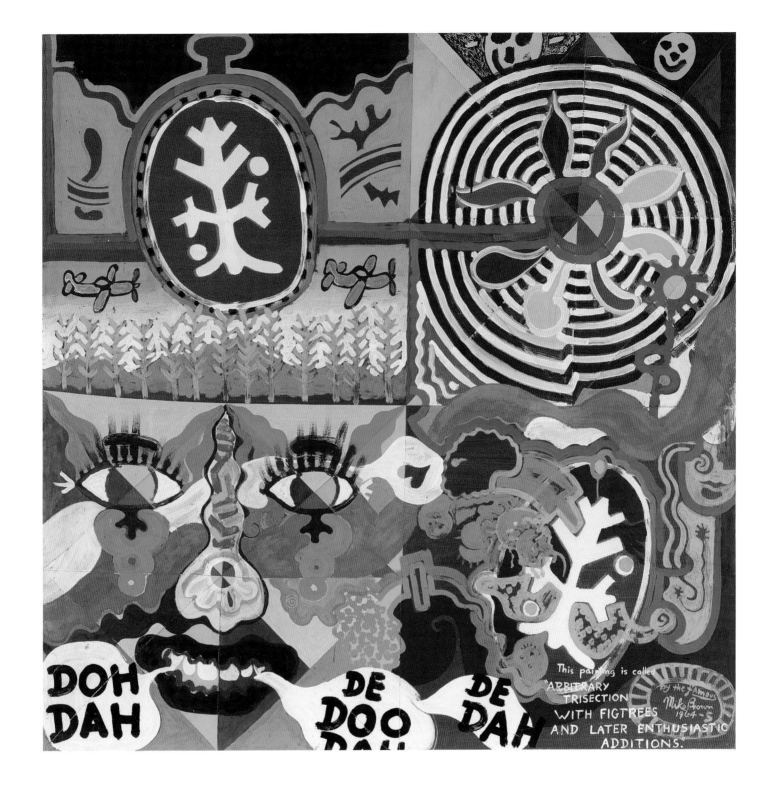

Mike Brown
Hallelujah! 1965
synthetic polymer paint
and collage on cotton duck
93.4 x 139.1 cm
Collection of Noel Hutchison

(opposite)

Mike Brown
**Arbitrary trisection with figtrees and
later enthusiastic additions** c1964–65
synthetic polymer paint on masonite
122 x 122 cm
Collection of Noel Hutchison

VIVIENNE BINNS
Vag dens 1967

When Vivienne Binns held her first solo exhibition at Watters Gallery, Sydney, in 1967, she achieved instant notoriety as the author of works that unabashedly revelled in the subjects of sex and female sexuality. Adopting a pop-fuelled aesthetic of wild colours and eccentric forms, Binns filled the gallery space with an assortment of junk sculptures, including a kinetic work that 'sucked and palpitated' as well as paintings featuring phalluses and vaginas in psychedelically morphing formations. The show appeared as a liberatingly messy accumulation of the stuff of ordinary life – both its material objects and imagery were gleaned from deeper psychological explorations of sexual urges and identity.

Vag dens 1967 has proven to be the enduring work of Binns' exhibition, and one that encapsulates the show's tenor of cheerful rebellion. With its title abbreviated to Australian slang, *Vag dens* was a playful take on the mythical *Vagina dentata* (toothed vagina) and its traditionally malicious imagery of Freudian-type castration nightmares. Binns instead conceived *Vag dens* as a joyful assertion of feminine power that confronted then taboos of female sexuality with the animated subversiveness of psychedelic forms. Created at the cusp of the feminist movement, Binns said that she did not produce the work with any political intent in mind. It was instead an image of a 'uniquely asserted female sexuality' that by 1975 was understood within the broader terms of the feminist movement and declared an emblem of women's liberation.[1]

Binns' *Vag dens* may pinpoint the subversive spirit of the pop generation, but the work more importantly stands in robust rebellion against much of the (largely) masculine-driven erotic iconography of the movement. If imagery of women as flawlessly conceived Playboy models or vacant, consumer-driven housewives became pop's recurring symbols of a commodified culture, then Binns' *Vag dens* put it out there that women could be of greater and more powerful substance. When provoked, they were definitely capable of biting back.

What might today appear more shocking than the *Vag dens* image is the level of hostility directed toward Binns from a group of mostly male reviewers of her show. One suggested that Watters Gallery had been transformed 'into a tenth rate phallic temple', another lamented the 'messy pornographics of monsters, genitalia in pop colours', and yet another the 'pure obscene horror' that 'affronts masculinity by its challenge and makes females feel inadequate'.[2] Binns' 'impulse to shock' was regarded as 'ungirlish' in an age when the challenges of avant-garde practices were clearly marked as masculine terrain.[3]

Amongst the chorus of critical outrage, Rodney Milgate's review stands out as a more discerning response to the show's initial impact. Warning readers that it will 'tear you apart and make you question every social value we live by', he nonetheless urged them to 'have a double brandy, grit your teeth and see it'.[4] In hindsight, his words can be read as a broader directive for confronting the encroaching age of feminist enlightenment for which Binns' 1967 exhibition provided a visual prelude. DM

Vivienne Binns
Vag dens 1967
synthetic polymer paint and
enamel on composition board
122 x 91.5 cm
National Gallery of Australia, Canberra,
purchased 1978

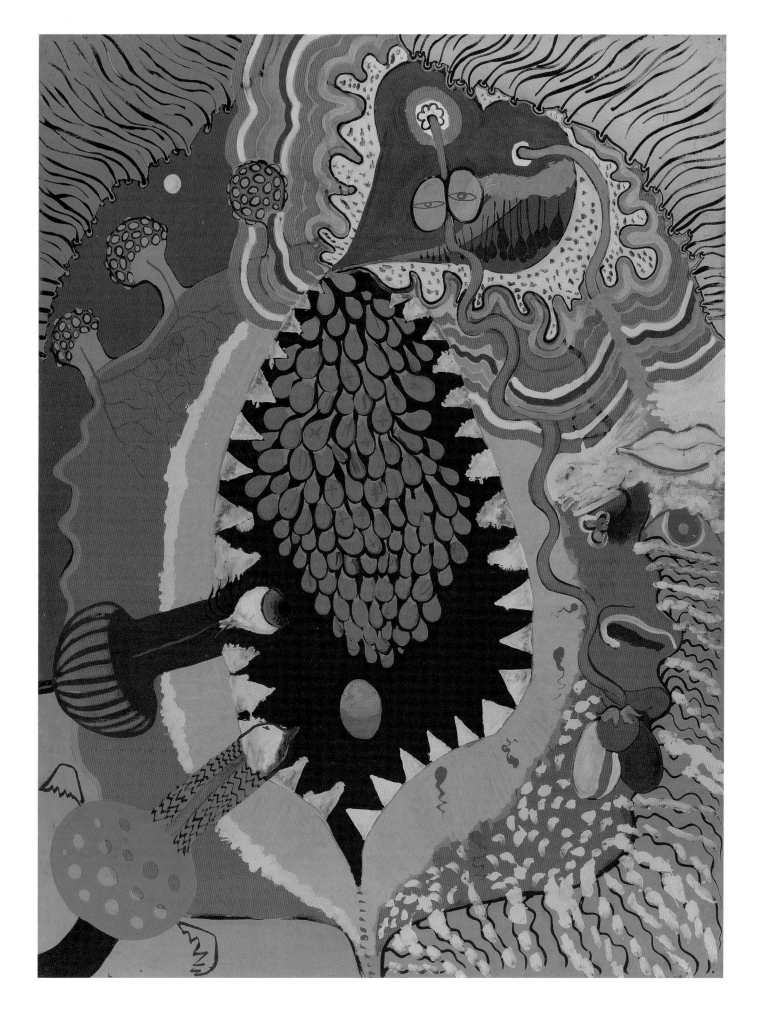

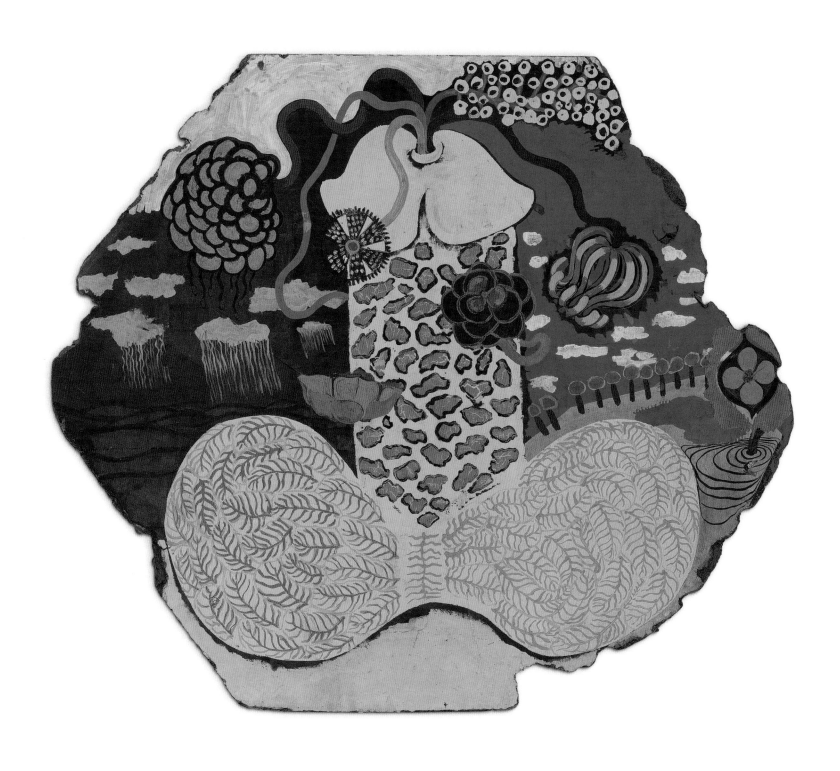

Vivienne Binns
Phallic monument 1966
synthetic polymer paint on
composition board
91.5 x 106 cm (irreg)
National Gallery of Australia, Canberra,
purchased 1993

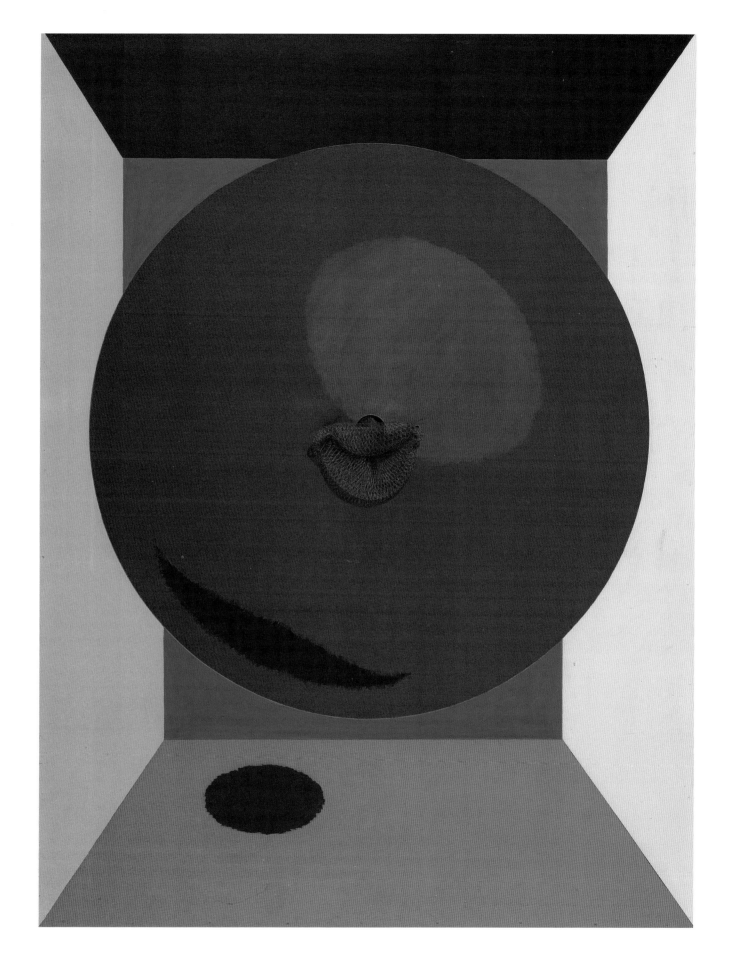

Vivienne Binns
Suggon 1966
enamel on composition board, electric
motor, synthetic polymer mesh and steel
122.2 x 92 cm
National Gallery of Australia, Canberra,
purchased 1977

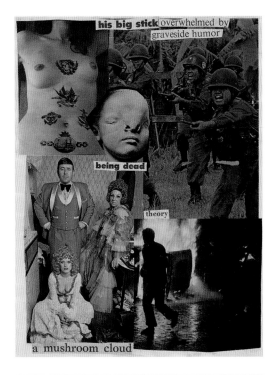

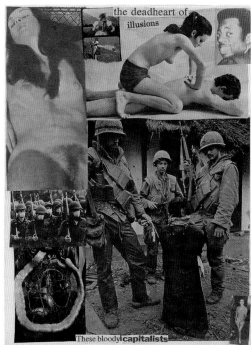

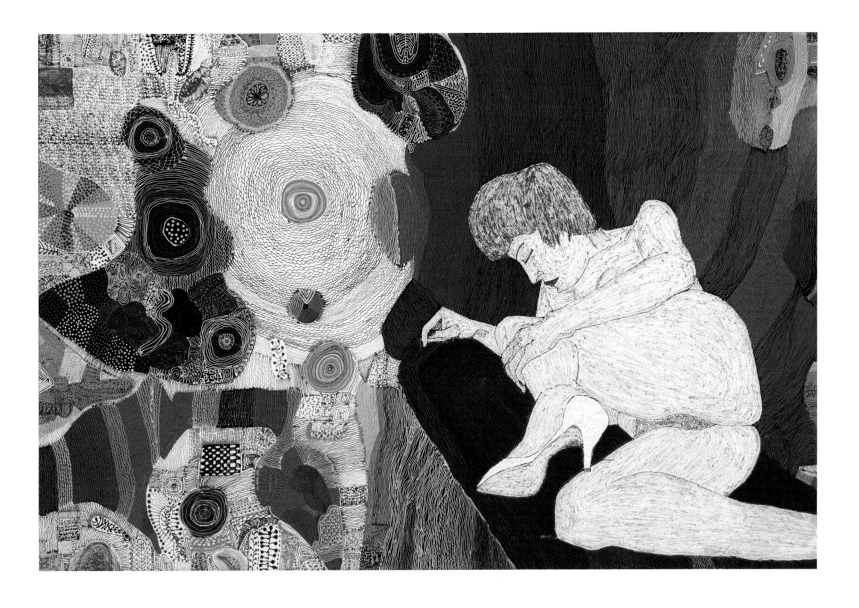

RICHARD LARTER
Dithyrambic painting no 6 1965

Dithyrambic painting no 6 1965 was included in Richard Larter's first Australian exhibition, held at Sydney's Watters Gallery in September 1965; critiques of the show were positive. Wallace Thornton, writing for *The Sydney Morning Herald*, said that the artist had talent and a freshness of vision.[1] James Gleeson, in *The Sun*, agreed but thought that he showed a 'divided allegiance'. Works like this one, combining the figurative with the abstract, were less successful – in Gleeson's opinion – than those that were either one or the other.[2]

'I was surprised to learn that people thought I was a divided man,' Larter recalled, 'the other surprise was that they called me a Pop artist. I did not see myself in those terms.'[3] To the 36-year-old English artist, who had arrived in Australia only three years before, the idea that 'the abstract and figurative could not co-exist in a unified whole' was nonsense.[4] He had begun painting in an abstract style but on witnessing the faddish conversion to abstraction of many British artists after a survey of contemporary

American art at the Tate in 1956, began exploring figuration, 'but not the kind of figuration as practiced by Sutherland, Piper or Bacon. I drew my images from popular culture – Elvis Presley, Sophia Loren, Rock'n'Rollers of both sexes.'[5]

While Larter acknowledged sourcing images from popular culture, he was not entirely happy to be labelled a pop artist. His art had a political edge and was critical of the glossy postwar prosperity that much of pop art celebrated. Also, the way he worked at this time, using a hypodermic syringe to draw in paint, contrasted with the flat, hard-edged techniques of other pop artists. Larter was amused when Daniel Thomas, the first curator of Australian art at the Art Gallery of New South Wales, characterised his style as 'poptical cop or coptical pop', combining elements of op and pop art, with 'cop art subject matter'.[6]

Some found his subject matter and its frank celebration of sexuality confronting. Prominent critic Sandra McGrath bought *Dithyrambic painting no 6* from the Watters exhibition but

got tired of taking it down each time her mother-in-law visited; she donated it to the Art Gallery of New South Wales in 1972, the first work by Larter to enter the collection.[7]

Although Wallace Thornton described this reclining nude with closed eyes, suspended on a sinuous scarlet ledge over a brilliant field of hallucinogenic swirls, as 'revealing while recumbent', the work is in fact revealing only on one level.[8] A 'dithyramb' was a hymn associated with the god Dionysius in ancient Greece. Friedrich Nietzsche, whom Larter was reading in the 1960s, characterised the Dionysian impulse as the original artistic force, ecstatic and spontaneous.[9] Larter's mysterious *Dithyrambic* paintings invite multiple interpretations: for some they are about the intensity of sensory experience, while others see in them a metaphor for the process of artistic creation and innovation. SM

Ticket box 1966 is representative of Ken Reinhard's reconciling of the fine arts with industrial aesthetics, commercial design and consumer culture from 1964. The American brand of pop art had paved the way for Reinhard, a former abstract expressionist educated in technical drawing and science, to respond to the processes, materials, forms and rhythms of his urbanised environment.[1] Abandoning the social comment indebted to British pop, and evident in his Sulman Prize-winning *The private public preview* 1964 (collection of the artist), the artist's following artworks began to articulate his 'tremendous excitement in Sydney as a place, in people, cars, the shops, the colour that's about, the fashions, the new fast cars in the shop windows along William Street'.[2]

Ticket box is a mélange of contrasting formal and structural elements – abstract hard-edge, op and pop art modes juxtaposed with academic figuration – repackaged into a slick, semi-sculptural construction. Trademark red, black and white patterning evoke the chequered flags and racing stripes of motor sports, but were in fact inspired by the diced hose Reinhard wore in the University of Sydney regiment band. This is fragmented by a three-dimensional surface, which is cubistically assembled from variously shaped wooden prisms. Far right, and cordoned off by a dotted line, is a hand-drawn torso of a seated female nude. Random words, diagrammatic lettering and commanding signage – such as arrows and asterisks – unite the artwork, yet obscure meaning. Like advertising, these devices manipulate the eye and direct attention up, down, across, in and out of the picture plane.

Ticket box debuted in Reinhard's solo exhibition at Darlinghurst Galleries, Sydney, in February 1966. At the well-publicised opening the paintings, sculptures and mobile installations were accompanied by an electronic music soundtrack and eight models sporting dresses, the designs of which related to the motifs in the artworks.

At the time Reinhard had been at the forefront of critical debate in the media concerning what constituted pop art.[3] Photographed handling *Ticket box*, he was quoted as saying: 'I wouldn't deny that this is pop or op art, but I'd prefer it not to be called that. I'd rather have it called one of those Reinhard messes.'[4] One public commentator questioned the 'happening' and queried whether Reinhard was a self-styled 'Aussie answer to Andy [Warhol]', to which the artist rebutted, 'Whose pop? What's pop? ... pop!'[5] NY

Ken Reinhard
Ticket box 1966
pencil, decal lettering, charcoal, oil and synthetic polymer paint on wood and composition board
126.8 x 184.6 x 17.6 cm
National Gallery of Victoria, Melbourne.
Gift of Dr Bronte Douglass 1988

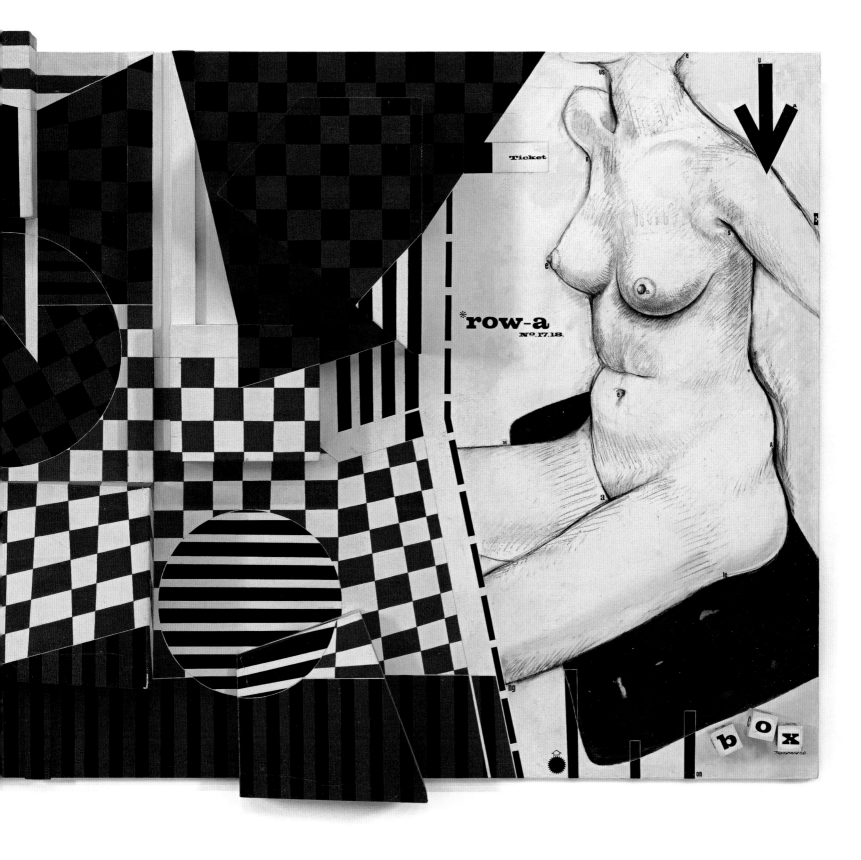

Michael Allen Shaw
Lawrence diptych 1965
synthetic polymer paint on board
and canvas
117.5 x 233.5 cm
Private collection

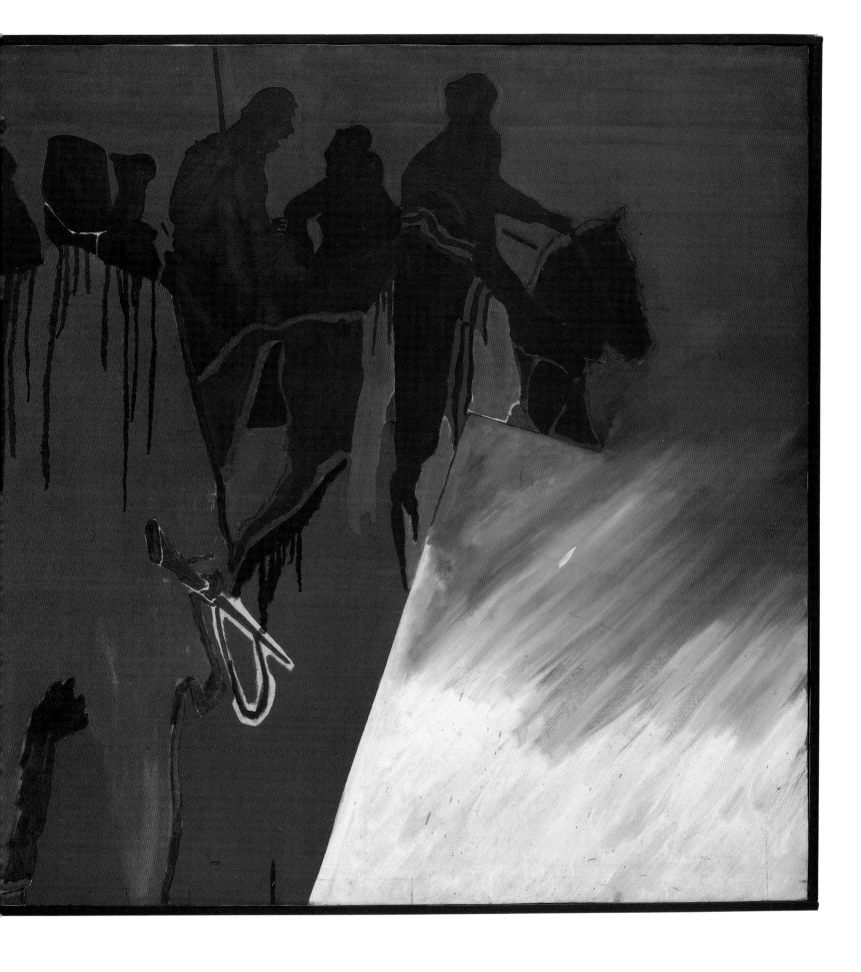

Martin Sharp moved to London in 1966 and became ensconced almost immediately in the countercultural music and art scene of 'swinging London' – he lived in The Pheasantry, in Chelsea; fellow tenants included Philippe Mora, Eric Clapton and Germaine Greer. He quickly gained a reputation as a major graphic artist, creating psychedelic posters, album cover designs and illustrations that came to define a generation.

Sharp had worked with his friend Richard Neville on the satirical *Oz* magazine from its launch in Sydney in 1963 and then its London incarnation from 1967 to 1969. *Oz* embodied the spirit of the 1960s anti-establishment, with innovative visual design and articles on contentious subjects including censorship, drugs, crime, sex and homosexuality, and politics.

Mister Tambourine Man 1967 was one of the first posters designed by Sharp to be published after his arrival in London, a tribute to one of his favourite songs by Bob Dylan.[1] The heroic figure of the singer/songwriter dominates the composition, reflecting his status as counterculture icon, while the bringing together of disparate elements – a blown-up version of a photograph Sharp found in a book, drawn decoration and text written by the artist – is typical of Sharp's method of picture making through collage and quotation.[2] The poster was produced in an unlimited edition and distributed by Peter Ledeboer, the printer of *Oz* magazine, after first appearing (in slightly different form) on the cover of issue 7 of *Oz* in October 1967. Ledeboer established The Big O Poster Company, publisher of this work, to produce posters after seeing their popularity with the *Oz* readership.

The psychedelic nature of Sharp's imagery at this time was in part an attempt to recreate the visual distortions and heightened colours experienced by those under the influence of drugs such as marijuana and LSD. The expression of this altered reality was an aspiration of many artists at the time. '"Psychedelic" was the style of the day amongst the youth ... I did some "psychedelic" painting for my first gallery exhibition in Sydney in 1965 ... I hadn't even heard of the word, not had a trip, nor smoked a joint. The style was in the air.'[3] AR

Martin Sharp
Mister Tambourine Man 1967
colour screenprint on gold foil laminated paper
75.4 x 49.8 cm (image/sheet)
Art Gallery of New South Wales, Sydney.
Thea Proctor Memorial Fund 1970

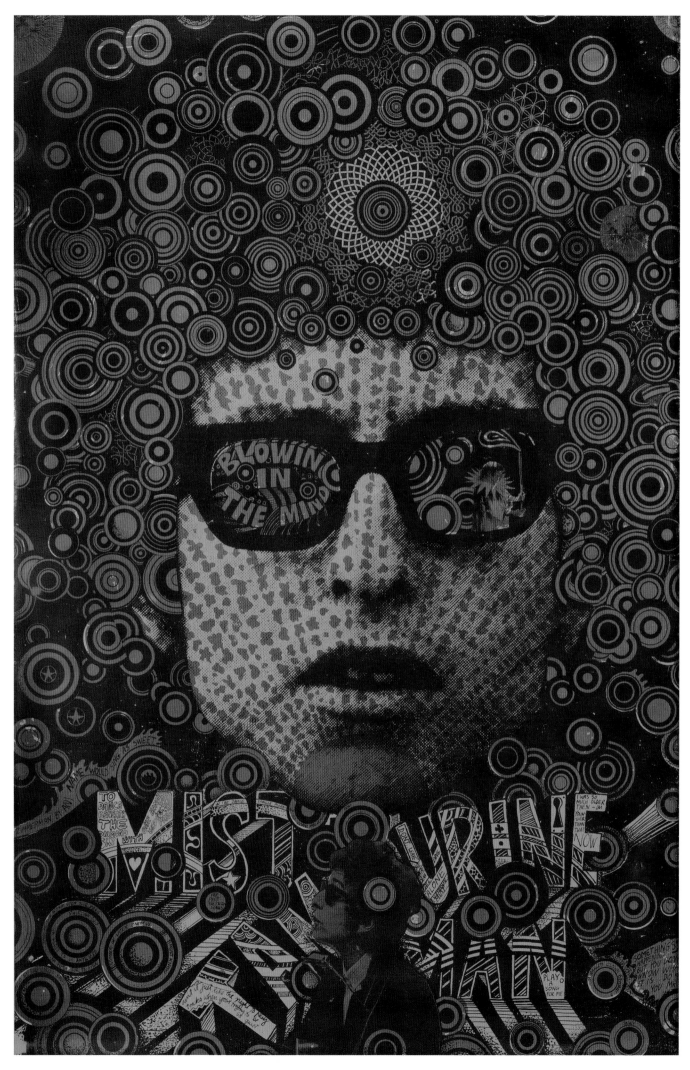

Martin Sharp
Jimi Hendrix c1971
enamel on synthetic polymer film
between two sheets of perspex
101 x 115 cm
National Gallery of Australia, Canberra.
Gift of Jim Sharman 1984

Gareth Sansom

The great democracy 1968
oil, enamel, synthetic polymer paint,
collage and pencil on composition board
180 x 180 cm
National Gallery of Australia, Canberra.
Gift of Emmanuel Hirsh in memory
of Etta Hirsh 2007

Alan Oldfield

Cliché c1968
synthetic polymer paint on canvas
183 x 152.5 cm
National Gallery of Australia, Canberra,
purchased 1969

(opposite)

Dick Watkins
The fall no 1 1968
synthetic polymer paint on canvas
183 x 152 cm
Private collection

Dick Watkins
The fall no 2 1968
synthetic polymer paint on canvas
183 x 156.5 cm
Private collection

When pop artists reflect the objects of the everyday world back to us in their works, the mundane and familiar appear humorous, even absurd in their inflated designs. Yet pop presents a curious breed of humour, one that is, as Melbourne artist Robert Rooney suggested, 'humorous and horrifying at the same time'.[1] Although Rooney did not set out to create humorous paintings[2] his idea of a double-edged joke had by the mid 1960s become ingrained in his work. At this time, he embarked on a series of seminal abstracts that introduced his signature deadpan style for blowing the trivial out of proportion to produce, as once critic claimed, 'ikons of banality'.[3] Rooney's escalation of the ordinary is very funny, but true to pop form, his humour works to probe deeper into modern consciousness.

Rooney formulated his art from the existence and habits of suburban life. His often-cited artistic awakening came before Charles Blackman's paintings of Melbourne's inner-suburban streets, populated by shadowed schoolgirls, but by the late 1950s the inspiration for his art was also coming from elsewhere. He became intently focused on gathering cultural relics of the everyday, including second-hand books on a strange array of human pursuits – exercising in the bath or methods for self-defence with a walking stick, for example. What also appealed to Rooney were the unexpected items he sometimes found stashed within a book's pages: random things, ranging from naughty bookmarks to highly personalised letters. These all formed an absurdist collection that Rooney called his 'spons'; a term gleaned from the *Goon show* that celebrated the spontaneity and irrationality characterising the classic radio program's humour.

Rooney's spons were a significant influence on his work, representing an 'attitude' that came to determine the very substance of his art.[4] Such thinking became manifest when he exhibited the *Slippery seals* in 1967, the first in a series of paintings using repetitive abstract motifs to suggest the motion of routine existence. Rooney based his abstraction at this time on what he termed 'devalued designs', which included the patterns of cheap lino or carpet floor coverings, or shapes cut out of breakfast cereal packets.[5] His compositions signalled the current forms of American and British abstractions but they retained something of the character of their suburban heritage. In claiming daily details as his subjects, enlarging their inherent absurdity by repeating and colouring them in modern acrylic paints, Rooney concluded, 'yes pop art is spon'.[6]

First exhibited in 1970, *Superknit 1* 1969 was Rooney's concluding painted statement on the seriality of ordinary life.[7] The work's enlarged stitches embody a heroic banality, appearing as a rhythmically formidable colour force. As distinct from others in the series, Rooney applied opposing colour sequences in *Superknit 1* that visually confuse spatial depth. Using knitting patterns as compositions of hard-edge abstraction and metaphors for human existence pinpoints the absurdist undercurrent of Rooney's art. Yet the joke is a visually and conceptually potent one that left one reviewer posing the question: 'What is the psychological significance of this excessive materialistic ordering, of this maniacal tidy-mindedness?'[8] DM

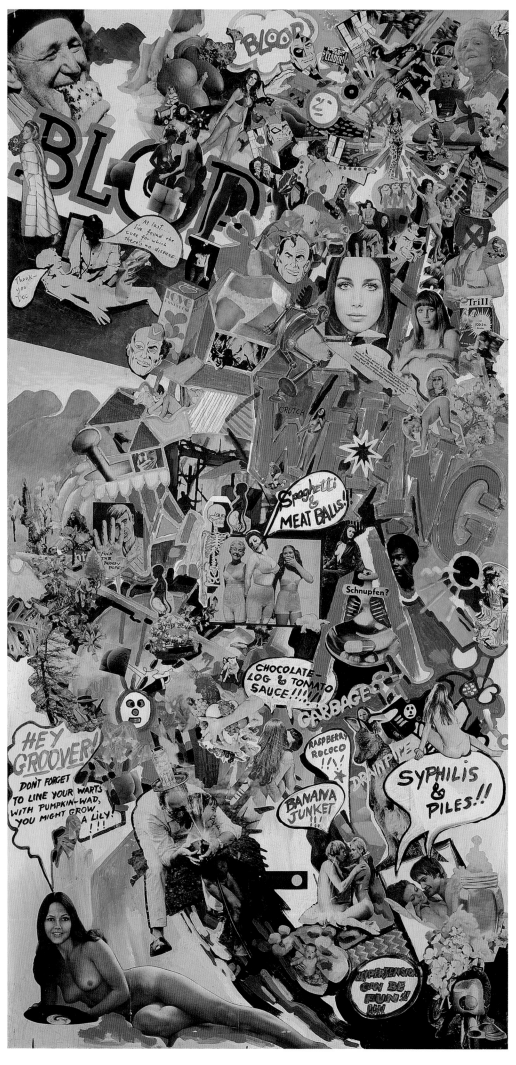

Mike Brown
Big mess 1964–c1970
synthetic polymer paint and collage
on plywood
183 x 91 cm
Private collection, courtesy
Charles Nodrum Gallery

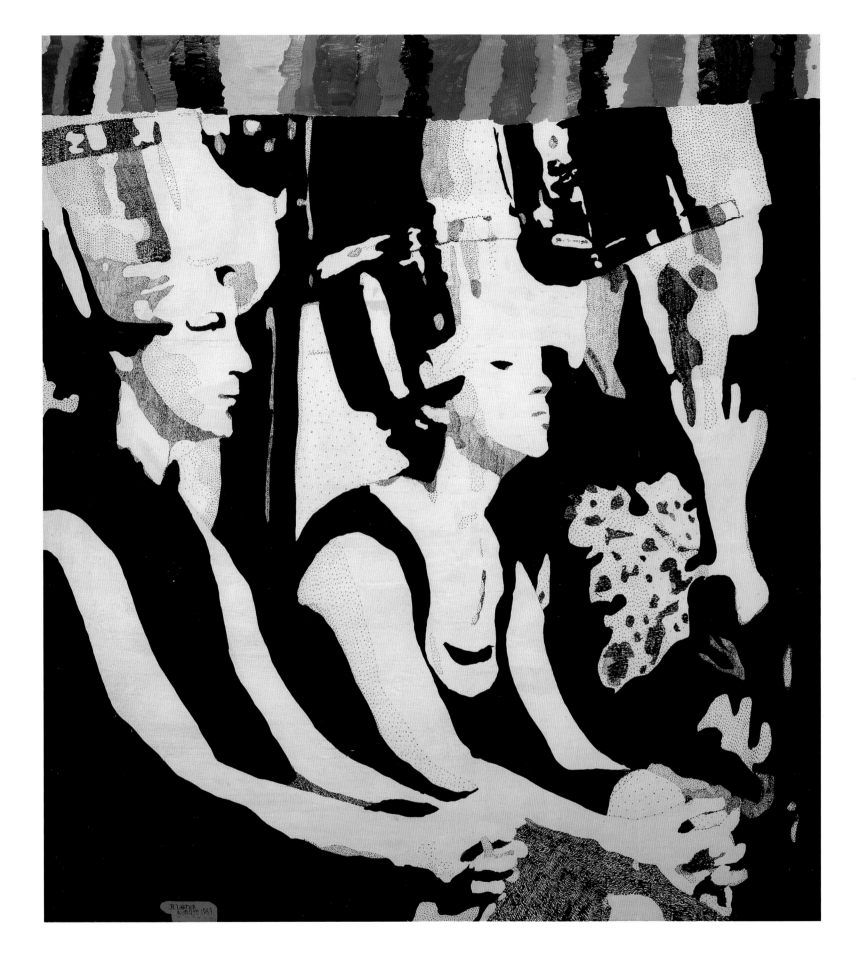

Richard Larter
The hairdresser 1969
synthetic polymer paint
on composition board
133 x 122 cm
Collection of Helen Eager
and Christopher Hodges

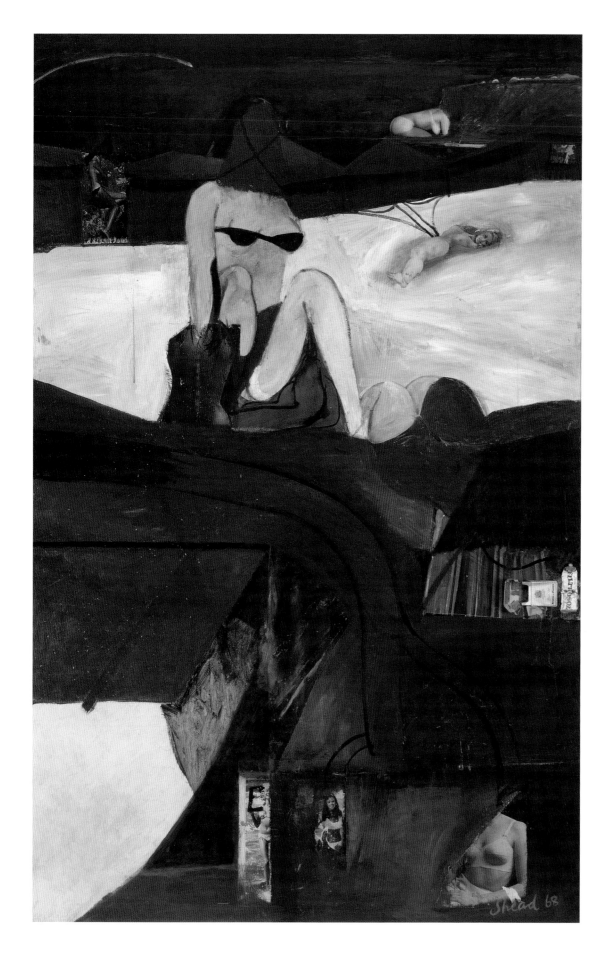

Garry Shead
Bondi 1968, 1998 (re-worked)
synthetic polymer paint and collage on board
216.5 x 137.5 cm
Art Gallery of New South Wales, Sydney.
DG Wilson Bequest Fund 1999

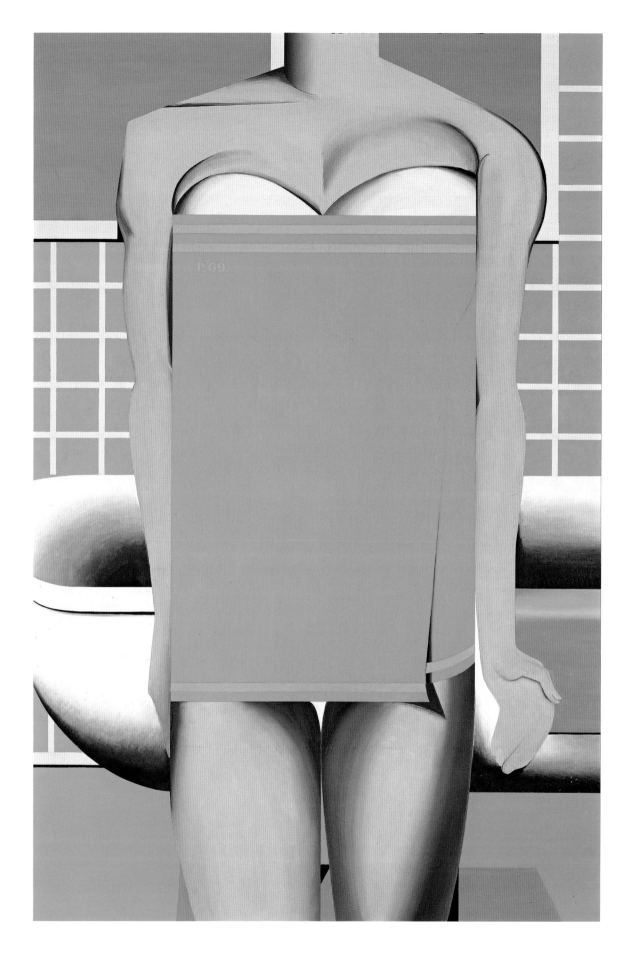

Peter Powditch
The big towel 1969
oil on composition board
183.6 x 122.4 cm
National Gallery of Victoria, Melbourne.
Samuel E Wills Bequest 1979

In the closing years of the 1960s Peter Powditch became known for his series of works that probed the veneer of Australian beach culture with subjects, that as James Gleeson noted, 'had been processed through the Pop machine'.[1] In simplified forms of broad block colour, and with a polished finish that alluded to commercial art, Powditch imaged bikinied beach girls, at times figured as close-range torsos, and others standing like cardboard cut-outs against a background of surfers and a pristine beach environment. His works pitched a sun-filled, hedonistic coastal cosmos populated by sexually funnelled, magazine-type models; imagery that led one critic to refer to Powditch as a 'commentator of the Australian *dolce vita*'.[2] Powditch's beach scenes have the deliberate guise of glossy fabrications, but his works also tapped into something unnervingly real: a sense of cultural vacuousness that the artist had wryly detected in the beach life around him.

Powditch's *Seascape II* was one of the artist's seminal works exhibited at Gallery A in Sydney and Melbourne in 1969. It appeared as the landscape equivalent to his flashy beach figures: a scene of a sun-infused, seeming make-believe perfection. The work sits aesthetically somewhere between hard-edge formalism and pop-style iconography. Its composition is built on a truncated series of pointed and rounded forms, and neatly interlocking planes, but in his colour application the artist shifts from flat areas of blue water and yellow sand to modulating greens that describe coastline scrub with an almost photographic look. Despite its clear abstractions, the painting has an effect of a manufactured hyperreality.

It can be difficult to gauge the gap between celebration and critique in Powditch's work.

For example, is *Seascape II* – as a vision of sun, sea and precisely formed headland – a sardonically perfected landscape of pop construction, or does it celebrate an essence of the New South Wales northern coastline vista? Perhaps something of both. But like other works from this period, the stamp of a 'manufactured' look implies a tool by which to scrutinise beyond the allure of flawless surfaces. Like Charles Meere in his earlier beach classic *Australian beach pattern* 1940 (Art Gallery of New South Wales), Powditch imaged a new generation of pin-up beach types and their coastal backdrops that in their absolute forms appear similarly cleansed of humanity.

From early in his career Powditch claimed an interest in painting things of the popular world around him. He assumed this task with an outward air of critical detachment, speaking of the hedonistic, coast-bound culture as one that he merely 'went along with'. He claimed in 1968 that 'if everyone had fast sports cars and jet tickets and Sunroid glasses it would be a fabulous world'.[3] More recently the artist let his cynical guise slip, reflecting that 'it seems to be there's something missing in this society, a sort of void that nobody wants to confront'.[4] It appears that Powditch painted the things around him in attempts to tackle this void. DM

Peter Powditch
Seascape II 1969
oil on plywood
244 x 244 cm
Art Gallery of New South Wales, Sydney.
Purchased with funds provided by
an anonymous purchase fund for
contemporary Australian art 1970

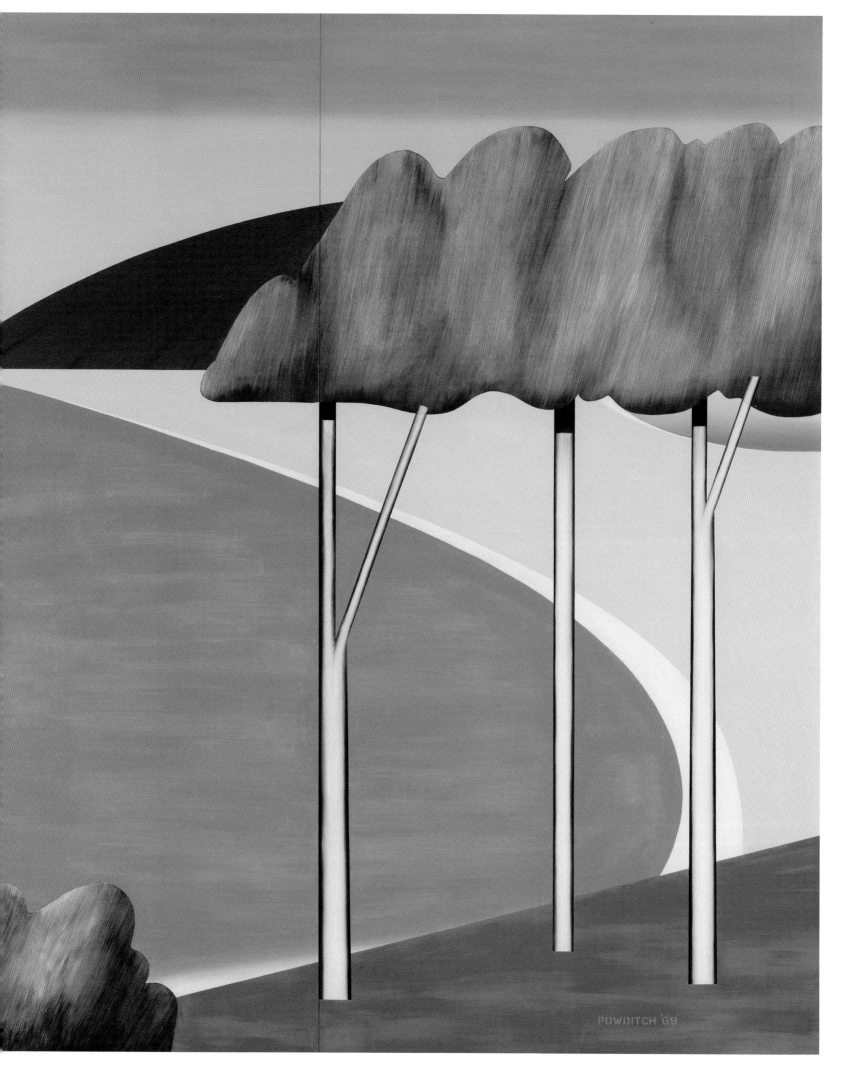

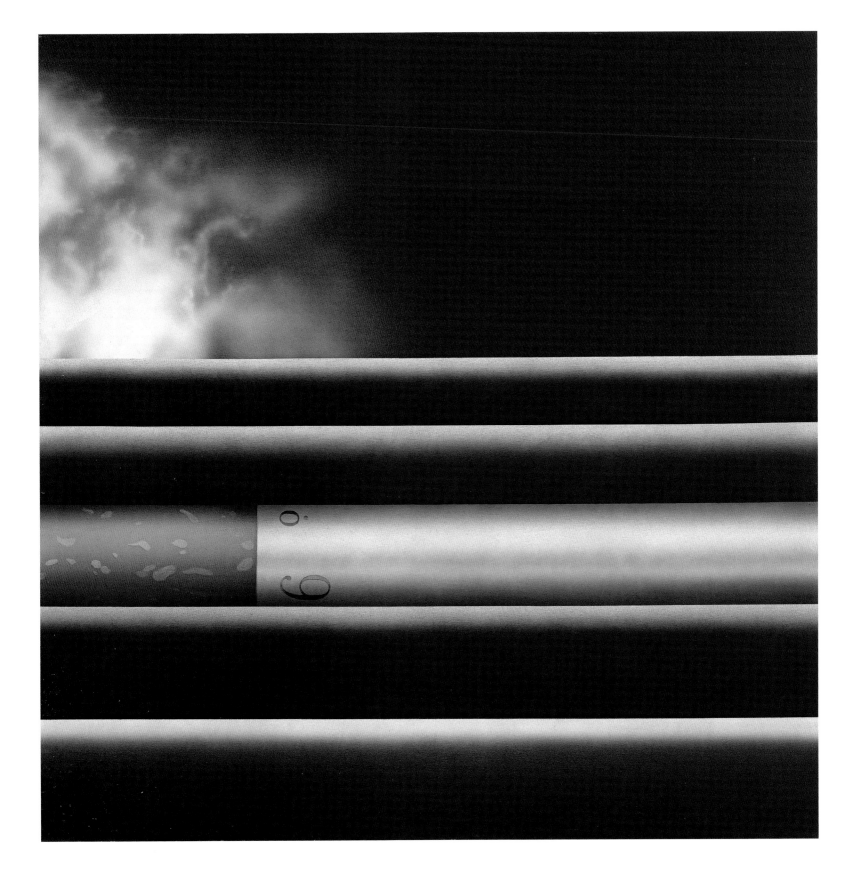

Robert Boynes
Premonition 1969
synthetic polymer paint on canvas
183 x 182.2 cm
National Gallery of Victoria, Melbourne,
purchased 1980

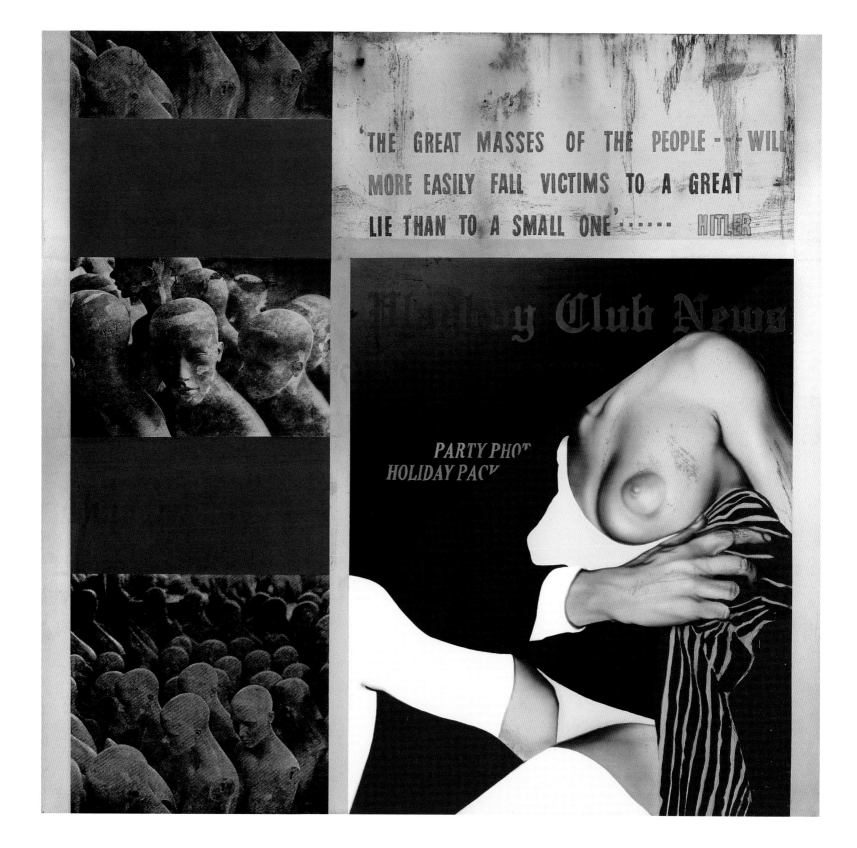

Robert Boynes
Playboy club news 1974
synthetic polymer paint on canvas
152 x 152 cm
Art Gallery of New South Wales, Sydney,
purchased 1983

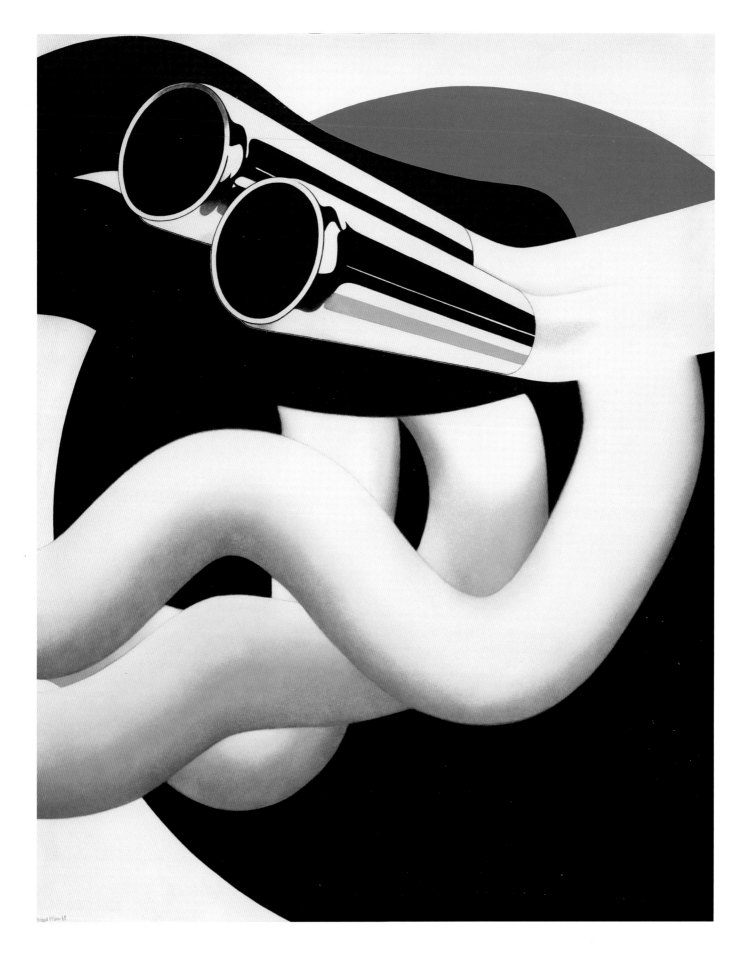

Bridgid McLean
Untitled 1969
synthetic polymer paint on canvas
152.5 x 122.1 cm
Art Gallery of New South Wales, Sydney.
Patrick White Bequest 2013

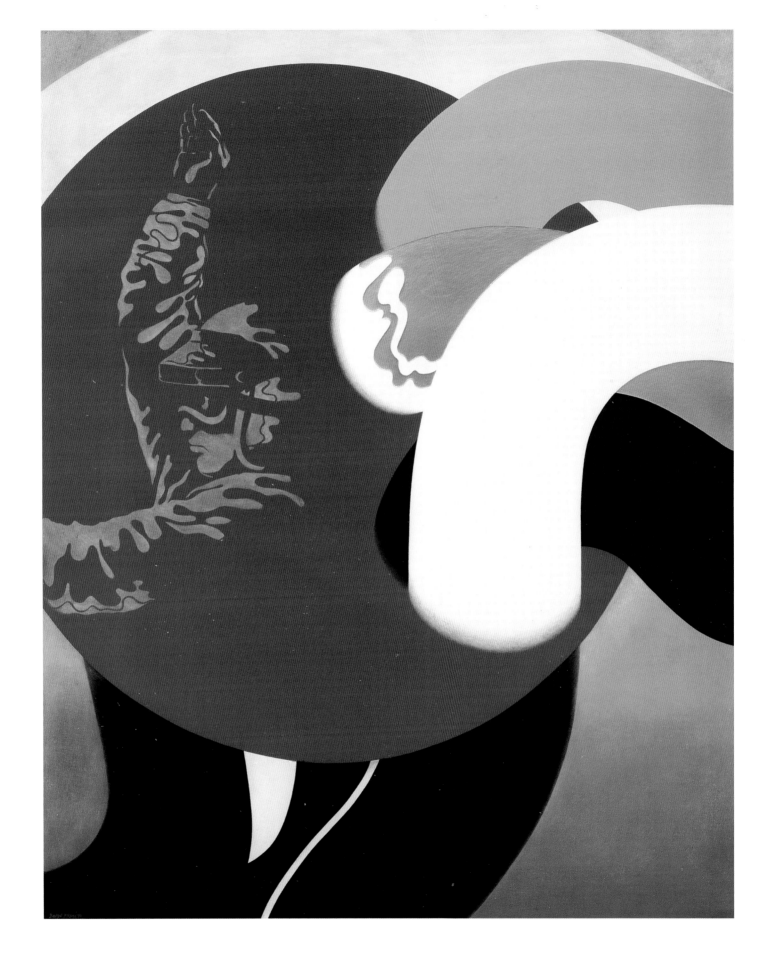

Bridgid McLean
Stop 1970
synthetic polymer paint on canvas
152.4 x 122.2 cm
Art Gallery of New South Wales, Sydney.
Patrick White Bequest 2013

Justin Paton

A DIVIDED CONSCIOUS-NESS

POP ART AFTER 1968

Evelyne Axell painting in her garden in front of *La grande sortie dans l'Espace*
(*The great journey into space*) 1967, Belgium, 1972

The word 'pop' arrived in the world of art in a burst of comic energy. It showed up first in Eduardo Paolozzi's collage *I was a rich man's plaything* 1947, erupting in block letters from a comic-book pistol as if in sexual response to the woman nearby. It appeared again, most famously, a decade or so later in Richard Hamilton's collage *Just what is it that makes today's homes so different, so appealing?* 1956 (Kunsthalle Tübingen, Germany), emblazoned on the end of a mock-phallic lollipop that is clutched by a bulging bodybuilder. Short, snappy, impossible to forget, and a pleasure to say out loud, it was a single word that summed up perfectly the mood of pop art's exuberant first decade. Far from harking back to the bangs and explosions of the war that had recently ended, those early 'pops' channelled the noisy optimism of the new postwar consumer society.

By 1968, however, there were bleaker sounds intruding. Gunfire of a very uncartoonish kind marks the start of pop art's darker second phase, with the shooting of Andy Warhol on 3 June 1968, followed two days later by the assassination of Senator Robert Kennedy and earlier Martin Luther King, on 4 April. We can measure the shift by comparing Hamilton's early collage with his 1970 screenprint *Kent State*, made in response to the shooting, at Kent State University earlier that year, of student demonstrators protesting against the United States of America's involvement in the war in Vietnam. In the well-known 1956 collage, Hamilton placed viewers on the threshold of a modern dream home, in a room comically crowded with conveniences that include a yammering television. In 1970, however, we find Hamilton in front of his own television with a shutter release in his hand, photographing scenes from the Kent State tragedy as they were broadcast live to the world. Produced in a vast edition of 5000 – the better to disseminate its conflicted message – the resulting print is a remarkable document of both violence and distance. Bulking large in the frame is the fallen body of student Dean Kahler, who was not killed but paralysed by National Guardsmen's fire. The image is terribly vague, as if degraded in the process of transmission, but there is no mistaking the flares of blood or the atmosphere of distress. On screen, of course, the news cycle rolled on and this image gave way to others. But by stilling the moment and imprinting it on paper, Hamilton strove to 'keep the shame in our minds'.[1]

To say that pop takes a political turn in the late 1960s is true but not quite adequate. Very little pop art addresses political matters with sloganeering directness; rather, it registers the background presence, the ominous hum, of politics in daily life – the way wars and calamities entered the living rooms of the western world amidst soap operas and ads for frozen vegetables. The poet of this divided consciousness was American painter James Rosenquist, who was unusually well qualified to confront the central dilemma faced by ambitious pop painters: how to reckon with the brave new world of billboards and television using a medium as old-fashioned as painting. A sometime painter of billboards, Rosenquist was fluent in the language of commercial seduction: wide-screen formats, grabby colour, free-floating objects and words. And he harnessed the kinds of accidental collage that occur in urban settings, when images are painted out, pasted over or blocked by other signs. His masterpiece in this mode, the anti-Vietnam war painting *F-111* 1964–65 (Museum of Modern Art, New York), has a span of more than 25 metres, engulfing viewers in what the art critic Robert Hughes called 'a yowling discharge of images'.[2] The related *F-111* screenprint from 1974, at almost 8 metres long, is still a work that fills one's field of view, and its chirpy magentas and yellows heighten the tension between American beauty and aggression. At first glance the work unfolds as a cavalcade of consumer stuff: cake, tyre, hairdryer, umbrella. A second glance uncovers a form ghosting through the sections: the F-111 attack aircraft that the American Air Force first deployed in the war in Vietnam. Then one notices signs of trouble: the broken egg or atom, the atomic cloud, the intestinal sea of spaghetti. The United States withdrew from Saigon the year after Rosenquist made this print, but *F-111* is a peerless evocation of a mood that has not gone away – a sense of menace moving beneath the surfaces of what novelist Don DeLillo calls 'lonely-chrome America'.[3]

'The political' rises much more ambiguously from Andy Warhol's *Mao* 1973. Recovering from the trauma of his shooting in 1968, Warhol re-emerged, in art historian Robert Rosenblum's words, as the 'court painter to the 1970s', setting down the faces of the famous, the royal and the extremely rich in his newly business-focused Factory.[4] It is dismaying to read about the industrial scale of Warhol's production at this time; in his recent history of pop, Bradford R Collins reports 2000 'Maos' emerging from the Factory in one month in the 1970s.[5] But there is no gainsaying the endurance and irritant power of this particular body of work. Creating images of a communist dictator to be sold to wealthy citizens of imperial United States, Warhol

could be seen as offering a capitalist parody of the communist art of 'the masses'. Or one could argue, conversely, that Warhol was using Mao to mock the certitudes of American life, equating the irrational western veneration of celebrities with the veneration of 'the Great Leader'. In the end, the works are too carefully muffled in tone to qualify as critique of either kind. As critic Peter Schjeldahl writes in his essay 'Warhol and class content', the artist manages to have it both ways, 'offer[ing] his patrons both a delicious horror and a promise of emotional mastery over it: they can hang it on their walls'.[6] This makes *Mao* a political painting of an unusual kind: a charm or negative icon, an apotropaic image, designed to ward off the very threat it reveals.

The presence of death and threat in post-1968 pop is rivalled by the presence of sex. As the historian Tony Judt has said of Britain in the 1960s, the so-called sexual revolution 'was almost certainly a mirage for the overwhelming majority of people, young and old alike'; despite the arrival of better and safer contraceptives, swinging London only swung for a few.[7] But what did change for everyone at this time was the public image of sex. There were more bodies on view in film and advertising, and those bodies had a lot less on. In pop art this yielded a new, hot–cold, highly artificialised take on one of art's oldest subjects: the (usually female) nude.

The British pop artist Allen Jones pushed the tradition of the nude into a realm that might be dubbed 'high kink'. Introduced by David Hockney in the mid 1960s to New York's fetish magazines and mail order catalogues[8], Jones was seized by the idea that the erotic, frankly presented, could be the platform for a popular aesthetic – 'art should be accessible to everyone on some level, and eroticism is one such level'.[9] *Come in* 1967 delivers on the breathy promise of its title with a *trompe l'oeil* stairway of chequered plastic tiles, at the top of which a pair of stilettoed legs rises into a red mist of, presumably, desire. Meanwhile, *Secretary* 1972 presents the ideal Jones woman as a swanky furnishing or S&M trophy, a sex object laced in skin-tight leather and locked into the architecture of the wall: Hans Bellmer meets Hugh Hefner. Twice physically attacked by feminists, Jones' sculptures remain hard to read with equanimity even today. But in their blatancy they anticipate the work of artists such as Jeff Koons and the Chapman brothers – radical reactionaries whose objects are designed expressly to test liberal tolerance. The other respect in which Jones looks contemporary is his work designing garments, posters and advertisements. Far from throwing spanners in the works of commercial culture, like traditional avant-garde artists, pop artists were riding increasingly in the very wheelhouse of the fashion industry, the seasonal cycles of which could bring an art 'look' to prominence and just as quickly leave it behind.

Across the Atlantic, Tom Wesselmann was the chief painter of eroticised pop, known best for his paintings of 'great American nudes' reclining in modern-day bedrooms. Wesselmann's hottest works (the word hovers in quotation marks) are those known as the Smokers, where cigarette smoke rises thickly from lipsticked female mouths. Like Rosenquist, Wesselmann had taken note of how advertisers fused selling with sex, and in cigarettes he found a product marketed almost solely on the grounds of 'satisfaction'. Where a feminist such as Martha Rosler sought to dissect and disarm advertising conventions, Wesselmann's method was to isolate and supercharge them, creating icons of all-American desire that floated free of any particular brand. Painted on a shaped canvas that appears to have been excerpted from a larger sign, Wesselmann's *Smoker #11* 1973 offers an ecstatically sighing mouth that is large enough to dive into. Though Hollywood directors had long used smoking as a tacit sign of sex, Wesselmann was especially bold in rhyming smoke with other sexual substances. This painterly innuendo is inseparable, however, from a mortal and gasping quality, as if this woman is exhaling her last. Wesselmann's painting is a visual condensation of every pop song in which a lover declares they're 'on fire' or 'burning up inside'.

Even when it is not addressing erotic subjects, pop art in the late 1960s and early 1970s often has an *excited* quality. This is not art that seeks to order and subdue the chaotic energy of the world beyond the studio; rather, it seeks to amplify and accelerate that energy, channelling the thrill of being 'on the scene' and in the moment. In Australia, few artists inhabited the moment as energetically as Richard Larter, whose tight-packed compositions seem to say, simultaneously, 'Too much!' and 'Give me more!' Sex, current events and signs of conflict come at us at once from *Big time easy mix* 1969, a painting produced seven years into Australia's involvement in the conflict in Vietnam. Even denser and more dissonant as a scrapbook of fragments is *Prompt Careb and how we never learn* 1975, in which a woman seems either to lick or disgorge three further faces, including a Nazi naval commander, Richard's wife Pat Larter, and a comic-book heroine who asserts: 'Fool you can't debase language …'[10] While *Prompt Careb*

could plausibly be construed as a painting about freedom of expression – Larter's retort to the kind of censorship that saw fellow artist Mike Brown handed a prison sentence in 1966[11] – what one registers, more than any 'message', is agitation and psychedelic overload, an effect driven by the pullulating, cell-like patterns on the painting's borders. The pursuit of intensity for intensity's sake is there, too, in the work of Martin Sharp, an Australian who had run afoul of censors in 1960s Australia and whose posters, cartoons and album covers, produced in London in the later 1960s, shaped the self-image of the youth revolution. Created a year after the musician died, Sharp's *Jimi Hendrix* c1971 glorifies the theatre, grandiosity and convulsive energy of the supreme pop form: rock music. However, it is also a startling vision of artistic climax as a kind of death. Pirating the signature painterly device of the abstract expressionist generation, Sharp turns Hendrix into a one-man eruption of Jackson Pollock drips. Where Hendrix has struck his guitar, the whole composition blooms red – as if struck by the gunfire heard elsewhere at this time.

Was this the end? By 1973, as Judt reports, the economic boom was over, and 'there was to be no return to the optimism – or the illusions – of the first postwar decades'.[12] Pop, too, seemed to be coming to a number of ends – an ironic fate, or perhaps a fitting one, for a movement alert to consumer obsolescence. By this time, many of pop's first-generation heroes were consolidating a 'look' and a brand, settling into mid-careers characterised less by provocation than production. If Roy Lichtenstein had once startled his audiences by launching mass-produced imagery into the realm of high art, in the 1970s he is found, just as often, turning high art (that of Mondrian and Monet, for instance) into mildly humorous collectibles. At the same time, other stars of pop had simply moved on to other territory; we find Hockney, for example, aerating his art in the hills of southern France, a long way from the postwar supermarketplace. This is also a period when many pop artists chafe (as did many minimalists) at the label that art history had assigned them. Ed Ruscha remarked in 1980–81 that the 'term Pop art made me nervous and ambivalent', preferring from early on to be known as a painter of 'common objects'. Even more insistent in his disavowal was the British painter Patrick Caulfield, maker of rigorously formal and powerfully melancholy scenes of middle-class interiors. Tellingly, it is Hockney, Ruscha and Caulfield who enjoy the richest creative lives beyond the 1970s, producing bodies of work that begin in pop but achieve an independent and idiosyncratic largeness.[13]

If some of pop's heroes start to look too settled in their roles in the 1970s, there has recently been a compensatory rediscovery of neglected heroines. Belgian painter Evelyne Axell is one notable re-emergence in the canon. In contrast to the portrayals of the female nude offered by Allen Jones and Tom Wesselmann, Axell was a woman painter portraying women's bodies (her own included) in a manner that was both staunch and highly sexualised; political and sexual liberation are frequent bedfellows in her work. Acquired and first exhibited by the Centre Pompidou, Paris, in 2009, *Le retour de Tarzan* 1972 offers a woman's-eye-view of sexual encounter, filtered through the conventions of American popular entertainment and the shrill colours of the British pop she had encountered in London in 1964.[14] Down swings a naked Tarzan from a dusky forest canopy, while his 'Jane' – played here by the bespectacled Axell – waits naked, thighs parted, with her pet lion in a red-hot glade. Tarzan looks, if anything, nervous about the assignation, while Axell has a self-possessed readiness. If sexual fantasy is on the agenda, Axell seems to be saying in this work, then let it be *mine* and no one else's. But Axell's role in reshaping erotic pop lasted less than a decade; she died in a car accident later in 1972.

Though utterly unlike Axell in her artistic thinking, Martha Rosler is likewise a recent reclamation for the history of pop; she and Axell appeared in the 2010 exhibition *Seductive subversion: women artists and pop 1958–1968*. One reason Rosler's anti-war photomontages did not figure prominently in earlier pop histories was her attitude to distribution; she made them not for gallery presentation but for mass-produced flyers. Born in the middle of World War II, and a left-leaning activist from early on, Rosler stands out among the makers of political pop for her clarity about what she wants to say: 'I was looking for a way to express, in public fashion, my opposition to a war that seemed to be brought to us in the living room, on TV, and which posited a "here" and a "there".'[15] From Hannah Hoch onwards, photomontage has been favoured by artists who want to argue with 'consensus reality', cutting through the apparent order of things and exposing the contradictions beneath. Setting to work with scissors, Rosler found a way to bring the 'here' of the United States and the 'there' of Vietnam back together, invading the front lawns and living rooms of *House Beautiful* magazine with stricken soldiers and victims. Here, for instance, two American marines search for mines near an immaculate kitchen; and here a happy couple test

their new mattress in someone else's battle-wrecked room. What Rosenquist's *F-111* hinted at, Rosler's works insist on: the connectedness of militarism and materialism.

Though Warhol and Lichtenstein occupy positions in art history that today seem unassailable, the lesser-known guests at pop's big party look especially interesting from the vantage of the present. Rosler's anti-war series is an important precedent for the vociferous contemporary collages of Thomas Hirschhorn and the text-and-image works of Barbara Kruger. Moreover, her *House beautiful: bringing the war home* is a reminder, like Hamilton's *Kent State*, that pop was often pointedly unpopular, using mass-cultural materials to deliver ugly truths about mass culture. The rambunctious master of this method was the West Coast assemblage artist Edward Kienholz, whose installations body forth a United States that is not new and crisply consumerist but clammy, heartbroken and tarnished. A figure of vast influence amongst artists today, not least the Los Angeles troublemaker Paul McCarthy, Kienholz was a maestro of what curators Scott Rothkopf and Donna de Salvo have recently dubbed 'sinister Pop'.[16] *Five car stud* 1969–72 (Kawamura Memorial DIC Museum of Art, Sakura, Japan), for instance, is a sculptural tableau that dramatises a gut-churning incident of racial violence; the related multiple *Sawdy* 1971 places us at the scene of the crime, peering out through a wound-down car window at an incident in which no one is intervening. Like Hamilton in *Kent State*, Kienholz is fascinated by the morality of looking; his car window is a mobile television screen that makes queasy voyeurs of us all. No contemporary viewer can help but think of the 1991 footage of the beating of Rodney King.

We exit this period past an unlikely sentinel: Duane Hanson's *Woman with a laundry basket* 1974. Hanson was not a pop artist, rather a realist of the American commonplace, but his *Woman* makes an indispensable point about the consumer culture that pop artists once gleefully borrowed. By this time the pop aesthetic of bright colours and come-ons no longer seemed exotic or novel; instead it was simply part of life, as mundane as the box of Tide at her feet. Far from being uplifted by consumer culture, Hanson's woman is weighed down by her daily chores; the further weight of her pregnant belly suggests the sexual revolution is only a memory. Produced in a year of rising inflation, deepening recession and political bad faith (it was the year of President Nixon's resignation in the wake of the Watergate scandal), she is the vividly downbeat counterpart to Jones' va-va-voom secretaries and Wesselmann's great American nudes. She, more than David Hockney's poolside watcher or the implied appreciators of Lichtenstein's jokes, is the inheritor of the new material world. As the laundry packet at her feet suggests, the tide of consumer culture is still coming in, and she, like many then and now, is simply keeping her head above water.

RICHARD HAMILTON
Swingeing London 67 – sketch 1968

On 12 February 1967 police raided the Sussex farmhouse of Rolling Stones guitarist Keith Richards, arresting a number of partygoers, including lead singer of the Stones, Mick Jagger, and art dealer Robert Fraser on suspicion of drug possession. In June both men were found guilty and were photographed the next day as they sat handcuffed together in a police vehicle on the way to court for sentencing.[1]

The scandal was widely reported in the media, becoming a cipher for the struggle between the individualism and permissiveness of 1960s 'swinging London' and the opposing values of the established social order.[2] Artist Richard Hamilton had a personal stake in the story: Robert Fraser was his art dealer and friend.[3] He responded with *Swingeing London '67*, a series comprising a poster, seven paintings and associated studies, and five prints made between 1967 and 1972.[4] The title is a pun: the presiding judge noted at Jagger and Fraser's hearing that 'There are times when a swingeing sentence can act as a deterrent'[5] – 'swingeing' being an obscure British word meaning very forceful, great or immense.

From the mid 1960s Hamilton increasingly modified photographic images in a variety of mediums, refuting the notion of objectivity that a photograph was popularly thought to express. The drawing *Swingeing London 67* was made early in the series, in 1968. Hamilton's soft, tonal rendering of the two figures in pastel and watercolour obscures the details of their faces, while reinforcing the glare of the original photographer's flash. The axis of the handcuffs' chains and the vulnerable shielding hands becomes the focus of the drawing, which, combined with the shallowness of the picture plane and cropping of the background details, conveys a sense of oppressive claustrophobia and intrusion. Hamilton sustained this obscuring tendency in the subsequent prints and paintings of the series; by reducing the amount of visual information, he allowed both a sense of detachment from the actual event and its protagonists, and subjective interpretations by the viewer.

The etching was developed from the drawing.[6] The variety of printmaking techniques used, particularly the addition of a rectangle of dark tone dominating the left of the image, add further layers of mediation between subject and viewer, as well as suggesting elements of high-art trends in formalist painting and design.

Hamilton made the *Swingeing London '67* works at a time when, internationally, media culture was gaining traction, foretelling the internet age in which the realms of privacy and celebrity collide, and the experiences of privileged individuals become trivialised fodder for the speculations of the masses – moral panic as entertainment. The series continues to have powerful contemporary resonance. AR

Richard Hamilton
Swingeing London 67 – sketch 1968
pencil, pastel, watercolour and
metalised acetate on paper
33 x 48 cm
Arts Council Collection, Southbank Centre,
London

(opposite above)

Richard Hamilton
Swingeing London '67 – etching 1968
etching, aquatint, embossing,
die stamp and collage
56.8 x 72.6 cm (sheet)
National Gallery of Australia, Canberra,
purchased 1982

(opposite)

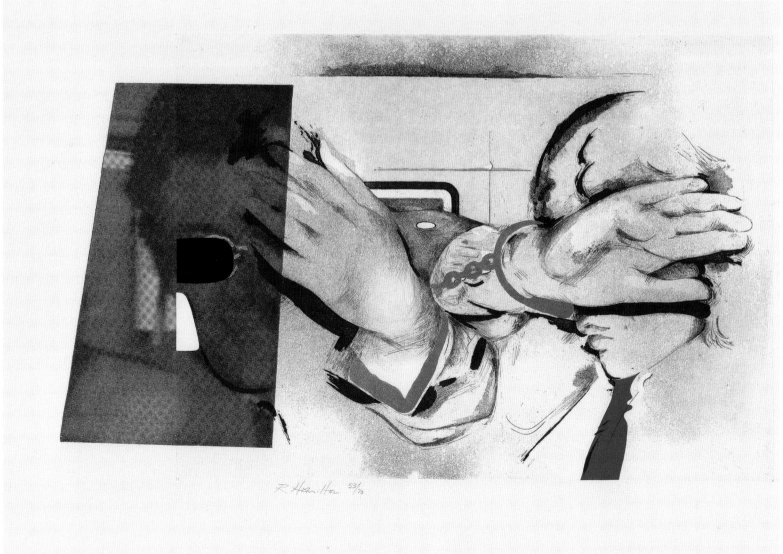

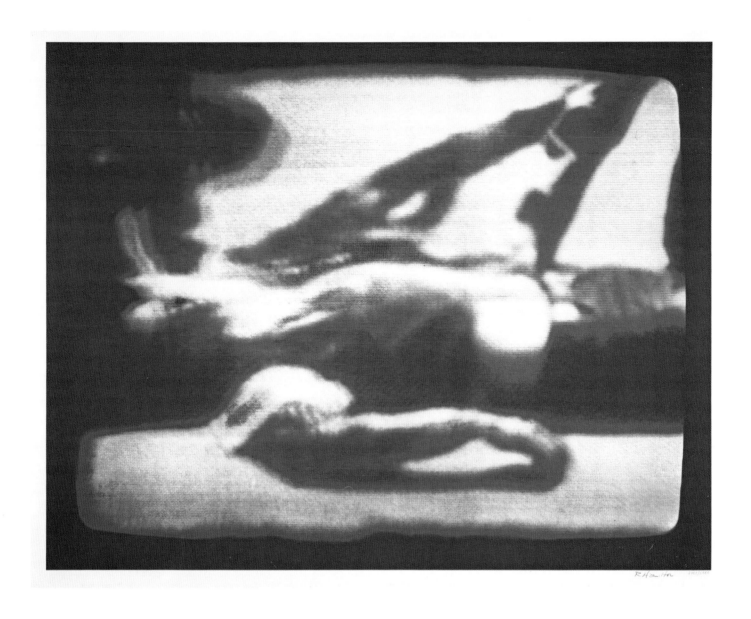

Richard Hamilton
Kent State 1970
colour photo screenprint
67.1 x 87.1 cm (image); 73 x 102 cm (sheet)
Art Gallery of New South Wales, Sydney,
purchased 1971

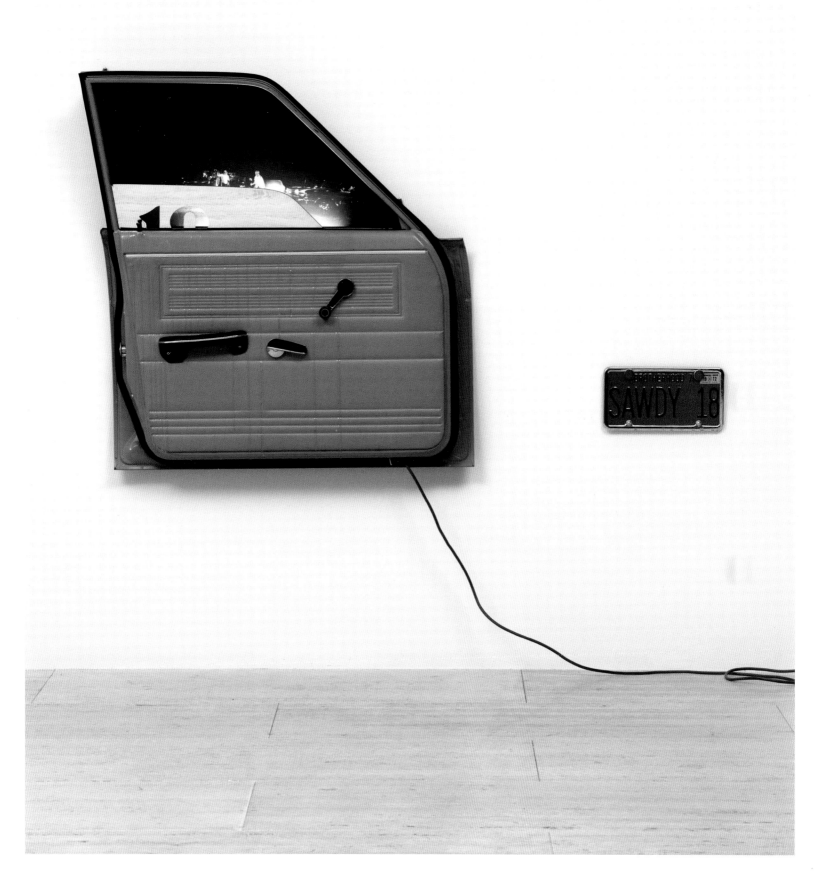

Edward Kienholz
Sawdy 1971
steel, rubber, chrome, aluminium, vinyl,
synthetic polymer paint, synthetic polymer resin,
mirror film, glass and screenprint on paper,
flourescent tube and unit
100 x 94 x 18.5 cm (irreg)
JW Power Collection, University of Sydney,
managed by Museum of Contemporary Art,
purchased 1972

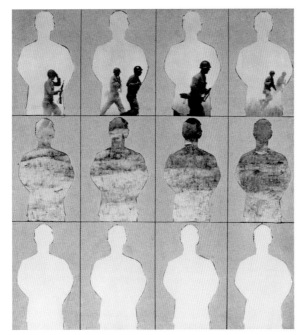
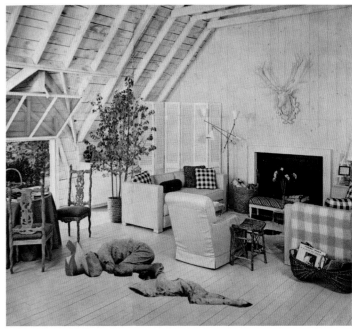

Martha Rosler
from the series
House beautiful:
bringing the war home 1967–72
photomontage
sheet dimensions
Courtesy of the artist and
Mitchell-Innes & Nash, New York

(top row from left)

Woman with cannon (dots)
61 x 50.8 cm
Red stripe kitchen
61 x 50.8 cm
Booby trap
61 x 50.8 cm
Empty boys
61 x 50.8 cm
Roadside ambush
50.8 x 61 cm
Playboy (on view)
61 x 50.8 cm
Beauty rest
61 x 50.8 cm

(middle row from left)

First Lady (Pat Nixon)
50.8 x 61 cm
Runway
50.8 x 61 cm
Tract house soldier
50.8 x 61 cm
Cleaning the drapes
50.8 x 61 cm
Scatter
50.8 x 61 cm
Honors (striped burial)
50.8 x 61 cm
Makeup/Hands up
61 x 50.8 cm

(bottom row from left)

Patio view
61 x 50.8 cm
House beautiful, Giacometti
61 x 50.8 cm
Tron (amputee)
61 x 50.8 cm
Boy's room
61 x 50.8 cm
Vacation getaway
50.8 x 60 cm
Balloons
61 x 50.8 cm

Out of the postwar moment of relative prosperity and wealth in the United States of America emerged the dream of home ownership, as well as the home design and improvement industries. Items that were once luxury became essential for social recognition. Domestic and individual appearances were assumed to be reflective of the general wellbeing of the nation. Photographic images played a key role in enabling the dissemination of consumer desire, which spread a univocal message about what the good life looked like. Photography was ripe for the picking, particularly for artists like Martha Rosler, who were involved in feminist and anti-war activism.

House beautiful: bringing the war home 1967–72 emerged from Rosler's observation of how *Life* magazine would nonchalantly place advertising images, often taken in the home, amongst illustrated editorials about the Vietnam War. Her collages draw a direct parallel between the 'beautiful house' (fitted with vacuum cleaners, lawnmowers, cars, beauty products, even famous artworks) and the homeland, the United States. The use of 'house' in Rosler's title is an ironic nod to the White House, which the collage of the then First Lady, Pat Nixon, exemplifies.

Rosler neatly inserts gruesome pictures of war-torn Vietnam within the happy homeland scenes. She suggests that the life projected by these images of domestic bliss is predicated on the unnecessary and brutal suffering of people elsewhere. In this group of works, the dynamic of 'here' and 'there' is collapsed, aligning the two to insist upon the inextricability of domestic consumerism and the international war industry. The artist's juxtaposition of seemingly disparate photographic genres comments on the way all images can mislead us. The photographs of

war atrocities are mediated, too, in a manner commensurate with those of prosperous, aspirational domesticity. Rosler does not aggressively force war photography onto the advertisements but rather makes them 'fit'. She places war amongst the drapes (*Cleaning the drapes*), on the carpet (*Roadside ambush*) and through the windows (*House beautiful, Giacometti*), showing that it very much belongs in this world, the homeland, not solely in another one far away.

The artist explains that 'in the most obvious way a photographic montage disrupts the notion of the real while still employing photographic material, which speaks to people with a great deal of intimacy'.[1] Rosler produced *House beautiful* over five years, foremost as an outlet for her rage towards her country's ongoing involvement in war. The foregrounding of sociopolitical concerns and their circulation is crucial to her oeuvre, and it is telling that these collages were initially distributed via alternative press outlets or as photocopies delivered like demonstration flyers. The art world's interest came much later. EW

n a secluded vacation spot, privacy isn't a problem, so you go all out with glass, for view, light, and visual spaciousness. Simple or no-pattern coverings, soft colors, and mall-scale furnishings add to illusion of size. Blue of the ceiling and brown of the beams extend through the glass walls to the eaves from living room to the outdoor

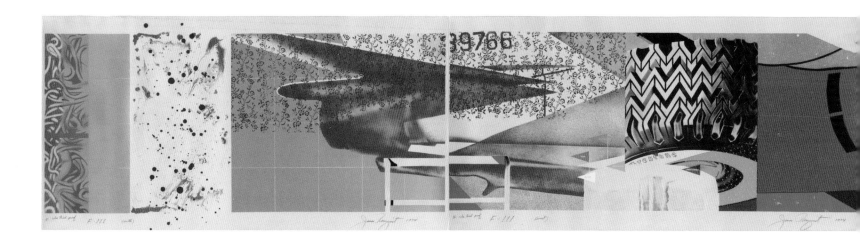

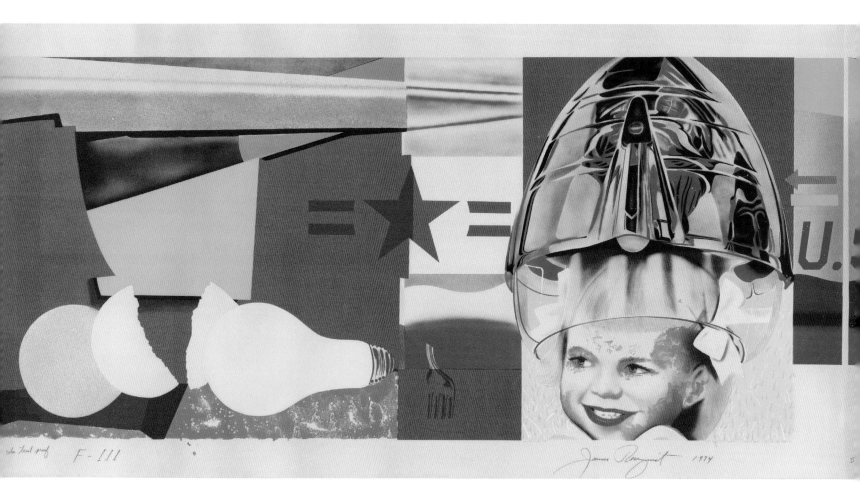

James Rosenquist
F-111 1974
lithograph and screenprint
4 sheets: 91.4 x 191 cm (each);
91.4 x 764 cm (overall)
National Gallery of Australia, Canberra,
purchased 1976

(detail bottom)

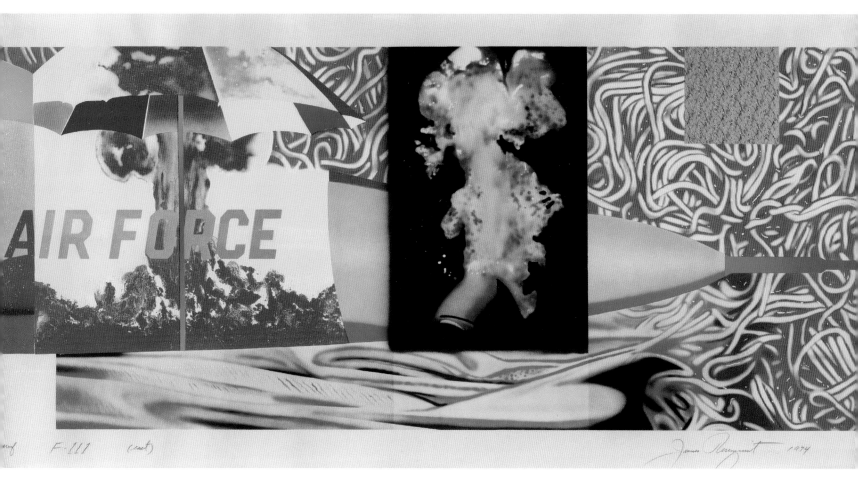

Roy Lichtenstein
Bull I–VI 1973
from the series **Bull profile**
lithograph, screenprint and line-cut
68.6 x 88.9 cm (sheet)
Art Gallery of New South Wales,
purchased with funds provided by
Hamish Parker 2013

Andy Warhol
Mao 1973
acrylic and silkscreen ink on linen
101.6 x 86.4 cm
The Andy Warhol Museum, Pittsburgh.
Founding Collection, Contribution
The Andy Warhol Foundation for the
Visual Arts Inc

(opposite)

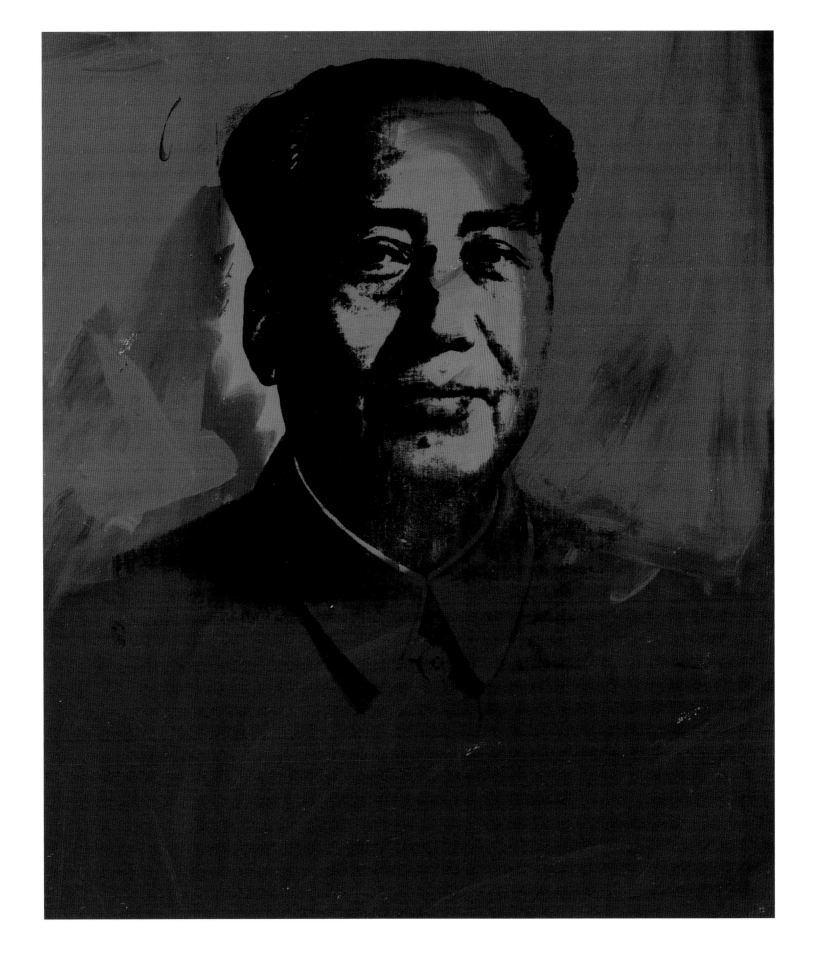

Allen Jones
Come in 1967
synthetic polymer paint on canvas, synthetic
polymer sheet on aluminium and iron
231 x 152.5 x 46 cm
JW Power Collection, University of Sydney,
managed by Museum of Contemporary Art,
purchased 1967

Allen Jones
Secretary 1972
fibreglass, aluminum and leather
105 x 45 cm
State Art Collection, Art Gallery of
Western Australia, purchased 1973

(opposite)

Belgian artist Evelyne Axell experienced a striking meteoric career spanning only eight years, ended tragically by a fatal car crash in 1972. *Le retour de Tarzan* was completed and exhibited in April 1972, just months before her death in September. Initially influenced by Belgian surrealism – notably by her tutor and compatriot René Magritte – and resonant with the British pop art movement that she encountered in London in the early 1960s, Axell developed her own style in which the female nude, sexually evocative and self-contained, often with herself as model, played a key role.

In her late works, including *Le retour de Tarzan*, Axell placed her solitary females in utopian settings of luscious jungle with exotic vegetation and idyllic waterfalls, creating a hedonistic vision of primeval nature and a metaphor out of a hidden realm of female desire. In *Le retour de Tarzan* the strong, wild, untamed male of the artist's dreams makes a dramatic appearance from above Jane – Axell's signature fashionable round glasses indicating that it is a self-portrait. Both are shamelessly naked; Tarzan leaps into this colourful, stage-like jungle setting, while Jane is seated in the foreground, voluptuously on her throne of various hues of warm pink and red. Men are rarely included in Axell's work, so Tarzan's opportune sudden descent suggests a sexual encounter, with Jane as the willing subject of male desire, ready to be taken out of her lonely fantasy, yet completely in control of herself.

This work showcases Axell's innovative style and signature technique, in which she cut out translucent pieces of plexiglas and painted both sides with bright enamel colours, mounting them on background panels that are coloured differently to create low-relief images. Enamel allowed the artist to achieve extreme flatness and sensuality, her opalescent paintings composed of strongly outlined fields in unmixed and muted colours on plastic.

Axell consciously adopted formal means from pop art, such as cool, bright colour and rich surface quality, as well as new materials, a stylised and schematised aesthetic – often obtained by mechanical or other non-expressive techniques that leave no trace of the artist's hand – though less often she took her themes from mass media and consumer culture. Referencing pop views of cliché gender stereotypes (the male creator and the female muse), *Le retour de Tarzan* remains a somewhat atypical example in Axell's oeuvre. Enthralled by the second feminist wave of the 1960s and leading a hedonistic life, the artist proclaimed the intellectual and sexual liberation of women, inventing a radical feminist dialogue with pop art, which celebrated women's bodies, sexuality and desire. Alongside her peers, the British artist Pauline Boty and Polish Alina Szapocznikow, Axell embraced pop to celebrate female sexuality and desire. Her works, dominated by erotic female nudes and often described as pop erotica, remain today, according to the French critic Pierre Restany, icons of the 'sexual revolution of art'.[1] AGA

Evelyne Axell
Le retour de Tarzan 1972
enamel on plexiglas
196 x 132 cm
Centre Pompidou, National Museum
of Modern Art Collection.
Don M Jean Antoine 2009

Ken Reinhard
EK 1972
wall construction: synthetic polymer
paint, brass, copper, plastic and
photograph on hardboard
186.7 x 186.6 x 32.3 cm
Art Gallery of New South Wales, Sydney,
purchased 1974

Patrick Caulfield
Dining recess 1972
oil on canvas
274.5 x 213.5 cm
Arts Council Collection,
Southbank Centre, London

(opposite)

DAVID HOCKNEY
Portrait of an artist 1972

'I'm not going to paint swimming pools,' David Hockney declared in 1980, 'I've done enough now.'[1] Ever since moving to California at the end of 1963, swimming pools and the element of water had been major motifs in Hockney's art, providing the subject for paintings such as *Picture of a Hollywood swimming pool* 1964 (private collection), *Two boys in a pool, Hollywood* 1965 (private collection), *Peter getting out of Nick's pool* 1966 (Walker Art Gallery, Liverpool) and *A bigger splash* 1967 (Tate). Water was everywhere in the semi-arid environment of California, and Hockney was attracted by the technical challenges of depicting its transparent and refracting characteristics. 'The point about water,' he noted, 'is you can look at it in so many different ways.'[2]

The pool at the centre of *Portrait of an artist* 1972 provides a surface that can be looked onto, into and through, from the decorative light patterns on the rippled surface to the shaded side wall and distorted figure swimming underneath. There is also a more subtle psychological tension operative in this work between surface and what lies beneath. The painting invites speculation about the human drama underpinning this seemingly simple image of one man watching another swim. The intense stare of the fully clothed man, the vulnerability of the underwater figure and the sharp light all hint at something amiss. Hockney had in fact just broken up with his boyfriend Peter Schlesinger, who is the fully clothed 'artist' in the painting.

Hockney once noted that his paintings fell into two distinct groups: 'One group being the pictures that started from … some "technical" device and another group being real dramas, usually with two figures. Occasionally these groups overlap in one picture.'[3] *Portrait of an artist* is one of these overlapping works. The drama was documented by filmmaker Jack Hazan in *A bigger splash* 1967.[4] Hockney was disappointed when this documentary was eventually released, as the focus of it was the break-up of his relationship, with his art virtually a subtext. The film did show what a meticulous technician Hockney was as an artist, carefully designing and reworking his paintings. This sun-drenched and expansive scene was completed in Hockney's cramped London studio, often at night under lamps lent to him by Hazan; yet Hockney recalled, 'I loved working on that picture, working with such intensity'.[5]

The work comes at the end of a period of increasing naturalism in Hockney's art, influenced in part by photorealism. Hockney frequently used photographs as the basis for work, with the subject of this painting suggested by the accidental juxtaposition of two photographs on his studio floor.[6] Yet he was wary of the deadening effect of photography upon his art. In *Portrait of an artist* one can observe Hockney searching for a new language of figuration, a struggle he characterised as one between realism and 'obsessive naturalism'.[7] SM

David Hockney
Portrait of an artist 1972
synthetic polymer paint on canvas
213.3 x 304.8 cm
The Lewis Collection

In the beginning was the word, and the word was 'boss'. Then came 'spam', 'ace', 'oof', 'flash', 'honk' and '20th Century Fox'. Rendered with a signwriter's care and clarity on fields of abstract colour, these words are the ambiguous verbal heroes of Ed Ruscha's early paintings. By the end of the 1960s they had earned him a reputation as a key artist of the West Coast pop scene, a painter with a talent for coaxing strangeness and poetry from common American language and signage.

Amidst this catalogue of free-floating verbal fragments the word 'gospel', star of this 1972 painting by Ruscha, carries a peculiar weight. The gospel, in biblical terms, is a record of the life of Christ, and when we say that someone's word is 'gospel' we mean that it is absolutely true. Gospel, moreover, is a form of American music that charges words with communal energy and spiritual force. In scale and look Ruscha's painting could almost be mistaken for the cover of a gospel album, with that uptilted word evoking the heavenwards hark of a choir in full voice. This, it seems, is not just a word painting but a painting about the word – about truth, proclamation, authority, and painting's powers of speech.

Ruscha, however, is not an artist who wants his words to deliver fixed meanings. A lapsed Catholic, he treats words with what might be described as reverent scepticism, thwarting and poetically stalling their meanings by treating them as objects, as painted *things*. The vehicles of that scepticism, in *Gospel*, are six store-bought aluminium arrows, which seem at once to chase the word across the canvas and to pin it helplessly in place. Ruscha first encountered the idea that a painting could be a physical target in Jasper Johns' *Target with four faces* 1955

(Museum of Modern Art, New York), a work that transfixed him as a young artist when he saw it in reproduction in 1957. When Niki de Saint Phalle aimed real bullets at her paintings in the early 1960s, she seemed to be taking Johns' suggestion to an aggressive extreme. Perhaps Ruscha with his arrows, like Saint Phalle with her bullets, was out to puncture the pieties of abstract painting, using real-world objects to skewer the then-current doctrines of 'flatness' and 'pure abstraction'.

But that reading, tidy though it is, makes Ruscha sound too oppositional, too strategic. From his early years in the nascent Los Angeles pop scene through to his current status as a globally revered 'artist's artist', Ruscha has always been more interested in paradox and productive bemusement than art-world positioning and the politics of style. Do those arrows rupture and arrest the word, or do they exalt it, carry it higher? Is he attacking the biblical truth, or asserting the alternative truth of unmoored words? In the gospel according to Ruscha, these questions remain permanently in the air. JP

Edward Ruscha
Gospel 1972
synthetic polymer paint and aluminium
on raw canvas
137.2 x 152.4 cm
Art Gallery of New South Wales, Sydney.
Gift of the Art Gallery Society of New South Wales
and Ed and Danna Ruscha with the support of
Gagosian Gallery 2013

Duane Hanson

Woman with a laundry basket 1974

surface paint oil, cardboard, resin, talc,
fibreglass, fabric, plastic, cardboard packaging
165 x 84 x 70 cm (irreg)
Art Gallery of South Australia, Adelaide.
South Australian Government Grant 1975

(opposite)

Tom Wesselmann

Smoker #11 1973

oil on canvas
224.8 x 216 cm
Claire Wesselmann

An ode to the inventive genius of Vincent van Gogh and his unrealised dream to create an artist colony in the sunlit south of France, Sydney's Yellow House was the brainchild of Australian artist Martin Sharp, whose guiding principle was to share art, life and love. After four years in London illustrating and designing *Oz* magazine with remarkable visual invention, Sharp returned to Sydney in 1969. Offered rent-free studio and living space at the former Clune Gallery site at 59 Macleay Street in Potts Point – near the red-light district of Kings Cross – in May 1970 Sharp held a solo show of collages and paintings, titled *Public view*, and began to develop total art environments in every corner of the house. Sharp invited friends, artists and students to paint murals, recite poetry, screen films, present plays and perform concerts in a spirit of creative and collective unity. The run-down terrace quickly became a magnet for Sydney's bohemian community. Filmmaker Albie Thoms established the Ginger Meggs Memorial School of Art, with classes in film and folk music, as an antidote to Sydney's conservative art education system.

With consent from the owner to transform the building's exterior, the white walls were painted bright yellow and the collective endeavour named after van Gogh's house at Arles. The Yellow House was formally launched on April Fools' Day 1971 by tap dancer and singer Little Nell (Nell Campbell). Sharp's offering of a group of diminutive photographs of collages with gilded frames, titled *Incredible shrinking exhibition*, was dedicated to American performer Tiny Tim, whom he had first seen in London in 1969.

Over the following months, rooms and corridors were transformed and given distinct identities. The Magritte Room combined framed prints by the surrealist painter set against Magritte-inspired wall, floor and ceiling murals, and hung with contemporary work by Peter Powditch and Brett Whiteley. The walls and doors of the Stone Room were given their ruinous appearance by Peter Kingston, and stoneware objects created by Joyce Gittoes were arranged on a *trompe l'oeil* 'stone' tablecloth. 'Stone' doors opened onto Martin Sharp's mural depicting Hokusai's *Under the wave, off Kanagawa* 1831–33, in homage to the Japanese master artist. George Gittoes created the Puppet Theatre with performances of mime, magic, experimental plays and puppetry. Séances, dadaist soirees and cabarets were conducted and performed by Yellow House residents and other invited guests.

Throughout 1971 over 80 films were screened at the Yellow House, including Raymond Longford's Australian classic *On our selection* (1920), Luis Buñuel's surrealist masterpiece *Un chien Andalou* (1928), Fritz Lang's expressionist *Metropolis* (1927) and Walt Disney's *Dumbo* (1941), as well as early work by contemporary Australian directors Mick Glasheen, Jim Sharman, Albie Thoms and Peter Weir.

The collective spirit of the Yellow House waned following Sharp's return to London in October 1971, and emotional and financial disillusion among its remaining residents saw the yellow doors chained shut the following year. While more a manifestation of the counterculture movement than pure pop as such, a popular culture ethos permeated the activities and work produced at the Yellow House throughout its brief but brilliant life. NW

(clockwise from top left)

The Yellow House on Macleay Street, Potts Point in 1971

Magritte Room, Martin Sharp

Stone Room designed by Martin Sharp, completed by George Gittoes, Joyce Gittoes and Peter Kingston

Infinity Room with sculpture by Julia Sale and photographs by Greg Weight

Fantomas Hall, Martin Sharp

Puppet Theatre, George Gittoes

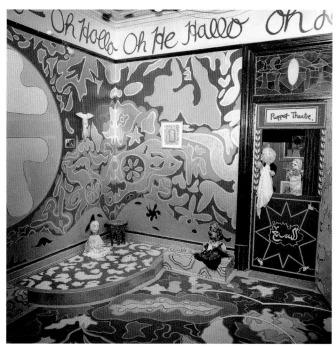

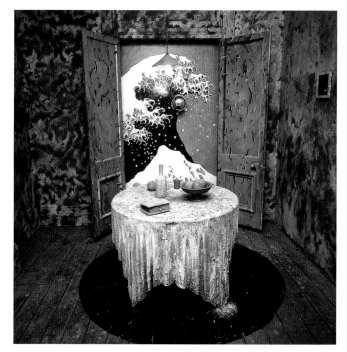

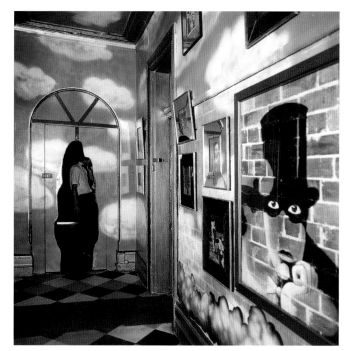

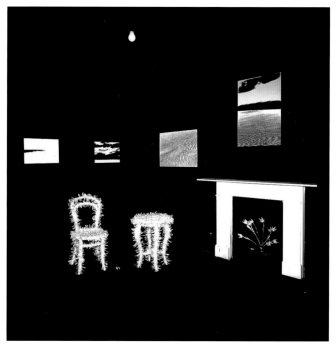

After returning from London in 1969, Martin Sharp established the Yellow House in Macleay Street, Potts Point. This chaotic, fertile creative hub of artists, performers, writers and filmmakers was inspired in part by Vincent van Gogh's dream of an ideal artist's community: 'the name was a tribute to van Gogh. I wanted to carry on his idea of a place in the south of France where artists could work and live together.'[1] The Yellow House was an all-embracing manifestation of the pop sensibility in the city for a short but brilliant time, from 1970 to 1972.

It was at the Yellow House that Sharp began collaborating with Tim Lewis. In 1973 they showed a series of paintings based on an earlier series of collages by Sharp, published in London in 1972.[2] *Art book* was a pocket-sized volume containing 38 'artoons' in which elements of iconic paintings cut from art books and posters were re-configured into witty, often surreal combinations. There was no accompanying text. Those quoted included canonical artists as diverse as Piero della Francesca and van Gogh, Magritte and de Chirico, Hokusai and Duchamp.

Appropriating images for re-use was typical of Sharp's approach to making art: 'I was ... interested in the migration of images ... first there is a painting ... [that] for some reason becomes popular and ... eventually becomes so often reproduced that someone like me can ... reset them in other landscapes, making a new image which then becomes the sketch for a painting'.[3] As with so many of his key themes – such as Tiny Tim, Luna Park and Arthur Stace's 'Eternity' motif – Sharp returned to this work later in life, painting another version in 1999.

Still life 1973 quotes two famous works of art: *Sunflowers* 1888 by van Gogh (Neue Pinakothek, Munich), and Andy Warhol's *Marilyn* series of 1962. The latter quotes another image in its turn, a publicity still of Marilyn Monroe from the 1953 film *Niagara*. The head of Warhol's Monroe, transposed onto a Tate Gallery poster of the van Gogh painting, was a chance arrangement of an iconic pop art image with the work of a revered muse; of all artists, van Gogh was perhaps one of the most important and enduring for Sharp, for both his work and life.

The source works for *Art book* and the related paintings were known to most people through reproduction, and had so permeated popular consciousness to be completely divorced from their original context for most: 'the original images had radiated so far out into the mass culture, that the original colours weren't there anymore, the scale wasn't there anymore, they'd lost their preciousness'.[4] AR

Martin Sharp, Tim Lewis
Still life 1973
synthetic polymer paint on canvas
117 x 91.5 cm (sight)
National Gallery of Australia, Canberra,
purchased 1973

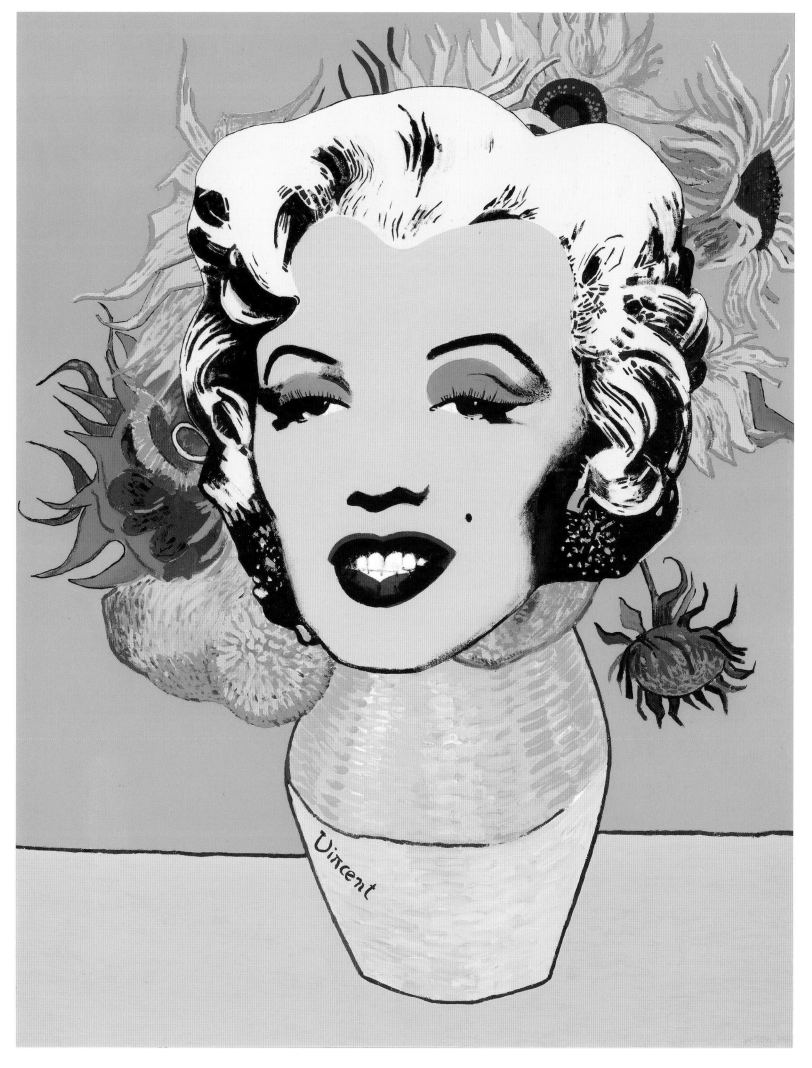

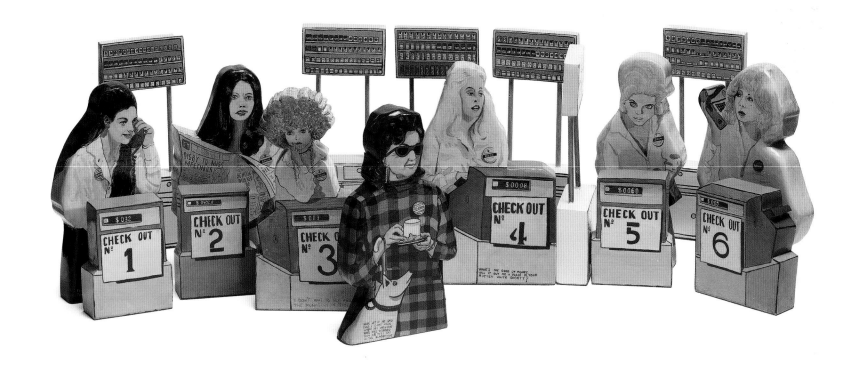

Peter Kingston
The checkout chicks 1976
wood, enamel, felt
28 x 90 x 60 cm (variable)
National Gallery of Australia, Canberra.
Gift of the Philip Morris Arts Grant 1982

Martin Sharp, Tim Lewis
**The unexpected answer
(Yellow House)** 1973
synthetic polymer paint on composition board
182.8 x 116.8 cm
National Gallery of Australia, Canberra.
Gift of the Philip Morris Arts Grant 1982

(opposite)

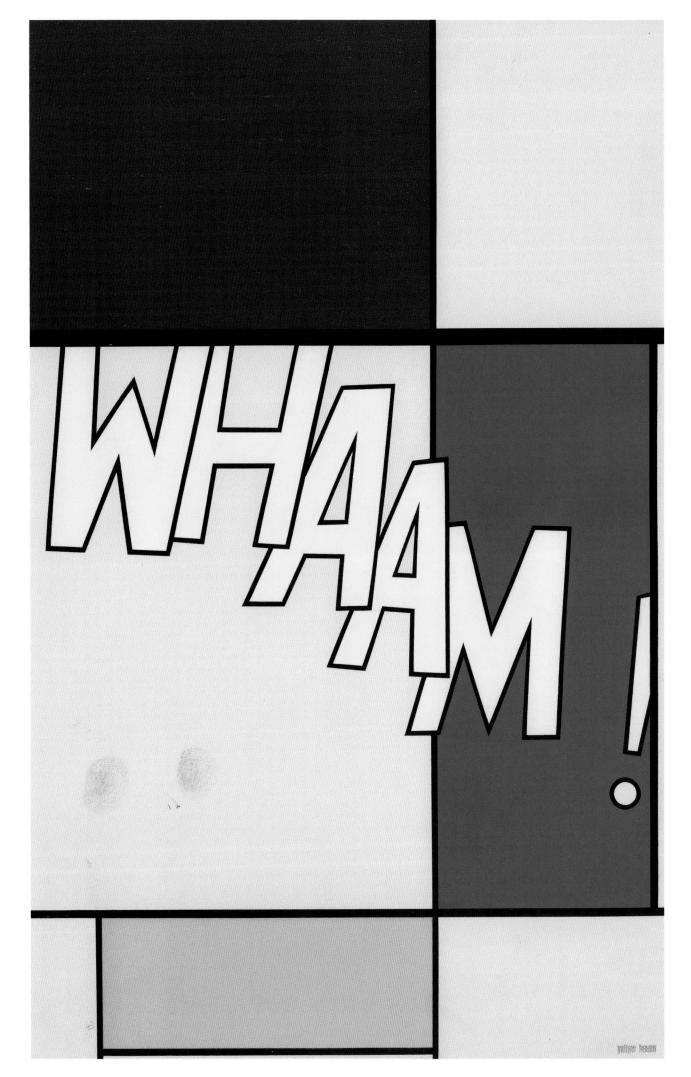

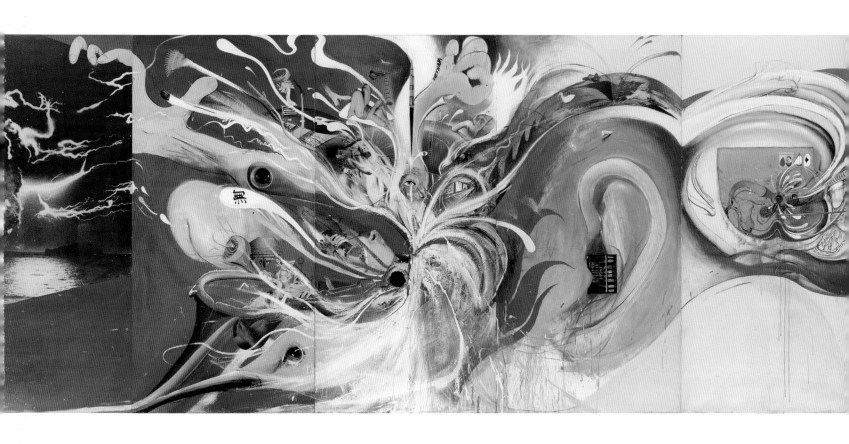

Brett Whiteley
The American Dream 1968–69
18 panels, mixed media on plywood
244.3 x 122.2 cm (a–n); 243 x 122 cm (o);
221 x 122 cm (p); 188 x 122 cm (q–r)
State Art Collection, Art Gallery of
Western Australia, purchased 1978

223

Brett Whiteley's *The American Dream* 1968–69 is a dystopian horror that depicts the disintegration of the American nation in an era of political crisis. His most ambitious work to date, it was Whiteley's clarion call to a society in which he saw 'ribbons of violence squealing from the T.V., [and] the dying capitalism of Bull America debowelling itself'.[1]

In 1967 Whiteley was awarded a Harkness fellowship that enabled him to work in New York. He was initially taken by Manhattan, calling it a 'living sculpture'[2]; however, this optimism was short lived. Deeply disenchanted by the escalation of the Vietnam War and the assassinations of John F Kennedy and Martin Luther King Jr, he determined 'to produce a monumental work of art that would summarise the sensation of the impending necessity for America to own up, analyse and straighten out the immense and immediately seeable MADNESS that seemed to run through most facets of American life'.[3] *The American Dream* was this magnum opus. Touching on the pop predilection for found-object collage, it contains a remarkable pastiche of materials, including oil and enamel paint, pen and ink, crayon, perspex, fibreglass, stuffed birds, valves, radio parts, shark teeth, a clock and a police siren.

The work can be read as a potential course for Cold-War America. An initial lyricism quickly devolves into apocalypse. The convex line of a bird is echoed by a bloody streak that frames a nuclear explosion; a lightning storm is gripped by an ethereal hand; and in the central panel, paint drips like blood and pus around a gaping wound encased by shark teeth. However, respite is found in the thirteenth panel, and a return to Eden is made on tropical shores.

The crisis in *The American Dream* was also autobiographical. 'It was working as a statement of my own existence – which had become violent, helped by drugs and drink and the temperature of New York', Whiteley recalled.[4]

The grand scale and multi-panelled composition of the work resonates with the monumentality of James Rosenquist's *F-111* 1964–65 (Museum of Modern Art, New York) and its Vietnam War subject. However, unlike the dissociative experience Rosenquist achieved by engorging his images, Whiteley relentlessly pursued emotive affect. 'I wanted to shock,' he recalled, 'I wanted people to wake up, to be, in short, transmuted'.[5]

Whiteley's gesture towards American pop during this time was tangential, perhaps academic. In fact, he admired the formalism of Barnett Newman and Mark Rothko, noting that '[Rothko's] paintings issue a strange personal struggle with serenity and agitation'.[6] The two American artists that most inspired him were Richard Diebenkorn and Arshile Gorky.

Perhaps unsurprisingly Whiteley's gallery, Marlborough-Gerson, refused to exhibit *The American Dream*; it was a terrible blow to the artist. 'This painting is a record of a struggle and my inability to resolve it,' he recorded, 'it is an admission of failure'.[7] In 1969 Whiteley abandoned the work and flew to Fiji, enacting the escape from chaos he had foretold. AY

Richard Larter
Big time easy mix 1969
synthetic polymer paint and pencil
on composition board
122.2 x 183.3 cm
National Gallery of Australia, Canberra.
Gift of the Philip Morris Arts Grant 1982

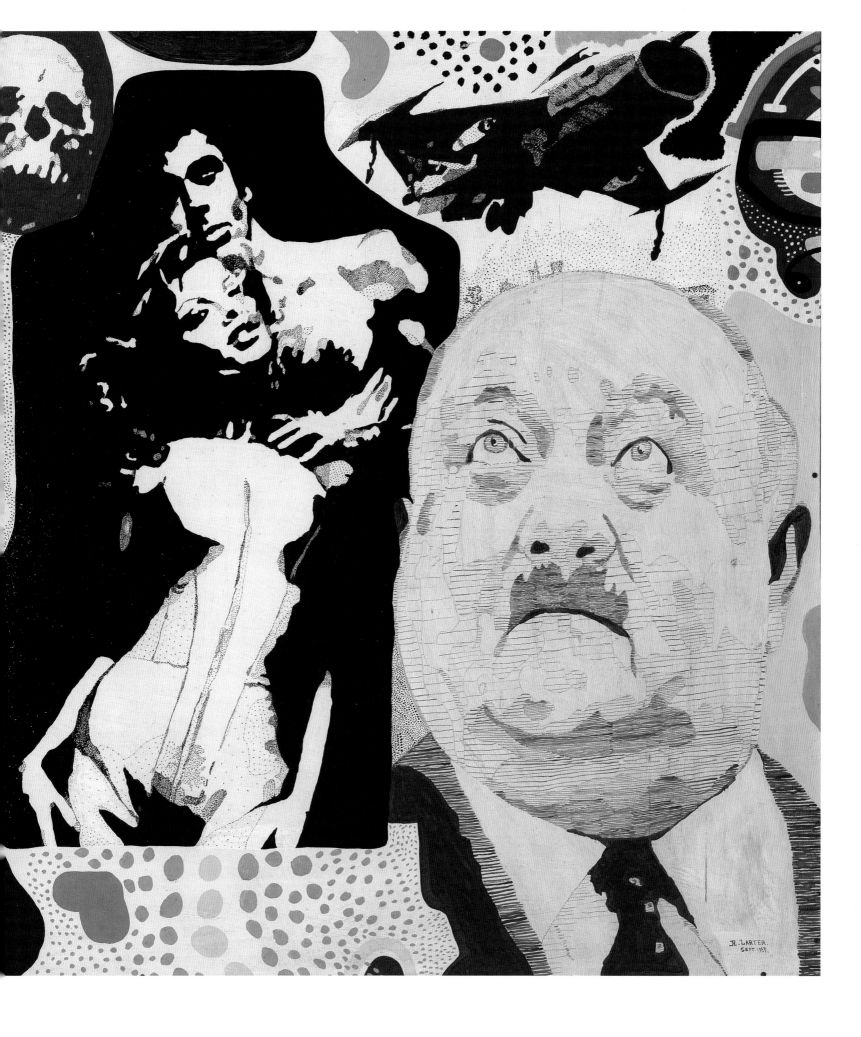

'Bollocks to the old world and its ways,' Richard Larter began one of his self-published bulletins, 'start LIVING in a new exciting prick swinging fashion. Resign from the living-dead.'[1] For Larter, the 'living-dead' encompassed leaders like the Nazi Admiral Karl Dönitz, shown here, and all those who routinely exploited others for their own ideological ends. Larter suspected back in 1975 what has become more widely acknowledged recently with investigations into institutional abuse: that the guardians of public morality are often hypocrites. Against such forces he contrasts the provocative, sceptical and defiant women of *Prompt Careb and how we never learn* 1975: one with her eyes closed and mouth suggestively open at the top of the image, his quizzical wife Pat at the centre, and a Lichtenstein-esque comic book character at the bottom. The title of this work alludes to London's Prompt Cafe, a popular haunt of artists when Larter was young, to a Japanese performer friend and to maxims about people not learning from past mistakes.

Much of Larter's art throughout the highly charged 1960s and 1970s had political content. Art, he believed, 'should be vital, dramatic and didactic – it should change people' and not be 'reserved for the cliquey few'.[2] Yet he agonised over how this could be done, over the question of how art communicates, with whom and for what purpose. The stylistic language he employed in the mid 1970s, borrowing images from printed media and using them in painted collages, was consciously anti-elitist. By the mid 1960s he had abandoned the technique of applying paint with a syringe and begun building up his images using linear hatching, Benday dots taken from comic books and photographic tone drop-out techniques, all of which made his

paintings – by his own admission – 'resemble the more standard Pop art paintings of the time'.[3]

Larter had been exposed to pop art in England during the late 1950s. A significant influence was Eduardo Paolozzi, whose collages based on images taken from magazines made a great impression.[4] Larter made a distinction between his style of 'hot pop', which he described as 'hot line linearity', and 'US cool pop', which was often slick, disengaged and uncritical of the values it promoted through an iconography of advertising and celebrity.[5] 'Rome burns,' he declared, while his generation 'strum their guitars and sing of yellow submarines ... to hell with the whole of pop-commercial culture'.[6] These were unconventional sentiments for a pop artist. While desiring to make accessible and significant art, Larter realised that his art, too, could be manipulated by the status quo or become just another commodity. In 1967 he held a 'non-exhibition' at the Watters Gallery, in protest against the censoring of fellow artist Mike Brown[7], yet he realised that to stop creating was a form of defeat. He issued a challenge to himself and to other artists: 'We must ration our culture: no visual arts for the guilty, no books or plays to napalm loving scum, no music and scientific co-operation for ... death-oriented politics.'[8] SM

Richard Larter
Prompt Careb and how
we never learn 1975
synthetic polymer paint on canvas
183.2 x 133 cm
Art Gallery of New South Wales, Sydney.
Visual Arts Board Australia Council
Contemporary Art Purchase Grant 1975

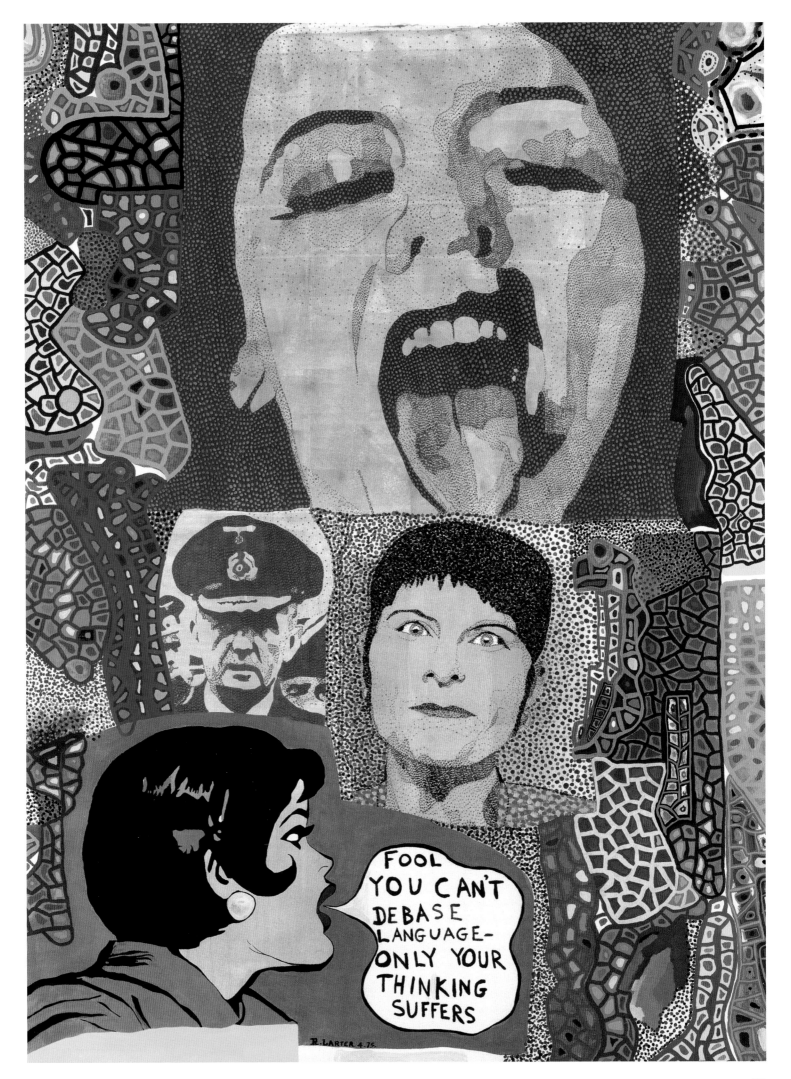

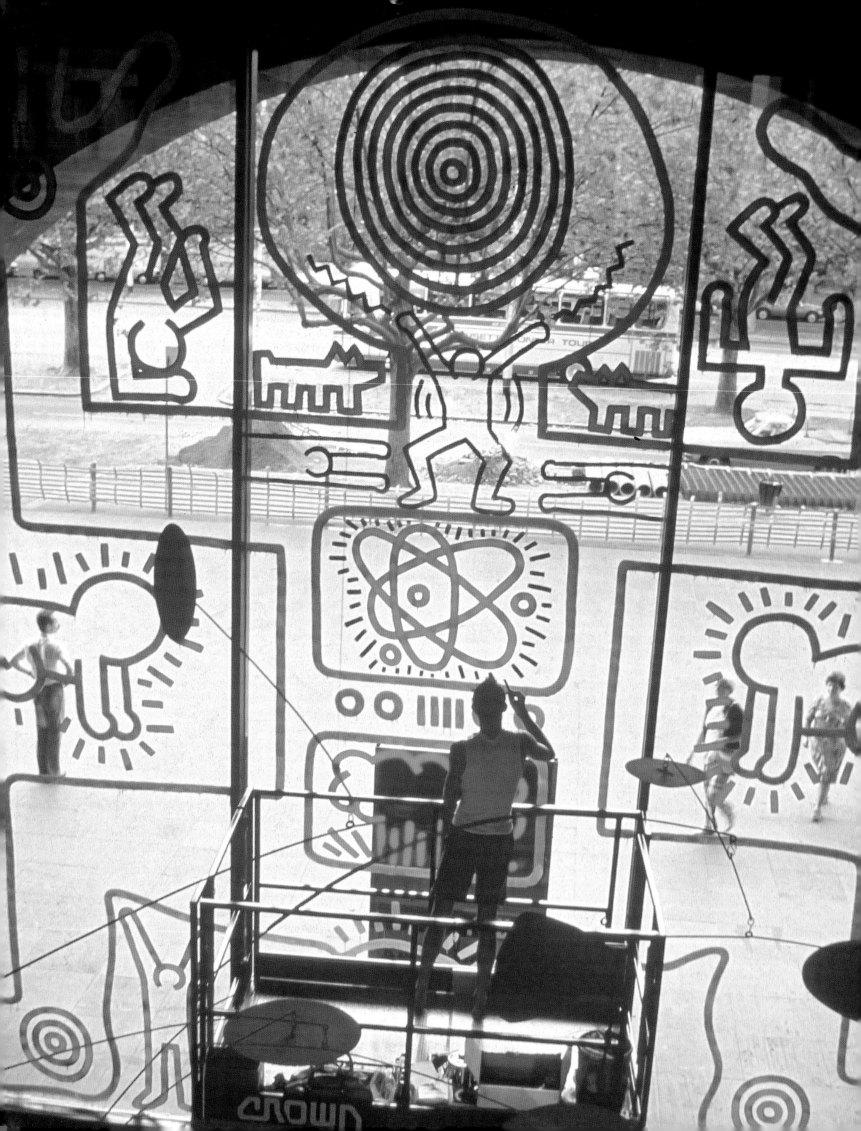

Anneke Jaspers

ART OF THE SECOND DEGREE

POST POP AND POPISM

At the end of the 1970s, pop art's trademark strategies resurfaced in the work of a younger generation of artists. The social and creative volatility of the preceding years lingered in the air, and nascent theories of postmodernism were building momentum, bringing the effects of a media-saturated culture and accelerated consumerism sharply into focus. For artists emerging within this context the devices of appropriation and simulation, and the entanglement of 'high' and popular forms of expression held fresh currency. This impulse marked a wilful departure from the minimal, conceptual and experimental practices that had dominated the decade, while shrewdly absorbing a number of their lessons into an aesthetic that was responsive to the times.[1] The return to a pop idiom also revived the question of pop art's critical potential, given its conventions had been thoroughly re-assimilated into the domain of commodity culture, as had the 'utopian promise' of the countercultures that followed in its wake.[2]

In Australia, the rise of a post-pop sensibility was affirmed by the exhibition *Popism* at the National Gallery of Victoria (NGV) in 1982, curated by the precocious art historian and critic Paul Taylor.[3] The show rallied a diverse group of practitioners engaged with amateur media and what Taylor termed the 'rhetoric of photography', signaling a series of conceptual concerns – mediation, artifice, fragmentation and reproducibility – rather than a strict basis in modes of mechanical reproduction. Polaroids and Super-8 films were shown alongside paintings, drawings, installation and performance. Significantly, the selected artists were further distinguished by their use of borrowed imagery and other pop-cultural fragments, from music clips to printed text. The effect of these intersecting tendencies, Taylor declared, was an art that 'layers meanings on old meanings … is endlessly copying and which offends the modernist canon of authenticity'.[4]

The artists clustered under the banner of *Popism* reflected the convergence of art and music that was a definitive feature of the moment. At one end of the spectrum were Richard Dunn, Robert Rooney and Imants Tillers, whose coolly analytical, post-conceptual painting practices were deeply invested in questions of image making and belonged to the gallery context. At the other end were artists working in media and performance who were embedded in the experimental music scene, amongst them David Chesworth, Paul Fletcher and Ian Cox. The rich and unruly middle ground was marked by a fluidity that is difficult to schematise. Howard Arkley and Juan Davila pursued animated, provocative painting styles that referenced suburban and pulp aesthetics respectively. Jenny Watson, Peter Tyndall and John Nixon (of The Society for Other Photography) traversed disciplinary margins, bringing their engagement with punk music to bear on an anti-aesthetic approach to painting and, in the case of the latter, sound work. Members of the collective →↑→ – which included Philip Brophy, Ralph Traviato, Jane Stevenson and Maria Kozic – also moved readily across contexts and mediums, from performance to film and installation, broadly taking their lead from the irreverent cover and remix strategies of disco.[5]

Popism was a provocative enterprise. Some critics vehemently dismissed the exhibition as contriving a 'false unity' between these threads of practice and as lacking a cohesive critical argument.[6] But ultimately Taylor's premise shaped the discourse on contemporary art in Australia for years to come. Notably, a concurrent exhibition curated by Judy Annear at Melbourne's George Paton Gallery, *Art in the age of mechanical reproduction*, contributed to this new theoretical orientation.[7] Riffing on Walter Benjamin's seminal essay of the 1930s, Annear's project considered the escalating influence of reproductive technologies and their effects on contemporary art.[8] There was significant crossover with the artists in *Popism* and the show negotiated comparable themes: appropriation and pastiche, repetition, mediation, and relative meaning. Taylor's additional emphasis on mass and pop culture relations arguably struck a deeper chord though, as the critic Rex Butler has noted, it was his subsequent alignment of appropriation art with the question of Australian identity that cemented popism's 'rhetorical charge'.[9]

Popism was essentially a vernacular expression of the 'new wave' subculture that was evolving out of the Euro–American punk scenes. The year prior to the NGV exhibition, Taylor laid the groundwork for this appraisal in an article penned for the first issue of *Art & Text*, a local journal of which he was the founding editor. Inserting visual art into a discourse that had predominantly focused on music, fashion and design, Taylor charted new wave's engagement with mass-produced popular culture from the past – particularly the 1960s – as a source of styles to be superficially scavenged and redeployed in the contemporary context's endless flow of signs and effects.[10] This approach was indebted to the tactics that emerged postwar in the form of mod, camp and punk styles, where individuals 'détourned' commodities and everyday practices as expressive markers to distinguish themselves from the mainstream.[11]

The affinity of new wave artists with dislocated cultural signs and styles prompted Taylor to famously describe their aesthetic as 'second degree'.[12] This concept then shadowed discussions on locality – now well rehearsed – that re-emerged in the Australian art world during the early 1980s with vigour. Challenging the cultural hierarchy of centre and periphery so mordantly described by Terry Smith in his 1974 article 'The provincialism problem', a new set of arguments pointed to the distinctive repercussions of Australia's geographic isolation.[13] Imants Tillers was a decisive voice, declaring that simulation was 'the quintessential quality of Australian life and culture', a culture contingent on imported reproductions and fundamentally estranged from the aura and materiality of originals.[14] Taylor, in turn, framed Australia as a 'media colony', fated to consume international orthodoxies through second-hand channels.[15] Both argued that the cultural circumstances of the early 1980s were ironically sympathetic to this antipodean bind: the inherently mediated, unoriginal logic of (white, urban) Australian art exemplified the postmodern condition.[16] This radical inversion of Australia's marginal cultural status was neatly mirrored in Taylor's mythologising claim that its art 'has gestated within the camera where things are naturally upside-down and is expressed in a carnivalesque array of copies, inversions and negatives. It is an ab-original, soulless, antipodal reflection with a name written on every stone.'[17]

Popism was thus symptomatic of an art 'born in mediation'[18], but it addressed these circumstances reflexively, knowingly trading in cover versions, counterfeits and displaced sources. Its typically un-expressionist character was widely read in opposition to the neo-expressionist styles of painting that were garnering considerable traction in the local context, as elsewhere, in the early 1980s. Where the rhetoric surrounding Australia's appropriation artists celebrated their peripheral relationship to the 'centre', the market and the mainstream, the local resurgence of figurative, expressionistic painting was geared toward staying in step with these forces. The exaggerated sincerity and metaphoric thrust of such work was certainly in stark contrast to Taylor's claim that popism was an art 'without hidden meanings' or 'social purpose', an art with 'no depth to be probed'.[19]

Taylor himself noted, as did others at the time, that this binary was in some ways contrived.[20] The international trans-avantgarde aesthetic was founded on the retrieval of regional historical styles – a conceptual gesture of pillaging and reiteration that found parallels in new wave art. It was more the humanistic ethos of such painting that the popists rejected, its private symbolism, emphasis on gesture, and claim to a raw, direct authenticity.[21] Like its pop precursors, popism tended to deflect attention away from the artist's subjectivity to the cultural context: its modes of mass production and reception, popular forms and intrinsic values. In addition, the question of how images (and other cultural fragments) were encountered and 'read' by the viewer was newly important; often works functioned as a meta-critique of meaning making.

Even so, there were clearly divergent intentions at play in the use of appropriation and relationships to content. As Philip Brophy reflected at the time, 'not all so-called "image scavengers" operate along strict lines of theft: some embrace their images, some are seduced by them, some analyse them, some pervert them'.[22] This slipperiness tended to be obscured by the strategic emphasis of Taylor and commentators like Adrian Martin on the ironic, detached, apolitical surface of popism.[23] Such a slant aligned a 'depthless' aesthetic with the emptiness of the commodity fetish and the simulacral image, alienated from its origin through reproduction. However, the works themselves provide a counterpoint, at times revealing affective and personal dimensions and often, deeply interrogative modes of inquiry. Perhaps more interestingly, a certain antagonism between these various attributes is frequently played out.

We see this, for instance, in Juan Davila's vast, phantasmagoric paintings of the period, in which references to art, history, politics, literature, comics, psychoanalysis and gay pornography jostle side by side. Many of these render the post-pop impulse literally, citing fragments from the canon of classic pop art, which are then juxtaposed with (or implicated in) brazen homoerotic narratives with Freudian connotations. To be sure, Davila's scenes are all veneer: a textual play of signs that contaminate the domain of high art with the promiscuous and popular. Yet his desire to radically transgress entrenched political and pictorial frontiers is aggressively clear. Elsewhere, an affective dimension can be discerned in Jenny Watson's *Painted pages* series of 1979–80, which stages a sophisticated and self-critical collision of painterly styles. Each of the canvases imitates the printed format of mass reproductions and Watson conspicuously foregrounds the mediated status of her quoted sources through the inclusion of margins, spines and page numbers. Nevertheless, the series also reflects how the popular media functions as a register for historical events – including the wax and wane of subcultural styles and icons – with subjective and, particularly, mnemonic resonances.

The paintings of both Watson and Davila invoke that order of compressed, homogenised visual experience engendered by the printing process and the studio work surface, influentially described by the critic Leo Steinberg as the 'flatbed' effect.[24] This hallmark of postmodern image making echoes through the works of Watson's popist peers aligned with the alternative Melbourne gallery Art Projects, who were equally invested in a post-structural critique of representation and meaning making. For Peter Tyndall this involved a programmatic analysis of the act of looking, through the depiction of scenes that allegorise cultural production and consumption. Richard Dunn, on the other hand, offered a riposte to the 'anything goes' attitude associated with bricolage by treating the sequencing, cropping and juxtaposing of quoted imagery as a source of information to be decoded by the viewer. Brophy later made the significant observation that Dunn's approach, along with that of Imants Tillers, in fact reflected a sophisticated 'mutual appropriation' and critique of both popism and trans-avantgardism.[25]

Popism underscored the synergies between such deconstructive visual art practices and those flourishing at the experimental edge of Melbourne's punk and new wave music scenes. The Clifton Hill Community Music Centre and the Crystal Ballroom in St Kilda were hotspots for these small communities, where outfits like Essendon Airport – which included David Chesworth, Ian Cox and Paul Fletcher – and →↑→ were presenting work that bridged theory and entertainment. Their use of citation was self-conscious and subversive: musical styles were plundered from the archive of recent history, distilled, repeated and mutated in a process that exposed the structural conventions of different genres. Relationships between action, image and sound were also explored through film or the mechanics of performance. For instance, in *What is this thing called 'disco'?* 1980, members of →↑→ lip-synched and mimed to a slowed down pre-recording of their act in a cool critique of disco's inherent artifice and simulation. One critic memorably labelled the group 'the God children of Andy Warhol', a title particularly apt for collective member Maria Kozic, whose solo work persistently channelled, and at times directly quoted, Warhol's oeuvre.[26]

Indeed, Warhol's legacy was the very foundation of the post-pop turn. In a gesture of homage, Taylor lifted the term 'popism' from the title of Warhol's memoir of the 1960s, articulating a debt to classic pop and Warhol's exhaustive exploration of the 'second degree', while amplifying the definite rupture in attitude and context.[27] Years later, in a poignant coincidence after Taylor had relocated to New York, he was the last person to interview Warhol before he died in 1987 – the event that bookends *Pop to popism*. Warhol's late practice in the 1980s was also pivotal to Taylor's premise. By this stage he had begun to re-appropriate his own archive of already-pilfered images in the *Reversal* and *Retrospective* series 1978–79 by printing earlier archetypal works flipped or in the negative, and sometimes collaging their base elements into disorderly, anthology-like compositions.

Warhol's *Reversal* series deftly evokes the spectral character of the simulacrum, but perhaps more significantly, it addresses the 'conversion of idiom into cliché' that transpired once pop art had been fully embraced by popular culture.[28] Roy Lichtenstein similarly broached this process of recuperation in his *Artist's studio* series of 1973–74, by inserting a copy of his own *Look Mickey* 1961 into one composition, and various elements that inferred (without definitively citing) his earlier works in others: a mirror, a stack of cups, an architectural entablature and so on. In Australia, only Robert Rooney had a hand in the periods of both classic and post-pop, and he too bridged these eras by self-referencing earlier work. Rooney's suite of screenprints *Pilkington predicts* 1982 (National Gallery of Australia) – one of which was exhibited in *Popism* – were enlargements of advertisements he had produced in the early 1960s for a glass company, though his most significant popist works were paintings that revisited the wartime imagery of his childhood, quoted from secondary sources.

Crucially, Warhol's New York scene in the late 1970s and 1980s was a broader point of reference for Australian thinkers and artists engaged with postmodern ideas and a reinvigorated pop aesthetic. The influence of *October* journal – then the foremost English-language platform for postmodern theory – was unequivocal, in particular its robust emphasis on the work of continental post-structural philosophers, such as Roland Barthes and Michel Foucault, which was becoming accessible in translation. Tellingly, in the extensive bibliography appended to the *Popism* catalogue, Taylor cites a series of formative *October* essays by Douglas Crimp and Craig Owens, which navigate the postmodern affront to notions of authorship, originality and aura by way of 'the photographic'.[29] These texts were, at least partially, an attempt to contextualise the work of a group of artists making waves in the New York scene, who later became known as the 'Pictures Generation'.

Like the popists, the Pictures artists had come of age during the era of rampant postwar consumerism and were natives of its entwined media culture. Their work was absorbed with the seductive and alienating effects of images, opening out the operation of film and television, advertising and magazines to intense intellectual critique. Cindy Sherman's finely staged *Untitled film stills* of the period are among the movement's most emblematic examples. Showing the artist in a seemingly endless number of guises that mimic popular feminine stereotypes, these heavily codified photographs demonstrate how the deferral of 'originality' under postmodernity and the constructed nature of identity are mirrored in media fictions.[30] Of the key Pictures protagonists, Sherman's character impersonations, Barbara Kruger's slogan-bearing photo-montages, and Richard Prince's impassive quotations re-photographed from advertisements had a notable presence in Australia during the 1980s.[31]

Art & Text was the key locus for discussions of postmodernity in the local context. While it clearly looked to the model of *October*, under Taylor's early editorship the journal also established a broader remit that spanned the more established discourses of so-called French theory and ideas emerging in the field of cultural studies. Hence, alongside the work of a diverse cohort of Australian writers, the first English translations of key texts by postmodern theorists such as Jean Baudrillard and Jean-François Lyotard were published in its pages, generating significant cachet for the journal internationally (and Baudrillard cult status locally).[32] Moreover, the journal reflected a new wave ethos: analysis of music, film and literature featured alongside texts dedicated to visual art. Popism was further contextualised by articles that discussed the work of its international counterparts, including Sherman and Kruger; other New York artists, such as Keith Haring, who presented a number of projects in Australia in the mid 1980s[33]; and those working with related ideas in Britain and Europe, like Gilbert & George.

Haring's practice reflects a strand of post-pop art that worked beyond a photographic vernacular, drawing instead on the energy and graphic sensibility found in street culture. His distinctive style mingled the languages of commercial graphics, tribal art and graffiti, and his early works were executed in the urban environment, like those of his affiliate Jean-Michel Basquiat, who hailed from the graffiti scene proper. In Australia their aesthetic found a parallel in Howard Arkley's restless airbrushed canvases, which included dense accumulations of suburban iconography and garish patterning quoted from domestic sources. As an extension of his art practice, in 1986 Haring opened the Pop Shop in New York's SoHo district and began selling merchandise emblazoned with his imagery, a gesture not unrelated to the cannibalising impulse in Warhol's late works.[34]

But where Haring embraced the total dissolution of art into popular culture, this was arguably a source of niggling friction in other post-pop work that sought to retain a critical distance in order to deconstruct its operations. In popism, for instance, the primacy of painting meant an unavoidable recourse to the production of singular, original, auratic objects. And elsewhere, Owens noted the 'impossible complicity' of work by Sherman and other Pictures artists engaged with strategies of mimicry and simulation, who were inevitably participating in the forms of spectacle they sought to expose.[35] Taylor echoed this sentiment in the wake of *Popism*, remarking that upon viewing the show installed, he felt it 'was almost describing rather than deconstructing the order of meaning' it set out to critique.[36] Of course, some artists thematised precisely such tensions, none more blatantly than Jeff Koons, whose sculptural installations of the period co-opted readymade commodities like vacuum cleaners and basketballs seamlessly into the domain of high art, inverting the logic of Haring's Pop Shop.

In the face of such postmodernist endgamism, by the mid 1980s the energy around post-pop appropriation had begun to wane. In Australia in 1985, the major exhibition *Pop art 1955–1970* toured from New York's Museum of Modern Art to a muted response.[37] This apathy foreshadowed the imminent dispersal of popism's main players along divergent lines of inquiry, from emotionally charged identity politics to an emphatic reinstatement of 'first degree' expression, which was sympathetic to the market. Nevertheless, the legacies of pop art and its postmodern iterations are evident everywhere today. At a time when the monetising and mediation of daily life continues unabated, and when the margins between so-called high and low culture are ever more indistinct, aspects of pop's ideology remain relevant, even if the aesthetic language to explore such ideas has continued to evolve. Evidently, Taylor's last words in his *Popism* manifesto now seem decisively prescient, well over half a century after pop art first emerged: 'Labelled as a *movement* in art, Pop easily becomes orthodox. As a *type* of art, "Pop" is always with us.'[38]

Andy Warhol
Mona Lisa c1979
acrylic and silkscreen ink on canvas
203.2 x 254 cm
The Andy Warhol Museum, Pittsburgh.
Founding Collection, Contribution The Andy
Warhol Foundation for the Visual Arts Inc

JENNY WATSON
A painted page 1: Twiggy by Richard Avedon 1979

An iconic image epitomising 1960s fashion and popular culture forms the basis for Jenny Watson's enigmatic work *A painted page 1: Twiggy by Richard Avedon* 1979. The image presents the model Twiggy – embodying the zeitgeist of 1960s youth culture – captured by the leading fashion photographer of the era, Richard Avedon. Produced for a 1967 issue of *Vogue*, the image emanates from a 'strategically manufactured environment of hyper-contemporaneity'.[1]

Watson appropriated the image from a book surveying fashion, in which it was reproduced; imported into her work, the image is dislocated from its original context. It is subsumed by a grid structure – transposed by the artist one unit at a time – and anchored to a corner of the canvas. Within the grid each square is treated as an autonomous unit: painted with distinct brushstrokes and tonal variations, each square is discrete from those adjacent to it. Revealing the artist's process, this visual device purposefully fragments and interrupts the image, emphasising the surface and composition of the painting. Accordingly, the subject of the work shifts: it is no longer Twiggy, nor the photograph of her that is the subject, but rather representation itself.

Beyond the image of Twiggy, the remaining canvas is painted mustard green. Thickly applied with painterly brushstrokes, the visual weight of this expansive colour plane is equal to that of the black-and-white image. The work appears as an amalgamation of styles – pop, minimal, photorealist – yet it is ultimately underpinned by a photographic way of seeing.[2] It not only adopts the subject of fashion and popular culture, but also its structure: the visual language of photomechanical reproduction.

Emulating the 'all-over textual and pictorial field of the printing plate', the work points to the artist's acute awareness of image construction.[3]

Watson's work is further distinguished by its diaristic and autobiographical nature, reflecting on the artist's personal memories. In this vein Twiggy, an icon of Watson's youth, represents an empowered young woman, transcending and rewriting notions of femininity.[4] Watson's feminist sensibility – exemplified by her involvement with the Women's Art Movement of the 1970s – is also manifest in her choice of 'girly' colours, rather than 'official serious art colours' in her *Painted pages* series 1979–80: a resolved stand against the male-dominated old guard of Australian art and the monolithic, masculinist language of high modernism.[5]

A painted page 1: Twiggy is the first of the *Painted pages* series, which was shown at the Institute of Modern Art, Brisbane, in June 1980 under the exhibition title *6 paintings 1979–80*. Similar in compositional structure, the works are based on a selection of printed pages drawn from newspapers, books, catalogues and magazines. They share the same base title, *A painted page*, with the remaining title component identifying the source from which each page is drawn. *Twiggy* was also included in Paul Taylor's exhibition *Popism* at the National Gallery of Victoria in 1982, which marked a new sensibility in Australian art, characterised by a postmodern approach to popular culture, pop art and appropriation. JW

Jenny Watson
A painted page 1:
Twiggy by Richard Avedon 1979
oil on canvas
105 x 153 cm
National Gallery of Victoria, Melbourne.
Michell Endowment 1982

Jenny Watson
**A painted page: pages 52 and 53
of "In the gutter" (The ears)** 1979
oil on canvas
162.5 x 178 cm
Collection of The University of Queensland,
purchased with the assistance of the Visual Arts
Board of the Australia Council, 1981

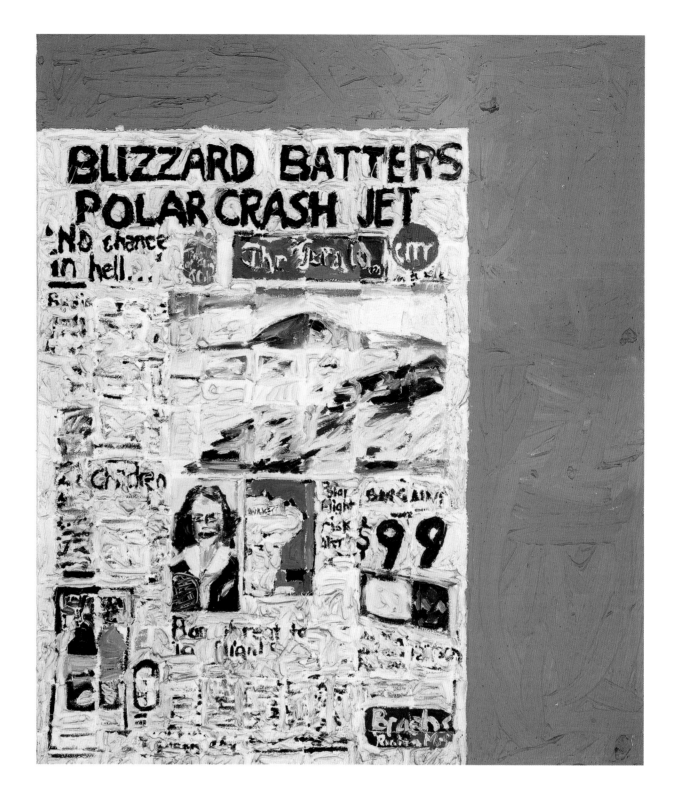

Jenny Watson
**A painted page:
the Herald 21/11/79** 1979–80
oil on cotton duck
60 x 76 cm
Courtesy of the artist and
Anna Schwartz Gallery

Imants Tillers
White Aborigines 1983
oil stick and synthetic polymer paint on canvas
254 x 381 cm
Museum of Contemporary Art. Gift of Loti
Smorgon AO and Victor Smorgon AC, 1995

Peter Tyndall

Title detail
 A Person Looks At A Work Of Art/
 someone looks at something...
 LOGOS/ HA HA

Medium A Person Looks At A Work of Art/
 someone looks at something...
 CULTURAL CONSUMPTION PRODUCTION
Date - 1985–87 -
Artist Peter Tyndall

synthetic polymer paint on canvas,
wood frame, plastic coated wire
340.4 x 243.4 cm (installed)
National Gallery of Victoria, Melbourne,
purchased from Admission Funds, 1988

Richard Dunn
Relief picture and figure 10 1981/2010
oil and acrylic on canvas, diptych
170.2 x 460.8 cm
Private collection

Figure 10

ational bridge from the known to the radically unknown, from a iven context of understanding to a changed context of understanding.

Miss Sigmund 1981 epitomises the iconography, themes and methods central to a series of radical, visually arresting paintings Juan Davila produced between 1979 and 1981. It emanates from a pivotal point in Davila's career, characterised by critical recognition and popular interest, and punctuated by moments of political controversy associated with the visually and conceptually confronting nature of his work and its overtly sexualised nature.[1]

Presented in a comic-strip format, *Miss Sigmund* is intended to be 'read' visually by the viewer[2], emphasising their role in the production of meaning within particular socio-political and historical contexts. Its mechanisms for constructing meaning are manifest through a series of carefully selected and deliberately presented visual cues. Stencilled text, reminiscent of cargo labels, acts as a narrative device, suggesting the elaboration of meaning. It seemingly identifies characters (Marilyn and Sigmund); spatio-temporal transitions ('Meanwhile ...'); and dialogue ('Miss Sigmund is sorry ...'). The dialogue evokes Col Porter's 1934 song 'Miss Otis regrets' which describes the lynching of a high-society woman, subverting conventional notions of race, class and gender associated with such violence.[3] The song was composed when awareness of lynching was widespread in the United States of America, with a federal anti-lynching bill being lobbied in an attempt to curb racist persecution. The horror of this dark history – and indeed Miss Otis's demise – is ostensibly echoed in the blood-red finger markings on the naked female figure in the lower-right corner of the work.

The background of *Miss Sigmund* is formed by a photographic plane overlaid with an arrangement of painted and collaged image fragments. Elements are grafted together to form a heterogeneous whole, problematising conventional media categories. These elements reference key pop works, such as Valerio Adami's *S. Freud in viaggio verso Londra (S. Freud on his way up to London)* 1973 (Fondation Margeurite and Aimé Maeght, Saint-Paul), Richard Lindner's *L'As de Trèfle (Ace of clubs)* 1973 (private collection) and Tom Wesselmann's *Great American nude no. 99* 1968 (Morton G Neumann Collection, Chicago), as well as Andy Warhol's Marilyn Monroe screenprints and a stiletto shoe motif derived from Allen Jones. A homoerotic male figure is appropriated from Tom of Finland; clad in black leather, his muscular build is also aligned with that of a comic-book superhero. These visual quotations are indexed by surnames within the work, in a manner that makes their origin transparent, parodying notions of authorship and originality, as well as the art-historical tendency to identify and categorise.

While the work's pornographic subject matter may be considered confronting, it is ultimately the act of combining erotic imagery with 'high art' that offends societal and cultural norms, and moreover acts to disrupt their very foundation. It enunciates Davila's view that the strength of art is its power of eruption: its destruction of traditional cultural constructs and its creation of new possibilities.[4] Along these lines, the work points to the impotence of painting – conveyed by the painter's drooping brush – and acts to fracture the myths of Australian identity and history fostered by this genre. It undermines distinctions between high and low culture, form and content, and the original and the copy: a postmodern approach acknowledged by the inclusion of *Miss Sigmund* in Paul Taylor's 1982 exhibition *Popism* held at the National Gallery of Victoria. It is this breakdown of conventional classifications and negation of final closure that Davila's work has at its core.[5] JW

Juan Davila
Miss Sigmund 1981
synthetic polymer paint on
photographic mural paper on canvas
200 x 260.5 cm
Queensland Art Gallery, Brisbane,
purchased 1991 with funds from the
1990 International Exhibitions Program

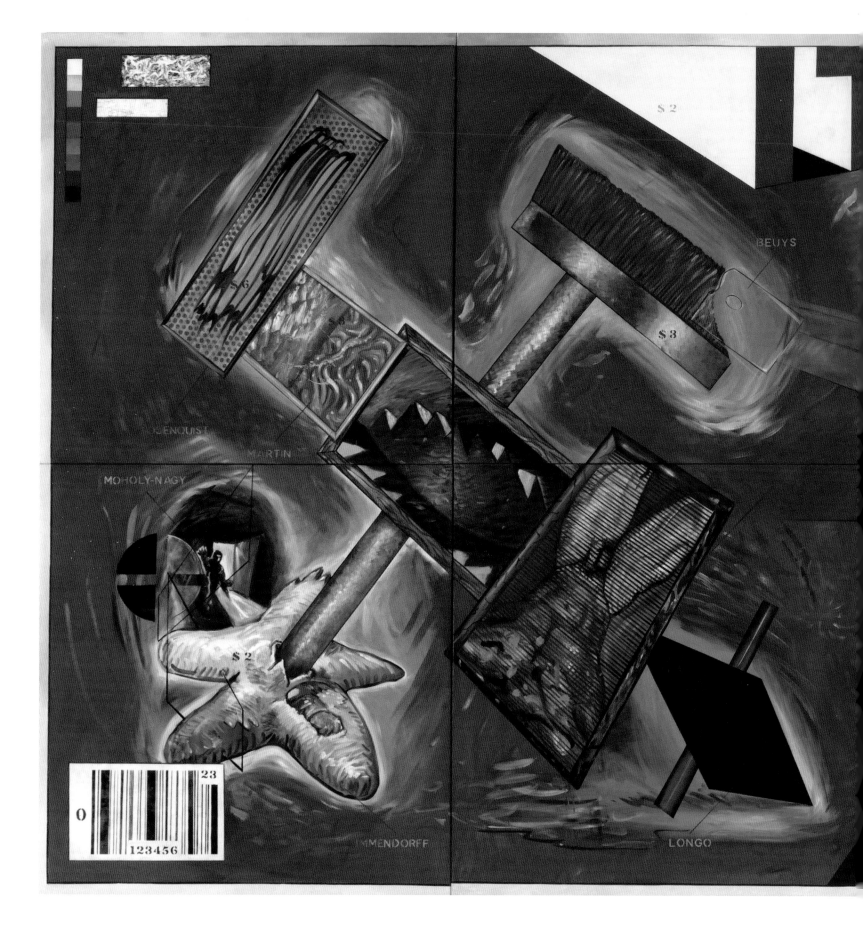

Juan Davila
Neo-pop 1983–85
oil on canvas
4 panels: 273.9 x 547.7 cm (overall)
Art Gallery of New South Wales, Sydney,
purchased 2003

252

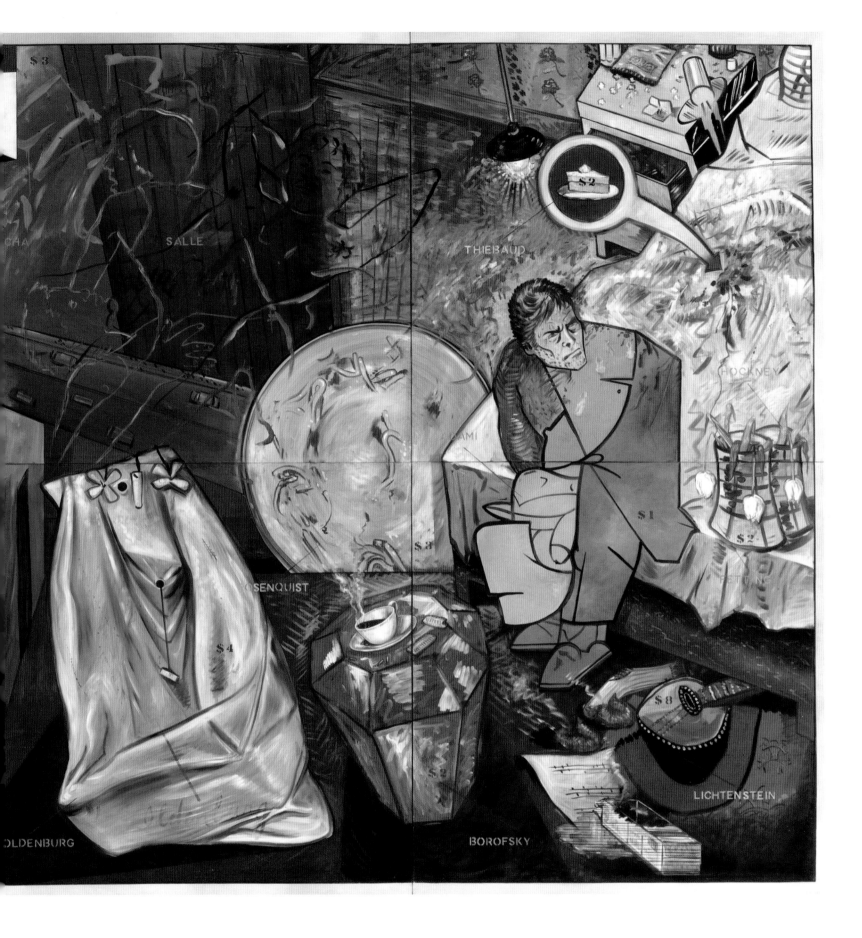

CINDY SHERMAN
Untitled 1982

Cindy Sherman uses her body to explore notions of identity by assuming different characters through the use of costume, make-up and role play. Sherman's photography-based oeuvre rejects the idea of a fundamental self – to which the historical idea of (male) artist is implicitly tied – in favour of a mutable (female) identity. This is evident in Sherman's early black-and-white series *Untitled film stills* 1977–80, in which the artist frames herself in the role of numerous familiar but unidentifiable female movie characters. Sherman's quasi-realistic 'stills' show the artist performing representational tropes of femininity. No one film is referenced, but the conventions of film are employed to suggest the limited roles dominant culture assigns women. Sherman asserts a certain equivalence or replaceability of her characters, self-consciously undermining the notion of artistic authorship as well.

This line of inquiry continues into Sherman's later, larger colour works. In the photograph

Untitled 1982 Sherman embodies the character Marilyn Monroe – superstar, bombshell and ultimate male construct – whose own image was likewise a product of a certain type of performance. The result is an atypical image of Monroe. Somewhere between a figure of female strength and vulnerability, it is difficult to tell whether her facial expression is one of desire or anguish. Sherman depicts Monroe in a defensive posture, crouched on the ground. However, her trousers, work shirt and flat ankle boots suggest this Marilyn is agile, less constrained than the customary dress and heels would make her. The sense of movement captured in this still photograph is notable given the subtext of cinema and that most portraits of Monroe show her as highly poised.

Sherman's photograph inevitably recalls Andy Warhol's pouting *Marilyn Monroe* 1967, arguably his most famous series of screenprints. Warhol's celebrities are reduced to graphic,

defining features and a limited, vivid palette. Though formally very different and separated by 15 years, Sherman's *Untitled* acknowledges Warhol's lineage, tacitly embedding his image of Marilyn in her own and multiplying the character yet further. The star's death in 1962 underscored the Warhol work and, 20 years later, Sherman's version also reads as a comment on the morbid side of the movie industry.

Photography is the medium par excellence to juggle with these multiple layers of reference and subjectivity. Being photographed, being seen by others, becoming image is key to the way in which pop culture functions. Without circulation, alteration and revisitation, there is invisibility. By incorporating these considerations into both the form and content of her work, playing with what art historian Abigail Solomon-Godeau calls the 'pregiven in visual systems'[1], Sherman performs not one subject but many. EW

Cindy Sherman

Untitled 1982
chromogenic colour print
50.8 x 40.6 cm (image)
Courtesy of the artist and
Metro Pictures, NY

Untitled #113 1982
type C photograph
114.3 x 75 cm (sight)
Art Gallery of New South Wales, Sydney.
Mervyn Horton Bequest Fund 1986

(opposite from left)

Cindy Sherman

(above left, from top)

Untitled film still #3 1977
16.1 x 24 cm (image); 30.4 x 35.4 cm (sheet)

Untitled film still #50 1979
16.4 x 24 cm (image); 30.4 x 35.4 cm (sheet)

Untitled film still #52 1979
16.1 x 24 cm (image)

gelatin silver photographs
National Gallery of Australia, Canberra,
purchased 1983

(above right, from top)

Untitled film still #35 1979
23.3 x 16.2 cm (image); 25.3 x 20.3 cm (sheet)

Untitled film still #46 1979
17 x 23.2 cm (image); 20.3 x 25.3 cm (sheet)

gelatin silver photographs
Art Gallery of New South Wales, Sydney.
Mervyn Horton Bequest Fund 1986

Richard Prince's *Untitled (cowboy)* 1980–89 is a manufactured fantasy that sells the romance of the American frontier. Like the pop artists of the 1960s, Prince appropriates images from magazines. In this work, re-photographed from a cigarette advertisement, he explores the seductive strategies by which advertisements arouse the desires of their viewers.

Prince's fascination with advertising began in the 1970s when he worked for Time-Life, clipping and filing articles from periodicals. There, amongst the images on the cutting-room floor, he identified parallels in composition and style that inspired him to investigate the visual language of advertising. In 1977 he began to re-photograph magazine advertisements, cropping their accompanying text and branding to create images that were slightly altered.

Prince began his *Cowboy* series in 1980, taking as his subject the Marlboro Man – an icon of American masculinity created in 1954 by advertising giant Leo Burnett to rebrand Marlboro's filtered cigarettes, which were until then marketed exclusively to women. In *Untitled (cowboy)* the Marlboro Man is captured galloping on horse with lasso in hand, against a looming, cloud-filled sky – he is reframed as a pioneer within a sublime American landscape.

The photograph does not simply comment on the power or morality of advertising. Rather, it speaks to the desires of the American imagination itself – to the masculine self-image embodied by the free will of the frontier spirit, to the pop-cultural power of John Wayne, Clint Eastwood, Charles Bronson and their predecessors in pulp fiction, to the bullish political conservatism of 1980s Reaganism.[1]

Prince's practice raises issues of authorship that run counter to the modernist belief in the uniqueness of the art object. He described re-photographing as a 'technique for stealing (pirating) already existing images, simulating rather than copying them, "managing" rather than quoting them', drawing comparisons to the culture of piracy that had blossomed with the advent of home-video recording and the emergence of remix culture in music.[2]

This appropriative practice developed alongside that of Cindy Sherman, Barbara Kruger and Sherrie Levine, leading figures in the Pictures Generation, whose name is derived from the seminal 1977 exhibition *Pictures*, curated by Douglas Crimp. However, Prince distinguished his appropriative methods from his contemporaries, noting that 'looking through the camera onto an already existing picture and depressing the shutter to make the exposure is … one of the fundamental requirements'.[3]

The act of looking is paramount to Prince; it defines him as the author of the resulting stolen image, while also equating him with the desires of his viewers. As critic Hal Foster has suggested, Prince aims to 'catch seduction in the act, to savour his own fascination with such images'.[4] It is this shared subjectivity between author and viewer that gives Prince's works power as reflections of popular culture. AY

Richard Prince
Untitled (cowboy) *1980–89*
Ektacolor photograph
181.5 x 271.5 cm (sight)
Art Gallery of New South Wales, Sydney.
John Kaldor Family Collection

Barbara Kruger
Untitled (You can't drag your money
into the grave with you) 1990
photographic silkscreen on vinyl
276.9 x 377.5 cm
The Seavest Collection

drag your

money

with you

Jeff Koons
New Hoover Convertibles 1984
two Hoover Convertibles, plexiglas,
fluorescent lights
147.3 x 104.1 x 71.1 cm
Courtesy Murderme

Jeff Koons
Three ball 50/50 tank
(Spalding Dr JK Silver series) 1985
glass, steel, distilled water, three basketballs
153.7 x 123.8 x 33.7 cm
Courtesy Murderme

(opposite)

JEFF KOONS
Three ball 50/50 tank
(Spalding Dr JK Silver series) *1985*

Jeff Koons first captured the public's attention in the early 1980s, with his surprising re-presentation of readymade objects. Since that time, he has created discreet bodies of work, grouped according to overarching narratives or themes. *Three ball 50/50 tank (Spalding Dr JK Silver series)* 1985 belongs to Koons' fourth consecutive series, in which he continued to enlist the banal and everyday for highly conceptual ends. Created for a 1985 exhibition entitled *Equilibrium*, the series comprises posters of basketball stars promoting Nike products; glass tanks containing one, two or three basketballs, either entirely submerged or hovering halfway above the waterline; and floating devices cast in bronze, such as a lifeboat and aqualung. Together these artworks were intended to address notions of personal ambition, transience and impending mortality.

In typical Koons fashion, the simple and almost whimsical appearance of *Three ball 50/50 tank* belies its heavy existential and sociological symbolism. The trinity of balls are miraculously suspended in an aquarium-like vessel, caught in a liminal state between rising and falling. Their stasis imbues the sculpture with an atmosphere of apprehension – an expression of pure potential. The basketballs are 'like a foetus in the womb', Koons explains, 'it's an ultimate state of being'.[1] But this poise was not made to last. The balls are subject to both movement and decay, thereby reminding us of the impermanent nature of happiness, of equilibrium, of life itself. Koons consulted the Nobel prize–winning physicist Dr Richard Feynman to devise a system that would hold the balls in place for as long as possible without the use of chemicals or oils. The solution involved filling the tanks with a mixture of water and sodium chloride reagent, while the balls themselves are filled with distilled water. Maintaining the artwork's balance and sense of newness requires effort and commitment; it is an ongoing battle designed to mirror humanity's struggle for success and perfection.

By choosing the basketball as his agent of meaning, Koons was referencing a sport often used by urban, working-class youths as a path for upward social mobility. His parallel message was that the middle classes use art in much the same way. This undercurrent of social consciousness was likely influenced by the era in which the work was created – a time when conspicuous consumption, Reaganomics and yuppies ruled the day, with material possessions increasingly becoming the primary means of defining cultural values and personal identity. Koons' appropriation of consumer goods was a logical aesthetic response to this reality. In his hands basketballs become surrogates for the self. He borrows the visual language of minimalism and scientific specimens to transform the mundane into the metaphysical, and in doing so he hints at the natural, political and social forces that shape our lives. These concepts have made the *Equilibrium* series hugely influential for other artists, not least for Damien Hirst, whose vitrines filled with preserved animals similarly aestheticise 'readymades' for the contemplation of life and death. FC

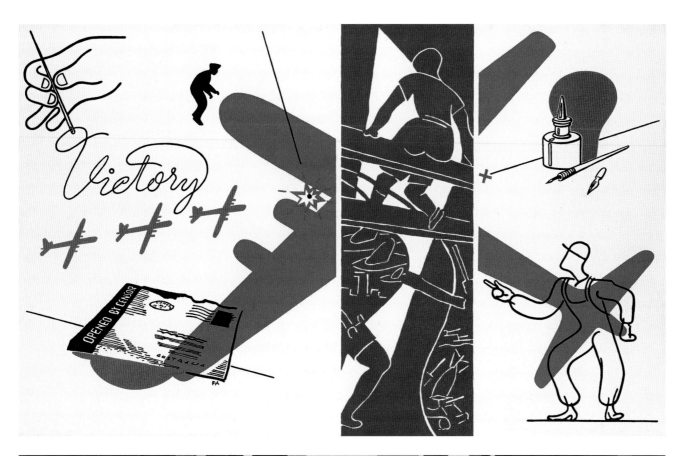

Robert Rooney
The setting sun 1984
synthetic polymer paint on canvas
121.8 x 198.2 cm
National Gallery of Victoria, Melbourne,
purchased from Admission Funds, 1987

(top)

Robert Rooney
Tumult in the clouds 1985
synthetic polymer paint on canvas
122.2 x 183 cm
Art Gallery of New South Wales, Sydney.
Gift of Terry and Tina Smith 2013,
donated through the Australian Government's
Cultural Gifts Program

Howard Arkley
Primitive gold 1982
synthetic polymer paint on canvas
210 x 209.8 cm
National Gallery of Victoria, Melbourne.
Michell Endowment 1982

HOWARD ARKLEY
Triple fronted 1987

Triple fronted 1987 is Howard Arkley's archetypical image of the Australian postwar home. The work depicts an exterior of a 'featurist' three-bedroomed brick veneer house, complete with front yard, concrete driveway and garage, set defiantly against a background of cartoonish blue sky and clouds. Many cheaply constructed houses like this could be found in Melbourne's middle and outer rings during the 1960s and 1970s, and are still a familiar sight today. The over-cropped composition has been lifted from real estate advertising featured in retro lifestyle magazines: photocopied, traced in radiography pen and celluloid, and then projected onto canvas. Arkley has then skilfully airbrushed in flat areas of fluorescent colour, with fuzzy black outlines detailing the patterns and textures of the masonry, roof tiling and bushes. The hands-free technique and resulting smooth surface lend the stylised iconography a commercial, somewhat classic pop look.

Triple fronted bridges Arkley's popist practice of the early 1980s with his suburbanist enterprise of the 1990s. It is foreshadowed by the artist's earlier 'door format' series of 1978–81, of abstract paintings that were inspired by his recognition of modernist motifs in his mother's flywire screen after returning from studio residencies in New York and Paris. He began to appropriate ubiquitous domestic graphics – like those found on Laminex surfacing, linoleum, and generic fabrics and textiles – and it dawned upon him that 'designers in the 1940s and 50s were ripping off people like Miró and Kandinsky for inspiration, and I found myself looking at the designers rather than the originals – I was feeding off the "tainted" version'.[1] This 'second degree' aesthetic aligned Arkley, although partially indifferent to its cause, with the group

of Australian artists Paul Taylor defined as popist.[2] Arkley shifted toward figuration with the doodled mural *Primitive* 1981 (private collection), and by 1983 had produced his first suburban postwar home motifs. He revisited the subject in landmark exhibitions *Suburban urban messages* in 1987 and *Recent paintings – houses and homes* in 1988, both of which included *Triple fronted*. The artist's verso inscriptions indicate that from 1991 *Triple fronted* had been incorrectly dated as 1988, leading to speculation that multiple versions of the work were exhibited in 1987 and 1988.

Arkley expanded upon his quotation of mass media to self-quotation at times throughout his career. For example, the composition of *Triple fronted* was reproduced in the bigger and brighter variant *Family home: suburban exterior* 1993 (Monash University Collection).[3] Following Arkley's death in 1999, *Family home* was printed on postage stamps, book covers, newspaper articles and posters, attaining iconic status and epitomising a collective Australian experience. NY

Howard Arkley
Triple fronted 1987
synthetic polymer paint on canvas
166.4 x 238.4 cm
Art Gallery of New South Wales, Sydney.
Mollie and Jim Gowing Bequest Fund 2014

Keith Haring
Untitled 1982
synthetic polymer paint on vinyl tarpaulin
with aluminium eyelets
213.5 x 220 cm
JW Power Collection, University of Sydney,
managed by Museum of Contemporary Art,
purchased 1982

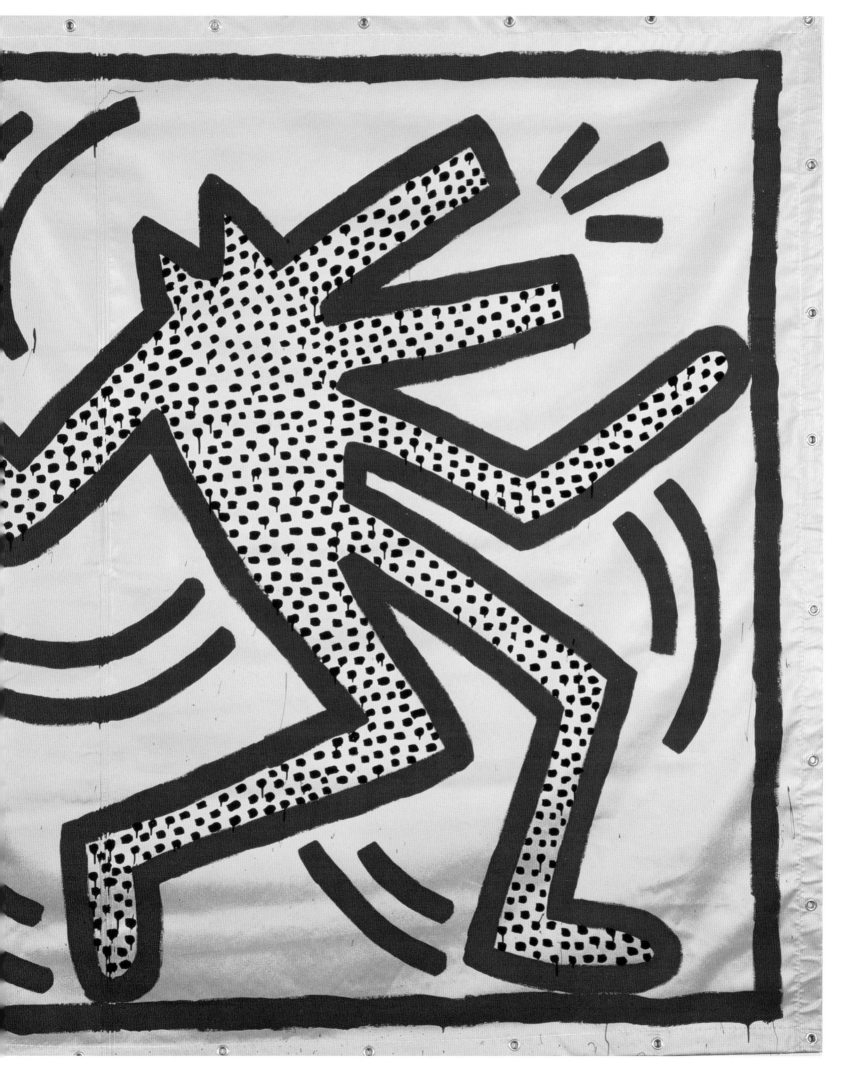

Jean-Michel Basquiat, Andy Warhol
Collaboration 1984–85
acrylic and oil stick on linen
193 x 264.5 cm
The Andy Warhol Museum, Pittsburgh.
Founding Collection, Contribution The Andy
Warhol Foundation for the Visual Arts Inc

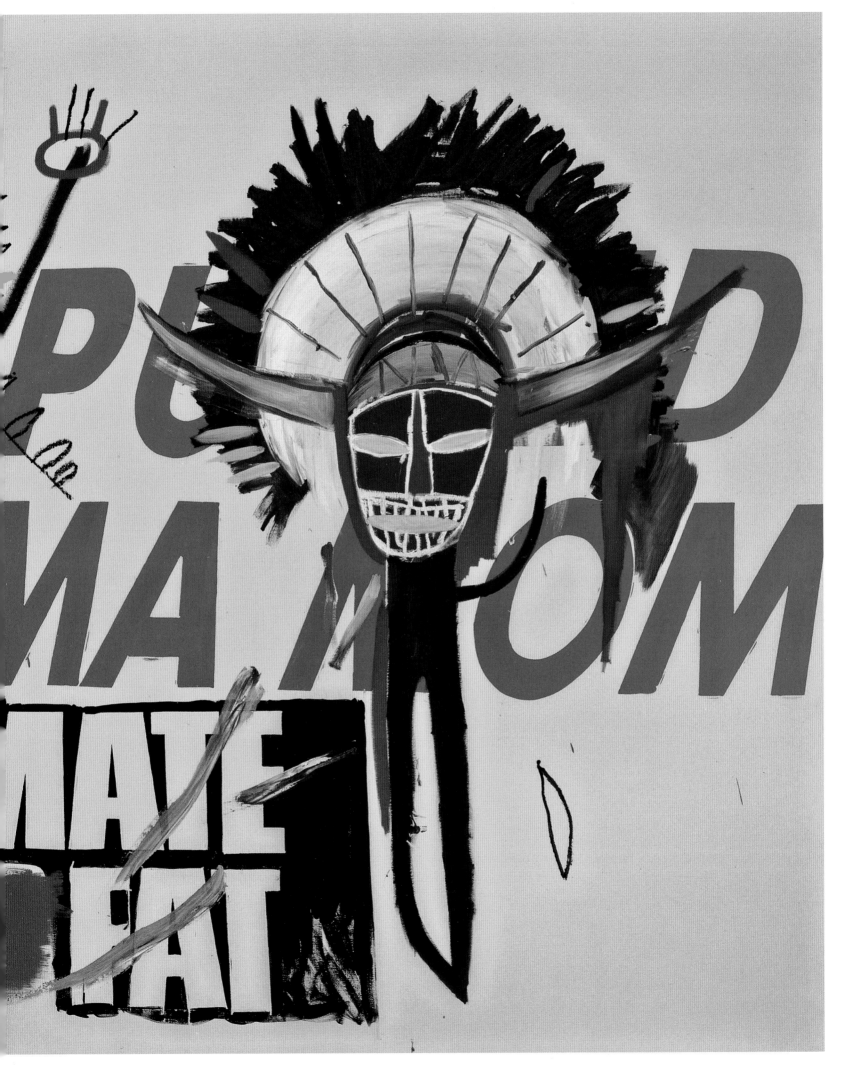

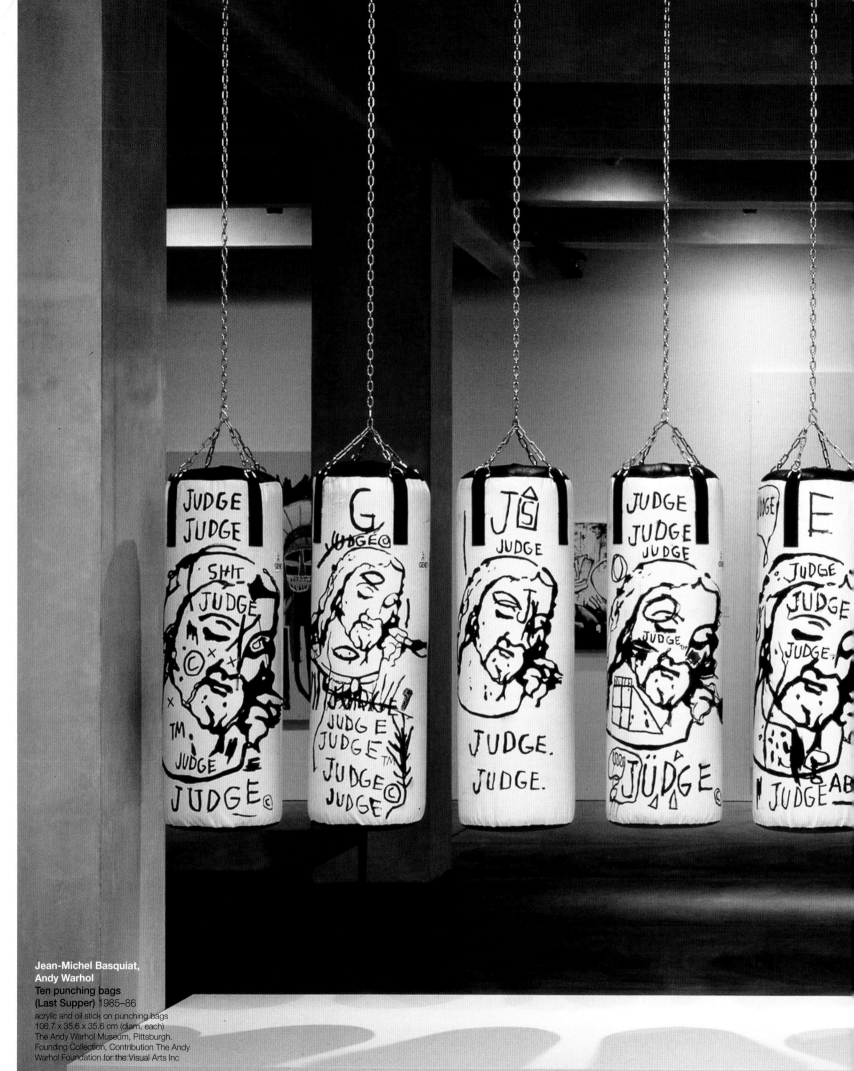

**Jean-Michel Basquiat,
Andy Warhol**
**Ten punching bags
(Last Supper)** 1985–86
acrylic and oil stick on punching bags
106.7 x 35.6 x 35.6 cm (diam, each)
The Andy Warhol Museum, Pittsburgh.
Founding Collection, Contribution The Andy
Warhol Foundation for the Visual Arts Inc

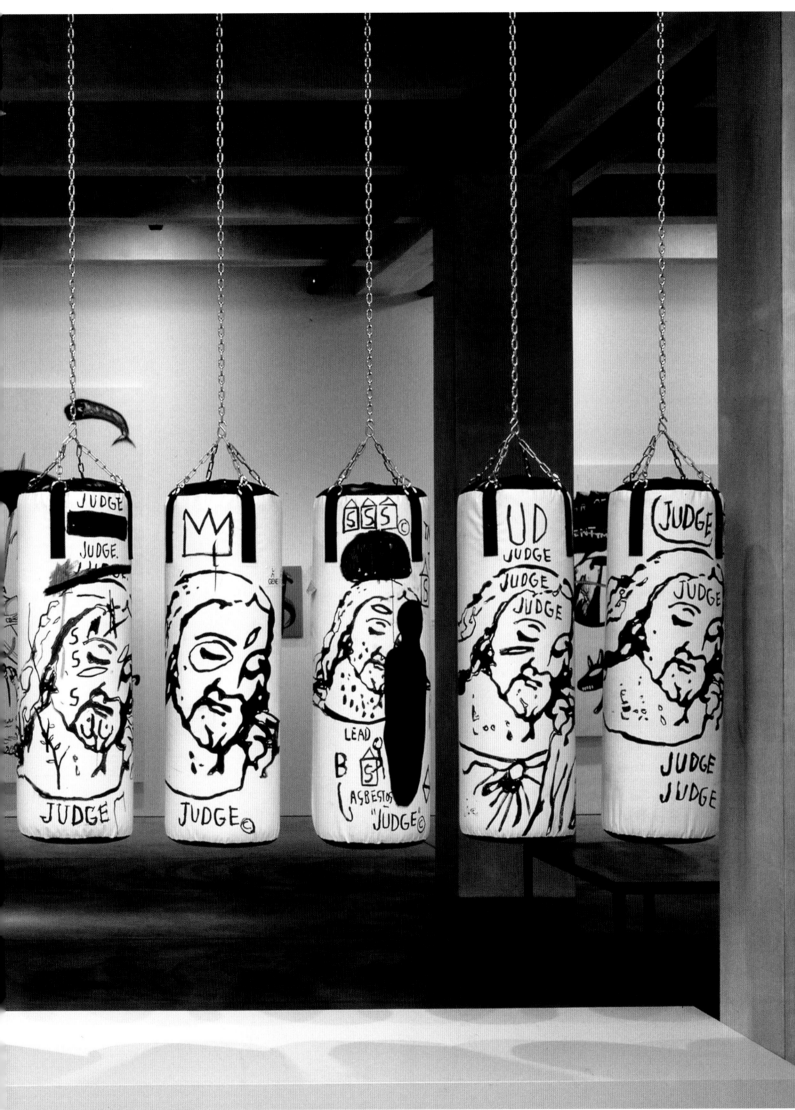

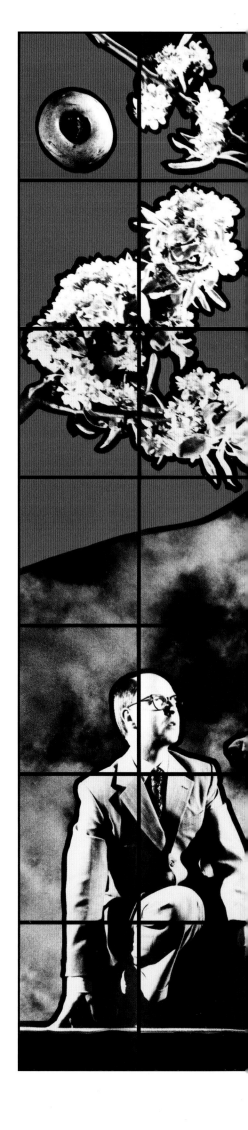

In *Friendship* 1982 Gilbert & George only have one pair of hands between them: George's are tucked behind his back, while Gilbert's are in plain view. These distinctive poses, of which there are variations in other works, are subtle manifestations of their desire to present themselves as one artist composed of two people. Living and working together as a couple and as full-time 'living sculptures' since 1967, theirs is the epitome of friendship.

Friendship is one of Gilbert & George's photo-pieces, which have been their primary mode of expression since 1971. They are created following a strict series of steps, from the initial harvesting of countless photographs taken in the studio or around their East End London neighbourhood, to the thematic indexing and finally to the actual work's sketched-out design, during which no one is allowed in the room. *Friendship* and other works created between 1980 and 1983 mark a decisive turning point in Gilbert & George's process and practice, most notably in the explosion of their palette, dimensions and subjects. Seen here, for example, is the introduction of acid yellow, more panels, plants and a profusion of models.[1]

While the theme of friendship, as revealed by the title, links to the extraordinary bond of the artists and the mateship of young boys, the work's pop art attributes suggest otherwise. The flatness, detachment and Warhol-like grid of this photo-piece give it an ironic twist. The way in which the figures are cut out, flattened, washed out and separated from each other by thick black outlines promotes an overall feeling of solitude and lack of affection. Gilbert & George pride themselves on being friendless and, with a couple of exceptions, depict only strangers in their work.[2] In a similar vein they have also claimed that 'art is the friendship between the viewer and the picture'[3], yet by eliminating their individual personalities and making only a joint 'persona' available to the public, there is a certain self-absorption that dissuades any kind of authentic audience involvement.[4]

On the other hand, the focus on youth and friendship is also what ties this work to its own time. The 1980s in Britain was a tumultuous decade, with race riots, gay liberation and the miners' strike. Here youth and camaraderie offer a kind of utopianism. Created just before the onset of AIDS[5], the images of the three adolescent boys represent for Gilbert & George an optimistic freshness: 'They haven't reached the point in life yet when society sets their faces.'[6] The presence of flowers and plants above is symbolic of this budding youthfulness, and the sky behind them suggests a vastness of future possibility. There is wistfulness to this work, as we are reminded of the cycle of life: earth/sky, boy/man, life/death. Even the gradual height increase from the crouching Gilbert to the upward-searching George is symbolic of an earthly progression. AG

Gilbert & George
Friendship 1982
photo-piece: screenprint on black-and-white
and colour photographs, and synthetic
polymer paint on metal frames
427 x 455 cm
JW Power Collection, University of Sydney,
managed by Museum of Contemporary Art,
purchased 1986

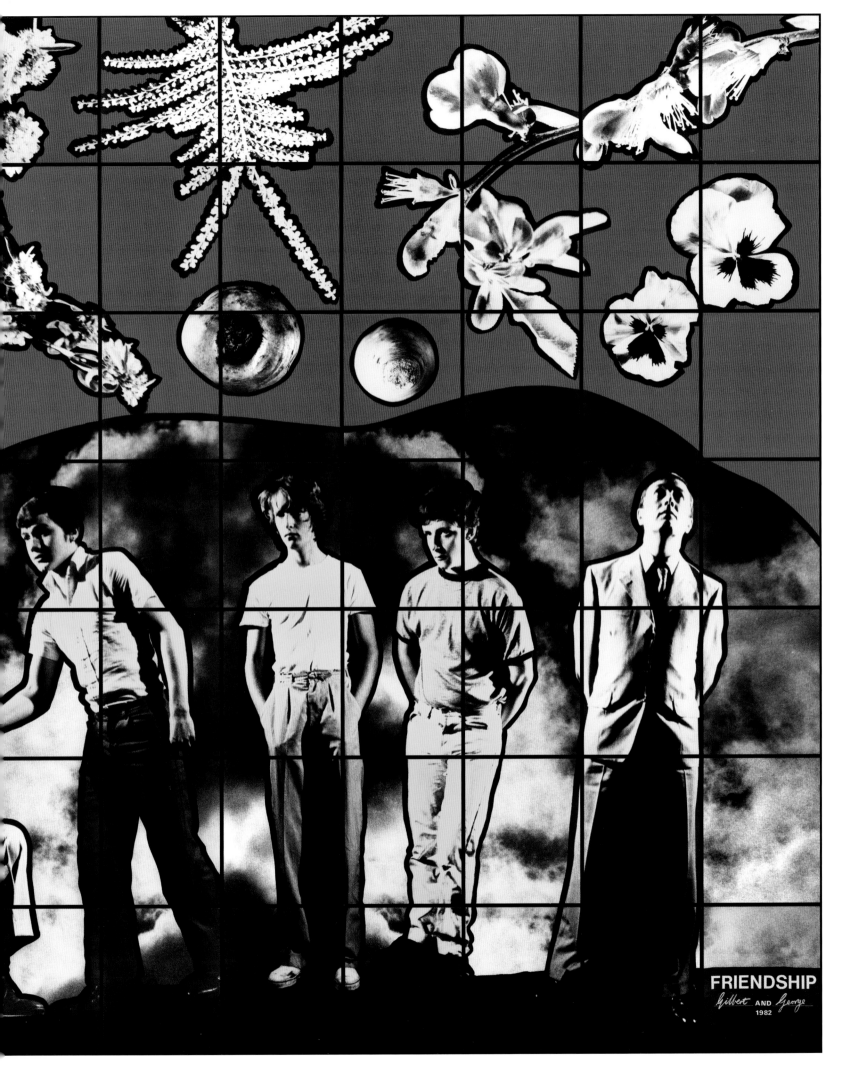

FRIENDSHIP
Gilbert AND *George*
1982

Andy Warhol's last series of self-portraits was painted only months before his premature death in February 1987 at the age of 58. As part of this group, *Self-portrait no 9* 1986 appears to have a prescient spectral quality, with Warhol's starkly lit face floating in a black void. Underlying this disembodied head is a layer of candy-coloured camouflage, a pattern that became one of Warhol's signatures in 1986. Warhol introduced camouflage to his repertoire in order to paint purely abstract compositions, but he eventually combined it with a range of figurative imagery, starting with the late self-portraits. The conflation of camouflage with a mask-like visage suggests Warhol's true nature is hidden from view; a condition the deeply private artist purposely cultivated through his famously detached and enigmatic personality. His contradictory desire for self-protection and public exposure is clearly embedded in *Self-portrait no 9*. The painting's eye-catching pink, apricot, yellow and blue hues invert the intended function of camouflage, just as Warhol's eccentric 'fright wigs' indiscreetly concealed his baldness. By drawing attention to this disguise, Warhol openly acknowledges the artifice of his public front, while continuing to uphold it.

Warhol's early pop self-portraits aligned him with the celebrities he was so fond of depicting, and transformed his image into a similarly valuable commodity. Yet each variant he made on the theme maintained an element of remove from the viewer, whether through the use of sunglasses, an indirect gaze, a strategically placed hand or deep shadows. The artist's last self-portraits are arguably the most candid, for they clearly express his strangely ambiguous character and his need to hide in plain sight. 'If you want to know about Andy Warhol, then just look at the surface of my pictures, my movies and me and there I am, there's nothing in between', Warhol once said.[1] That he kept much of his life secret from even his closest associates renders this statement disingenuous, but in a sense, Warhol created nothing *but* self-portraits, by documenting his predilections, obsessions and anxieties in a myriad of ways throughout his career.

In the grand tradition of self-portraiture, this painting is an attempt at self-investigation that skilfully balances personal revelation and contrivance to encapsulate the myth and the man. When the related series was exhibited in London, viewers were deeply moved by the confronting image of Warhol's gaunt, aging features. Many perceived the pictures to be a kind of *memento mori* motif, an emblem of life's brevity, and some were even moved to tears. Indeed, skulls regularly appeared in Warhol's art during the last decade of his life, as did religious subjects, such as his appropriation of Leonardo de Vinci's *Last supper*. Together these works, and Warhol's recycling of early pop imagery immediately before them, show the artist reflecting back on his legacy while grappling with the threat of his encroaching mortality. FC

Andy Warhol
Self-portrait no 9 1986
synthetic polymer paint and
screenprint on canvas
203.5 x 203.7 cm
National Gallery of Victoria, Melbourne,
purchased through The Art Foundation of
Victoria with the assistance of the National
Gallery Women's Association, Governor, 1987

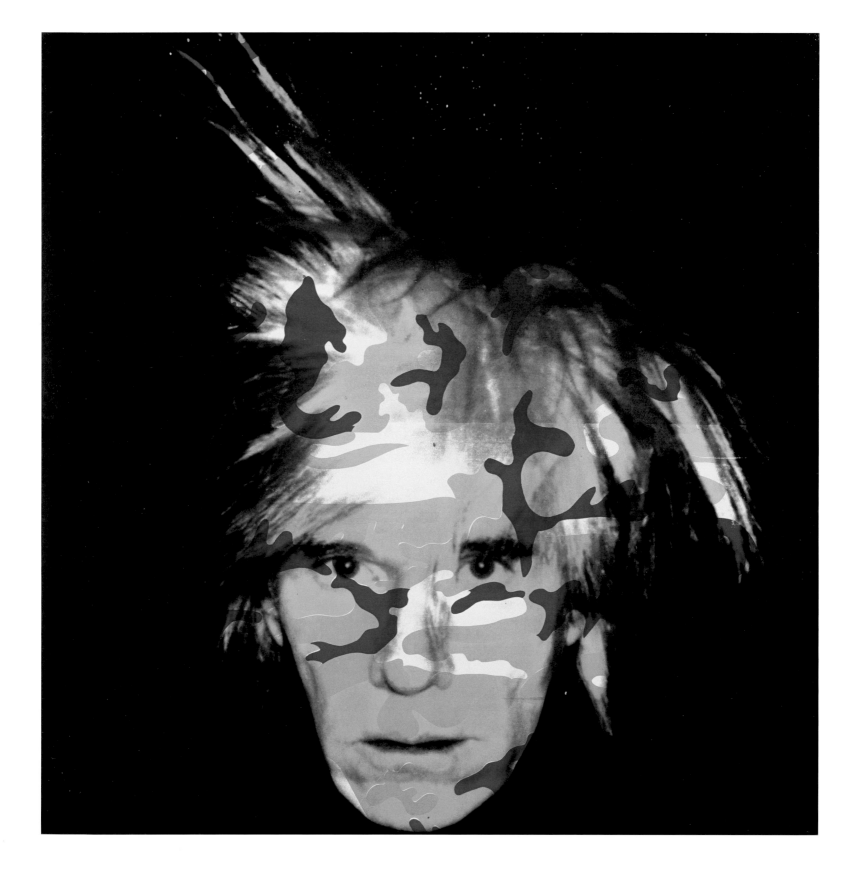

Maria Kozic was the most agile of all the popists, working fluidly across numerous high and low art mediums, and directly into the domain of commodity culture. During the first half of the 1980s her practice was preoccupied with the character of the multiple. Familiar subjects co-opted from popular culture and generic signs from everyday life were reproduced in serial form: an image of the Queen depicted from a range of angles, portraits of Clint Eastwood and David Bowie repeated in orderly rows, a flock of plastic birds, a brood of chooks, and so on. These early works reflect the folksy character of the 'handmade readymade', a phrase coined to describe the interplay between original and copy in Roy Lichtenstein's earliest pop paintings.[1] They also owe a debt to Andy Warhol's tropes of seriality and manufacture, and his fascination with the overcoded and banal.

Kozic's interest in muddling distinctions between the unique and the reproduced extended beyond her sewn sculptures and screenprinted images to her paintings of the period. Some of these depict icons from film and television, reworking sources that piqued the artist's curiosity as a genuine pop-culture aficionado, while others borrow from art history. In 1985 she produced the series *Lichtenstein dots*, comprising four works that depict progressively enlarged details of 1960s comic-style paintings by Lichtenstein, culminating with the foundational unit of his technique: a singular, stain-like Benday dot. The following year Kozic continued this playfully atomising approach in the series *MASTERPIECES* 1986, in which she translated images by twentieth-century art 'masters' onto canvases that are literally fractured into large irregular shards, imitating the depiction of explosions in comics.

MASTERPIECES (Warhol) cites one of Andy Warhol's legendary *Campbell's soup cans*, the subject of his inaugural solo exhibition at the Ferus Gallery in Los Angeles in 1962, which he subsequently depicted in a range of variations. The other *MASTERPIECES* simulate signature works by Piet Mondrian, Jackson Pollock, Edvard Munch and Pablo Picasso. With characteristic wit, Kozic's gesture of 'blowing up' such iconic images parodies the rupture to modernist values that was unfolding at the time under the conditions of postmodernity: notions of originality and authenticity, the patriarchal bias of the art historical canon, and the authority of the Euro-American cultural 'centres' were all being thoroughly challenged and dismantled. Correspondingly, the series seems to make light of postmodernism's embrace of high theory, much of which was invested in the rhetorical 'deconstruction' of images as repositories for meaning.

Nevertheless, the droll iconoclasm of *MASTERPIECES (Warhol)* reflects the broader spirit of Kozic's practice as neither one of passive consumption nor pointed critique. Her idiosyncratic use of popular imagery led one writer to suggest that Kozic's critical intent and 'personal investment' in the subjects of her work 'remains unclear, indecipherable'.[2] Fittingly, such a charge was levelled at Warhol also. *MASTERPIECES (Warhol)* was later reproduced on the cover of Paul Taylor's edited anthology *Post-pop art* (1989), invoking Warhol's oeuvre as a touchstone for postmodern appropriation practices and, more subtly, the unique manifestation of a post-pop idiom in the Australian context. AJ

Maria Kozic
MASTERPIECES (Warhol) 1986
synthetic polymer paint on wood
182 x 122 cm
JW Power Collection, University of Sydney,
managed by Museum of Contemporary Art,
purchased 1987

POP TO POPISM
Wayne Tunnicliffe
page 10

1 Letter reproduced in *Pop art is*, Gagosian Gallery, London, 2007, unpaginated.

2 Published in *Flash Art*, no 133, Apr 1987, pp 40–44.

/

THE FUTURE IS NOW
Origins of pop art
Wayne Tunnicliffe
page 17

1 Lawrence Alloway, 'Dada 1956', *Architectural Design*, Nov 1956, reprinted in David Robbins (ed), *The Independent Group: postwar Britain and the aesthetics of plenty*, MIT Press, Cambridge, MA, 1990, p 164.

2 There were significant proto-pop works being made in Europe and various other locations, but as it was the American and British artists who became known in Australia we have retained that focus in this exhibition.

3 The membership of the Independent Group was somewhat loose and evolving, with differing recollections as to who constituted the core group. Jacqueline Bass, in Robbins (ed) 1990, p 8: 'Although there will never be an agreed upon inclusive "membership list", our working list of the Independent Group contains the following names: the critics Lawrence Alloway and Reyner Banham; publications designer and critic Toni del Renzo; musician Frank Cordell; artists Magda Cordell, Richard Hamilton, Nigel Henderson, John McHale, Eduardo Paolozzi, and William Turnbull; architects Geoffrey Holroyd, Alison and Peter Smithson, James Stirling, and Colin St John Wilson.'

4 Lawrence Alloway, 'The long front of culture' (1959), reprinted in John Russell and Suzi Gablik (eds), *Pop art redefined*, Praeger, New York, NY, 1969, p 41.

5 About 35 people were in attendance, one of the largest audiences for an Independent Group lecture. See Robbins (ed) 1990, p 20. For the mixed reception, and in particular Banham's negative response, see John-Paul Stonard, 'The "Bunk" collages of Eduardo Paolozzi', *Burlington Magazine*, Apr 2008, pp 240–41.

6 Two of Schwitters' collages that are sometimes positioned as pop precursors are *En morn* 1947 (Centre Pompidou, Paris), which includes a glamorous colour image of a young woman, and *Untitled (for Kate)* 1947 (private collection), which features a collage of characters from various comics.

7 Eduardo Paolozzi, quoted in Bradford R Collins, *Pop art: the Independent Group to neo pop, 1952–1990*, Phaidon, London, 2012, p 29.

8 For an analysis of the three types of collage present in the group of works that later became the *Bunk* portfolio, see Stonard 2008, pp 238–49.

9 There are parallels in what Paolozzi visually presents in these collages and the connections Marshall McLuhan makes between sex and technology in advertising in *The mechanical bride*, published in 1951. See Stonard 2008, and for an extended analysis, see Robin Spencer in Spencer et al, *Eduardo Paolozzi: recurring themes*, Trefoil for the Scottish Sculpture Trust, London, 1984.

10 One associated collage was reproduced and titled with the descriptor 'work sheet collage c.1954' in Lawrence Alloway's chapter, 'The development of British pop', in Lucy Lippard et al, *Pop art*, Thames & Hudson, London, 1966, p 37. Paolozzi's collages were not discussed in Alloway's text. These works are most often experienced in the *Bunk* portfolio of prints and the originals in reproduction, yet this enacts a process of 'cleaning up', which does not give a sense of the worn and damaged nature of many of the collaged components. Stonard 2008 makes the valuable observation that Paolozzi seems to have often preferred well-used magazines and comics, p 249. This coincidentally parallels Robert Rauschenberg's use of discarded junk materials in his combines, and in both cases the used materials embody a sense of time passing.

11 Alloway, quoted in the unpaginated preface to the reprint of the exhibition catalogue *This is tomorrow*, Whitechapel Art Gallery, London, 1956 (reprinted 2010).

12 It is a matter of debate how much the younger pop artists – most of whom were studying at the Royal College of Art – knew of Independent Group activities or artworks; however, the group's ideas on the relevance of popular culture were published in articles in the college's magazine *Ark* in 1956–57 and were influential on some students' choice of subject matter.

13 See Richard Morphet et al, *Richard Hamilton*, Tate Gallery, London, 1992, p 149.

14 The original collage was reproduced in a large near 1:1 scale, in black and white in Jasia Reichardt's article 'Pop art and after', *Art International*, Feb 1963, p 42. It was also reproduced in Mario Amaya's *Pop as art: a survey of the new super-realism*, Studio Vista, London, 1965, and in Lucy Lippard (ed), *Pop art*, Thames & Hudson, London, 1966, as well as in most pop art books subsequently. Hamilton adjusted the title of the reprints to reflect the passage of time: *Just what was it that made yesterday's home so different, so appealing? Upgrade* 2004.

15 Clement Greenberg, 'Avant-garde and kitsch', *Partisan Review*, New York, VI, no 5, Fall 1939, pp 34–49. Reprinted in Charles Harrison and Paul Wood, *Art in theory 1900–2000*, Blackwell, Oxford, 2003, pp 539–49.

16 Jasper Johns, quoted in 'His heart belongs to dada', *Time*, 4 May 1959, p 58, quoted in Kirk Varnedoe, *Jasper Johns: a retrospective*, Museum of Modern Art, New York, NY, 2006 (1996), p 9; in 1969 Suzie Gablik wrote, 'Rauschenberg's assertion that painting relates as much to life as it does to art is by now sufficiently well-known to be part of history', in John Russell and Suzie Gablik, *Pop art redefined*, Praeger, New York, NY, 1969, p 14.

17 Johns has often cited his flag dream in interviews since 1963; this particular quote is from Emile de Antonio and Mitch Tuchman, *Painters painting: a candid history of the modern art scene 1940–1970*, Abbeville Press, New York, NY, 1984, p 97, quoted in Varnedoe 2006, p 124.

18 Johns has said he did not know of Duchamp's work until the late 1950s; however, his interest then extended to writing an article in 1960 on the newly published English translation of Duchamp's *Green box* 1960 – his notes on *The bride stripped bare by her bachelors, even (the large glass)* 1915–23 – in *Scrap*, 23 Dec 1960. Johns wrote of Duchamp's readymades in an observation that parallels his own choice of subjects: 'The machined ready-mades *serve* as works of art and *become* works of art through this service.' Quoted in Jeffrey Weiss et al, *Jasper Johns: an allegory of painting 1955–65*, National Gallery of Art and Yale University Press, Washington, DC and New Haven, CT, 2007, p 19.

19 Robert Rosenblum, 'Castelli Group', *Arts 31*, no 8, May 1957, p 53; quoted in Varnedoe 2006, p 127.

20 The other works are *Target with four faces* 1955 and *Green target* 1955. Barr also persuaded architect Phillip Johnson to buy *Flag* 1954–55, with the intention of donating it later to Museum of Modern Art, which he did in 1973 – Barr had felt that its potential to be viewed as unpatriotic may have made it a more controversial acquisition for the trustees.

21 The materiality of Johns' practice was diminished in reproduction, which made his painted images seem flatter and closer to the pop art that was to come than they actually are.

22 Parts of this text on Rauschenberg previously appeared in Wayne Tunnicliffe, 'Robert Rauschenberg', in *John Kaldor Family Collection*, Art Gallery of New South Wales, Sydney, 2011, pp 45–47.

23 Rauschenberg's double-ended arrow was used on the cover of the exhibition catalogue as an emblem for the exhibition.

/

WHEN BRITAIN WENT POP
British pop art
Michael Desmond
page 35

1 Lawrence Alloway, 'The arts and the mass media', first published in *Architectural Design* in Feb 1958, reproduced in Charles Harrison and Paul Wood, *Art in theory 1900–2000: an anthology of changing ideas*, Blackwell Publishing, Oxford, UK, 2003, pp 715–17.

2 Lawrence Alloway, 'The development of British pop', in Lucy R Lippard, *Pop art*, Thames & Hudson, London, 2001 (1966), 3rd edn, p 50.

3 Film versions of *Lucky Jim* and *Room at the top* were produced soon after publication and were joined by such films as *Look back in anger* (1959), *Saturday night, Sunday morning* (1960), *A taste of honey* (1961) and *Billy liar* (1963).

4 Peter Blake, quoted in an interview with Sabine Durrant about Pauline Boty, 'The darling of her generation', *The Independent*, 7 Mar 1993.

5 According to Lawrence Alloway, 'The term "Pop Art" is credited to me, but I don't know precisely when it was first used. (One writer has stated that 'Lawrence Alloway first coined the phrase "Pop Art" in 1954'; this is too early.) Furthermore, what I meant by it then is not what it means now. I used the term, and also "Pop Culture", to refer to the products of the mass media, not to works of art that draw upon popular culture.

In any case, sometime between the winter of 1954–55 and 1957, the phrase acquired currency in conversation, in connection with the shared work and discussion among members of the Independent Group.' Alloway 2001, p 27.

6 Pauline Boty, quoted in Richard Cork, 'Pauline Boty, Pallant House Gallery, Chichester, UK – review', *Financial Times*, London, 30 Dec 2013, quoting from the original source, an interview in *Scene 9*, Nov 1962.

7 Alloway 2001, p 66.

8 Alloway 2001, p 66.

9 Thomas Hess, quoted in Michael Archer, *Art since 1960*, Thames & Hudson, London, 2002, p 23.

10 The Annandale Imitation Realists, Australia's earliest manifestation of pop, clearly owed a debt to British pop, particularly Eduardo Paolozzi and Peter Blake. Colin Lanceley, one of the trio, moved to London in 1964 to see firsthand what was happening. Sidney Nolan was already there, as were Brett and Wendy Whiteley. Many others were to follow: artists, photographers, writers, designers, musicians.

11 Robert Hughes, *Art of Australia*, Penguin Books, Harmondsworth, UK, 1970, p 315.

12 For instance, artists Lawrence Daws, Charles Blackman, Michael Johnson, Vernon Treweeke, Peter Upward, William Delafield Cook, Martin Sharp; designers Jenny Kee and Linda Jackson; performer Barry Humphries; writers Clive James, Germaine Greer, Robert Hughes and Richard Neville; photographers Lewis Morley, Juno Gemes and Robert Whitaker; and many, many more. An exhibition held in Sydney in 2003 provided an overview of this cultural migration and ferment; see Nick Waterlow and Annabel Pegus, *Larrikins in London: an Australian presence in 1960s London*, Ivan Dougherty Gallery, College of Fine Arts, University of New South Wales, Paddington, Sydney, 2003.

Peter Blake
Self-portrait with badges 1961
page 40

1 Peter Blake, quoted in Roya Nikkhah, 'Sir Peter Blake: why I chose pop over pot', *Daily Telegraph*, 25 Jul 2010, p 15.

2 Lewis Biggs, *Peter Blake 1–10 (collages, constructions, drawings and sculpture) and the Marcel Duchamp paintings*, Waddington Galleries, London, 2005, p 5.

3 Richard Cork, 'Peter Blake and pop music', *Financial Times* (UK), 3 Jul 2012, p 12.

4 Marco Livingstone, *Peter Blake: one man show*, Lund Humphries, Farnham, Surrey, UK, 2009, pp 43–44.

Derek Boshier
Drinka pinta milka 1962
page 42

1 Derek Boshier, in Robert Brown, 'Conversation with Derek Boshier, July 2013', in *When Britain went pop*, Christie's, London, 2013, p 290. Lawrence Alloway, who has been credited with coining the term 'pop art', reflected that he used the term 'to refer to the products of the mass media, not to works of art that draw upon popular culture'. Lawrence Alloway, 'The development of British pop', in Lucy Lippard (ed), *Pop art*, Thames & Hudson, London, 1966, p 27.

2 Derek Boshier, quoted in Brown 2013, p 290.

3 Dick Hebdige, 'In poor taste: notes on pop', in Lawrence Alloway et al (eds), *Modern dreams: the rise and fall and rise of pop*, Institute for Contemporary Art, New York, NY, 1988, pp 77–78; see also Boshier's own reflections on the documentary's shortcomings in Brown 2013, pp 291, 293.

Allen Jones
Reflected man 1963
page 48

1 Allen Jones, *Image in progress*, Grabowski Gallery, London, 1962, reproduced in Marco Livingstone (ed), *Pop art*, Royal Academy of Arts, London, 1991, p 158.

2 See Jasia Reichardt, *Aspects of new British art*, Conference of State Art Gallery Directors of Australia, 1967, cat 27.

3 Reichardt 1967, cat 27.

4 Allen Jones, quoted in Robert Brown, 'Conversation with Allen Jones, July, 2013', in *When Britain went pop*, Christie's, London, 2013, p 303.

David Hockney
Man in shower in Beverly Hills 1964
page 54

1 *Tea painting in an illusionistic style* 1961, oil on canvas, 23.25 x 83 cm, Tate.

2 David Thompson, 'Foreword', in *The new generation*, Whitechapel Art Gallery, London, 1964, np. This exhibition showed the work of 12 artists selected by the director of the Whitechapel Art Gallery, Bryan Robertson.

3 David Hockney, quoted in Nikos Stangos (ed) *David Hockney by David Hockney*, Thames & Hudson, London, 1976, p 99.

4 Hockney eventually painted a number of works incorporating elements from this painting, such as the patterned tiles, the leaves of a plant and an interior room. Two such works include *Boy about to take a shower* 1964 and *Man taking shower* 1964.

5 Stangos (ed) 1976, p 99.

RB Kitaj
Walter Lippmann 1966
page 56

1 RB Kitaj, quoted in 'Painting: literary collage', *Time*, 19 Feb 1965, p 42, quoted in Marco Livingstone, *R.B. Kitaj*, Phaidon, Oxford, UK, 1985, p 16.

2 RB Kitaj, quoted in Livingstone, 1985, p 10.

3 See letter from the artist, Jul 1968, published in 'Ronald Kitaj', *Contemporary art 1942–72: collection of the Albright-Knox Art Gallery*, Praeger Publishers, New York, NY, Washington, DC, and London, 1972, p 149. While he does not explicitly specify the 1943 film adaptation of *The constant nymph*, directed by Edmund Goulding, Kitaj's young, pigtailed female protagonist in a check-patterned dress closely resembles Joan Fontaine's character Tessa in this version.

4 RB Kitaj, 'Walter Lippmann', in Livingston, 1985, p 148. Later reproduced in Richard Morphet (ed), *R.B. Kitaj: a retrospective*, Tate Gallery, London, 1994, p 88.

5 'Ronald Kitaj', *Contemporary art 1942–72*, 1972, p 149.

6 Richard Morphet, 'The art of R.B. Kitaj: "To thine own self be true"', in Morphet (ed) 1994, p 12.

7 Morphet (ed) 1994, p 22.

/
**A BRAND
NEW WORLD**
American pop art
Chris McAuliffe
page 59

1 For a history of the Bell Labs, see Jon Gertner, *The idea factory: Bell Labs and the great age of American innovation*, Penguin, Ringwood, Vic, 2012.

2 Marshall McLuhan and Quentin Fiore, *The medium is the message*, Penguin, Harmondsworth, UK, 1967, pp 14, 8.

3 McLuhan uses this phrase in Marshall McLuhan and Harley Parker, *Through the vanishing point: space in poetry and painting*, Harper and Row, New York, NY, 1968, p 7.

4 Daniel Boorstin, *The image, or, what happened to the American dream*, Penguin, Harmondsworth, UK, 1963, p 2.

5 Marshall McLuhan, 'Letter to Maurice Stein, 15 May 1964', in Matie Molinaro, Corinne McLuhan, William Toye (eds), *Letters of Marshall McLuhan*, Oxford University Press, Toronto, Canada, 1987, p 300.

6 Patrick Brantlinger, *Bread and circuses: theories of mass culture as social decay*, Cornell University Press, Ithaca, NY, 1983, p 185.

7 Roy Lichtenstein, quoted in Gene Swenson, 'What is pop art? Part 1', *Art News* Nov 1963, reprinted in Steven H Madoff (ed), *Pop art: a critical history*, University of California Press, Berkeley, CA, 1997, p 107.

8 Max Kozloff, 'Pop cultures, metaphysical disgust and the new vulgarians', *Art International*, vol 6, no 2, Mar 1962, reprinted in Madoff 1997, p 36.

9 Alvin Toffler coined this phrase in an article in *Fortune* magazine, 1961, and later expanded upon it in his book *The culture consumers* (1964). For a discussion of the culture boom and its perceived negative impact on taste see Sara Doris, *Pop art and the contest over American culture*, Cambridge University Press, Cambridge, UK, 2007, p 99. Doris also traces the development of the concepts of high-brow, middle-brow and low-brow in magazines such as *Harpers* and *Life*, pp 73–76.

10 Dwight Macdonald, *Against the American grain*, Vintage Books, New York, NY, 1962, p ix.

11 Dwight Macdonald, 'Masscult & midcult' (1960), in Macdonald 1962, p 37.

12 Stanley Kunitz, quoted in 'A symposium on pop art' (Dec 1962), reprinted in Madoff 1997, pp 73–74. Later, art historian Christin Mamiya argued that pop art's long-term impact lay in the introduction of the corporate management and marketing procedures that are now entrenched in the contemporary art market; Christin Mamiya, *Pop art and consumer culture: American super market*, University of Texas Press, Austin, TX, 1992, pp 158–71.

13 Commencing in 1964, Drexler wrote nine novels and 19 plays, for which she received three Obie [Off-Broadway] awards.

14 Stanley Kunitz, quoted in Madoff 1997, p 75.

15 Dore Ashton, quoted in 'A symposium on pop art' (Dec 1962), reprinted in Madoff 1997, p 70.

16 Kunitz in Madoff 1997, p 74.

17 Daniel Horowitz compiled this summary list in his *Consuming pleasures: intellectuals and popular culture in the postwar world*, University of Pennsylvania Press, Philadelphia, PA, 2012, p 23. All were used by Bernard Rosenberg in his introduction to Bernard Rosenberg and David Manning White (eds), *Mass culture: the popular arts in America*, The Free Press, New York, NY, 1957.

18 Robert Indiana, quoted in Gene Swenson, 'What is pop art? Part 1', reprinted in Madoff 1997, p 107.

19 Macdonald, 'Masscult & midcult' (1960), in Macdonald 1962, p 27.

20 Lucy Lippard, *Pop art*, rev 3rd edn, Thames & Hudson, London, 1970, p 9.

21 James Rosenquist, quoted in Mary Anne Staniszewski, 'James Rosenquist', *Bomb*, no 21, Fall 1987, http://bombmagazine.org/article/956/james-rosenquist (accessed 30 Mar 2014).

22 'Oral history interview with Robert Indiana', 12 Sep – 7 Nov 1963, Archives of American Art, Smithsonian Institution, www.aaa.si.edu/ (accessed 30 Mar 2014).

23 'Oral history interview with Tom Wesselmann', 3 Jan – 8 Feb 1984, Archives of American Art, Smithsonian Institution, www.aaa.si.edu/ (accessed 30 Mar 2014).

24 'Oral history interview with Tom Wesselmann'.

25 Robert Rauschenberg, interview with Richard Kostelanetz, *Partisan Review*, no 35, 1968, reprinted in Sam Hunter, *Robert Rauschenberg: works, writings and interviews*, Ediciones Poligrafa, Barcelona, 2006, p 138.

26 Emerson's essay 'Self-reliance' was first published in 1841. For a discussion of centrality of Emerson's 'possessive individualism' to abstract expressionism, see Roger Cranshaw, 'The possessed: Harold Rosenberg and the American artist', *Block*, no 8, 1983, pp 2–11.

27 'Oral history interview with Robert Rauschenberg', 21 Dec 1965, Archives of American Art, Smithsonian Institution, www.aaa.si.edu/ (accessed 30 Mar 2014).

28 Jasper Johns, 'Interview with David Sylvester, June 1965', reprinted in Kirk Varnedoe (ed), *Jasper Johns: writings, sketchbook notes, interviews*, Museum of Modern Art, New York, NY, 1996, p 113.

29 Staniszewski 1987.

30 Jasper Johns, 'Book A' (c1963–64), reprinted in Varnedoe 1996, p 54.

31 John Cage, 'On Robert Rauschenberg, artist, and his work' [1961], in his *Silence*, Wesleyan University Press, Hanover, NH, 1973, p 101.

32 See Thomas Crow, 'The absconded subject of pop', *RES: Anthropology and Aesthetics*, no 55/56, 2009, p 5.

33 McLuhan and Fiore 1967, p 63.

34 Norman Mailer, *The armies of the night*, Penguin, Harmondsworth, UK, 1968, p 98.

35 Cage 1973, p 105.

36 Leo Steinberg, 'Reflections on the state of criticism', *Artforum*, Mar 1972, p 49.

37 Steinberg's use of the term 'post-Modernism' in *Artforum*, Mar 1972, came on the heels of its appearance in *Art News* (Mar 1968), *Art Now* (Nov 1969) and *Artforum* (Jan and Feb 1971). In May 1971 *Art in America* published an editorial by Brian O'Doherty, entitled 'What is

post-modernism?' The term was not applied exclusively to pop art and referred broadly to any art disputing the terms of formal and colour-field abstraction.

38 Arthur C Danto, *Art after the end of art*, Princeton University Press, Princeton, NJ, 1997, p 125.

39 Danto 1997, p 125.

Roy Lichtenstein
Look Mickey 1961
page 68

1 Roy Lichtenstein, quoted in 'BBC interview with David Sylvester', Jan 1966, in *Some kind of reality: Roy Lichtenstein*, Anthony d'Offay Gallery, London, 1997, p 7.

2 Andy Warhol began painting comic characters in 1960, but he abandoned the enterprise after learning that Lichtenstein had gained the support of New York's Leo Castelli Gallery in 1961.

3 Roy Lichtenstein, quoted in Gene Swenson, 'What is pop art?', *Art News*, vol 62, no 7, Nov 1963, p 25.

James Rosenquist
Silver skies 1962
page 74

1 Gene R Swenson, 'Reviews and previews: new names this month', *Art News*, Feb 1962, p 20.

2 James Rosenquist, quoted in Lucy R Lippard, 'James Rosenquist: aspects of a multiple art', *Artforum*, 1965, p 41.

3 James Rosenquist, quoted in Robert C Scull, 'Re the F-111: a collector's notes', *Metropolitan Museum of Art Bulletin*, Mar 1968, p 283.

Edward Ruscha
Noise, pencil, broken pencil, cheap Western 1963
page 76

1 Ed Ruscha, quoted in Bernard Blistene, 'Conversation with Edward Ruscha', reproduced in Alexandra Schwartz (ed), *Ed Ruscha: leave any information at the signal: writings, interviews, bits, pages*, MIT Press, Cambridge, MA, 2004, p 305.

Marisol
John Wayne 1963
page 78

1 Don Moser, 'The Western hero: America's cowboy rides the range the world over', *Life*, 20 Dec 1963, p 104.

2 Marisol's work has also featured on numerous *Time* magazine covers, including sculptures of Hugh Hefner (Mar 1967), Bob Hope (Dec 1967), Henry Kissinger and Richard Nixon (Jan 1973), and Nelson Rockefeller (Sep 1974).

Andy Warhol
Triple Elvis 1963
page 80

1 As seen in Warhol's films *Horse* (1965) and *Lonesome cowboys* (1968), and the print series *Cowboys and Indians* 1986.

2 Andy Warhol, quoted in Andy Warhol and Pat Hackett, *Popism: the Warhol sixties*, Penguin, London, 2007 (1981), p 50.

Robert Rauschenberg
Quote 1964
page 84

1 Robert Rauschenberg, quoted in GR Swensen, 'Rauschenberg paints a picture', *Art News*, vol 62, Apr 1963, p 45.

2 Julia Blaut, 'Transfer drawings, prints, and silkscreened paintings 1958–1970', in Walter Hopps and Susan Davidson (eds), *Robert Rauschenberg: a retrospective*, Guggenheim Museum, New York, NY, 1997, p 156.

3 Written in the spiraling text in Rauschenberg's lithograph *Autobiography* 1968.

4 Calvin Tomkins, 'The Sistine on Broadway', in Roni Feinstein, *Robert Rauschenberg: the silkscreen paintings 1962–64*, Whitney Museum of American Art, New York, NY, 1990, p 15.

5 The photograph comes from an article on a group of new astronauts in *Life*, Sep 1963, p 38. See Feinstein 1990, p 83.

6 See Feinstein 1990, p 83.

7 Robert Rauschenberg, quoted in Dean Swanson, *Robert Rauschenberg: paintings 1953–1964*, Walker Art Centre, Minneapolis, MN, 1965, np.

8 Brian O'Doherty, 'Rauschenberg and the vernacular glance', *Art in America*, vol 61, Sep–Oct 1973, pp 82–87.

9 Max Kozloff, 'Art', *The Nation*, 7 Dec 1963, p 403.

Tom Wesselmann
Still life #29 1963
page 88

1 Tom Wesselmann, journal entry, 26 Jan 1983, quoted in Nathalie Bondil, 'Tom Wesselmann's bombshells: an art named desire', in Stephane Aquin (ed), *Tom Wesselmann*, Del Monico Books, Munich, London and New York, 2012, p 16.

2 Slim Stealingworth, *Tom Wesselmann*, Abbeville Press, New York, NY, 1980, p 20.

3 Brian O'Doherty, '"Pop" show by Tom Wesselmann is revisited', *The New York Times*, 28 Nov 1968, p 36.

4 Tom Wesselmann, interview with G Swenson, *ARTnews*, 1964, p 44.

5 Annabelle Teneze, 'Tom Wesselmann's challenge: painting along with the history of art', in Aquin (ed) 2012, p 32.

6 Slim Stealingworth, 'Notes on Tom Wesselmann', in Celia Bagnoli et al, *Tom Wesselmann*, Edizioni Charta, Milan, Italy, 2003, p 21.

7 Monographs on his work did not appear until 1994. See Sam Hunter, *Tom Wesselmann*, Rizzoli, New York, NY, 1994; John Wilmerding, *Tom Wesselmann: his voice and vision*, Rizzoli, New York, NY, 2008.

8 *Beyond pop art: Tom Wesselmann*, Montreal Museum of Fine Art, 19 May – 7 October 2012. The exhibition travelled to the Virginia Museum of Fine Arts, Richmond, in 2013, and then to the Cincinnati Art Museum in 2014.

9 Slim Stealingworth, *Tom Wesselmann*, Abbeville Press, New York, NY, 1980, np.

Rosalyn Drexler
Home movies 1963
page 90

1 Lee Bernstein, 'The man in the pin-striped suit: Lucky Luciano and the Federal Bureau of Narcotics', in *The greatest menace*, p 108, quoted in Kalliopi Minioudaki, 'Women in pop: difference and marginality', PhD diss, New York University, New York, NY, 2009, p 127.

2 Sid Sachs, 'Drexler', in *Power up: female pop art*, Kunsthalle Wien, Austria, 2010, p 129.

3 Kalliopi Minioudaki, 'Pop's ladies and bad girls: Axell, Pauline Boty and Rosalyn Drexler', *Oxford Art Journal*, vol 30, no 3, 2007, p 411.

4 The vertical white bands are reminiscent of Barnett Newman's 'zips', a technique he used to separate fields of colour to define the painting's spatial structure.

5 Minioudaki 2007, p 134.

6 Statement by Drexler in the archival records of the Hirshhorn Museum and Sculpture Garden, Smithsonian Institution, Washington, DC, quoted in Sidra Sich, *Made in U.S.A.: an Americanization in modern art, the '50s and '60s*, University Art Museum, University of California, Berkeley, CA, 1987, p 177.

Robert Indiana
The Demuth American dream no 5 1963
page 92

1 Robert Indiana, quoted in Susan Elizabeth Ryan, *Robert Indiana: figures of speech*, Yale University Press, New Haven, CT, 2000, p 93.

2 William Carlos Williams, quoted in Robert Indiana, 'The Demuth American dream no. 5', in *Robert Indiana*, Institute of Contemporary Art, University of Pennsylvania, Philadelphia, PA, 1968, p 27.

3 Robert Indiana, quoted in Jan van der Marck, 'Foreword', in *Robert Indiana*, Dayton's Gallery, Minneapolis, MN, 1966.

4 Indiana 1968, p 27.

5 Mario Amaya, *Pop art … and after*, Viking Press, New York, NY, 1965, p 79.

Claes Oldenburg
Giant soft fan – ghost version 1967
page 106

1 Claes Oldenburg, quoted in Barbara Rose, 'Claes Oldenburg's soft machines', in Steven Henry Madoff (ed), *Pop art: a critical history*, University of California Press, Berkeley, CA, 1997, p 229. Originally published in *Artforum*, Jun 1967, pp 30–35.

2 Rose 1997, p 226.

3 Rose 1997, p 226.

4 Claes Oldenburg, quoted in Barbara Haskell, *Claes Oldenburg: object into monument*, Pasadena Art Museum, Pasadena, CA, 1971, p 53.

5 Oldenburg often created a version of his soft sculptures in canvas as a way to experiment with form. He dubbed them 'ghost versions' because of their white colour.

6 Claes Oldenburg, quoted in Haskell 1971, p 53.

7 Claes Oldenburg, quoted in Germano Celant, *Claes Oldenburg: an anthology*, Guggenheim Museum, New York, NY, 1995, p 5.

/

WHAT WAS EURO POP?
European pop art
Ann Stephen
page 111

1 This listing is taken from the invitation to the first exhibition in Düsseldorf of Kuttner, Lueg, Polke and Richter at the Ladengalerie, May 1963. Reproduced in Robert Storr, *Gerhard Richter: forty years of painting*, Museum of Modern Art, New York, NY, 2002, p 32.

2 Marcel Broodthaers, 'Gare au défi: pop art, Jim Dine and the influence of René Magritte' (1963), trans Paul Schmidt, *October*, no 42, special issue *Marcel Broodthaers: writing, interviews, photographs*, autumn 1987, p 34.

3 Niki de Saint Phalle, Gallerie Alexandre Iolas, 1965, cited by Sarah G Wilson, 'Tu es moi: the sacred, the profane and the secret in the work of Niki de Saint Phalle', Simon Groom (ed), *Niki de Saint Phalle*, Tate Publishing, London, 2008, pp 22, 110.

4 Three of the founding members of *nouveaux réalisme*, Yves Klein, Ramon and Arman, had come from Nice, like Raysse, and all identified with its hedonistic southern beach culture. See Rosemary O'Neill, 'Ecole de Nice, 1956–1971', PhD diss, City University of New York, New York, NY, 2003.

5 The exhibition *Dylaby: dynamic labyrinth* included the two Rauschenberg combines in *Pop to popism*, both titled *Dylaby*, the smaller of which was purchased by Sydney collector John Kaldor in 1966 and is now in the Art Gallery of New South Wales collection.

6 Amy J Dempsey, 'Niki de Saint Phalle enters the art scene with a bang', in Groom (ed) 2008, p 57.

7 Sarah Wilson, 'Paris in the 1960s: towards the barricades of the Latin Quarter', *Paris: capital of the arts, 1900–1968*, Royal Academy of the Arts, London, 2002, p 336.

8 Barbara Rose, 'Niki as Nana', in Groom (ed) 2008, p 86.

9 Kuttner, Lueg, Polke and Richter's proclamation about their exhibition in Düsseldorf at the Ladengalerie, May 1963. From 'Letter to a newsreel company, 29 April 1963' in Hans-Ulrich Obrist (ed), *Gerhard Richter: the daily practice of painting; writing and interviews 1962–1993* Anthony d'Offay Gallery, London, 1995, p 16.

10 Gerhard Richter, quoted in Coosje van Bruggen, 'Gerhard Richter: painting as a moral act', *Artforum*, vol XXIII, no 9, May 1985, p 86.

11 Gerhard Richter, quoted in 'Interview with Benjamin H. D. Buchloh', trans Stephen Duffy, in Roald Nasgaard, *Gerhard Richter: paintings*, Thames & Hudson, London, 1988, p 20.

12 Walter Grasskamp, 'Flamingos, colour charts, shades of brown: Capitalist Realism and German pop', in *Euro pop*, Tobia Bezzola and Franziska Lentzsch (eds), *Euro pop*, Kunsthaus, Zurich, 2008, p xlix.

13 Öyvind Fahlström, *Take care of the world*, 1966, cited in Jean-François Chevrier (ed), *Fahlström: another space for painting*, Museu d'Art Contemporani de Barcelona and ACTAR, Barcelona, Spain, 2001, pp 196–98.

14 Chevrier (ed) 2001, p 198.

15 Mike Kelley, 'Myth science', in *Öyvind Fahlström: the installations*, Cantz, Bremen-Cologne, 1996, p 23.

16 Julian Alvard, *Three trends in contemporary French art*, National Gallery of Victoria, Melbourne, 1969, p 8.

17 Thomas Crow, *The art of the sixties*, George Weidenfeld and Nicholson, London, 1996, p 145.

18 Beginning in 1968, the Power Bequest collection was annually exhibited with

accompanying exhibition catalogues featuring new acquisitions: Bernard Smith, *The Power Bequest exhibition 1968*, Power Bequest, Sydney, 1968; Elwyn Lynn, *Power Bequest exhibition 1*, Bonython Art Gallery, Sydney, 1969; Elwyn Lynn, *Power Bequest exhibition 2*, Farmer's Blaxland Gallery, Sydney, 1969. Bernard Smith invited Baj to lecture in Australia in 1969, and six of his prints were added to the Power Bequest.

19 Gordon Thomson, 'Introduction', in Alvard 1969, np. In 1967 Thomson had been the first Power curator.

Martial Raysse
Rear view mirror 1962
page 116

1 Martial Raysse, extract from the interview 'L'Ecole de Nice à la Biennale de Paris', *Communications*, no 4, Oct–Nov 1961, p 22, quoted in Didier Semin and Véronique Dabin, *Martial Raysse*, Galerie nationale du Jeu de Paume, Paris, 1992, p 46.

2 Michel Foucault, *The order of things* (trans from French *Les mots et la chose*, first published in 1966), Routledge, London and New York, NY, 2005, p 5.

Niki de Saint Phalle
Black beauty 1968
page 120

1 Martin Walkner, 'Niki de Saint Phalle', in Angela Stief and Martin Walkner (eds), *Power up: female pop art*, Kunsthalle, Wien, and DuMont Buchverlag, Köln, 2010, p 97.

2 Catherine Dossin, 'Niki de Saint-Phalle and the masquerade of hyperfemininity', *Woman's Art Journal*, vol 31, no 2, 2010, pp 34–35.

3 Kalliopi Minioudaki, 'Pop proto-feminisms: beyond the paradox of the woman pop artist', in Sid Sachs and Kalliopi Minioudaki (eds), *Seductive subversion: women pop artists 1958–1968*, University of the Arts and Abbeville Press, Philadelphia, PA, and New York, NY, 2010, p 103.

4 This is also exemplified by exhibition titles such as *Nana power* (held at La Hune, Paris, in 1970 and Svensk-Franska Konstgallerier, Stockholm, in 1971).

5 Sarah Wilson, 'The sacred, the profane and the secret in the work of Niki de Saint Phalle', in *Niki de Saint Phalle*, Tate, Liverpool, UK, 2008, p 10 (www.courtauld.ac.uk/people/wilson-sarah/NikideSaintPHALLE.pdf).

6 Realised in association with Jean Tinguely and Per Olof Ultvedt.

Gerhard Richter
Helga Matura with her fiancé 1966
page 124

1 Benjamin HD Buchloh, 'Gerhard Richter's atlas: the anomic archive', in *Gerhard Richter*, Centro per l'Arte Contemporanea Luigi Pecci, Prato, Italy, 1999, p 159.

2 Gerhard Richter, quoted in Benjamin HD Buchloh, 'Interview with Gerhard Richter', in *Gerhard Richter: paintings*, Thames & Hudson, 1988, p 17.

3 Gerhard Richter, quoted in Buchloh 1988, pp 17–18.

4 Dietmar Elger, *Gerhard Richter: a life in painting*, trans Elizabeth M Solaro, University of Chicago Press, Chicago, IL, 2009, pp 126–28.

5 Gerhard Richter, 'Interview with Doris von Drathen 1992', in Hans-Ulrich Obrist

(ed), *Gerhard Richter: the daily practice of painting: writings and interviews, 1962–1993*, Anthony d'Offay Gallery, London, 1995, p 233.

6 As Richter explained: 'A painting of a murder is of no interest whatever; but a photograph of a murder fascinates everyone. This is something that just has to be incorporated into painting.' 'Interview with Dieter Hülsmanns and Fridolin Reske, 1966', in Obrist (ed), 1995, p 57.

Enrico Baj
General 1961
page 128

1 Jean Petit, *Baj: catalogue of the graphic work and multiples, volume I 1952–1970*, Editions Rousseau, Geneva, 1973, np.

2 Transcript of lecture published as 'Enrico Baj', *Art and Australia*, Sep 1969, p 167.

3 Enrico Baj, quoted in Baj et al, 'The end of style', *Leonardo*, vol 3, no 4, Pergamon Press, Great Britain, 1970, pp 465–66. This manifesto begins with a reflection on the first manifesto of the Nuclear Movement from 1952, also co-authored by Baj, which rallied against academicism in art.

4 Enrico Baj, quoted in Ellen Wardell Lee, 'Baj on Baj: an interview with Enrico Baj', in Robert A Yassin (ed), *Enrico Baj: selections from the Milton D Ratner Family Collection*, Indianapolis Museum of Art, Indianapolis, IN, 1978, np. No doubt intensifying his interest for Baj, in 1959 de Gaulle transitioned from his military role to become the first president of the Fifth Republic of France.

5 Lucy Lippard, *Pop art*, Thames & Hudson and Frederick A Praeger, London and New York, NY, 1966, p 188.

6 Enrico Baj, quoted in 'Enrico Baj', p 167.

Erró
Pop's history 1967
page 132

1 Laurent Gervereau, in *Erró: 50 ans de collages*, Centre Pompidou, Paris, 2010, pp 31–32.

2 Christian Briend, in *Erró: 50 ans de collages*, p 18.

3 Danielle Kvaran, project manager, Erró collection, email correspondence with the author, 25 Mar 2014.

4 Gervereau 2010, pp 32–33.

Öyvind Fahlström
ESSO-LSD 1967
page 134

1 Barry Schwabsky, 'Öyvind Fahlström: Museu d'Art Contemporani de Barcelona', *Artforum International*, Mar 2001, p 138.

2 See *Öyvind Fahlström*, The Solomon R Guggenheim Museum Foundation, New York, NY, 1982, pp 66–67.

3 See Mark Francis and Hal Foster (eds), *Pop*, Phaidon, London and New York, NY, 2005, p 175; and *Öyvind Fahlström*, p 67.

4 Mike Kelly, 'Myth science', in Francis and Foster (eds) 2005, p 271.

5 Merton Peck & Frederick M Scherer, *The weapons acquisition process: an economic analysis*, Harvard Business School, Boston, MA, 1962, p 619. Note the company was operating as Standard Oil at the time.

6 Celia McGee, 'The open road wasn't quite so open to all', *New York Times*, 22 Aug 2010.

/

'THE EASEL DID NOT GO POP: IT WENT BANG!'
Australian pop art
Wayne Tunnicliffe
page 137

1 In *The Guttenberg galaxy: the making of typographic man, 1962*, University of Toronto Press, Toronto, Canada, 1962.

2 In the late 1960s Brack's flat, poster-like forms and bright, garish colours in his ballroom dance series and his portrait of *Barry Humphries in the character of Mrs Everage* 1969 (AGNSW) came to look remarkably like pop art.

3 The Melbourne exhibition opened on 13 February 1962 and the Sydney exhibition on 23 May 1962. The name Annandale Imitation Realists would seem to be a nod to the nouveaux realistes whose work they may have known of if they saw a copy of the catalogue for the 1961 *The art of assemblage* exhibition held at the Museum of Modern Art in New York.

4 There are art brut, folk art and neo-primitivist elements to these works; an important regional influence was, as art historian Richard Haese argues, 'in the traditions of the Sepik, Aboriginal and Maori cultures of Oceania – that vast resource of tribal myth and formal inventiveness that had been tapped by expressionist, dadaist and surrealist alike'. Richard Haese, *Permanent revolution: Mike Brown and the Australian avant-garde 1953–1997*, Miegunyah Press, Melbourne, 2011, p 8.

5 There had previously been minor neo-dada events, such as Barry Humphries' satirical exhibitions in Melbourne in the 1950s, and the *Muffled drums* group exhibition at Terry Clune Galleries in Sydney in 1959.

6 Daniel Thomas, 'Art is upon the town', *Sunday Telegraph*, 27 May 1962, p 66.

7 Elwyn Lynn, 'Pop goes the easel', *Art and Australia*, vol 1, no 3, 1963, pp 166–72. While the title of the article is an obvious word play that Lynn could easily have come up with, it was also the title of the remarkable 1962 film made by Ken Russell on four young British pop artists – Peter Blake, Derek Boshier, Pauline Boty, Peter Phillips – for the BBC Monitor program and the title of one of the first pop art exhibitions in the United States at the Museum of Contemporary Art, Houston, in Apr 1963.

8 Lynn cites Americans Indiana, Rivers, Dine, Segal and Oldenburg, and Warhol's *Campbell's Soup Cans*, Wesselmann's *Great American nude* series and Lichtenstein's comic strips paintings; he discusses British pop in more depth than American pop and the article is illustrated with works by Boshier, Tilson and Hockney, alongside works by the AIR, including Colin Lanceley's *Love me stripper* 1963, then owned by Robert Hughes.

9 Lynn 1963, p 168.

10 Lynn 1963, p 168. Richard Hamilton wrote a letter to Alison and Peter Smithson on 16 Jan 1957, which includes a now-famous definition of popular culture (p 11). Lynn presumably saw this definition when it was first printed in Jasia Reichardt's article 'Pop art and after', *Art International*, Feb 1963, p 43.

11 Lynn 1963, p 172. In the same edition Robert Hughes discusses the history of irrational imagery in Australian art in the early and mid twentieth century, and locates the AIR within this also relevant context. Robert Hughes, 'Irrational imagery in Australian painting', *Art and Australia*, vol 1, no 3, 1963, pp 150–59.

12 Collage had precedents in Australian art – in the work of Nolan, Klippel, Lynn, Webb and Plate amongst others – but these were often private practices known to the artists and their immediate circles. Apart from maquettes for larger paintings, Plate also made a series of collages in the mid 1940s, now in the AGNSW collection, which are clearly surrealist in inspiration, but in some he uses contemporary magazine pages and text, which echo Paolozzi's collages of the same period. Assemblage had occasionally been used by sculptors, notably by Klippel in a small group of surreal sculptures of 1947–48.

13 The reasons for its rejection became clouded when a member of the Commonwealth Arts Advisory Board, the conservative artist Douglas Pratt, claimed he was responsible.

14 For an account of this episode, see Haese 2011, pp 103–06. Tragically this significant early manifestation of Australian pop was later destroyed by the artist.

15 Daniel Thomas, 'Pop art and "ad" men', *Sunday Telegraph*, 19 Apr 1964, p 91.

16 James Gleeson, 'Young painters of true talent', *Sun*, 15 Apr 1964, p 44.

17 As part of their robust exploration of local and international developments in art, CASNSW hosted a pop art symposium in 1964, reported in their October *Broadsheet* as 'one of the most successful the society has held this year' (p 8). Chaired by Ken Reinhard with Dick Watkins, Mike Brown and Michael Allen Shaw as speakers, the *Broadsheet* also reported that the speakers 'were neither fully enough involved in the movement, nor sufficiently detached from it, to handle the subject with any feeling of confidence' (p 8).

18 This exhibition was well reviewed, with Wallace Thornton describing Reinhard in *The Sydney Morning Herald* as a 'brilliant young man', p 21; and James Gleeson wrote in *The Sun*, 'this is one of the most auspicious first one-man shows we have seen for some time', p 46; both reviews 16 Sep 1964.

19 Watkins established his eclecticism early in the decade, which was remarked on from his first reviews, both positively and pejoratively. The most well-known early pop painting by Watkins is *The west front* 1964; it shows the influence of the American artist resident in London, RB Kitaj, who was a catalyst and mentor for many of the young British artists at the Royal College of Art. *The west front* is in a private collection in Melbourne but has suffered from the vicissitudes of time, which is why it is not included in *Pop to popism*.

20 Biographical notes for Shaw in the 1960s suggest he studied at the Royal College of Art concurrently with the British pop artists and that he exhibited alongside them in the 1959 *Young contemporaries* exhibition. Research to date has not uncovered evidence for Shaw being at the RCA or exhibiting in the *Young contemporaries* exhibitions.

21 Wallace Thornton, *Sydney Morning Herald*, 9 Dec 1964, p 13.

22 The subject may seem nostalgic, but it was also topical, as David Lean's film *Lawrence of Arabia* starring Peter O'Toole was released in 1962.

23 Elwyn Lynn, 'They heave heavily', *Australian*, 29 May 1965, p 11.

24 See Deborah Hart, *Richard Larter*, National Gallery of Australia, Canberra, 2008, p 37.

25 Larter may have attended Eduardo Paolozzi's lecture at the Institute of Contemporary Arts in 1954, in which he projected through an epidiascope collages made from cut-outs of American mass-market magazines (see Hart 2008, p 25), but is more likely to have seen Paolozzi's collages when they began to be exhibited from 1954.

26 Cartooning, art, experimental films and theatre were all integral to the underground scene in Australia in the 1960s. Shead had been making an experimental film since 1961, *Ding a ding day*, which starred Sharp and Neville amongst others and was completed in 1966. They also connected with student theatre producer and then experimental filmmaker Albie Thoms who established the film collective Ubu Films in 1965.

27 Sharp cites Lanceley as an inspiration. George Alexander, 'Get Back, Martin Sharp', *Art & Text*, Jun–Aug 1987, p 99.

28 These were illustrations for the forthcoming novel by Peter Draffin, *Pop: a novelty*, Script, London and Melbourne, 1967.

29 Ben Davie, 'Everything goes', *Sun*, 13 Sep 1966, p 13; Craig McGregor, *Sydney Morning Herald*, 17 Sep 1966, p 18. Sharp illustrated McGregor's book *People, politics and pop: Australians in the 1960s*, Ure Smith, Sydney, 1968.

30 'London: the swinging city', *Time*, 15 Apr 1966; see Nick Waterlow and Annabel Pegus, *Larrikins in London: an Australian presence in 1960s London*, Ivan Dougherty Gallery, College of Fine Arts, University of New South Wales, Sydney, 2003.

31 Famously, in Australia at least, the Tate bought one of these abstract paintings – *Untitled red painting* 1960 – in 1961 when Whiteley was 22, making him the youngest artist ever bought by the Tate.

32 Whiteley wrote of his experience in New York and the genesis of this work: 'All hope of peace seemed to break apart with the evening television news. There seemed no signs of reconciliation between old and young, black and white, hip and square etc. and the eyes of the riot squad bespoke of everything one had ever imagined of human collapse.' See Sandra McGrath, *Brett Whiteley*, Bay Books, Sydney, 1979, pp 88–89.

33 Both Rooney and Sansom read *Ark* in Melbourne; Sansom recalls it being available in a 'culture room' at the State Library of Victoria. Conversation with the author, May 2014.

34 'How pop art keeps company with antiques', *Vogue Australia*, Oct 1965, pp 93–95.

35 Mario Amaya, *Pop as art: a survey of the new super realism*, Studio Vista, London, 1965; John Rublowsky, *Pop art*, Basic Books, New York, NY, 1965; *CASNSW Broadsheet*, Feb 1966, p 7.

36 Bryan Robertson, John Russell and Lord Snowden, *Private view, the lively world of British art*, Thomas Nelson, London, 1965.

37 This painting was titled *Decorative painting two friends* in the Lynn article, but exhibited as *Two friends* at the AGNSW; it has subsequently also been known as *Two friends (in a cul-de-sac)*.

38 Elwyn Lynn, 'The travelling exhibition of selected paintings from the James A Michener Foundation Collection', *Art and Australia*, vol 2, no 3, Dec 1964, p 204. International pop prints began also to be seen in Australia in the mid 1960s in touring exhibitions, in private collections and at commercial galleries. The print and multiple boom in the 1960s was a highly effective way to distribute work globally and remains the largest representation of 1960s international pop practice in Australian public collections.

39 'Pop art: cult of the commonplace', *Time*, 3 May 1963, pp 73–75. Sonnabend was to become one of the great dealers in pop art, along with her ex-husband Leo Castelli's gallery in New York; Kaldor established an enduring friendship and professional relationship with both.

40 Kaldor also collected significant works by Christo, who was sometimes associated with pop in the 1960s, prior to commissioning Christo's major Sydney project *Wrapped coast, Little Bay* in 1969. Lucy Lippard included Christo in her seminal book Lucy Lippard et al, *Pop art*, Thames & Hudson, London, 1966. The works by Christo, Lichtenstein and Rauschenberg remain in the John Kaldor Family Collection, and *Peanut butter cup* 1962 and *Dylaby* 1962 are both included in this exhibition.

41 Sansom and Rooney cite Hockney, Boshier, Blake and other artists associated with British pop as influences. 'On the prowl, Gareth Sansom talks to Robert Rooney', in Francis Lindsay (ed), *Gareth Sansom Paintings 1956–1986*, University Gallery, University of Melbourne, Melbourne, 1986, p 14.

42 Terence Maloon, 'Gareth Sansom and the music of the spheres', in Bala Starr (ed), *Welcome to my mind: Gareth Sansom, a study of selected works 1964–2005*, Ian Potter Museum of Art, University of Melbourne, Melbourne, 2005, p 15.

43 Sansom, interviewed by Claudia Wright, 'Candid boy of canvas', *Sydney Morning Herald*, 31 Jul 1968, p 32.

44 Noel Hutchison, *Sydney Morning Herald*, 22 Aug 1968, p 14.

45 *American pop art prints*, Central Street Gallery, Sydney, 19 Apr – 13 May 1966.

46 *American prints and posters*, Central Street Gallery, Sydney, 4–29 Jul 1967. Works by Johns, Warhol, Oldenburg, Rauschenberg, Indiana and Lichtenstein were shown with a diverse group of works by Jackson Pollock, Helen Frankenthaler, Ellsworth Kelley, Joseph Albers and Victor Vasarely, amongst others.

47 Watkins recounts that the title of these two paintings was a response to a review by Elwyn Lynn, in which he described Watkins' works as a 'fall from grace'. Email from Dick Watkins to Sarah Hetherington, May 2014.

48 *The fall no 1* was included in the exhibition of works for Clement Greenberg on 22 May 1968 at the University of Sydney Staff Club, by which he seems to have been unimpressed, regarding Australian hard edge as 'not good enough'; recounted in Daniel Thomas, 'Introduction', in Mervyn Horton (ed), *Present day art in Australia*, Ure Smith, Sydney, 1969.

49 *Alan Oldfield and Wal Randolph*, Watters Gallery, Sydney, opened 26 Oct 1966; *Survey 7*, Farmer's Blaxland Gallery, Sydney, 16–26 Aug 1967.

50 Slides held in the AGNSW archives.

51 See Jenepher Duncan's exemplary 'Robert Rooney: biography', in *From the homefront: Robert Rooney works 1953–88*, Monash University Gallery, Melbourne, 1988.

52 The exhibition had toured Japan and India, beginning in 1966, before coming to the NGV 6 Jun – 9 Jul and the AGNSW 26 Jul – 26 Aug 1967.

53 Andy Warhol's *Electric chairs* 1964 is now titled and dated *Triple silver disaster* 1963; *Jackies* 1964 consisted of 42 panels and is now a 35-panel work known as *Thirty-five Jackies* 1964; the six works that comprised *Campbell's soup* 1965 are now individually catalogued as *Coloured Campbell's soup can* 1965. While some of the works in the exhibition were for sale, none of the pop works were purchased for Australian collections. It was not until 1973 that major American pop works were purchased by James Mollison for the national collection, beginning with Andy Warhol's *Elvis* 1963 in 1973.

54 Charles Green and Heather Barker, 'The watershed: *Two decades of American painting* at the National Gallery of Victoria', *Art Journal of the National Gallery of Victoria*, Melbourne, 2011, pp 65–77.

55 Patrick McCaughey, 'Great American moderns', *Age*, 10 Jun 1967, p 24.

56 Wallace Thornton, 'An art survey to remember', *Sydney Morning Herald*, 19 Jul 1967, p 15; James Gleeson, 'It's a landmark in art shows', *Sun*, 18 Jul 1967, p 32.

57 Earlier in the year there had been the chance to see firsthand more examples of British pop when *Aspects of new British art* toured state galleries and included significant pop constructions by Tilson and Allen Jones' paintings, including *Reflected man* 1963. The first Power collection exhibition in 1968 included Jones' typically fetishist *Come in* 1967. In 1968 *Marcel Duchamp: the Mary Sisler Collection* toured state galleries, and Duchamp was identified as an important precursor to pop art by this stage. The most significant grouping of British pop art to come to Australia was not until 1970 in *Recent British painting: a Peter Stuyvesant Foundation collection* at the Art Gallery of South Australia for the Adelaide Festival of Arts in March 1970. It included major 1960s pop works by Blake, Boshier, Caulfield, Kitaj, Jones and Phillips.

58 Binns studied at the National Art School, East Sydney, at the same time as the AIR artists and as Martin Sharp. She was later involved in a brief but intense relationship with Mike Brown.

59 Ann Stephen, 'At the edge of a feminist criticism: an interview with Lucy Lippard', *Meanjin Quarterly*, vol 34, issue 4, Dec 1975, p 384.

60 Noel Hutchison, *The Union Recorder*, 26 Mar 1969, p 9.

61 For a discussion of this critical response, see Jenny Phillips, 'Man of savage passion', *Australian*, 30 Mar 1968, p 11.

62 Ken Reinhard, quoted in Sandra McGrath 'Chrome goddesses from a modern Olympus', *Australian*, 30 Sep 1972, p 15.

63 James Gleeson, *Sun*, 20 Jun 1973, p 56.

64 Apart from the artists explored in this essay who have a more direct engagement with pop art, a dispersed pop style of contemporary urban subjects, often with collage elements and which blended abstraction and figuration, was common in painting by this time, both in the work of older artists such as Louis James and younger artists like Bill Brown.

65 Craig McGregor, David Beal, David Moore and Harry Williamson, *Australian art and artists in the making*, Thomas Nelson (Australia), Melbourne and Sydney, 1969; Mervyn Horton *Present day art in Australia*, Ure Smith, Sydney and London, 1969, p 11.

66 James Gleeson, *Modern painters 1931–1970* (Australian painting studio series), Lansdowne Press, Melbourne, 1971, p 11; Bernard Smith *Australian painting 1788–1970*, 2nd rev edn, Oxford University Press, London, 1971, p 387.

67 Robert Hughes, *The art of Australia*, rev edn, Penguin Books, Harmondsworth, UK, 1970.

68 Thomas 1969, p 8. Thomas goes on to identify three genuine pop artists: Michael Allen Shaw, Richard Larter and Ken Reinhard.

69 Reinhard, who is identified by Thomas and Smith as one of our most international pop artists, sold very few works in the 1960s. His use of a commercial style seems to have been too close to commercialism to be respected as art by collectors.

Mike Brown, Ross Crothall, Colin Lanceley
Byzantium 1961–62
page 148

1 Annandale is a suburb in Sydney's inner west.

2 The 'crown' was Mike Brown's individual creation, titled 'The happy cat', cat no 71. See Richard Haese, *Permanent revolution: Mike Brown and the Australian avant-garde 1953–1997*, Miegunyah Press, Melbourne, 2011, p 80. For installation photographs, see Anthea Gunn, 'Here in Byzantium: Ross Crothall's trans-Tasman career', *Australian and New Zealand Journal of Art*, vol 12, 2012, p 84. All 'appendages' were later 'dismembered' from the work.

3 William Butler Yeats, 'Byzantium' 1930, was first published in WB Yeats, *Words for music perhaps and other poems*, Cuala Press, Dublin, 1932.

4 See Joe Klinkerbof, 'Poor little Beat girl', *Australian Women's Weekly*, 19 Aug 1959, p 37.

5 Jack Kerouc, 'Belief and technique for modern prose', in César Graña and Marigay Graña (eds), *On bohemia: the code of the self-exiled*, Transaction Publishers, New Brunswick, Canada, 1990, pp 620–22.

6 The beat generation's leading artists, Wallace Berman and Bruce Connor, were considered the 'fathers' of California assemblage art.

7 *The subterraneans*, film, 89 min, Arthur Freed Productions and Metro-Goldwyn-Mayer Corp, 1960.

8 Ross Crothall, 'Letter to the editor', *Arty Wild Oat*, no 2, Jul 1962, p 2, cited in Gunn 2012, p 88.

Colin Lanceley
Love me stripper 1963
page 150

1 Art historian and critic Robert Hughes cites a popular pulp fiction novel as a

source for the title of this work, but while there was a plethora of pulp novels at this time featuring strippers, it has not been possible to trace a novel titled 'Love me stripper'. Robert Hughes and William Wright, *Colin Lanceley*, Craftsman House, Sydney, 1987, p 10.

2 Elwyn Lynn, 'Pop goes the easel', *Art and Australia*, vol 1, no 3, 1963, pp 166–72.

3 Robert Hughes, 'Irrational imagery in Australian painting', *Art and Australia*, vol 1, no 3, p 153.

4 Frank Cozzarelli, 'Rubenstein: hack's birthright', *Art and Australia*, vol 2, no 3, 1964, pp 184, 186.

Tony Tuckson
Pyjamas and Herald 1963
page 152

1 Tony Tuckson, quoted in Daniel Thomas, *Tony Tuckson 1921–1973*, Watters Gallery and Margaret Tuckson, Sydney, 1982, p 9.

2 Leo Steinberg, *Other criteria*, Oxford University Press, London, Oxford and New York, 1972, p 91.

3 Steinberg 1972, p 88.

Mike Brown
Hallelujah! 1965
page 154

1 See Bernard Smith and Terry Smith, *Australian painting 1788–1990*, 3rd edn, Oxford University Press, Melbourne, 1995, pp 333–52.

2 Drawing upon the anti-art of dadaism, from 1963 to 1966 Brown adopted and abandoned current styles, including pop art.

3 See Elwyn Lynn, 'Officially approved meaningless', *Australian*, 20 Nov 1965, p 12.

Vivienne Binns
Vag dens 1967
page 156

1 Beverly Garlick and Janine Burke, 'Six women artists', *Meanjin*, vol 38, no 3, Sep 1979. Also noted by Joan Kerr, 'The art of Vivienne Binns', *Art and Australia*, vol 30, no 3, autumn 1993, p 338. The quote referenced is Kerr's.

2 Elwyn Lynn, 'Ruffling plumage', *The Bulletin*, 18 Feb 1967; John Henshaw, *Australian*, 11 Feb 1967, p 13; Wallace Thornton, *Sydney Morning Herald*, 1 Feb 1967, p 15. These and other reviews were reproduced as a form of parody in the feminist journal *Refractory Girl*, no 8, Mar 1975, p 16.

3 Helen Sweeney wrote of Binns' 'ungirlish impulse to shock' in 'The week in art', *Sunday Telegraph*, 5 Feb 1967, p 103. Joan Kerr wrote of the entrenched view in the 1960s of the avant-garde as an all-male territory in *Art in Australia* 1993, p 338.

4 Rodney Milgate, 'She's a shocker', Feb 1967, unsourced press clipping, Watters Gallery file, AGNSW Research Library and Archive; also cited in *Refractory Girl*, no 8, Mar 1975, p 16.

Richard Larter
Dithyrambic painting no 6 1965
page 161

1 Wallace Thornton, 'Leonard French at Rudy Komon and other exhibitions', *Sydney Morning Herald*, 1 Sep 1965, p 13.

2 James Gleeson, 'French gives us gems', *Sun*, 1 Sep 1965, p 22.

3 Richard Larter, 'Still trying to learn: the Richard Larter story', in Richard Larter, *Incondite incantations for Pat*, self-published, Canberra, 2000, p 102.

4 Richard Larter, 'Commentary on paintings sent to Frank Watters by a not really a pop painter, hot line linearity perhaps?', manuscript notes from MS2004.7, Watters Gallery Archive, box 33, folder 5, AGNSW Research Library and Archive, Sydney.

5 Larter 2000, p 2.

6 Daniel Thomas, 'Architecture and art', *Telegraph*, 5 Sep 1965, p 8.

7 'I remember *Dithyrambic painting no 6* coming into the gallery ... the fact that it was the McGraths giving the painting meant it was accepted. If the donor had been from a less establishment background ... they would have rejected it.' Email from Joanna Mendelssohn to Steven Miller, 31 Mar 2014.

8 Thornton, 'Leonard French at Rudy Komon and other exhibitions'.

9 In 1888 Nietzsche published a collection of nine poems entitled *Dionysos-Dithyramben*.

Ken Reinhard
Ticket box 1966
page 162

1 For an account of the artist's affinity with American pop art, see transcript of Ken Reinhard, interview with James Gleeson, 25 Sep 1979, sound recording, 'James Gleeson oral history collection', National Gallery of Australia Research Library, Canberra, p 9.

2 Ken Reinhard in *Chance*, Adelaide, vol 1, no 5, 1967, p 51, quoted in Ken Scarlett, *Australian sculptors*, Thomas Nelson (Australia), West Melbourne, 1980.

3 For example, Alfred Lee, '£100 a pop: is it really art?', *Sun*, Sydney, 17 Sep 1965, p 5; Daniel Thomas, 'No! No! 171 times no! That's what the judges said about entries in this year's £900 Archibald Prize', in *Sunday Telegraph*, Sydney, 24 Jan 1965, pp 8–9.

4 Anonymous, 'Music in paintings', *Sun*, Sydney, 30 Jan 1966, p 17.

5 Ken Reinhard, quoted in Gawen Rudder, 'Controversy?' in *Broadsheet of the Contemporary Society of South Australia (NSW branch)*, Sydney, Mar 1966, pp 2–3.

Martin Sharp
Mister Tambourine Man 1967
page 166

1 'I adored that song, "Mister Tambourine Man".' Sharp, quoted in Norman Hathaway and Dan Nadel, *Electrical banana, masters of psychedelic art*, Damiani Editore, Bologna, Italy, 2011, p 39.

2 'I remember my dear friend Eifa Vehka-aho creating all the beautiful circles that make up Bob Dylan's hair.' Martin Sharp, quoted in *Australian art in the National Gallery of Australia*, National Gallery of Australia, Canberra, 2002, p 263.

3 Hathaway and Nadel 2011, p 41.

Robert Rooney
Superknit 1 1969
page 174

1 Robert Rooney, artist statement, in *Project 8: Robert Rooney*, Art Gallery of New South Wales, Sydney, 1975, np.

2 Rooney claims it was American artist James Doolin who first pointed out to him that his works were funny. See Denise

Mimmocchi, Simon Ives interview with Robert Rooney, 24 Sep 2010, AGNSW files.

3 GR Lansell, 'Subversive Rooney', *Nation*, 19 Sep 1970, p 20.

4 Rosemary Adam, 'Spons I have seen', in *From the homefront: Robert Rooney works 1953–1988*, Monash University Gallery, Melbourne, 1990, p 11.

5 In his interview with Rooney, Gary Catalano refers to 'devalued designs'. See Gary Catalano, *Building a picture: interviews with Australian artists*, McGrawHill, Sydney, 1997, p 65. Rooney was alert to the pun of his cereal/serial paintings.

6 Robert Rooney, letter to John and Rosemary Adam, nd, cited in Adam 1990, p 13.

7 Rooney revised these themes in his photographic practice throughout the 1970s.

8 Lansell, p 20.

Peter Powditch
Seascape II 1969
page 180

1 James Gleeson, 'A slice of originality', *Sun Herald*, 24 May 1970.

2 GR Lansell, 'Sydney's new men', *Nation*, 25 Mar 1967, p 19.

3 Peter Powditch, quoted in Jenny Phillips, 'Man of savage passions', *Australian*, 30 Mar 1968.

4 Peter Powditch, quoted in Andrew Saw, 'A search for subtlety', *Weekend Australian*, 15–16 May 1982, p 16.

/

A DIVIDED CONSCIOUSNESS
Pop art after 1968
Justin Paton
page 187

1 Richard Hamilton, *Richard Hamilton: collected words 1953–1982*, Thames & Hudson, London, 1982, p 94.

2 Robert Hughes, *The shock of the new*, rev edn, Knopf, New York, NY, 1991 (1980), p 354.

3 Don DeLillo, *Underworld*, Picador, London, 1998 (1997), p 84.

4 Robert Rosenblum, 'Andy Warhol: court painter to the 70s', in *On modern American art: selected essays by Robert Rosenblum*, Harry N Abrams, Inc, New York, NY, 1999.

5 Bradford R Collins, *Pop art*, Phaidon, London, 2012, p 368.

6 Peter Schjeldahl, *The hydrogen jukebox*, University of California Press, Berkeley and Los Angeles, CA, 1991, p 49.

7 Tony Judt, *Postwar: a history of Europe since 1945*, Vintage Books, London, 2009 (2005), p 396.

8 See Victor Arwas, 'Allen Jones', in *Allen Jones*, Academy Editions, London, 1993, p 35.

9 Allen Jones, quoted in Arwas 1993, p 39.

10 I rely here on Deborah Hart's discussion in Deborah Hart, *Richard Larter*, National Gallery of Australia, Canberra, 2008, pp 61, 63.

11 Hart 2008, p 40. Brown's sentence was reduced to a fine.

12 Judt 2009, p 453.

13 Ed Ruscha, quoted in Neal Benezra, 'Ed Ruscha: painting and artistic license', in *Ed Ruscha*, Hirshhorn Museum and Sculpture Garden, Smithsonian Institution, Washington, DC, Museum of Modern Art, Oxford and Scalo, 2000, p 150. Tom Wesselmann's relationship with the label was spelt out in the title of a 2012 survey of his art: *Beyond pop*; Caulfield's relationship with, and resistance to, the 'pop' label is discussed by Marco Livingstone in *Patrick Caulfield*, Lund Humphries, Aldershot, UK, 2005, pp 250–51.

14 Collins 2012, p 331.

15 'Interview with Martha Rosler', http://artpulsemagazine.com/interview-with-martha-rosler (accessed Apr 2014).

16 This was the title of a 2012 exhibition curated by de Salvo and Rothkopf at the Whitney Museum of American Art, New York.

Richard Hamilton
Swingeing London 67 – sketch 1968
page 192

1 They were photographed by press photographer John Twine, for *The Daily Sketch*.

2 The reports grew increasingly divergent and divorced from the facts of the case, which Hamilton parodied in a lithographic poster *Swingeing London 67 – poster* 1967–68 (Tate), replicating contemporary press cuttings on the scandal as if glued on a scrap book page.

3 'I ... felt a strong personal indignation at the insanity of legal institutions which could jail anyone for the offence of self-abuse with drugs.' See Richard Hamilton, 'The swinging sixties', *Collected words, 1953–1982*, Thames & Hudson, London, 1982, p 104.

4 For an excellent, focused account and analysis of the series, see Andrew Wilson, *Richard Hamilton Swingeing London 67 (f)*, Afterall Books, London, 2011.

5 See Hamilton 1982, p 104.

6 Drawing and printmaking were major aspects of Hamilton's practice; this series marked a return to etching, a technique he had not used since the mid 1950s.

Martha Rosler
House beautiful: bringing the war home 1967–72
page 196

1 Martha Rosler, quoted in Rebecca Morse, 'Martha Rosler', in Cornelia Butler and Lisa Gabrielle Mark (eds), *WACK! Art and the feminist revolution*, MIT Press, Cambridge, UK, 2007, p 290.

Evelyne Axell
Le retour de Tarzan 1972
page 206

1 Art critic Pierre Restany declared these words during a stormy debate he led on 'The sexual revolution in art', following a performance by Axell at Foncke Gallery in Ghent, Belgium, in 1969.

David Hockney
Portrait of an artist 1972
page 210

1 David Hockney, 'Making paper pools', in *David Hockney Paper Pools*, Thames & Hudson, London, 1980, p 100.

2 Hockney 1980, p 48.

3 Statement by the artist for the *The new generation* catalogue, Whitechapel Art Gallery, London, 1964.

4 *A bigger splash*, screenplay by Jack Hazan and David Mingay, directed by Jack Hazan, Buzzy Enterprises, London, 1974.

5 Nikos Stangos (ed), *David Hockney by David Hockney*, Thames & Hudson, London, 1976, p 248.

6 Hockney gives a detailed account of how he created this painting in Stangos (ed) 1976, pp 240, 242, 247. Hockney began an earlier version of the painting in September 1971, reworking it in 1972. He eventually destroyed that version and repainted the work entirely in two weeks, changing the angle of the pool.

7 David Hockney, quoted in Martin Gayford, *A bigger message: conversations with David Hockney*, Thames & Hudson, London, 2011, p 50.

Martin Sharp, Tim Lewis
Still life 1973
page 218

1 Martin Sharp, quoted in Christine France, 'Martin Sharp, a democratic surrealism', *Art and Australia*, vol 47, no 1, spring 2009, p 96.

2 'Art exhibition' opened at Bonython Gallery, Sydney, 5 Apr 1973, in conjunction with the Australian release of Sharp's *Art book* (Mathews Miller Dunbar, London, 1972).

3 'Martin Sharp interviewed by Nick Waterlow', in *The everlasting world of Martin Sharp, paintings from 1948 to today*, Ivan Dougherty Gallery, Sydney, 2006, pp 13–14.

4 'Martin Sharp interviewed by Nick Waterlow', p 14.

Brett Whiteley
The American Dream 1968–69
page 222

1 Brett Whiteley, letter to Beryl Whiteley from New York, 1968. Cited in Barry Pearce, 'Persona and the painter', in Barry Pearce (ed), *Brett Whiteley: art and life*, Art Gallery of New South Wales, Sydney, 1995, p 34.

2 Brett Whiteley, quoted in 'Painting: plaster apocalypse', *Time*, 10 Nov 1967.

3 Brett Whiteley, quoted in Sandra McGrath, *Brett Whiteley*, Angus and Robertson, Sydney, rev edn, 1992, p 69.

4 Brett Whiteley, quoted in Adrian Read, 'He climbed into his own picture', *Australian*, 8 Nov 1969.

5 Brett Whiteley, quoted in McGrath 1992, p 67.

6 Brett Whiteley, quoted in Pearce 1995, p 22.

7 Brett Whiteley, quoted in McGrath 1992, p 72.

Richard Larter
Prompt Careb and how we never learn 1975
page 230

1 Richard Larter, 'A timely word of advice from above', *Bulletin*, no 2, c1968, MS2004.7, Watters Gallery Archive, box 33, folder 4, AGNSW Research Library and Archive, Sydney.

2 Richard Larter, 'For limited circulation. Only those alive shall read', *Bulletin*, no 1, c1968, MS2004.7, Watters Gallery Archive, box 33, folder 4 and Notebook, box 33, folder 5, AGNSW Research Library and Archive, Sydney.

3 Richard Larter, 'Still trying to learn: the Richard Larter Story', in *Incondite*

incantations for Pat, self published, Canberra, 2000, p 7.

4 *This is tomorrow* at the Whitechapel Art Gallery, London, in Aug 1956.

5 Richard Larter, 'Commentary on paintings sent to Frank Watters by a not really a pop painter, hot line linearity perhaps?', manuscript notes from MS2004.7, Watters Gallery Archive, box 33, folder 5, AGNSW Research Library and Archive, Sydney.

6 Richard Larter, 'Rome burns', *Bulletin*, no 6, c1968, MS2004.7, Watters Gallery Archive, box 33, folder 4, AGNSW Research Library and Archive, Sydney.

7 *Richard Larter non-exhibition*, Watters Gallery, Sydney, 16–19 Aug 1967.

8 Richard Larter, *Manifesto*, 25 Apr 1967, Watters Archive, MS2004.7, Watters Gallery Archive, box 33, folder 4, AGNSW Research Library and Archive, Sydney.

/

ART OF THE SECOND DEGREE
Post pop & popism
Anneke Jaspers
page 233

1 In particular, regarding authorship and originality (as an extension of the territory already staked out by pop art), critical self-reflexivity, non-traditional art contexts and materials, cross-disciplinary engagement and cultural positions beyond the mainstream.

2 Douglas Eklund, *The pictures generation, 1974–1984*, Metropolitan Museum of Art, New York, NY, 2009, p 16.

3 *Popism*, National Gallery of Victoria, Melbourne, 16 Jun – 25 Jul 1982.

4 Paul Taylor, *Popism*, National Gallery of Victoria, Melbourne, 1982, p 2.

5 The collective ⌐↱ (also referred to as Tsk Tsk Tsk or Tch Tch Tch) formed in Melbourne in 1977 and was active for the following decade with the involvement of various collaborators.

6 See, for example, Memory Holloway, 'Popism', *Art Network*, no 7, spring 1982, pp 16–18; and Alison Fraser, 'Popism', in Leon Paroissien (ed), *Australian Art Review*, Warner Associates and Oxford University Press, Melbourne, 1983, pp 90–94.

7 *Art in the age of mechanical reproduction*, George Paton Gallery, University of Melbourne, 7–28 Jul 1982. An important precursor was *Noise & Muzak*, George Paton Gallery, 27 Jul – 7 Aug 1981.

8 Walter Benjamin, 'The work of art in the age of mechanical reproduction' (1936), in Hannah Arendt (ed), Harry Zohn (trans), *Illuminations*, Schocken Books, New York, NY, 1969, pp 217–51.

9 Rex Butler, 'Introduction', in Rex Butler (ed), *What is appropriation?*, 2nd edn, Institute of Modern Art, Brisbane, 2004, p 20. Butler's expansive essay, first published in 1996, remains the most authoritative overview on appropriation practices in Australia throughout the 1980s.

10 Paul Taylor, 'Australian "new wave" and the "second degree"', *Art & Text*, no 1, autumn 1981, pp 23–32. In the same issue, artist Philip Brophy reviews Dick Hebdige's related and definitive text *Subculture: the meaning of style*, Methuen, London, 1979.

11 Taylor later included Guy Debord's pithy summation of détournement – the

misappropriation and 'reinvestment' of extant artistic elements by the Situationist International – as the opening statement in his edited anthology on post-pop art. See Guy Debord, 'Detournement as negation and prelude', in Paul Taylor (ed), *Post-pop art*, MIT Press, Cambridge, MA, 1989, pp 7–9.

12 Taylor 1981.

13 Terry Smith, 'The provincialism problem', *Artforum*, vol 13, no 1, Sep 1974, pp 54–59.

14 Imants Tillers, 'Locality fails', *Art & Text*, no 6, 1982, p 60. See also Tillers' later essays, 'Fear of texture', *Art & Text*, no 10, 1983, pp 8–18; and 'In perpetual mourning', *ZG/Art & Text*, no 11, Sep 1984, pp 22–23.

15 Paul Taylor, 'A culture of temporary culture', *Art & Text*, no 16, summer 1984, pp 94–106 (specifically p 96).

16 Paul Taylor, 'Popism – the art of white Aborigines', *Flash Art*, no 112, May 1983, pp 48–50; Tillers 1984; and drawing also on Anthony Gardner's account in 'Post-provincial, still peripheral: Australian art on the global stage 1980–2009', in Jaynie Anderson (ed), *The Cambridge companion to Australian art*, Cambridge University Press, Cambridge, UK, and Melbourne, 2011, p 234.

17 Taylor 1983, p 48. Such an appropriation of Aboriginality, which had broader purchase in the local context, was later dismissed as neo-colonial and fantasy: see, for example, Juan Davila, 'Aboriginality: a lugubrious game', *Art & Text*, no 23/24, Mar–May 1987, pp 53–56; and Adrian Martin, 'Before and after *Art & Text*', *Agenda*, issue 2, vol 1 (art papers supplement), 1988, p 18. For a detailed account of the dialogue between Aboriginal and contemporary art in Australia throughout the 1980s, see Ian McLean, 'Strategic Aboriginalism: Paul Taylor, postmodernism, neo-expressionism and Aboriginal art', in Helen Hughes and Nicholas Croggon (eds), *Impresario: Paul Taylor, the Melbourne years, 1981–1984*, Surpllus and MUMA, Melbourne, 2014, pp 34–56.

18 Taylor 1983, p 48.

19 Taylor 1982, p 3; and Taylor 1983, p 49.

20 Christina Davidson, 'Interview: Paul Taylor', *Art Network*, no 10, 1983, p 46; see also Tillers 1983, pp 12–13.

21 See Paul Taylor, 'Angst in my pants', *Art & Text*, no 7, 1982, pp 48–60.

22 Philip Brophy, 'A face without a place', *Art & Text*, no 16, summer 1984, p 79.

23 See Adrian Martin, 'Living on the surface', lecture delivered 23 Jun 1982 at the National Gallery of Victoria in conjunction with *Popism*, published in Hughes and Croggon (eds) 2014, pp 167–79.

24 Leo Steinberg, 'Other criteria', in *Other criteria: confrontations with twentieth-century art*, Oxford University Press, New York, NY, 1972, pp 55–91 (specifically p 82 onwards).

25 Philip Brophy, 'A face without a place', p 74 (fn 1).

26 Robert Lewis, interview with ⌐↱, *VOX*, 16 Apr 1981, reprinted in *Made by ⌐↱, 1977–1982*, self-published, Melbourne, 1983, p 86.

27 Andy Warhol and Pat Hackett, *POPism: the Warhol sixties*, Harcourt Brace Jovanovich, New York, NY, 1980.

In retrospect, Robert Rauschenberg's screenprint works of the 1960s and Gerhard Richter's photo paintings can also be seen as important precursors, given their emphasis on the re-mediation of mass-circulation photographic imagery.

28 James Lawrence, 'Studio artist', in *Roy Lichtenstein: a retrospective*, Art Institute of Chicago and Tate Modern, London, 2012, p 74.

29 See in particular, Douglas Crimp, 'Pictures', *October*, vol 8, spring 1979, pp 75–88; 'On the museum's ruins', *October*, vol 13, summer 1980, pp 41–57; 'The photographic activity of postmodernism', *October*, vol 15, winter 1980, pp 91–101; and Craig Owens, 'The allegorical impulse: toward a theory of postmodernism', part 1, vol 12, spring 1980, pp 67–86, and part 2, vol 13, summer 1980, pp 58–80.

30 See Owens 1980, part 2, pp 77–80.

31 Sherman and Kruger exhibited in the Biennale of Sydney, 11 Apr – 17 Jun 1984, and their works then toured with a selection from the show to George Paton Gallery in Melbourne, 16 Jul – 3 Aug 1984; Prince was included in the Biennale of Sydney, 16 May – 6 Jul 1986; Kruger showed again in the Biennale of Sydney, 18 May – 3 Jul 1988, which also toured to the National Gallery of Victoria, Melbourne, 4 Aug – 18 Sep 1988; and in the same year the Australian Centre for Photography, Sydney, presented the solo project *Barbara Kruger: the trips of power: billboard works*, 10 May – 30 Jun. Works by all three artists entered public and private collections in Australia during the decade and had further exposure in these contexts.

32 Jean Baudrillard, 'The precession of simulacra, *Art & Text*, no 11, spring 1983, pp 3–47; Jean-François Lyotard, 'Les Immaterioux', *Art & Text*, no 17, Apr 1985, pp 47–57. As noted by Gardner 2011, p 234, and Charles Green, *Peripheral vision: contemporary Australian art 1970–1994*, Craftsman House, Sydney, 1995, p 71.

33 Haring visited Australia for three weeks in 1984, executing temporary murals at the National Gallery of Victoria, Melbourne (21–22 Feb) and Art Gallery of New South Wales, Sydney (28 Feb – 1 Mar), and a third and still surviving outdoor mural at Collingwood Technical College, Melbourne (6 Mar); he held a solo exhibition at the Australian Centre for Contemporary Art, Melbourne, 10 Oct – 17 Nov 1985, and a solo exhibition of prints at the Roslyn Oxley9 Gallery, Sydney, 20 Feb – 8 Mar 1986.

34 An observation that draws on Philip Brophy's broader diagnosis of pop art's response to its own popularisation in the 1970s in 'Robert Rooney as pop', *From the homefront: Robert Rooney works 1853–1988*, Monash University Gallery, Melbourne, 1990, p 22.

35 Owens 1980, part 2, p 79.

36 Paul Taylor, quoted in Davidson 1983, p 46.

37 *Pop art 1955–70* (organised under the auspices of the International Council of the Museum of Modern Art, New York), Art Gallery of New South Wales, 27 Feb – 14 Apr 1985; Queensland Art Gallery, 1 May – 2 Jun 1985; and National Gallery of Victoria, 26 Jun – 11 Aug 1985.

38 Taylor 1982, p 12.

Jenny Watson
A painted page 1:
Twiggy by Richard Avedon 1979
page 240

1 Chris McAuliffe, 'Trying to live now: chronoptic figures in Jenny Watson's *A painted page* series', http://contemporaneity.pitt.edu/ojs/index.php/contemporaneity/article/view/98 (accessed Jun 2014). McAuliffe discusses that Avedon's role was to 'compress time and space into utter contemporaneity'; to create a visual statement of 'Now'.

2 Paul Taylor, 'Jenny Watson's "Mod"ernism', *Art International*, vol 24, nos 5–6, Sep–Oct 1980, pp 209, 217.

3 McAuliffe 2014, np.

4 Yet the image of Twiggy is complex and unresolved. While it reflects the emancipation of young women, it does so within the framework of fashion photography, which in essence emphasises physical appearance, objectifying the predominantly female models.

5 McAuliffe 2014, np. Jenny Watson identifies as a feminist in an interview, published in Geoffrey De Groen, *Conversations with Australian artists*, Quartet Books, Melbourne, 1978, p 25.

Juan Davila
Miss Sigmund 1981
page 250

1 Exemplified also by the censorship of Davila's painting *Stupid as a painter* 1981 during the 1982 Biennale of Sydney.

2 *Comic stripping*, George Paton Gallery, Melbourne, 1983, pp 10–11.

3 Though Davila explicitly denies making reference to Porter's song.

4 Juan Davila, interview with Paul Foss, published in Paul Taylor, *Hysterical tears: Juan Davila*, Greenhouse Publications, Richmond, Vic, 1985, p 15.

5 Taylor 1985, pp 14, 20.

Cindy Sherman
Untitled 1982
page 254

1 Abigail Solomon-Godeau, 'The woman who never was: self-representation, photography, and first-wave feminist art', in Cornelia Butler and Lisa Gabrielle Mark (eds), *WACK! Art and the feminist revolution*, MIT Press, Cambridge, MA, 2007, p 339.

Richard Prince
Untitled (cowboy) 1980–89
page 256

1 Nancy Spector, 'Nowhere man', in *Richard Prince*, Guggenheim Museum, New York, NY, 2007, p 34.

2 Prince, 'Practicing without a licence 1977', www.richardprince.com/writings/practicing-without-a-license-1977/ (accessed Jul 2014).

3 Richard Prince, letter to Craig Owens, 1982, quoted in Lisa Phillips, *Richard Prince*, Whitney Museum of American Art, New York, NY, 1992, p 33.

4 Hal Foster, 'The expressive fallacy', in *Recordings: art, spectacle, cultural politics*, Port Townsend, Bay Press, Washington, DC, 1985, p 68.

Jeff Koons
Three ball 50/50 tank
(Spalding Dr JK Silver series) 1985
page 261

1 Jeff Koons, quoted in David Sylvester, 'Jeff Koons (2000)', *Interviews with American artists*, Chatto and Windus, London, 2001, p 340.

Howard Arkley
Triple fronted 1987
page 266

1 Howard Arkley, quoted in Ashley Crawford and Ray Edgar, *Spray: the work of Howard Arkley*, Craftsman House, North Ryde, NSW, 1997, p 31.

2 For Arkley's account of his association with popism, see Richard Brown, 'Howard Arkley: spraying the suburban dream', *Tension*, no 18, Oct 1989, pp 35–41.

3 See Richard Brown and Virginia Trioli, *Howard Arkley: casual works: working drawings, source material, doodles*, Gertrude Street Artists Spaces, Fitzroy, Vic, 1988.

Gilbert & George
Friendship 1982
page 274

1 Gilbert & George directly relate this turning point to acquiring a new studio in which they taught themselves to make bigger, more complex works. See François Jonquet, *Gilbert & George: intimate conversations with François Jonquet*, Phaidon Press, New York, NY, 2004, p 114.

2 Stuart Jeffries, 'Gilbert and George: the odd couple', *Guardian*, 25 Jun 2009, www.theguardian.com/artanddesign/2009/jun/24/gilbert-george-white-cube (accessed Apr 2014).

3 Gilbert & George, quoted in Joan Wallace and Geralyn Donohue, 'The fear of Gilbert & George', *Art & Text*, vol 20, 1985, p 11.

4 Charles Green, *The third hand: collaboration in art from conceptualism to postmodernism*, University of Minnesota Press, Minneapolis, MN, 2001, p 155.

5 After the onset of AIDS in 1984, the interpretation of these portraits shifted to symbols of untimely deaths – of 'fruit falling from the tree before they were ripe'. Gilbert & George, quoted in Jonquet, 2004, p 121.

6 The media wrongfully described the youths as rent boys or East End thugs, Jonquet, 2004, p 120.

Andy Warhol
Self-portrait no 9 1986
page 276

1 Andy Warhol, quoted in Gretchen Berg, 'Nothing to lose: an interview with Andy Warhol', *Cahiers du Cinema in English*, no 10, May 1967, p 40.

Maria Kozic
MASTERPIECES (Warhol) 1986
page 278

1 Brian O'Doherty, 'Doubtful but definite triumph of the Banal', *New York Times*, 27 Oct 1963, section 2, p 21, cited in David Deitcher, 'The handmade readymade', in Paul Taylor (ed), *Post-pop art*, Flash Art Books, MIT Press, Cambridge, MA, 1989, p 141.

2 Adrian Martin, 'Chain her down', *Art in Australia*, vol 29, no 1, spring 1991, p 60.

BIBLIO-
GRAPHY

INTERNATIONAL

Alloway, Lawrence. *American pop art*, Collier Books, New York, NY, 1974

Alloway, Lawrence. 'The arts and the mass media', first published in *Architectural Design*, Feb 1958 and reproduced in Charles Harrison and Paul Wood, *Art in theory 1900–2000: an anthology of changing ideas*, Blackwell Publishing, Oxford, UK, 2003, pp 715–17

Alloway, Lawrence. *Modern dreams: the rise and fall and rise of pop*, Institute for Contemporary Art, New York, NY, 1988

Amaya, Mario. *Pop as art, a survey of the new super realism*, Studio Vista, London, 1965

Bezzola, Tobia, and Franziska Lentzsch (eds). *Europop*, DuMont and Kunsthaus Zurich, Cologne, Germany, and Zurich, Switzerland, 2008

Boorstin, Daniel. *The image, or, what happened to the American dream*, Penguin, Harmondsworth, UK, 1963

Brauer, David E, Christopher Finch, Ned Rifkin, James Edwards, Walter Hopps and Ned Rifkin. *Pop art: US/UK connections, 1956–1966*, Menil Collection in association with Hatje Cantz Publishers, Ostfildern, Germany, 2001

Collins, Bradford R. *Pop art*, Phaidon, London, 2012

Compton, Michael. *Pop art*, Hamlyn, London, 1970

Crow, Thomas. *The art of the sixties*, George Weidenfeld & Nicholson, London, 1996

Doris, Sara. *Pop art and the contest over American culture*, Cambridge University Press, Cambridge, UK, 2007

Eklund, Douglas. *The Pictures Generation, 1974–1984*, Metropolitan Museum of Art, New York, NY, 2009

Ferguson, Russell (ed), Donna De Salvo, Paul Schimmel, David Deitcher, Stephen C Foster, Dick Hebdige, Linda Norden, Kenneth E Silver and John Yau. *Hand-painted pop: American art in transition, 1955–62*, Museum of Contemporary Art and Rizzoli International Publications, Los Angeles, CA, and New York, NY, 1992

Foster, Hal. *The first pop age: painting and subjectivity in the art of Hamilton, Lichtenstein, Warhol, Richter and Ruscha*, Princeton University Press, Princeton, NJ, 2014

Francis, Mark (ed). *Les Années pop 1956–1968*, Centre Pompidou, Paris, 2001

Francis, Mark (ed), and Hal Foster. *Pop*, Phaidon, London and New York, NY, 2005

Geldzahler, Henry. *Pop art 1955–70*, International Cultural Corporation of Australia, Sydney, 1985

Grunenberg, Christoph. *Summer of love: art of the psychedelic era*, Tate, London, 2005

Horowitz, Daniel. *Consuming pleasures: intellectuals and popular culture in the postwar world*, University of Pennsylvania Press, Philadelphia, PA, 2012

Kries, Mateo and Mathias Schwartz-Clauss (eds). *Pop art design*, Vitra Design Museum, Weil am Rhein, Germany, 2012

Lippard, Lucy R (ed). *Pop art*, Thames & Hudson, London, 1966 (1st edn) and 1970 (3rd edn)

Livingstone, Marco (ed). *Pop art*, Royal Academy of Arts and Weidenfeld & Nicolson, London, 1991

Livingstone, Marco. *Pop art: a continuing history*, Thames & Hudson, London, 2000

Livingstone, Marco, and Amanda Lo Iacono. *When Britain went pop: British pop art: the early years*, Christie's International Media Division, London, 2013

Macdonald, Dwight. *Against the American grain*, Vintage Books, New York, NY, 1962

Madoff, Steven H (ed). *Pop art: a critical history*, University of California Press, Berkeley, CA, 1997

Mamiya, Christin. *Pop art and consumer culture: American super market*, University of Texas Press, Austin, TX, 1992

Massey, Anne. *The Independent Group: modernism and mass culture in Britain, 1945–59*, Manchester University Press, Manchester, UK, 1995

Robbins, David (ed). *The Independent Group: postwar Britain and the aesthetics of plenty*, MIT Press, Cambridge, MA, 1990

Robertson, Bryan, John Russell and Lord Snowdon. *Private view, the lively world of British art*, Nelson, London, 1965

Robinson, Julia (ed). *New realisms: 1957–1962: object strategies*, Museum Nacional Centre de Arte Reina Sophia, Madrid and MIT Press, Cambridge, MA/London, 2010

Rosenberg, Bernard, and David Manning White (eds). *Mass culture: the popular arts in America*, The Free Press, New York, NY, 1957

Rublowsky, John. *Pop art*, Basic Books, New York, NY, 1965

Russell, John, and Suzi Gablik. *Pop art redefined*, Federick A Praeger, New York, NY, and Washington, DC, 1969

Sachs, Sid, and Kalliopi Minioudaki (eds). *Seductive subversion: women pop artists 1958–1968*, University of the Arts, Philadelphia & Abbeville Press Publishers, New York, NY, 2010

Stief, Angela, and Martin Walkner (eds). *Power up: female pop art*, Kunsthalle Wien, Vienna and DuMont Buchverlag, Cologne, 2010

Taylor, Paul. *After Andy: Soho in the eighties*, Schwartz City, Melbourne, 1995

Taylor, Paul. *Post-pop art*, MIT Press, Cambridge, MA, 1989

Varnedoe, Kirk, and Adam Gopnik. *Modern art and popular culture, readings in high and low*, Museum of Modern Art and Harry N Abrams, New York, NY, 1991

Whiting, Cécile. *A taste for Pop: pop art, gender and consumer culture*, Cambridge University Press, Cambridge, UK, and New York, NY, 1997

Whiting, Cécile. *Pop L.A.: Art and the city in the 1960s*, University of California Press, Oakland CA, 2008

AUSTRALIAN

Bonython, Kym (ed). *Modern Australian painting 1950–1975*, Rigby, Adelaide, 1980

Butler, Rex (ed). *What is appropriation?*, 2nd edn, Institute of Modern Art, Brisbane, 2004

Catalano, Gary. 'The absence of pop', in *The years of hope: Australian art and criticism 1959–1968*, Oxford University Press, Melbourne, 1981

Davis, Rhonda, Kate Hargraves and Leonard Janiszewski (eds). *Sixties explosion*, Macquarie University, Sydney, 2012

Desmond, Michael, and Christine Dixon. *1968*, National Gallery of Australia, Canberra, 1995

Gardner, Anthony. 'Post-provincial, still peripheral: Australian art on the global stage 1980–2009', in Jaynie Anderson (ed), *The Cambridge companion to Australian art*, Cambridge University Press, Melbourne, 2011

Gleeson, James. *Modern painters 1931–1970*, Lansdowne Press, Melbourne, 1971

Green, Charles. *Peripheral vision, contemporary Australian art, 1970–1995*, Craftsman House, Sydney, 1995

Harrison, Sylvia. 'Sydney pop and social internationalism in the 1960s', *Art and Australia*, vol 25, no 4, 1988, pp 500–05

Hart, Deborah. *Andy and Oz, parallel visions*, National Gallery of Australia and Andy Warhol Museum, Canberra and Pittsburgh, PA, 2007

Horton, Mervyn (ed). *Present day art in Australia*, Ure Smith, Sydney and London, 1969

Hughes, Helen, and Nicholas Croggon (eds). *Impresario: Paul Taylor: the Melbourne years, 1980–1984*, Surpllus and Monash University Museum of Art, Melbourne, 2013

Hughes, Robert. 'Irrational imagery in Australian painting', *Art and Australia*, vol 1, no 3, Nov 1963, pp 150–59

Janiszewski, Leonard (ed). *Central Street live*, Penrith Regional Gallery and the Lewers Bequest and Macquarie University Art Gallery, Sydney, 2003

Lindsay, Robert. *Field to figuration, Australian art 1960–1986: works from the National Gallery of Victoria*, National Gallery of Victoria, Melbourne, 1986

Lynn, Elwyn. 'Pop goes the easel', *Art and Australia*, vol 1, no 3, Nov 1963, pp 166–72

McAuliffe, Chris. *Art and suburbia*, Craftsman House, Sydney, 1996

McGregor, Craig. *People, politics and pop: Australians in the sixties*, Ure Smith, Sydney and London, 1968

McGregor, Craig, David Beal, David Moore and Harry Williamson. *Australian art and artists in the making*, Thomas Nelson (Australia), Melbourne and Sydney, 1969

Mendelssohn, Joanna. *The Yellow House 1970–72*, Art Gallery of New South Wales, Sydney, 1990

Murphy, John. *Gallery A Sydney 1964–1983*, Campbelltown Arts Centre, Campbelltown, NSW, 2009

National Gallery of Victoria. *The field*, National Gallery of Victoria, Melbourne, 1968

Neville, Richard. *Hippie hippie shake*, Bloomsbury, London, 1995

Phipps, Jennifer with Kirsty Grant and Susan van Wyk. *I had a dream: Australian art in the 1960s*, National Gallery of Victoria, Melbourne, 1997

Smith, Bernard, 'Pop art and the traditional genres 1960–70', in Smith, Bernard with Terry Smith and Christopher Heathcote, *Australian painting, 1788–2000*, 3rd edn, Oxford University Press, South Melbourne, Vic, 2001, pp 387–417

Smith, Terry, 'Postmodern plurality 1980–90' in Smith, Bernard with Terry Smith and Christopher Heathcote, *Australian painting, 1788–2000*, 3rd edn, Oxford University Press, South Melbourne, Vic, 2001, pp 452–94

Taylor, Paul (ed). *Anything goes: art in Australia 1970–1980*, Art & Text, Melbourne, 1984

Taylor, Paul. *Popism*, National Gallery of Victoria, Melbourne, 1982

Thoms, Albie. *My generation*, Media21 Publishing, The Rocks, NSW, 2012

Waterlow, Nick, and Annabel Pegus. *Larrikins in London: an Australian presence in 1960s London*, Ivan Dougherty Gallery, College of Fine Arts, University of New South Wales, Sydney, 2003

ARTISTS

Valerio Adami
Damisch, Hubert, and Henry Martin. *Adami*, Leon Amiel and Maeght, New York, NY, and Paris, 1974

Valtolina, Amelia (ed). *Valerio Adami*, Carlo Cambi Editore, Poggibonsi, Italy, 2010

Howard Arkley
Crawford, Ashley, and Ray Edgar. *Spray: the work of Howard Arkley*, updated and rev edn, Craftsman House, Sydney, 2001

Gregory, John. *Carnival in suburbia: the art of Howard Arkley*, Cambridge University Press, Port Melbourne, Vic, 2006

Evelyne Axell
Decan, Liesbeth. *Axelleration: Evelyne Axell 1964–1972*, Lannoo, Tielt, Belgium, 2011

Evelyne Axell: from pop art to paradise [le pop art jusqu'au paradis], Somogy and Musée provincial Félicien-Rops, Paris and Namur, Belgium, 2004

Enrico Baj
del Re, Marisa, and Giò Marconi (eds). *Enrico Baj: the garden of delights*, Fabbri, Milan, Italy, 1991

Lust, Herbert. *Enrico Baj dada impressionist: the catalogue raisonné for Baj's complete works*, Enrico Crispolti (ed), Giulio Bolaffi Publishing House, Turin, Italy, 1973

Jean-Michel Basquiat
Marshall, Richard (ed). *Jean-Michel Basquiat*, Whitney Museum of American Art, New York, NY, 1992

Mayer, Marc (ed). *Basquiat*, Merrell in association with Brooklyn Museum, London and New York, NY, 2005

Vivienne Binns
Clarke, Deborah, Merryn Gates, Maria Kunda, Christopher Dean and Penny Peckham. *Vivienne Binns*, Tasmanian Museum and Art Gallery, Hobart, 2006

Peckham, Penelope. 'The political and the avant-garde in the work of Vivienne Binns', PhD thesis, La Trobe University, Melbourne, 2007

Peter Blake
Grunenberg, Christoph, and Laurence Sillars (eds). *Peter Blake: a retrospective*, Tate Liverpool, London, 2007

Livingstone, Marco. *Peter Blake: one man show*, Lund Humphries, Farnham, UK, and Burlington, VT, 2009

Derek Boshier
Livingstone, Marco. *Pop art: a continuing history*, Thames & Hudson, London, 2000

Livingstone, Marco, and Amanda Lo Iacono. *When Britain went pop: British pop art: the early years*, Christie's International Media Division, London, 2013

Robert Boynes
Haynes, Peter. *Robert Boynes 3 decades: a survey of the artist's work from the 1960s to the 1990s*, Nolan Gallery, Canberra, 1995

North, Ian. 'Robert Boynes', *Art International*, vol 28, no 2, 1974, pp 25–27, 41, 55

Mike Brown
Haese, Richard. *Permanent revolution: Mike Brown and the Australian avant-garde 1953–1997*, Miegunyah Press, Melbourne, 2011

Haese, Richard, Mike Brown and Charles Nodrum. *Power to the people: the art of Mike Brown*, National Gallery of Victoria, Melbourne, 1995

Patrick Caulfield
Livingstone, Marco. *Patrick Caulfield*, Lund Humphries, Aldershot, UK, and Burlington, VT, 2005

Wallis, Clarrie. *Patrick Caulfield*, Tate Publishing, London, 2013

Ross Crothall
Gunn, Anthea. 'Here in Byzantium: Ross Crothall's trans-Tasman career', *Australian and New Zealand Journal of Art*, vol 12, 2012, p 84

Haese, Richard. *Permanent revolution: Mike Brown and the Australian avant-garde 1953–1997*, Miegunyah Press, Melbourne, 2011

Juan Davila
Brett, Guy, and Roger Benjamin. *Juan Davila*, Museum of Contemporary Art and Miegunyah Press, Sydney and Carlton, Vic, 2006

Lakin, Shaune. 'Reprise: Juan Davila's *Miss Sigmund* 1981', in Lynne Seear and Julie Ewington (eds), *Brought to light II: contemporary Australian art 1966–2006 from the Queensland Art Gallery Collection*, Queensland Art Gallery Publishing, South Brisbane, Qld, 2007, pp 125–31

Taylor, Paul. *Hysterical tears: Juan Davila*, Greenhouse Publications, Richmond, Vic, 1985

Jim Dine
Celant, Germano, and Clare Bell. *Jim Dine: walking memory, 1959–1969*, Guggenheim Museum, New York, NY, 1999

Livingstone, Marco. *Jim Dine: the alchemy of images*, Monacelli Press, New York, NY, 1998

Rosalyn Drexler
Glimcher, Arnold B. *Rosalyn Drexler: I am the beautiful stranger: paintings of the '60s*, PaceWildenstein, New York, NY, 2007

Minioudaki, Kalliopi. 'Pop's ladies and bad girls: Axell, Pauline Boty and Rosalyn Drexler', *Oxford Art Journal*, vol 30, no 3, 2007, pp 404–30

Richard Dunn
Duncan, Jenepher. *Richard Dunn: selected writings 1978–1994*, Monash University Gallery, Clayton, Vic, 1994

Maloon, Terence. *Richard Dunn: the dialectical image: selected work 1964–1992*, Art Gallery of New South Wales, Sydney, 1992

Erró
Combalía, Victoria. *Erró: el gran collage del mundo*, Institut Valencià d'Art Modern, and Comunidad de Madrid, Consejería de Cultura y Deportes, Valencia, Spain, and Madrid, 2006

Erró: 50 ans de collages, Centre Pompidou, Paris, 2010

Öyvind Fahlström
Chevrier, Jean-François. *Öyvind Fahlström: another space for painting*, Museu d'Art Contemporani de Barcelona and ACTAR, Barcelona Spain, 2001

Öyvind Fahlström, Solomon R Guggenheim Museum Foundation, New York, NY, 1982

Gilbert and George
Debbaut, Jan, Ben Borthwick, Michael Bracewell and Marco Livingstone. *Gilbert and George*, Tate Publishing, London, 2007

Jonquet, François (ed). *Gilbert and George: intimate conversations with François Jonquet*, Phaidon, London and New York, NY, 2004

Richard Hamilton
Foster, Hal, with Alex Bacon (eds). *Richard Hamilton*, MIT Press, Cambridge, MA, 2010

Godfrey, Mark, Paul Schimmel and Vicente Todolí (eds). *Richard Hamilton*, Tate Publishing, London, 2014

Hamilton, Richard. *Richard Hamilton: collected words 1953–1982*, Thames & Hudson, London and New York, NY, 1982

Duane Hanson
Buchsteiner, Thomas, and Otto Letze (eds). *Duane Hanson: sculptures of the American dream*, Hatje Cantz, Ostfildern, Germany, 2007

Varnedoe, Kirk. *Duane Hanson*, Abrams, New York, NY, 1985

Keith Haring
Adriani, Götz (ed). *Keith Haring: heaven and hell*, Hatje Cantz, Ostfildern, Germany, 2001

Deitch, Jeffrey, Suzanne Geiss and Julia Gruen. *Keith Haring*, Rizzoli, New York, NY, 2008

David Hockney
Barron, Stephanie, Maurice Tuchman, Henry Geldzahler, Christopher Knight, Gert Schiff, Anne Hoy, Kenneth E Silver and Lawrence Weschler. *David Hockney, a retrospective*, Los Angeles County Museum of Art, Los Angeles, CA and Thames & Hudson, London, 1988

Livingstone, Marco. *David Hockney*, rev edn, Thames & Hudson, New York, NY, 1996

Stangos, Nikos (ed). *David Hockney by David Hockney: my early years*, Thames & Hudson, London, 1988

Robert Indiana
Haskell, Barbara. *Robert Indiana: beyond Love*, Whitney Museum of American Art, New York, NY, 2013

Ryan, Susan Elizabeth. *Robert Indiana: figures of speech*, Yale University Press, New Haven, CT, 2000

Unruh, Allison (ed). *Robert Indiana: new perspectives*, Hatje Cantz, Ostfildern, Germany, 2012

Alain Jacquet
Scarpetta, Guy. *Alain Jacquet: camouflages, 1961–1964*, David Macey (trans), Cercle d'art, Paris, 2002

Scarpetta, Guy. *Alain Jacquet: camouflages et trames*, Musée d'art moderne et d'art contemporain, Nice, France, 2005

Jasper Johns
Garrels, Gary (ed). *Jasper Johns: seeing with the mind's eye*, San Francisco Museum of Modern Art in association with Yale University Press, San Francisco, CA, and New Haven, CT, 2012

Varnedoe, Kirk. *Jasper Johns, a retrospective*, Museum of Modern Art, New York, NY, 1996

Weiss, Jeffrey, Kathryn A Tuma, John Elderfield, Robert Morris and Carol Mancusi-Ungaro. *Jasper Johns, an allegory of painting 1955–1965*, National Gallery of Art with Yale University Press, Washington, DC, New Haven, CT, and London, 2007

Allen Jones
Lambirth, Andrew. *Allen Jones: works*, Royal Academy of Arts, London, 2005

Livingstone, Marco with Richard Lloyd. *Allen Jones: prints*, Prestel, Munich, Germany, and New York, NY, 1995

Edward Kienholz
Allington, Edward, David Anfam, Rosetta Brooks, Pippa Coles and Elizabeth Ann Macgregor. *Kienholz*, Baltic Centre for Contemporary Art, Gateshead, UK, 2005

Reddin-Kienholz, Edward and Nancy, Rosetta Brooks and Walter Hopps. *Kienholz, a retrospective*, Whitney Museum of American Art in association with DAP/Distributed Art Publishers, New York, NY, 1996

Peter Kingston
Wilson, Gavin. *Harbourlights: the art and times of Peter Kingston*, Craftsman House, Melbourne, 2004

RB Kitaj
Bartley, Tracy, Inka Bertz, Edward Chaney, Roman Martin Deppner, Michal Friedlander, Eckhart Gillen, Cilly Kugelmann and David N Myers. *Obsessions: R.B. Kitaj 1932–2007*, Kerber, Berlin, 2012

Livingstone, Marco. *Kitaj*, Phaidon, London, 2010

Jeff Koons
Holzwarth, Hans Werner (ed). *Jeff Koons*, Taschen, Hong Kong, 2009

Rothkopf, Scott. *Jeff Koons: a retrospective*, Whitney Museum of American Art, New York, NY, 2014

Vischer, Theodora (ed). *Jeff Koons*, Hatje Cantz Verlag, Ostfildern, Germany, 2012

Maria Kozic
Duval, Danielle. *Pages from Maria Kozic's book*, Artspace, Melbourne, 1987

Martin, Adrian. 'The desire of Maria Kozic', *Art and Text*, no 2, 1981, pp 18–26

Barbara Kruger
Alberro, Alexander, Hal Foster, Martha Gever, Miwon Kwon, Carol Squiers and Barbara Kruger. *Barbara Kruger*, Rizzoli International Publications, New York, NY, 2009

Kruger, Barbara, Rosalyn Deutsche and Ann Goldstein. *Thinking of you*, Museum of Contemporary Art and MIT Press, Cambridge, MA, and London, 1999

Colin Lanceley
Edwards, Deborah. *Colin Lanceley: the dry salvages 1963–64 and Gemini 1964*, Art Gallery of New South Wales, Sydney, 2001

Hughes, Robert, and William Wright. *Colin Lanceley*, Craftsman House, Seaforth, NSW, 1987

Richard Larter
Hart, Deborah, with Deborah Clark and Joanna Mendelssohn. *Richard Larter*, National Gallery of Australia, Canberra, 2008

Larter, Richard. *Incondite incantations for Pat*, Richard Larter, self-published, Canberra, 2000

Roy Lichtenstein
Babington, Jaklyn. *Roy Lichtenstein: pop remix*, National Gallery of Australia, Canberra, 2012

Rondeau, James, and Sheena Wagstaff. *Roy Lichtenstein: a retrospective*, Art Institute of Chicago and Tate Modern, Chicago, IL, and London, 2012

Waldman, Diane. *Roy Lichtenstein*, Guggenheim Museum, New York, NY, 1993

Konrad Lueg
Kellein, Thomas. *Ich nenne mich als Maler Konrad Lueg [I call myself as a painter Konrad Lueg]*, Kunsthalle, Bielefeld, Germany, 1999

Meschede, Friedrich, and Guido de Werd (eds). *With a probability of being seen: Dorothee und Konrad Fischer: Archives of an Attitude*, Richter, Düsseldorf, Germany, 2010

Marisol
Grove, Nancy. *Magical mixtures: Marisol portrait sculpture*, Smithsonian Institution Press for the National Portrait Gallery, Washington, DC, 1991

Pacini, Marina. *Marisol: sculptures and works on paper*, Brooks Museum of Art and Yale University Press, Memphis, TN, and New Haven, CT, 2014

Claes Oldenburg
Celant, Germano. *Claes Oldenburg: an anthology*, 2nd edn, Guggenheim Museum, New York, NY, 1995

Hochdörfer, Achim, and Barbara Schröder (eds). *Claes Oldenburg: the sixties*, Museum Moderner Kunst, Vienna, Prestel, Munich, Germany and DelMonico Books, New York, NY, 2012

Alan Oldfield
Haynes, Peter. 'Alan Oldfield', *Art and Australia*, vol 18, no 4, winter 1981

Haynes, Peter. *Project 35: Alan Oldfield*, Art Gallery of New South Wales, Sydney, 1981

Eduardo Paolozzi
Miles, Rosemary. *The complete prints of Eduardo Paolozzi: prints, drawings, collages 1944–77*, Victoria and Albert Museum, London, 1977

Whitford, Frank. *Eduardo Paolozzi*, Tate Gallery, London, 1971

Peter Phillips
Livingstone, Marco. *Retrovision: paintings 1960–1982*, Walker Art Gallery, Liverpool, UK, 1982

Livingstone, Marco, and Amanda Lo Iacono. *When Britain went pop: British pop art: the early years*, Christie's International Media Division, London, 2013

Sigmar Polke
Halbreich, Kathy (ed). *Alibis, Sigmar Polke 1963–2010*, Museum of Modern Art, New York, NY, 2014

Hentschel, Martin, Hans Belting, Charles H Hexthausen, Rudi H Fuchs and Friedrich Wolfram Heubach. *Sigmar Polke: the three lies of painting*, Cantz Verlag, Ostfildern-Ruit, Germany, 1997

Lange-Berndt, Petra, and Dietmar Rübel (eds). *Sigmar Polke: we petty bourgeois! Comrades and contemporaries, the 1970s*, Walther König, Cologne, Germany, 2011

Peter Powditch
Brown, Peter. 'Peter Powditch', *Art and Australia*, vol 11, no 4, Apr–Jun 1974

Murphy, John. *Gallery A Sydney 1964–1983*, Campbelltown Arts Centre, Campbelltown, NSW, 2009

Richard Prince
Brooks, Rosetta, Luc Sante and Jeffrey Rian. *Richard Prince*, Phaidon, London and New York, NY, 2003

Phillips, Lisa. *Richard Prince*, Whitney Museum of American Art, New York, NY, 1992

Spector, Nancy, Glenn O'Brien, John Dogg and Jack Bankowsky. *Richard Prince*, Guggenheim Museum, New York, NY, 2007

Robert Rauschenberg
Hopps, Walter, and Susan Davidson. *Robert Rauschenberg: a retrospective*, Guggenheim Museum, New York, NY, 1997

Joseph, Branden W (ed). *Robert Rauschenberg*, MIT Press, Cambridge, MA, 2002

Schimmel, Paul (ed). *Robert Rauschenberg: combines*, Museum of Contemporary Art and Steidl Verlag, Los Angeles, CA, and Göttingen, Germany, 2005

Martial Raysse
Gingeras, Alison. *Martial Raysse*, Luxembourg & Dayan, New York, NY, 2013

Grenier, Catherine (ed). *Martial Raysse rétrospective 1960–2014*, Centre Georges Pompidou, Paris, 2014

Ken Reinhard
Lynn, Elwyn. 'Ken Reinhard', *Art International*, vol X, 5/8, Oct 1971, pp 28–32

Reinhard, Arianne Jennifer. 'A study of the emergence of pop art in the Australian social and cultural milieu of the 1960s with particular reference to the work of Sydney artist, Ken Reinhard', unpublished thesis (MA Hons), Macquarie University, Sydney, 1994

Gerhard Richter
Godfrey, Mark, and Nicholas Serota (eds). *Gerhard Richter: panorama*, Centre Pompidou, Paris, 2012

Obrist, Hans-Ulrich (ed). *The daily practice of painting: writings and interviews 1962–1993*, David Britt (trans), Thames & Hudson and Anthony d'Offay Gallery, London, 1995

Storr, Robert. *Gerhard Richter: forty years of painting*, Museum of Modern Art and Thames & Hudson, New York, NY, and London, 2002

Robert Rooney
Duncan, Jenepher. *From the homefront: Robert Rooney, works 1953–1988*, Monash University Gallery, Clayton, Vic, 1990

Lindsay, Robert. 'Robert Rooney', *Art and Australia*, vol 14, no 1, 1976, pp 50–59

James Rosenquist
Hopps, Walter, and Sarah Bancroft. *James Rosenquist: a retrospective*, Guggenheim Museum, New York, NY, 2003

Lobel, Michael. *James Rosenquist: pop art, politics, and history in the 1960s*, University of California Press, Berkeley, CA, 2009

Martha Rosler
de Zegher, Catherine (ed). *Martha Rosler: positions in the life world*, Ikon Gallery, Generali Foundation and MIT Press, Birmingham, UK, Vienna and Cambridge, MA, 1998

Rosler, Martha. *Decoys and disruptions: selected writings, 1975–2001*, October Books, MIT Press, Cambridge, MA, 2006

Ed Ruscha
Ellroy, James, Ralph Rugoff and Alexandra Schwartz. *Ed Ruscha: fifty years of painting*, Hayward Publishing, London, 2009

Marshall, Richard D. *Ed Ruscha*, Phaidon, London and New York, NY, 2003

Schwartz, Alexandra (ed). *Ed Ruscha: leave any information at the signal: writings, interviews, bits, pages*, MIT Press, Cambridge, MA, and London, 2004

Niki de Saint Phalle
de Grèce, Michel, Pontus Hulten, Ulrich Krempel, Yoko Masuda, Janice Parente and Pierre Retany. *Niki de Saint Phalle: Monograph*, Acatos, Lausanne & Benteli, Bern, 2001

Groom, Simon (ed). *Niki de Saint Phalle*, Tate Publishing, London, 2008

Gareth Sansom
Gareth Sansom: paintings, 1956–1986, University Gallery, University of Melbourne, Parkville, Vic, 1986

Starr, Bala (ed). *Welcome to my mind: Gareth Sansom: a study of selected works 1964–2005*, Ian Potter Museum of Art, University of Melbourne, Melbourne, 2005

Martin Sharp
Alexander, George. 'Get back, Martin Sharp', *Art & Text*, 25, Jun–Aug 1987, p 99

Neville, Richard. *The everlasting world of Martin Sharp: paintings from 1948 to today*, Ivan Dougherty Gallery, Paddington, NSW, 2006

Garry Shead
Catalano, Gary. *Building a picture, interviews with Australian artists*, McGraw-Hill, Sydney, 1997

Grishin, Sasha. *Garry Shead and the erotic muse*, Craftsman House, Sydney, 2001

Cindy Sherman
Burton, Johanna (ed). *Cindy Sherman*, MIT Press, Cambridge, MA, 2006

Respini, Eva, with Johanna Burton and John Waters. *Cindy Sherman*, Museum of Modern Art, New York, NY, 2012

Wayne Thiebaud
Nash, Steven A, and Adam Gopnik. *Wayne Thiebaud: a paintings retrospective*, Thames & Hudson, London, 2000

Wilmerding, John. *Wayne Thiebaud*, Acquavella Galleries, Rizzoli, New York, NY, 2012

Imants Tillers
Coulter-Smith, Graham. *The postmodern art of Imants Tillers: appropriation 'en abyme', 1971–2001*, Fine Art Research Centre, Southampton Institute, and Paul Holberton Publishing, Southampton, UK, and London, 2002

Curnow, Wystan. *Imants Tillers and the 'book of power'*, Craftsman House, Sydney, 1998

Hart, Deborah (ed). *Imants Tillers, one world and many visions*, National Gallery of Australia, Canberra, 2006

Joe Tilson
Gooding, Mel. *Tilson: pop to present*, Royal Academy of Arts, London, 2002

Livingstone, Marco. *Joe Tilson: a survey*, Marlborough Fine Art, London, 2013

Tsk Tsk Tsk
Brophy, Philip. *Made by ↲↑→, 1977–1982*, self-published, Melbourne, 1983

Tony Tuckson
Maloon, Terence. *Painting forever: Tony Tuckson*, National Gallery of Australia, Canberra, 2000

Thomas, Daniel, Renee Free and Geoffrey Legge. *Tony Tuckson*, Craftsman House, Roseville, NSW, 1989

Peter Tyndall
Chapman, Christopher. 'Peter Tyndall: the act of looking', in Lynne Seear and Julie Ewington (eds), *Brought to light II: contemporary Australian art 1966–2006 from the Queensland Art Gallery Collection*, Queensland Art Gallery Publishing, South Brisbane, Qld, 2007, pp 276–83

Hansford, Pamela. *Peter Tyndall: dagger definitions*, Greenhouse Publications, Richmond, Vic, 1987

Andy Warhol
Celant, Germano. *Superwarhol*, Skira, Grimaldi Forum, Monaco, 2003

Francis, Mark (ed). *Andy Warhol: the late work*, Prestel, Munich, Germany, 2004

Frei, Georg, and Neil Printz (eds). *The Andy Warhol catalogue raisonné: paintings and sculpture 1961–1963*, vol 1, Phaidon Press, New York, NY, and London, 2002

Frei, Georg, and Neil Printz (eds). *Paintings and sculpture 1964–1969*, vol 2, Phaidon Press, New York, NY, and London, 2004

Printz, Neil (eds). *The Andy Warhol catalogue raisonné, volume 03, paintings and sculpture 1970–1974*, Phaidon Press, New York, NY, and London, 2010

Warhol, Andy, and Pat Hackett. *Popism: the Warhol sixties*, Harcourt Brace Jovanovich, New York, NY, 1980

Dick Watkins
Eagle, Mary. 'Dick Watkins', *Art Monthly Australia*, no 35, Oct 1990

Gunn, Grazia. 'Dick Watkins', *Art and Australia*, vol 21, no 2, 1983

Jenny Watson
McAuliffe, Chris. *Jenny Watson: here, there and everywhere*, Ian Potter Museum of Art, University of Melbourne, Melbourne, 2002

McAuliffe, Chris. 'Trying to live now: chronoptic figures in Jenny Watson's a painted page series', 2014, published online at http://contemporaneity.pitt.edu/ojs/index.php/contemporaneity/article/view/98 (accessed Aug 2014)

Taylor, Paul 'Jenny Watson's "Mod"ernism', *Art International*, vol 24, nos 5–6, Sep–Oct 1980

Tom Wesselmann
Aquin, Stephane (ed). *Tom Wesselmann*, Del Monico Books, Munich, Germany, London and New York, NY, 2012

Wilmerding, John. *Tom Wesselmann: his voice and vision*, Rizzoli, New York, NY, 2008

Brett Whiteley
McGrath, Sandra. *Brett Whiteley*, Bay Books, Sydney, 1979

Pearce, Barry. *Brett Whiteley: art and life*, Art Gallery of New South Wales, Sydney, 1995

Sutherland, Kathie. *Brett Whiteley: a sensual line 1957–67*, Macmillan, Melbourne, 2010

Valerio Adami
Italy 1935–

Valerio Adami was born in Bologna and trained under Achille Funi at the Accademia di Belle Arti di Brera, Milan, between 1951 and 1954. In 1956 he made his first trip to Paris and in the following years spent time in London, Italy and other parts of Europe. Adami's early works were humorous and often violent, expressionistic paintings inspired by comic strips and the work of Roberto Matta, but by the mid 1960s he was working in a style akin to Dutch De Stijl and French cloisonnism, with flat areas of interlocking colour bordered by black outlines. In 1962 Roland Penrose invited him to exhibit at the Institute of Contemporary Arts in London, which brought him into contact with Jim Dine and Richard Hamilton. While Adami favoured everyday subject matter such as domestic interiors, shop windows and hotel rooms in the 1960s, by the 1970s he was motivated by political events and literary, mythological and philosophical themes. In 1968 Adami had a dedicated room at the Venice Biennale. In addition to his painting career, he has also produced a feature-length film in 1971 and the stage design for Richard Wagner's *Der Fliegende Holländer* at the San Carlo Theatre, Naples, in 2004. In 1985 the Centre Pompidou, Paris, held a major retrospective of his work.

Howard Arkley
Australia 1951–99

Melbourne-based Howard Arkley studied at the Prahran College of Advanced Education, where Fred Cress, an artist and lecturer, introduced him to the airbrush, which became Arkley's trademark. He began his artistic career as an abstract painter in the 1970s and in 1975 held his first exhibition of 'white paintings' with Tolarno Galleries. His interest in architectural features was sparked when he travelled overseas with the support of a fellowship in 1977–78, living and working in Paris and New York. In the 1980s his 'classic' style emerged and he held his first suburban-focused show, *Houses and homes*, in 1988 at Tolarno Galleries, which seemingly celebrated the decorative kitsch of Australian suburbia. His exploration of a suburban vernacular developed beyond the generic house to also include references to street and pop culture, drugs and psychedelic imagery. Using various stencils and commercial paints, Arkley achieved a dizzying array of textures and tones that, with his characteristic black outline, resembled the comic-book imagery used by pop artists like Roy Lichtenstein and the luminous finish of commercial advertising. Just before his death in 1999, Arkley represented Australia at the 48th Venice Biennale with *Home show*. In 2007 the National Gallery of Victoria organised a retrospective of his work, which toured to the Art Gallery of New South Wales.

Evelyne Axell
Belgium 1935–72

Evelyne Axell is best known for her pop paintings of female nudes in the 1960s. She trained in ceramics at the Académie des Beaux-Arts de Namur, Belgium, and the dramatic arts at the Conservatoire d'art dramatique, Brussels. From 1955 to 1962 she pursued an acting career and married the art film director Jean Antoine. After starring in several films directed by Antoine, Axell abandoned acting for painting in 1963 and met René Magritte in Brussels once a month for tutoring and exchange on painting methods. During this period Antoine's films set in London and New York brought Axell into contact with pop artists such as Allen Jones, Peter Blake and Pauline Boty. In the late 1960s Axell gave her erotic female figures a sexual agency and liberation usually denied them in paintings by male pop artists. Her vibrant, graphic painting style derived from commercial imagery, and she later experimented with industrial materials, such as automotive paint, and new plastic materials, including plexiglas. Axell held her first solo exhibition in 1967 at Palais des Beaux-Arts, Brussels, and came to prominence with the support of the founder of *nouveau réalisme*, Pierre Restany. In 1969 she won the prestigious Prix de la Jeune Peinture Belge (now the Young Belgian Art Prize). Axell's work was included in *Seductive subversion: women pop artists 1958–1968* at the Rosenwald-Wolf Gallery, Philadelphia, in 2011.

Enrico Baj
Italy 1924–2003

Enrico Baj was a leading Italian artist and intellectual of the 1960s. He studied painting part-time at the Accademia di Belle Arti di Brera, Milan (1945–48), and completed a law degree at the University of Milan. In 1951 his first solo show was held at the Galleria San Fedele, Milan, and in the same year he co-founded the *Movimento d'Arte Nucleare* with Sergio Dangelo, exemplifying his direct engagement with topical issues and his alignment with anarchism. In 1953 he joined the *Mouvement International pour un Bauhaus Imaginiste* with founder Asger Jorn and other members of the artists' group CoBrA. Baj is best known for his caricature-like paintings, collages and assemblages developed from 1955. Baj's role in the development of assemblage art was recognised with his inclusion, alongside artists such as Robert Rauschenberg and Edward Kienholz, in the groundbreaking exhibition *The art of assemblage* at the Museum of Modern Art, New York, in 1961. His frequent association with the *nouveaux réalistes* and his friendship with Marcel Duchamp in the 1960s are reflected in his use of readymade and waste materials, sometimes combined with oil paint. Baj's literary achievements include writing, editing and illustrating over 50 books, and co-founding the Milan Institute of Pataphysics, associated with the French College of Pataphysics, in 1963. In 1964 Baj exhibited at the Venice Biennale and the Milan Triennale.

Jean-Michel Basquiat
USA 1960–88

Jean-Michel Basquiat was raised in Brooklyn, New York, the son of a Haitian father and a Puerto Rican mother. Although he had no formal training in fine art, Basquiat's mother encouraged him to draw and often took him to art museums as a child. As a teenager in the late 1970s Basquiat gained notoriety for spray-painting aphorisms around Manhattan using the pseudonym *SAMO* (same old shit). During this period he participated in New York's vibrant art and music scene and survived by selling T-shirts and collages. He began painting neo-expressionist images derived from autobiographical and pop culture references and was included in the seminal Times Square show in 1980 with Jenny Holzer and Keith Haring, amongst others. In 1982 Basquiat had his first solo exhibition at the Annina Nosei Gallery, New York, and became the youngest artist ever shown in *Documenta* in Kassel, West Germany. His inclusion in the 1983 Whitney Biennial bolstered his celebrity status, and by 1985 he was featured on the cover of the *New York Times* magazine. Between 1983 and 1985 Basquiat collaborated on paintings with his hero Andy Warhol, initially including Italian artist Francesco Clemente. Basquiat died of a drug overdose aged only 27, but he left behind a substantial body of work addressing diverse themes such as capitalism, colonialism and urban racism.

Vivienne Binns
Australia 1940–

Vivienne Binns studied painting and drawing at the National Art School, East Sydney (1958–62). Binns travelled to Melbourne after graduating and returned to Sydney in 1964, where she developed a friendship with Mike Brown, who shared her interest in merging high and low art, and confronting social and cultural hypocrisy. Binns' first solo exhibition at Watters Gallery, Sydney, in 1967 included vibrant and decorative semi-abstract paintings of female and male genitalia, which scandalised critics. Binns abandoned painting for 18 years following the exhibition and turned to enamelling, amongst other practices, creating work that highlighted her interest in the intersection between the fine and applied arts, and high art and popular culture. Binns was a founding member of the Women's Art Movement in Sydney in 1974 and initiated several pioneering community art projects, including *Mothers' memories others' memories* 1979–81. In the 1980s Binns returned to painting and took up various teaching positions at art schools and universities. From 1994 to 2012 she lectured at the Australian National University School of Art, Canberra, and is now emeritus fellow. She was awarded the Order of Australia Medal for Services to Art and Craft in 1983. Surveys of her work were organised by the Tasmanian Museum and Art Gallery, Hobart, in 2006 and touring, and the La Trobe University Museum of Art in Melbourne in 2012.

Peter Blake
England 1932–

Peter Blake rose to prominence in the 1960s, attracting a mass audience for his uniquely British pop aesthetic. He studied at Gravesend Technical College and Gravesend School of Art (1946–51), and after serving in the Royal Air Force (1951–53), returned to study at the Royal College of Art, London, graduating in 1956. Blake introduced pop subjects into his work as early as 1954, and during 1956–57 travelled through Europe studying popular art. He participated in the groundbreaking 1961 *Young contemporaries* exhibition at the Royal Society of British Artists, alongside other Royal College of Art graduates, such as

David Hockney, Derek Boshier and Allen Jones. By this time Blake had established a distinctive pop idiom that incorporated everyday, readymade materials and reflected his fascination with comics, book illustrations, tattoos, pin-ups, and commercial and circus imagery. Although his subject matter was contemporary, his approach was nostalgic, and he adopted a naïve painting style similar to that of the American realists. Blake gained significant recognition for his graphic work, especially the cover he designed with Jann Haworth for The Beatles' 1967 album *Sgt Pepper's Lonely Hearts Club Band*. In the 1970s Blake pursued a more illustrative painting style, influenced by English folklore and Victorian art. Retrospectives of his work have been organised by the Stedelijk Museum, Amsterdam (1973–74), Tate Gallery, London (1983), and Tate Liverpool (2007). In 2002 Blake was knighted.

Derek Boshier
England 1937–

Derek Boshier studied painting and lithography at Yeovil School of Art, Somerset (1953–57); Guildford College of Art, Surrey (1957–59); and the Royal College of Art, London (1959–62). While at the Royal College he produced paintings with a satirical edge that referenced contemporary events, the effects of mass media and American cultural imperialism. At the height of his pop phase, Boshier participated in the 1961 *Young contemporaries* exhibition alongside fellow students David Hockney and RB Kitaj, and featured in the BBC documentary *Pop goes the easel* (dir Ken Russell, 1962), with Peter Blake, Pauline Boty and Peter Phillips. After graduating he spent a year travelling on a scholarship in India, and on his return established a hard-edged geometric style of painting, before producing minimalist sculpture and later photographs, films, collages and graphic design. When he returned to painting in 1979, Boshier briefly revisited the advertising and mass-media themes that were a hallmark of his earlier pop works, although his move to Houston, Texas, in 1980 marked the introduction of awkward, comical figures in response to his new environment. Boshier lectured at several institutions in the 1970s and 1980s, including the Royal College of Art, London, and the University of Houston, Texas.

Robert Boynes
Australia 1942–

Robert Boynes studied painting and printmaking at the South Australian School of Art from 1959 to 1961, and 1962 to 1964, and film at Flinders University, Adelaide, in 1974. As a result of his multimedia training, his subsequent practice includes photography, screen-printing, film and painting. During the 1960s Boynes was influenced by American and, in particular, British pop art, to which he was exposed directly while teaching painting in England in 1968–69. On returning to Adelaide he became involved with other politically active artists in the Progressive Art Movement, formed in 1974, which further impacted the social and political consciousness of his work. Boynes' subject matter in recent years is most often derived from urban environments, although the figures and spaces are rarely

recognisable, appearing modulated through the various lenses of television, surveillance footage and cinema. His numerous group exhibitions include *Fieldwork: Australian art 1968–2002*, held in 2003 at the National Gallery of Victoria, Melbourne, and *Interesting times: focus on contemporary Australian art*, held in 2005 at the Museum of Contemporary Art, Sydney. Boynes moved to Canberra in 1978, where his distinguished academic career includes senior lecturer and head of painting (1978–2004), associate professor (2004–06), and since 2006 adjunct associate professor at the Australian National University School of Art.

Mike Brown
Australia 1938–97

Mike Brown was a founding member of the Annandale Imitation Realists with Ross Crothall and Colin Lanceley in 1961, having met Crothall and Lanceley at the National Art School, East Sydney, where he studied from 1956 to 1958. Brown moved to Annandale to live and work with Crothall from 1961 to 1962. Often working collectively, the Imitation Realists' works challenged traditional art practices by integrating found materials and text into complex, richly textured and painted assemblages. In addition to neo-dada, assemblage art and mass-media imagery, Brown's paintings responded to the perceived directness of Aboriginal, Polynesian and Melanesian art, with which he came into contact while travelling in New Zealand and working in New Guinea with the Australian Commonwealth Film Unit in 1960. Brown's provocative style and subject matter in his 1965 exhibition *Paintin' a-go-go!* at Gallery A in Paddington, Sydney, led to his prosecution and conviction for obscenity, and a jail term with hard labour, later reduced on appeal to a fine of $20. The National Gallery of Victoria, Melbourne, held two survey exhibitions of Brown's work – *Embracing chaos* in 1977 and *Power to the people* in 1995 – and in 2013 a survey exhibition, *The sometimes chaotic world of Mike Brown*, was organised by the Heide Museum of Modern Art in Bulleen, Victoria.

Patrick Caulfield
England 1936–2005

Reminiscent of sign painting and commercial imagery, Patrick Caulfield's still lifes and interiors are amongst the most recognisable works associated with British pop art, though he resisted this label. Caulfield studied in London at the Chelsea School of Art (from 1956) and at the Royal College of Art (1960–63), where he was one year behind David Hockney, RB Kitaj, Peter Phillips, Derek Boshier and Allen Jones. Caulfield exhibited alongside these artists in the 1961 *Young contemporaries* exhibition at the Royal Society of British Artists Galleries, and his inclusion in the 1964 exhibition *The new generation* at Whitechapel Art Gallery further consolidated his alignment with pop art. In the early 1960s Caulfield travelled to Greece and subsequently incorporated the crude, colourful qualities of Minoan frescoes into his practice. He was also influenced by the formal rigour of European modernists such as Juan Gris and Fernand Léger. Caulfield gave his figurative paintings of banal domestic

subjects a machine-produced aesthetic by delineating monochromatic colour fields with strong, black outlines. In the mid 1960s he extended his practice to screenprinting. During the 1970s his work became more detailed, and featured contrasting idioms and techniques, but he later returned to a graphic, abbreviated style of painting. Major exhibitions of Caulfield's work have been organised by the Walker Art Gallery, Liverpool (1981); Serpentine Gallery, London (1992–93); Hayward Gallery, London (1999); and Tate Britain (2013).

Ross Crothall
New Zealand 1934–unknown

Ross Crothall's artistic career lasted only a decade. Born in Otorohanga, New Zealand, Crothall studied at Otahuhu College in 1953 before enrolling at Ardmore Teachers College. Unsuited to teaching, from 1954 to 1958 Crothall commenced his informal artistic training under Theo Schoon, who introduced him to Maori art, art brut, Jean Dubuffet, and the work of Colin McCahon. In 1958 Crothall moved to Sydney, where he took evening classes at the National Art School, East Sydney. Crothall abandoned the school after only two months, but his later meeting with Mike Brown and Colin Lanceley led to the establishment of the Annandale Imitation Realists in 1961. Brown moved into Crothall's Annandale house during this period and all three worked there, producing many individual and several collective works made from everyday ephemera. Their raw, naïve style and use of non-traditional subjects and materials derived from 'primitive' and 'outsider' art, was also a local form of proto-pop art. After studying sign writing at Sydney Technical College, Ultimo, Crothall returned to Auckland in 1965 following the death of his parents. He settled in Ponsonby, and held his first and only solo exhibition at the New Vision gallery, Auckland, in 1966. He returned to Sydney in September and intended to hold another exhibition in 1967, but by 1968, after a temporary admission to the Callan Park Mental Hospital in Rozelle, he had disappeared.

Juan Davila
Chile 1946–

Juan Davila was born in Santiago in 1946, and studied law (1965–69) and fine arts (1970–72) at the University of Chile before settling in Melbourne in 1974. His father knew the Chilean surrealist Roberto Matta, whose influence prevails in Davila's dreamscapes of the 1970s. Davila is renowned for his method of cultural quotation, an assemblage of images and text appropriated from sources as diverse as fashion magazines, underground pornography, fine art, comic books and graffiti. Davila painted directly from his sources onto dramatic, mural-size canvases, pointing to the heroic scale of pop paintings by Roy Lichtenstein and James Rosenquist, and the socialist murals of Diego Rivera. Davila used this hybrid pictorial language to critique western art history, and sexual and cultural identities in the 1980s, and increasingly Australian politics in the 1990s. In 1991 Davila collaborated with Howard Arkley on *Blue chip instant decorator: a room*, an installation of large-scale canvases, furniture and found objects painted and

combined to create, in Davila's words, a 'pictorial battle', which was shown at Tolarno Galleries, Melbourne. More recently, Davila has embraced a style of grand salon painting, with a high finish and unified pictorial space. Davila exhibited in the Biennale of Sydney in 1982 and 1984, and *Documenta XII* in 2007 in Kassel, Germany. In 2006 a major survey exhibition of his work was organised by the Museum of Contemporary Art, Sydney, and travelled to the National Gallery of Victoria, Melbourne, in 2007.

Jim Dine
USA 1935–

Jim Dine is a prolific painter, printmaker, performance artist, stage designer and poet. Born in Cincinnati, Ohio, he studied at the Art Academy of Cincinnati, the School of the Museum of Fine Arts in Boston and Ohio University, Athens, where he graduated in 1957. Dine married Nancy Minto that same year, and in 1958 the couple moved to New York, where Dine participated in the emergence of happenings with Allan Kaprow and Claes Oldenburg, and became a leading figure in American pop art. Dine's art of the 1960s depicted everyday imagery and common objects in a gestural style, influenced by abstract expressionism. Often integrating domestic objects, clothing and painting paraphernalia, these works were distinctively autobiographical. During the 1960s Dine also made sculptures, installations and environments. In 1959 he began organising exhibitions and performances at the artist-run Judson Gallery, New York, and had his first solo show at the Reuben Gallery, New York, in 1960. Between 1967 and 1971 Dine and his family lived in London. In the 1970s Dine altered his approach by working predominantly in two dimensions, in a more traditionally figurative style. The Whitney Museum in New York organised the first major retrospective of his work in 1970, and more recently, the Guggenheim Museum, New York, held the large-scale survey *Jim Dine: walking memory, 1959–1969* in 1999.

Rosalyn Drexler
USA 1926–

Rosalyn Drexler (née Bronznick) briefly attended Hunter College in New York before marrying Sherman Drexler in 1946 and moving to Berkeley, California. Following a stint as a professional wrestler, Drexler's first assemblage sculptures were exhibited with her husband's work in 1955. She returned to New York and had her first solo exhibition at the Reuben Gallery in 1960, which brought her into contact with artists such as Claes Oldenburg and Allan Kaprow. From 1961 Drexler focused on figurative paintings of everyday scenes, often incorporating materials from tabloid magazines and film posters. Her subjects included celebrities, gangsters and businessmen placed against flat, monochromatic fields. Drexler was one of very few women artists represented in the early pop art narrative, exhibiting alongside her male counterparts in *Pop art USA* at the Oakland Art Museum and *Mixed media and pop art* at the Albright-Knox Art Gallery in 1963, and in the *First international girlie show* at Pace Gallery, New York, in 1964. Drexler also staged her first play *Home movies* at the Judson

Theatre in 1964, which won three Obie Awards. During the 1960s and 1970s Drexler pursued her writing career, producing award-winning television scripts, plays and novels. PaceWildenstein, New York, organised a retrospective of her work in 2007, and she participated in the travelling exhibitions *Power up: female pop art*, Kunsthalle Wien (2010); and *Seductive subversion: women pop artists, 1958–1968* (2011) organised by the Brooklyn Museum.

Richard Dunn
Australia 1944–

Born in Sydney, Richard Dunn studied architecture at the University of New South Wales, painting with John Olsen and sculpture at the National Art School, East Sydney, all between 1962 and 1964. Dunn moved to London to study at the Royal College of Art from 1966 to 1969, and lived between London and Paris until 1976. His early work of the 1960s was influenced by psychoanalysis and abstract painters such as Ian Fairweather. Professing an interest in the complex and the minimal, Dunn's diptychs of photography and painting in the 1970s were informed by Greek philosophy, minimalism and conceptual art. Dunn lived in New York during 1984–85 as a resident of the International Studio Program, PS1 Contemporary Art Center (now MoMA PS1). During the 1980s he experimented with a pop aesthetic, appropriating photographic sources from advertising and media culture in bold juxtapositions. He was included in the National Gallery of Victoria's *Popism* exhibition of 1982, and the Biennale of Sydney in 1979, 1986, 1988 and 1990. Surveys of his work were held at the Art Gallery of New South Wales, Sydney, in 1992 and Monash University Museum of Art, Melbourne, in 1994. Dunn has exhibited internationally, including solo museum exhibitions at Kunstsammlungen Chemnitz, Germany, in 2004 and 2005. He was director of the Sydney College of the Arts from 1988 to 2001 and is currently emeritus professor in contemporary visual art at the University of Sydney.

Erró
Iceland 1932–

Born Guðmundur Guðmundsson in Ólafsvík, Erró studied at the Fine Art School in Reykjavík (1949–51), before specialising in fresco painting and printmaking at the Kunstakademiet, Oslo (1952–54). He attended the Accademia di Belle Arti, Florence, and Studio Arte del Mosaico, Ravenna (1954–56), and settled in Paris in 1958. There Erró met surrealist Roberto Matta and came into contact with pop art and *nouveau réalisme*, which emerged in 1960. From this time he started to produce collages appropriated from comic strips, advertising, mass media and, subsequently, western art history. He also participated in the development of happenings in France and in the field of experimental filmmaking. Erró's pop was witty and critical, assembling complex imagery in order to engage with politics, war and sexuality. Erró spent time in New York during the winters of the 1960s, meeting several American pop artists and befriending James Rosenquist, who was a significant influence on the artist. During this period his pop cultural

pastiches also resembled those of his friend Öyvind Fahlström. Since the 1960s Erró has divided his time between Paris, the Mediterranean island of Formentera, Bangkok and Reykjavík. His most recent major exhibition, a 50-year survey of his collages, was held at the Centre Pompidou, Paris, in 2010.

Öyvind Fahlström
Brazil 1928 – Sweden 1976

Öyvind Fahlström grew up in São Paulo, Brazil, before moving to Stockholm, Sweden, in 1939. Following compulsory military service, Fahlström enrolled in art history and classical archaeology at the University of Stockholm, from which he graduated in 1952. During this period Fahlström supported himself by working as a journalist, while also writing poetry and plays. In 1952 he began his first experimental composites, and by the late 1950s these most often took the form of detailed drawings incorporating text and decontextualised fragments of comic strips, such as *Krazy Kat* and *Mad Magazine*. Following a two-year stay in Paris and his marriage to Swedish pop artist Barbro Östlih, Fahlström moved to New York in 1961. Having already befriended Robert Rauschenberg in Stockholm in the late 1950s, he moved into Rauschenberg's former studio at 128 Front Street. During the 1960s Fahlström was a pioneer of happenings in New York and also invented 'variable structures' with movable parts. He also designed plays and films, and sometimes, in periods of artistic latency, returned to newspaper and television journalism. His journalistic concern with socio-political issues emerged in his late prints and paintings. He participated in the *New realists* exhibition at the Sidney Janis Gallery, New York, and the Venice Biennale in 1962 and 1964 respectively, and was honoured with a retrospective in 1969 organised by the Museum of Modern Art, New York.

Gilbert & George
Italy 1943–, England 1942–

The presiding ideology of Gilbert & George is to bring together art and life by creating 'art for all'. Gilbert Proesch, born in Dolomites, Italy, and George Passmore, born in Plymouth, Devon, met in 1967 while studying at St Martin's School of Art in London. Dissatisfied with the elitist and traditional approach to sculpture at the school, Gilbert & George abandoned their separate identities and presented themselves as 'living sculpture'. They subsequently performed in gallery spaces and toured internationally. Gilbert & George have lived and worked in East London for over 40 years, and their urban environment has inspired much of their work. In the early 1970s they made charcoal drawings and also their first photo-pieces, which continue to dominate their practice. By the early 1980s these had evolved from black-and-white photo arrangements into brightly coloured and tightly gridded works on a monumental scale. Focused on banal, autobiographical subjects in the 1970s, their more recent photo-pieces deal with themes of class, religion, sex, nationalism, death, identity and politics. Gilbert & George represented Britain at the Venice Biennale in 2005. Major touring exhibitions of their work have been organised by Galleria

d'Arte Moderna, Bologna (1996), Kunstmuseum, Bonn (1999) and Tate Modern, London (2007).

Richard Hamilton
England 1922–2011

Richard Hamilton's diverse formal training included painting at the traditional Royal Academy School, London (1938–40, 1946), engineering draughtsmanship at a government training centre (1940), and modern art at Slade School of Art (1948–51). This was augmented by experience in commercial art gained at the Design Unit (1941–42) and the EMI record company (1942–45). Thereafter he designed several exhibitions, including the Institute of Contemporary Arts' *Man, machine and motion* in 1955. He was a leading member of the Independent Group, founded in 1952, which sought to revolutionise conservative British art by engaging with popular culture, advertising and the mass media. Hamilton made a groundbreaking contribution to the science-fiction and pop-culture exhibition *This is tomorrow* at the Whitechapel Art Gallery, London, in 1956, a turning point in the development of pop art. His paintings and collages of the late 1950s and throughout the 1960s derived from pop-cultural subjects and mass-circulation imagery, providing critical and ironic observations of consumer culture. Printmaking dominated Hamilton's practice from the late 1970s; in the 1980s his work took a more political turn, and he began experimenting with computerised production methods. In addition to James Joyce, Marcel Duchamp was a significant influence. Hamilton represented Britain at the 1993 Venice Biennale, and the Tate Modern, London, organised major surveys of his work in 1970, 1992 and 2014.

Duane Hanson
USA 1925–96

Duane Hanson studied art at Luther College in Iowa, and the University of Washington, Seattle (1943–44). In 1945 he studied under Arnold Hauser at Macalester College in St Paul, Minnesota. He subsequently undertook postgraduate studies at the University of Minnesota and at Cranbrook Academy of Art in Michigan, where he graduated in 1951. After moving to West Germany in 1953 Hanson became familiar with synthetic media, including polyester resin and fibreglass, which he began to utilise on his return to the United States of America in 1961. While teaching in Miami Hanson produced his first life-sized figurative works in 1967. Influenced by the ascendancy of pop and the naturalistic sculptures of George Segal, Hanson's meticulously rendered sculptures responded directly to American everyday life. His works of the late 1960s focused on political themes, such as the American involvement in the Vietnam War, homelessness and gang victims. In 1969 Hanson moved to New York, and by the early 1970s his approach was less didactic, addressing the banal lives of janitors, housewives, museum guards and dishwashers. In 1973 Hanson moved back to Florida, where he continued to use the working classes as his subjects. The first retrospective of his work toured Europe in 1974 and

the United States in 1976. A more recent survey, *Duane Hanson: sculptures of the American dream*, toured numerous European museums from 2007 to 2014.

Keith Haring
USA 1958–90

Famous for his energetic, interlocking, cartoon-like figures, Keith Haring aspired to bring art and life together with his pop art of the 1980s. An admirer of Dr Seuss and Walt Disney, Haring started drawing cartoons from a young age. In 1978, after studying briefly at the Ivy School of Professional Art in Pittsburgh, he moved to New York to attend the School of Visual Arts. In the late 1970s he participated in the New York club scene and developed rhythmic, graffiti-style designs that he often realised in the New York subway. He also befriended fellow street-inspired artists Jean-Michel Basquiat and Kenny Scharf. Haring's drawings of the 1980s arose from diverse sources, such as Islamic and Japanese art, and the frenetic, image-saturated environment of New York City. In 1982 Haring broadcast his animated imagery from a 'spectacolour' billboard in Times Square. He produced more than 50 public artworks worldwide between 1982 and 1989, and in 1984 he visited Australia, undertaking projects at the Art Gallery of New South Wales in Sydney, and the National Gallery of Victoria and Collingwood Technical School in Melbourne. In 1986 Haring opened Pop Shop in New York, a retail outlet devoted to selling commercial objects bearing his imagery. Haring died of AIDS-related complications at the age of 31.

David Hockney
England 1937–

During his time at Bradford School of Art (1953–57) David Hockney painted in the tradition of the Euston Road School and, following a two-year hiatus working in hospitals (a condition of conscientious objection), he continued studying at the Royal College of Art, London, graduating in 1962 with the gold medal. Already recognised as a skilled draftsman, Hockney's inclusion in the 1961 *Young contemporaries* exhibition at the Royal Society of British Artists consolidated his position as a leading artist associated with pop, though he did not identify with the term. During this period Hockney employed a range of subjects, both personal and pop cultural, and painted in a naïve style akin to Jean Dubuffet and Pablo Picasso. Time spent in Los Angeles from 1963 (where he settled permanently in 1976) impacted on Hockney's practice; he abandoned oils for acrylics, flattened his compositions, and attempted to capture the warmth and sensuality of California with his pool scenes. In the 1970s and 1980s Hockney's diverse practice included stage design, etchings and lithographs, photomontage, photocopied prints and paintings. Following his first survey exhibition at the Whitechapel Art Gallery in London (1970), major touring exhibitions of Hockney's work have been organised by the Los Angeles County Museum of Art (1988); Museum of Fine Arts, Boston (2006); National Portrait Gallery, London (2006–07); and the Royal Academy of Arts, London (2012).

Robert Indiana
USA 1928–

Robert Clark adopted his birth state, Indiana, as a surname early in his career, an indication of the importance he placed on midwest American iconography. He studied at the Art Institute of Chicago (1949–53), the Skowhegan School of Painting and Sculpture in Maine (1953) and Edinburgh University (1953). In 1954 he settled in New York, and in 1956 he exhibited his first hard-edge paintings. By the late 1950s he identified as a 'sign painter', using stencilled text on wooden sculptures created from found materials. He called these early works 'herms' after ancient Greek signposts. He continued to use a hard-edge aesthetic, influenced by friends such as Ellsworth Kelly, and developed a bold, dissonant colour scheme reminiscent of highway signs. Indiana used the paradox of the American Dream as his subject matter, with its bright optimism and superficial materialism. Indiana's attentiveness to the banal imagery of everyday life and current American themes bolstered his reputation as a prominent American pop artist. He was often inspired by American literature, and in particular, the writings of Herman Melville, Walt Whitman and William Carlos Williams. Indiana is most famous for his emblematising the word 'love', a potent sign for the countercultural generation of the late 1960s. In 1978 Indiana moved to a remote island in Maine, where he continues to sculpt and paint. His first New York retrospective took place at the Whitney Museum of American Art in 2013.

Alain Jacquet
France 1939 – USA 2008

Alain Jacquet studied architecture at the École des Beaux-Arts, Paris, in 1960, but did not undertake formal training as an artist. He trained himself in painting and held his first solo exhibition at Galerie Breteau, Paris, in 1961. The following year he developed a series of 'camouflage' works composed of masterpieces from western art history covered in military camouflage patterns, later using magnified pixels (or Benday dots) to obscure the image underpinning his composition. As the series progressed Jacquet juxtaposed masterpieces with objects and imagery drawn from everyday life and pop culture. Like the *nouveaux réalistes*, his preference for representational content and practices of appropriation opposed the dominance of art informel abstract painting; however, he found he had more in common with the American pop artists, and from 1964 divided his time between Paris and New York. Exhibiting at Alexandre Iolas Gallery in New York, Jacquet met Andy Warhol and Roy Lichtenstein, and abandoned painting for 'mec art' (mechanical art), specifically, the photo-mechanical reproduction of images using screen-printing. With imagery derived from advertising and the mass media, Jacquet exaggerated scale and used unusual cropping and deliberate misregistrations of the screen for aesthetic effect. He also experimented with the illusion of textures by incorporating photographic imagery of materials such as burlap and wood into his works. In the 1970s he produced a series of paintings based on photography of Earth from space. Jacquet represented France at the Venice Biennale in 1976 and the São Paulo Biennial in 1989.

Jasper Johns
USA 1930–

Renowned for his instantly recognisable paintings of flags, targets and maps, Jasper Johns is one of the leading figures of American proto-pop art. Having only completed three semesters at the University of South Carolina, Johns is usually regarded as a self-taught artist. He moved to New York in late 1948, and after a brief period of military service stationed in Japan, he returned to the city to form enduring friendships with Robert Rauschenberg, the choreographer Merce Cunningham and the composer John Cage. Johns was profoundly influenced by the philosophy of Ludwig Wittgenstein and the conceptual art of Marcel Duchamp, who he met in 1959. During the 1950s Johns lived in the same building as Rauschenberg, and together they introduced recognisable subject matter into their paintings at a time when abstract expressionism was the dominant movement. Johns' work rose to prominence when Leo Castelli gave him a solo show in 1958. By this time Johns was making sculptures from everyday readymade objects and using stencilled lettering in his paintings. In 1960 he made his first lithographs. Johns' work of the 1980s and 1990s was more introspective and self-referential than his earlier practice, and his recent works were shown at the exhibition *Jasper Johns: regrets* at the Museum of Modern Art, New York, in 2014. A recent noteworthy survey show was held in 2013 at the San Francisco Museum of Modern Art.

Allen Jones
England 1937–

Allen Jones is a painter, sculptor and printmaker associated with the emergence of British pop art in the 1960s. Jones studied intermittently at Hornsey College of Art, London, between 1955 and 1961, and for a year at the Royal College of Art, London (1959–60). At the Royal College he met artists Derek Boshier, David Hockney, RB Kitaj and Peter Phillips, with whom he exhibited in the 1961 *Young contemporaries* exhibition, which he also helped to organise. Jones was influenced by the lyrical colour abstractions of Wassily Kandinsky and Robert Delaunay, and the theories of Carl Jung and Friedrich Nietzsche. He lived in New York from 1964 to 1965 and was inspired by the erotic imagery found in pin-up art, popular illustration and fetish magazines. His subsequent paintings were explicitly erotic, borrowing the linear and graphic treatment of such printed media to emphasise the sexuality of his subjects. The most notorious extension of this sensibility manifested in the late 1960s, with his fibreglass sculptures of sexually provocative and fetishistic female figures transformed into furniture. Jones was also a prolific lithographer, and developed costume and stage designs for theatre, film and television. Between 1961 and 1983 he taught periodically in the United Kingdom, Europe and the United States of America. Major exhibitions of his work have been organised by the Institute of Contemporary Arts, London (1978); Walker Art Gallery, Liverpool (1979); and Barbican Centre, London (1995).

Edward Kienholz
USA 1927–94

Famous for his politically charged tableaux, Edward Kienholz pioneered environmental assemblage art in the 1950s. He briefly studied at Eastern Washington College of Education in Cheney, and Whitworth College in Spokane. While he gained basic skills in carpentry, metalworking and mechanics, he never received formal art training. His work in a psychiatric hospital in 1947 directly impacted the psychological resonance of his future works. In 1953 he moved to Los Angeles, and the following year made his first wooden reliefs. In 1956 he opened one of the first alternative spaces in Los Angeles, the Now Gallery, and in 1957 he co-founded the Ferus Gallery with the curator Walter Hopps and the poet Bob Alexander. Having a meagre income in the late 1950s, Kienholz resourcefully used materials he found in the street to make assemblages with explicit social and political import. His use of waste materials and his devotion to contemporary events aligned him with artists such as Jasper Johns and Robert Rauschenberg in the United States of America, and *nouveaux réalistes* such as Arman and Daniel Spoerri in France. Kienholz sold his share in the Ferus Gallery in 1958 and started making largescale tableaux in 1961. These elaborate, often confrontational environments incorporated a range of materials, such as mannequins, cars, furniture, taxidermy and photography. From 1972 Kienholz worked in collaboration with his wife, Nancy Reddin Kienholz, and from 1973 they divided their time between Hope, Idaho, and Berlin.

Peter Kingston
Australia 1943–

Peter Kingston was born in Sydney and in the 1950s was encouraged to pursue art by his teacher at Cranbrook School, the artist Justin O'Brien. Kingston studied arts and architecture at the University of New South Wales (graduating with a Bachelor of Arts in 1965), where he also published cartoons in the student magazine *Tharunka*. His cartoons were subsequently included in *Oz*, the satirical magazine edited by Richard Neville, Richard Walsh and Martin Sharp, and he participated in the *Oz supa art market* exhibition at Sydney's Clune Galleries in 1966. In 1971 Kingston was involved in the Yellow House artists' collective and exhibition space, where he completed the Stone Room 'installation' with George and Joyce Gittoes, and participated in magic shows and performances. During the 1970s Kingston's diverse work, including several experimental films, had a distinctly pop aesthetic derived from vernacular Sydney subjects. In 1974 he moved to Sydney's Lavender Bay, living next-door to Brett Whiteley. With Sharp he formed the Friends of Luna Park, following the tragic ghost train fire in 1979, and from the 1980s became dedicated to depicting the historic funfair and Sydney's rapidly changing harbour foreshore. Kingston has frequently exhibited in the Dobell, Wynne and Sulman prizes. A survey exhibition, *Peter Kingston: harbourlights*, was curated by the Manly Art Gallery and Museum in 2004.

RB Kitaj
USA 1932–2007

Ronald Brooks Kitaj's Jewish identity and broad cultural experience contributed to his autobiographical approach to figurative painting. Kitaj studied at the Cooper Union Institute in New York and the Academy of Fine Art in Vienna in the early 1950s. During this time he also visited Cuba, Mexico and South America as a merchant seaman. After serving in the United States Army, mostly in France, he studied at the Ruskin School, Oxford (1958–59), and the Royal College of Art, London (1959–61). Kitaj participated in the landmark 1961 *Young contemporaries* exhibition at the Royal Society of British Artists, and although he never identified as a pop artist, his graphic style of painting and collage-based prints bore a resemblance to advertising and commercial imagery. In 1976 Kitaj's promotion of figurative painting was consolidated in *The human clay*, an Arts Council exhibition of British artists that also included Lucien Freud, Francis Bacon and Hockney, amongst others – a group he identified as the 'School of London'. In 1995 Kitaj was awarded the Golden Lion lifetime achievement award at the Venice Biennale. Retrospective exhibitions of his work have been organised by the Tate, London (1994); the Metropolitan Museum of Art, New York (1994–95); and the Hamburger Kunsthalle and the Jewish Museum Berlin (2012–13).

Jeff Koons
USA 1955–

Jeff Koons came to prominence in the 1980s with his glamorous, sentimental and sexually provocative celebrations of popular culture. Koons studied at the Maryland Institute College of Art, Baltimore, and moved to New York in 1976, where he eventually worked as a Wall Street commodities broker to fund his practice. Since his first solo show at the New Museum of Contemporary Art, New York, in 1980, Koons has blurred the line between high art and pop culture by adopting the imagery of marketing, advertising and the entertainment industry. Working in sculpture, painting and photography, Koons employs a team of artisans, specialists and technicians to transform his concepts and appropriations into glossy works of art. His sculptures include monumental puppies constructed from flowers, porcelain models of Michael Jackson and the Pink Panther, and plexiglas-encased vacuum cleaners. His photography and sculpture includes the notorious *Made in heaven* series (1989–91), featuring sexually explicit tableaux with his then wife Ilona Staller – the former porn star known as 'La Cicciolina' and member of Italian parliament. A large group of Koon's sculptures were exhibited in the gardens and palace of Versailles in 2008 and the Whitney Museum, New York, held a major retrospective of his work in 2014, touring to the Centre Pompidou, Paris, and the Guggenheim Museum, Bilbao, in 2015.

Maria Kozic
Australia 1957–

Maria Kozic's practice incorporates a diverse range of materials, techniques and disciplines, from sculpture, installation, video and painting, through to music and short-run magazines. Kozic studied

art at the Philip Institute of Technology in Melbourne (1978–80), and was part of the experimental music collective ⌐⌐ (or Tsk Tsk Tsk, pronounced as three tongue clicks). With Philip Brophy, Kozic played synthesiser and participated in the group's performances, films and multimedia events. Her practice in the 1980s had a recognisable pop sensibility, appropriating the work of artists such as Andy Warhol and Roy Lichtenstein, and deriving both style and subject matter from popular culture. Subverting the visual language of advertising, her later billboards and posters shared the exploration of power and gender adopted by Barbara Kruger and Cindy Sherman. Kozic's work was featured in the 1982 Biennale of Sydney and the 1986 Venice Biennale as part of the Aperto section, as well as the *Australian perspecta* exhibitions at the Art Gallery of New South Wales in both 1985 and 1995. In the 1990s her engagement with pop culture extended to children's toys, and Japanese manga and anime. Her inflatable *Blue boy*, installed on the roof of the Museum of Contemporary Art in 1992, was a playful extension of these themes.

Barbara Kruger
USA 1945–

Barbara Kruger spent a year at Syracuse University, New York, in 1964 before studying at the Parsons School of Design, New York, under the photographer Diane Arbus and graphic designer Marvin Israel, the art director of *Harper's Bazaar*. Israel persuaded Kruger to assemble a professional portfolio, and she subsequently joined the design department of *Mademoiselle* magazine, where she was quickly promoted to chief designer. During this period Kruger started writing poetry and attending readings. In the early 1970s she experimented with craft-based practice and photography, but by 1979 she was superimposing provocative slogans over imagery appropriated from American print-media sources. Drawing on her experience of commercial graphic design, Kruger developed a bold trademark colour scheme of black, red and white. She also used personal pronouns to implicate the viewer in issues of sexism, consumerism, politics and power relations. Kruger blurred the line between art and commerce by distributing her imagery on photographs, posters, electronic signboards, billboards, T-shirts, mugs, bus shelters and public parks. In the 1980s Kruger developed a multimedia practice, producing immersive environments in which every surface was covered with still and moving images and text. Since the mid 1970s she has also held teaching positions in numerous institutions across California. In 2005 Kruger was awarded the Venice Biennale's Golden Lion award for lifetime achievement, and the Kunsthaus Bregenz, Austria, mounted a major retrospective of her work in 2013.

Colin Lanceley
New Zealand 1938–

Born in Dunedin, New Zealand, and raised in Sydney, Colin Lanceley is a painter, sculptor and printmaker. At 16 Lanceley apprenticed as a photoengraver in the printing industry in Sydney, and subsequently enrolled in a diploma of art at the National Art School, East Sydney,

in 1956. After graduating in 1960 Lanceley formed the Annandale Imitation Realists with Mike Brown and Ross Crothall in 1961. During this period Lanceley was interested in 'primitive' and 'outsider' art, as well as the paintings of Jean Dubuffet. He reconciled art and everyday life by collaging found objects and detritus into his three-dimensional assemblages. After he was awarded the Helena Rubinstein Travelling Scholarship in 1964 Lanceley travelled extensively throughout Europe, and lived in London in the 1960s and 1970s before returning to Australia in 1981. Lanceley has lectured in painting since 1966 in several institutions in the United Kingdom and Australia. His international exhibition record spans decades and includes a print survey at the Tate Gallery, London, in 1976. A survey of Lanceley's work and a collection focus were held at the Art Gallery of New South Wales in 1987 and 2001 respectively. Lanceley also participated in the 1983 *Australian perspecta* at the Art Gallery of New South Wales, and the 1986 Biennale of Sydney. In 1990 Lanceley was awarded an Order of Australia and was a board member of the National Gallery of Australia from 1995 to 1999.

Richard Larter
England 1929 – Australia 2014

Richard Larter was born in Hornchurch, Essex, east of central London and migrated to Australia with his wife Pat and children in 1962. Larter attended visual arts classes at St Martins School of Art while he was a teenager, and later night classes in drawing and art history at Toynbee Hall. He travelled to Paris in 1949 and subsequently travelled extensively in Europe, visiting art galleries and going to Algiers in 1951, where he was strongly affected by Islamic art and culture. The Larters attended many exhibitions in London, and in 1956 saw *This is tomorrow* at the Whitechapel Art Gallery. Larter's admiration of Eduardo Paolozzi's collages is visible in his figurative paintings of the 1960s and 1970s, in which he patchworked imagery derived from pop culture and pornography. These paintings, often featuring Pat, used techniques as diverse as screenprinting to a pointillist paint application. In 1965 Larter was invited to exhibit with Watters Gallery in Sydney, where he still exhibits. Larter lived in Luddenham, Sydney, until 1982, when he moved to rural Yass in southern New South Wales and subsequently Canberra in 1999. The Australian Centre for Contemporary Art, Melbourne, and the National Gallery of Australia, Canberra, held surveys of Larter's work in 1985 and 2008 respectively.

Tim Lewis
Australia 1949–

Tim Lewis studied at the National Art School, East Sydney (1969–71); Sydney College of the Arts, University of Sydney (1978–79); and Sydney Teachers College (1981). In 1971 he was introduced to the collective artist project Yellow House by photographer Jonny Lewis and subsequently contributed a number of paintings to the space. At the Yellow House Lewis met Martin Sharp, who became a friend and long-term collaborator. For *Art exhibition*, held at Bonython Galleries, Sydney, in 1973,

Lewis and Sharp produced paintings of collages juxtaposing images drawn from art-historical sources. Also in 1973 they worked with Richard Liney on the restoration of Sydney funfair Luna Park, most notably renovating and repainting the iconic laughing face that marks the entrance. The same year the trio created the stage design for the production *Kaspar* at Sydney's Nimrod Theatre. In 1975 Lewis held a solo exhibition, titled *Self-portrait*, at Coventry Galleries, Sydney, and assisted Sharp on a mural-sized commission for Macquarie University depicting the American singer Tiny Tim. From the 1990s up until the 2000s Lewis executed the underpainting on several late artworks by Sharp, which appeared in the Martin Sharp retrospectives at Ivan Dougherty Gallery in 2006 and Museum of Sydney in 2010. Lewis participated in the exhibition *The Yellow House 1970–72* at the Art Gallery of New South Wales in 1990.

Roy Lichtenstein
USA 1923–97

One of the principal figures of American pop art, Roy Lichtenstein was a painter, sculptor and printmaker born in New York. Aside from a military service hiatus (1943–46), he studied fine arts at Ohio State University (1940–49). His early abstract paintings were influenced by cubism and abstract expressionism, but while teaching at Rutgers University in New Brunswick (1960–63) he came into contact with Allan Kaprow and other innovative artists who encouraged his interest in cartoon imagery. Lichtenstein's successful 1962 solo show at the Leo Castelli Gallery in New York consolidated his famous comic-book style. Featuring simple colour schemes and Benday dots borrowed from commercial printing techniques, Lichtenstein painted pop subjects appropriated from comic strips, advertisements and art historical subjects. Humorously creating a pastiche of the artistic styles of Piet Mondrian, Pablo Picasso and Jackson Pollock, Lichtenstein attributed the same banality and artificiality to both pop culture and fine art. In the late 1960s Lichtenstein made paintings and sculptures based on the geometric forms of the art-deco era. In the 1970s he parodied other twentieth-century styles, including futurism and surrealism, and in his *Artist's studio* series of 1973–74 reworked his own earlier imagery – prefiguring a postmodern approach to appropriation. The Art Institute of Chicago and Tate Modern, London, presented a touring retrospective of Lichtenstein's work in 2012–13, and a survey of his print projects, *Roy Lichtenstein: pop remix*, was organised by the National Gallery of Australia during the same period.

Konrad Lueg
Germany 1939–96

Konrad Lueg studied at the Kunstakademie Düsseldorf under Bruno Goller and Karl-Otto Götz from 1958 to 1962. In 1963, after exhibiting in May with his fellow students Gerhard Richter and Sigmar Polke, he co-organised with Richter a fluxus-inspired happening at a furniture shop, entitled *Leben mit pop, eine demonstration fur den Kapitalistischen Realismus* (*Living with pop: a demonstration for Capitalist*

Realism), in which the artists parodied British and American pop art by placing furniture on plinths and exhibiting works derived from contemporary pop culture. Their embrace of West German postwar consumerism with *Kapitalistischen Realismus* (Capitalist Realism), also humorously critiqued East German socialist realism. During this period Lueg produced several paintings of football players and boxers using photographs cut from newspaper. In 1965 he extended his figure series to portraits of his own family, also incorporating wallpaper and other gaudy, domestic fabrics that featured patterns. He subsequently developed a series of 'pattern paintings' that resembled an array of decorative motifs derived from everyday linen, such as towels and cleaning cloths. In 1968 Lueg gave up painting to concentrate on his career as an art dealer. He had opened the Galerie Konrad Fischer in Düsseldorf the previous year under his given name, and quickly established a reputation for representing contemporary international artists, such as Sol LeWitt, Bruce Nauman and Richard Long.

Bridgid McLean
Australia 1946–

Bridgid McLean is one of Australia's few female pop artists. She completed a diploma in painting at the National Art School, East Sydney, in 1968, and held her first solo exhibition in 1973 at the Watters Gallery, Sydney. Her first exhibition depicted the hyper-masculine world of racing cars and their drivers with a vibrant, graphic style, and was critically well received. McLean's prior interest in Formula One racing led to her attending the British Grand Prix in 1970 during a visit to Europe and England, where Australian Jack Brabham led the race until the last corner, when he ran out of fuel. During the 1970s she travelled to the United States of America, Europe, India and Japan. From the mid 1970s McLean altered her style, moving from her spray gun and masking tape compositions to smaller, more intricate works that recalled the surreal pop aesthetic of the Chicago Imagists. These more visceral and humorous paintings often depict people and body parts subjected to forms of pressure. McLean's group exhibitions include *Ocker funk*, an exhibition that toured regionally from 1976 to 1977, and *Australian art of the last 20 years*, held at the Museum of Contemporary Art, Brisbane, in 1988. She has seldom exhibited since the late 1970s.

Marisol
France 1930–

Born in Paris to affluent Venezuelan parents, Marisol Escobar spent much of her peripatetic childhood between the United States of America and Venezuela. In 1950, after a year's study in Paris, she moved to New York and immersed herself in its bohemian art scene. From 1950 to 1954 she trained with the Art Students League, the New School of Social Research and Hans Hofmann. During this time she dropped her surname and began experimenting with sculptural form, creating small clay figures influenced by pre-Columbian art. In 1957 Marisol held her first solo exhibition at the Leo Castelli Gallery in New York, but its daunting success prompted a move to

Rome for two years. She developed her trademark boxlike figures upon her return to New York, incorporating carved wood, plaster casts, readymade materials and painted or drawn elements. Her 1962 Stable Gallery show caused a public sensation and she participated in pivotal group exhibitions heralding the arrival of pop art. She also appeared in several early Andy Warhol films, including *Kiss* (1963) and *13 most beautiful women* (1964). Marisol has continued sculpting figure arrangements addressing family life, politics, famous personages and personal identity, and her long career has been honoured with major retrospectives at the Neuberger Museum of Art in Purchase, New York, in 2001 and the Memphis Brooks Museum of Art in Memphis, Tennessee, in 2014.

Claes Oldenburg
Sweden/USA 1929–

Born in Stockholm, Sweden, Claes Oldenburg moved with his family to Chicago in 1936. He studied art and literature at Yale University in New Haven (1946–50) before returning to Chicago, where he attended the Art Institute. Oldenburg moved to New York in 1956, where he collaborated with artists such as Jim Dine and Allan Kaprow. In the late 1950s Oldenburg participated in several happenings, and in 1960 he transformed the Judson Gallery in New York into *The street*, an urban environment composed of cardboard, burlap and newspaper. His 1962 happening *The store* at the Green Gallery, New York, incorporated painted plaster sculptures of commodities such as food, cigarettes, lingerie and shoes. This celebration of consumer products formed the basis for his giant, soft sculptures of the 1960s that deliberately perverted the scale, texture and colour of familiar objects, such as hamburgers, toilets and typewriters. In the mid 1960s he started planning outdoor sculptures and by 1969 he had produced his colossal lipstick on caterpillar tracks. Oldenburg has subsequently devoted himself predominantly to large-scale public commissions and since 1976 has collaborated with the Dutch writer Coosje van Bruggen, whom he married in 1977. A touring retrospective of Oldenburg's work was organised by the Guggenheim Museum, New York, in 1995, and a touring survey of his works from the 1960s was organised by the Museum of Modern Art (MUMOK), Vienna, in 2012.

Alan Oldfield
Australia 1943–2004

Alan Oldfield first came to prominence with his inclusion in the hard-edge and colour field abstraction exhibition *The field*, at the National Gallery of Victoria, Melbourne, and Art Gallery of New South Wales, Sydney, in 1968. Having graduated from the National Art School, East Sydney, in 1966 at the age of 21, he was one of the youngest exhibitors. During this period Oldfield experimented with figurative, pop and abstract painting; the latter brought him into contact with several artists involved with Sydney's Central Street Gallery, where he also exhibited in the late 1960s. Between 1970 and 1976 Oldfield travelled intermittently throughout Europe and the United States of America, where he was captivated by renaissance and baroque art, as well as more recent

practice. In the 1970s and 1980s Oldfield's style shifted from colour field abstraction to figurative painting influenced by the British artists David Hockney and Patrick Proctor. He was also a stage designer for the Sydney Dance Company (1978–80), and the Australian Ballet (1987). His love of Anglo-Catholic traditions and medieval mysticism were represented in his later work, earning him the Blake Prize in 1987 and 1991. In the late 1980s Oldfield was artist-in-residence at Linacre College, Oxford University, and in 1981 he had a solo survey exhibition at the Art Gallery of New South Wales, Sydney. Oldfield had a distinguished 20-year lecturing career at the City Art Institute, Sydney, which later became the College of Fine Arts, University of New South Wales.

Eduardo Paolozzi
England 1924–2005

Born in Leith, Scotland, to Italian parents, Eduardo Paolozzi attended Edinburgh College of Art (1943), St Martin's School of Art in London (1944), and studied sculpture at the Slade School of Fine Art in Oxford (1945–47). In 1947 he had his first solo show at The Mayor Gallery, London, and then settled in Paris, where he met several surrealists, including Alberto Giacometti who, along with the art brut of Jean Dubuffet, were a significant influence on his work. Between 1941 and 1952 Paolozzi made a series of collages based on imagery derived mostly from magazines, which he collectively entitled *Bunk*. On his return to London Paolozzi taught at the Central School of Arts and Crafts from 1949 to 1955. He was a member of the Independent Group (1952–55) and in its formative stages gave an illustrated presentation that introduced his *Bunk* imagery and a variety of other popular material in an intellectual context. In 1956 he participated in the landmark exhibition *This is tomorrow* at the Whitechapel Art Gallery, London. During the 1960s Paolozzi collaborated with industrial engineering firms to create machine-aesthetic sculptures. He also produced several animated films and experimental books. Retrospectives of his work have been organised by the Tate Gallery, London, in 1971, and Nationalgalerie, Berlin, in 1975; a print retrospective was held at the Victoria and Albert Museum, London, in 1977. Paolozzi was knighted in 1989.

Peter Phillips
England 1939–

Peter Phillips was one of the pre-eminent British pop artists to emerge in the 1960s. He studied at Birmingham College of Art (1955–59), and the Royal College of Art in London (1959–62). While at the Royal College Phillips exhibited in several *Young contemporaries* exhibitions at the Royal Society of British Artists, and helped curate the 1961 edition. Influenced by Italian pre-Renaissance painting, hard-edge geometrical abstraction, and non-fine-art disciplines such as sign painting and heraldry, Phillips' imagery derived from popular sources, including pin-ups, comic books and pinball machines. In 1964 Phillips moved to the United States of America on a Harkness Fellowship and toured North America with fellow graduate Allen Jones in 1965. The same year his first solo show was held at the Kornblee Gallery, New York.

During this period Phillips gave his works a factory-produced aesthetic using a glossy airbrush technique, and often worked at billboard scale, representing machine parts, cars and pin-ups. In 1966 Phillips returned to Europe, and during the 1970s he extended his airbrush draftsmanship with illusionistic composites of pop themes. Phillips' increasingly abstract paintings of the 1980s featured objects free floating in monochromatic fields of colour. In 1972 a survey exhibition of his work was held at Westfälischer Kunstverein, Münster, and in 1982–83 the Walker Art Gallery, Liverpool, organised a touring retrospective.

Sigmar Polke
Germany 1941–2010

Sigmar Polke was born in Oels, Silesia, East Germany (now Oleśnica, Poland), and in 1953 moved with his family to Mönchengladbach, West Germany. In 1961 Polke studied with Gerhard Hoehme and Karl Otto Götz at the Staatliche Kunstakademie, Düsseldorf, where he befriended Gerhard Richter and Konrad Lueg. Together they formed a pop-inspired art movement called *Kapitalistischen Realismus* (Capitalist Realism). Exhibiting together in Düsseldorf from 1963 to 1966, the *Kapitalistischen Realisten* appropriated mass-media imagery in a humorous critique of pop art and socialist realism. Ordinary foodstuffs, such as sausages, cakes and sweets, were frequent motifs in Polke's work, and his handcrafted 'dot' paintings parodied the screenprints of Roy Lichtenstein and Andy Warhol. In the 1960s and 1970s Polke's experimentation with numerous subjects, techniques and materials – for example, his grid pictures and fabric pictures – consistently challenged the conventions of painting. In the 1970s Polke lectured at the University of Fine Arts, Hamburg, where he was made professor in 1975, eventually resigning in 1991. In the mid 1970s Polke travelled extensively throughout Pakistan and Afghanistan, and later visited Australia, where he captured photographs and film footage that he went on to integrate into his work. Polke's large, gestural paintings of the 1980s feature process-driven geological layering of various washes, varnishes and rust. Polke was awarded the Golden Lion Prize for painting at the 1986 Venice Biennale. A touring retrospective of his work was organised by the Museum of Modern Art, New York, and Tate Modern, London, in 2014.

Peter Powditch
Australia 1942–

Peter Powditch is one of Australia's most recognisable pop artists, known for his paintings of Australian beach culture. Powditch moved from Taree in rural New South Wales to Sydney and enrolled at the National Art School, East Sydney, in 1960, training in sculpture under Lyndon Dadswell. Powditch also took classes in painting at the Mary White School of Art, at Desiderius Orban's Studio school, as well as other art schools, and John Olsen was an influential teacher. His work became widely known through his Gallery A exhibitions from 1966 in Sydney and Melbourne; at the Rudy Komon Gallery, Sydney, in 1971; and then through solo exhibitions at the Ray Hughes Gallery, Sydney, since 1970. Powditch's polished, graphic images of the female

body and beach scenes, and his flattened, erotic style of pop related to that of the American artist Tom Wesselmann. In 1972 Powditch won the prestigious Sulman Prize, and subsequently visited New York on a grant from the Australia Council. In the 1980s he turned towards abstraction, and his recent paintings are primarily abstracted landscapes on board. In addition to his many solo exhibitions, Powditch exhibited in the inaugural Biennale of Sydney in 1973, and in *The Australian landscape*, which toured China and was then presented at the Art Gallery of New South Wales, Sydney, in 1975. Powditch lectured at the National Art School, East Sydney (1968–73), and subsequently at most Sydney art schools and colleges, including the Sydney College of the Arts, University of Sydney, and the College of Fine Arts, University of New South Wales.

Richard Prince
Panama Canal Zone/USA 1949–

Richard Prince was born in the Panama Canal Zone in 1949, and his family relocated to Boston in 1954. In 1973 Prince moved to New York, where he found a job clipping and filing articles for Time-Life publications. The saturation of advertising material he encountered during this period informed his early works: combinations of rephotographed, decontextualised magazine images that explore the artifice of consumer culture. Along with Cindy Sherman and Barbara Kruger, Prince became known as one of the so-called Pictures Generation, named after the exhibition *Pictures*, curated by Douglas Crimp at Artists Space, New York, in 1977. During the 1980s Prince played in new-wave bands in New York and developed grids of appropriated images that he called 'gangs'. These groupings revolved around specific pop or sub-cultural motifs, such as bikers, pornography, sunsets and, most famously, cowboys. In the late 1980s Prince began experimenting with diverse techniques and practices. His *Joke* series featured screenprinted jokes on monochromatic painted backgrounds, and he created sculptures from readymade objects, such as car hoods and tyres. More recently Prince derived inspiration from the covers of pulp romance novels and the art of Willem de Kooning. In 2007 the Guggenheim Museum, New York, organised Prince's 30-year retrospective, which travelled to the Walker Art Centre, Minneapolis, and the Serpentine Gallery, London.

Robert Rauschenberg
USA 1925–2008

Between 1947 and 1952 Robert Rauschenberg studied at the Kansas City Art Institute, the Académie Julian in Paris, the Art Students League in New York and Black Mountain College, North Carolina, where he befriended the avant-garde composer John Cage and dancer Merce Cunningham. After travelling in Italy and North Africa with Cy Twombly, he returned to New York in 1953 and exhibited a series of monochromatic paintings. By 1954 he was creating his first multimedia 'combine paintings', which were influenced by Kurt Schwitters' *Merz* collages of waste materials and the chance processes adopted by Cage. Living in the same buildings from 1955

to 1961, Rauschenberg and Jasper Johns' interest in representation and the everyday was pivotal to the emergence of pop art. In the late 1950s Rauschenberg experimented with manual transfer processes, progressing to screenprinting in the 1960s, when he also worked on several collaborative projects, including performances, set and costume designs, and founding the Experiments in Art and Technology organisation. In 1964 Rauschenberg received international critical acclaim for winning the Grand Prize for painting at the Venice Biennale. A major touring retrospective of Rauschenberg's work was organised by the Guggenheim Museum, New York, in 1997, followed in 2005 by a touring survey of the artist's combines, organised by the Museum of Contemporary Art, Los Angeles, and the Metropolitan Museum of Art, New York.

Martial Raysse
France 1936–

A self-taught artist born into a family of ceramicists, Martial Raysse started his career by making assemblages, some of them transparent plexiglas boxes containing found objects. Fascinated by the polished sterility of consumer society, Raysse applied this 'hygiene of vision' to his practice, including his work based on shop windows for the 1961 Biennale de Paris. In 1960 Raysse was one of nine artists to sign the art critic Pierre Restany's manifesto and found the *nouveaux réalistes*. Raysse's work was included in the now-famous *New realists* exhibition at Sidney Janis Gallery, New York, in 1962 and in the seminal exhibition *The art of assemblage* at the Museum of Modern Art, New York, in 1961. During the 1960s Raysse developed a more pictorial approach, making luminous, fluorescent paintings and screenprints derived from high art, fashion magazines and advertising, but still frequently incorporating found objects, such as neon tubing. In the late 1960s Raysse produced several experimental films, and although he divided his time between Paris and New York during this period, he returned to Paris in 1968 to participate in the protests at the École des Beaux-Arts and produce associated posters and propaganda. In the 1970s and 1980s Raysse predominantly worked in pastel and tempera, turning to more traditional subject matter such as pastoral scenes and mythology. The Centre Pompidou, Paris, organised a retrospective of his work in 2014.

Ken Reinhard
Australia 1936–

Ken Reinhard studied at the National Art School, East Sydney (1954–56), and at the Sydney Teachers College (1957). During the 1960s he combined abstraction and figuration in his glossy collages and sculptures of nudes and machines. Reinhard used materials drawn from advertising, pop culture and everyday life to construct works in which the female body is eroticised in a similar way to contemporary advertising campaigns for consumer goods, while also referring to traditions of the academic nude in painting. In 1964 Reinhard was awarded the Sulman Prize, and he exhibited frequently in Melbourne and Sydney between 1964 and 1972. In

addition to op art and pop art, kinetic art was an important influence on Reinhard's work, especially his sculptures. In 1970 Reinhard was awarded the Marland House Sculpture Commission for a work for the forecourt of Marland House in Melbourne. In 2004 the McClelland Gallery and Sculpture Park, Melbourne, held a survey exhibition of his work. Reinhard's distinguished academic career included the directorship of the City Art Institute in Sydney (1982–89), which later became the College of Fine Arts, University of New South Wales, where he was the founding faculty dean and director (1990–98). Reinhard was appointed a Member of the Order of Australia in 1994 and emeritus professor at the University of New South Wales in 1998.

Gerhard Richter
Germany 1932–

Gerhard Richter studied painting at the Dresden Kunstakademie from 1952, before leaving the eastern bloc in 1961 prior to the erection of the Berlin Wall. He continued his studies in West Germany at the Düsseldorf Kunstakademie (1961 –63), under the instruction of a leading art informel painter Karl Otto Götz. He came into contact with fluxus and American and British pop art in the 1960s, and in 1963 held an exhibition with fellow student Konrad Lueg, *Leben mit pop, eine demonstration fur den Kapitalistischen Realismus* (*Living with pop: a demonstration for Capitalist Realism*). A West German capitalist equivalent to East German Socialist Realism, the *Kapitalistischen Realismus* (Capitalist Realists) parodied the characteristics of pop art: banal and mass-produced materials and imagery derived from pop culture and contemporary (representational) subject matter. During this period Richter first produced his photo paintings: enlarged copies of readymade imagery derived from snapshots as well as mass media. Since the 1960s his painting practice has also encompassed monochromes, gestural and geometric abstractions, landscapes and history paintings. He has exhibited numerous times at the Venice Biennale and *Documenta* in Kassel. Major touring retrospectives of his work have been organised by the Museum of Modern Art, New York (2002); the Tate Modern, London (2012); Neue Nationalgalerie, Berlin (2012); and Centre Pompidou, Paris (2012).

Robert Rooney
Australia 1937–

Drawn to the patterns and repetition of everyday life, Robert Rooney studied graphic design at Melbourne's Swinburne Technical College from 1954 to 1957. Citing Warhol's influence on his use of secondary sources, Rooney derived his subject matter in the 1960s from domestic ephemera, pop culture and the mass media. In 1967 he began using packaged mass-produced goods, such as inserts in cereal boxes as stencils to make brightly coloured, abstract paintings in synthetic polymer paint. In 1968 one of these paintings was included in the exhibition of hard-edge and colour field abstraction, *The field*, at the National Gallery of Victoria in Melbourne and the Art Gallery of New South Wales in Sydney. After a decade of photographic practice in the

1970s Rooney returned to painting in the 1980s with a graphic style incorporating text, media material and urban symbols, such as logos and street signs, some of which date from the mid-twentieth century. He was included in the 1982 exhibition *Popism* at the National Gallery of Victoria, and was an art critic for the *Age*, Melbourne (1980–82) and the *Australian* (1982–99) newspapers. A four-decade survey of Rooney's work was organised by Monash University Gallery, Melbourne, in 1990, and his interest in conceptual art, serial-based practice and the everyday was traced in the group exhibition *Endless present* at the National Gallery of Victoria in 2010–11.

James Rosenquist
USA 1933–

Renowned for his billboard-scale composites of pop cultural themes, James Rosenquist is one of the United States of America's leading pop artists. He attended the University of Minnesota (1952–54) and learnt the trade of billboard painting after his graduation. In 1955 Rosenquist moved to New York, where he studied at the Art Students League and soon met Robert Indiana, Jasper Johns and Robert Rauschenberg. From 1957 to 1959 he was employed to paint billboards around New York, including Times Square. In 1960 Rosenquist started to apply similar techniques to his paintings, working at a monumental scale in a polished, factory-produced style, with unusual juxtapositions of images derived from films, mass media and advertising. His first solo exhibition was at the Green Gallery, New York, in 1962, and in 1963 architect Philip Johnson commissioned a mural for the New York State Pavilion at the 1964 New York World's Fair. In the 1970s Rosenquist experimented with printmaking and alternative materials, such as neon lights, plastic sheets, mirrors and perspex, but he has continued to produce his distinctive billboard-style works. A major touring retrospective of his work was organised by the Guggenheim Museum, New York, in 2003.

Martha Rosler
USA 1943–

While studying at Brooklyn College, City University of New York, Martha Rosler participated in the East Village scene and civil rights and anti-war protests. After graduating in 1965 she moved to San Diego, where she became involved in the Southern California feminist movement. From the mid 1960s Rosler started producing photomontages derived from advertising imagery taken from magazines such as *Vanity Fair*. Prioritising representations of women in advertising, she used her photomontages to question social assumptions about gender roles and expectations of health and beauty. Through them she also targeted the United States of America's involvement in the Vietnam War by juxtaposing documentary photography of conflict against idyllic images of suburban United States derived from home décor magazines. In 1971 she enrolled at the University of California, San Diego, where she came into contact with Herbert Marcuse and Fredric Jameson. She subsequently took up several teaching posts in photography, film and media

across the country, and has published widely in several books and journals. Throughout the 1970s Rosler continued to produce agitational works on social issues, including her famous video and performance works about the political nature of private life. In 2010 Rosler was included in the watershed exhibition *Seductive subversion: women pop artists, 1958–1968* at the Brooklyn Museum, New York, alongside artists such as Niki de Saint Phalle and Rosalyn Drexler.

Edward Ruscha
USA 1937–

Ed Ruscha moved from Oklahoma City to Los Angeles in 1956, and graduated from the Chouinard Art Institute in 1960. Having familiarised himself with the work of Jasper Johns, in the late 1950s Ruscha began making small collages with found materials, eventually integrating text and everyday subjects, and adopting the techniques of commercial graphics. This led to his inclusion, along with Andy Warhol and Roy Lichtenstein, in the 1962 exhibition *New painting of common objects* at the Pasadena Art Museum. In 1965 he began working as a layout designer for *Artforum* magazine. Although Ruscha made several short films in the 1970s, he is best known for his books of serial, deadpan photography of urban Los Angeles, and his prints and paintings of words and phrases against monochromatic colour fields or stylised background images. He also used unconventional materials in his work, such as gunpowder, red wine, flowers, axle grease and a variety of foodstuffs. His major retrospectives include the San Francisco Museum of Modern Art's travelling exhibition of 1982–83, and *Ed Ruscha: fifty years of painting*, organised by the Hayward Gallery, London, 2009. A survey of Ruscha's work was organised by the Museum of Contemporary Art in Sydney in 2004, and he was the American representative at the Venice Biennale in 2005.

Niki de Saint Phalle
France 1930 – USA 2002

Catherine Marie-Agnès Fal de Saint Phalle was born in 1930 at Neuilly-sur-Seine in France, but was raised in New York from 1933. In the late 1940s she modelled for *Vogue* and *Harper's Bazaar*, and featured on the cover of *Life* magazine. A self-taught artist, she returned to France in the 1950s with her first husband, Harry Mathews. During this period she met Jean Tinguely – whom she later married in 1971 – and in 1960 gained recognition for her *Shooting* paintings. Comprised of found objects and sachets of paint concealed in white plaster, these chance compositions, when shot by the artist or an audience member, parodically resembled abstract expressionist and art informel paintings. In 1961 Pierre Restany, the founder of the *nouveaux réalistes*, asked her to join the group and organised her first solo show at Galerie J in Paris, where Robert Rauschenberg bought one of her paintings. Saint Phalle then focused on her *Nana* series of vibrant, playful female figures inspired by Antoni Gaudí from 1965, producing numerous monumental sculptures for public spaces, for which she is now renowned. She also made films, including

Daddy (1973), designed the scenery and costumes for Roland Petit's ballet *Eloge de la folie* (1966), and produced several illustrated books.

Gareth Sansom
Australia 1939–

Sansom studied painting at the Royal Melbourne Institute of Technology from 1959 to 1964, developing a taut compositional balance of abstraction and figuration in his works. While Francis Bacon was a cited influence on his early work, the integration of collaged elements from contemporary life also signalled the inspiration of British artists like Peter Blake. During the 1970s Sansom's themes included gender identity, personal relationships, political satire, mortality and pop culture. In this period Sansom painted on hardboard panels, combining oil paints, enamels, photomontage and collage. He also initiated a more performative practice, photographing himself masquerading as women, including Hollywood stars such as Joan Crawford. Sansom was head of painting (1977–86) and dean (1986–91) of the School of Art at the Victorian College of the Arts, Melbourne. He was visiting artist at the Stedelijk Museum in Amsterdam in 1982, and exhibited in the Seventh Indian Triennale, New Delhi, in 1991; the Asia Pacific Triennial, Queensland Art Gallery, Brisbane, in 1993; and *Cross currents: focus on contemporary Australian art*, Museum of Contemporary Art, Sydney, in 2007. In 2005 the Ian Potter Museum of Art, Melbourne, held the retrospective *Gareth Sansom: welcome to my mind*, and in 2008 he won the John McCaughey Memorial Prize, as well as the Art Gallery of New South Wales Dobell Prize for Drawing in 2012.

Martin Sharp
Australia 1942–2013

Regarded as one of Australia's most prominent pop artists, Martin Sharp was a Sydney-based artist, filmmaker, cartoonist and designer. He enrolled at the National Art School, East Sydney, in 1960 and briefly switched to architecture at the University of Sydney in 1961, before returning to the National Art School until 1963. In 1962 Sharp founded the student magazine *The Arty Wild Oat* with Garry Shead, which ran for two issues, and contributed cartoons and drawings to the popular press, university publications and the satirical magazine *Oz*, which he co-founded in 1963 with Richard Neville and Richard Walsh. He lived in London for two years from 1967, where *Oz* was relaunched and became synonymous with Sharp's graphic style. Befriending musicians and artists, and designing posters for Cream and Bob Dylan, Sharp's psychedelic imagery responded to 1960s counterculture and LSD experimentation and shows the influence of both surrealism and art nouveau. On his return to Sydney in 1970 Sharp established the Yellow House in Potts Point, a multimedia work of art itself, and a hub of local artistic activity. During the 1970s Sharp was preoccupied with the redesign of Sydney's Luna Park entrance and the cult pop musician Tiny Tim. An exhibition on the Yellow House was held at the Art Gallery of New South Wales in 1990, and a survey

exhibition, *Martin Sharp: Sydney artist*, was held at the Museum of Sydney in 2009–10.

Michael Allen Shaw
England 1937–

Born in the Isle of Wight, Michael Allen Shaw studied painting at the Southern College of Art, Portsmouth (1957–61). In 1962 he designed theatre sets in London and regional England. He settled in Australia in 1963 as an artist for ABC Television and the Elizabethan Theatre Trust. During this period he also produced flat, graphic oil paintings and watercolours that focused on popular culture including sport, nudes, pulp-fiction book covers and other imagery derived from mass-media printed materials. He quickly established himself in the Sydney art scene, befriending artists such as Richard Larter and Colin Lanceley. Shaw held his first solo show at Dominion Galleries, Sydney, in 1963; between 1963 and 1966 he had five more solo shows at the Dominion and Watters galleries, and *Australian beach girls* 1967 at Strines Gallery, Melbourne. He exhibited in many group shows while in Australia, including the *Young contemporaries* exhibitions at the Farmer's Blaxland Gallery in 1964 and 1965, and was included in *The nude in Australian art* at Gallery A, Sydney, in 1966. Later that year he returned to England briefly and travelled in Europe before settling in Formentera and later Ibiza. He continued to send work back to Australia for exhibition until the late 1960s.

Garry Shead
Australia 1942–

Garry Shead spent two years at the National Art School, East Sydney (1961–62), during which time he co-founded the two-issue *The Arty Wild Oat* student magazine with Martin Sharp and began shooting his first experimental film, *Ding a ding day*, which was not completed until 1966. He also established himself as a satirical cartoonist, with published work in *The Bulletin* and *The Sydney Morning Herald*. He subsequently became a regular contributor to the controversial satirical magazine *Oz*, launched on 1 April 1963. After working as a scenic artist with ABC TV for three years, Shead held his first exhibition at the Watters Gallery, Sydney, in 1966 and his deliberately provocative paintings were a sexual satire on middle-class suburban life in Sydney's upper-north shore. The *Wanda* and *Lane Cove* series, exhibited in 1967, confrontingly referred to two notorious unresolved murders in the 1960s at Wanda Beach and Lane Cove River, both of which were sexual in nature. Shead collaborated with Sharp and Peter Kingston in 1974 on monumental murals for Luna Park. In the 1980s his work became increasingly more lyrical and painterly, reflecting his literary interests in DH Lawrence and the poetry of fictitious Australian author Ern Malley. Shead won the Archibald Prize in 1993 and the Dobell Prize for Drawing in 2004.

Cindy Sherman
USA 1954–

Cindy Sherman grew up in suburban Glen Ridge, New Jersey, and like many other artists of the Pictures Generation

group, she was compelled by 1960s television culture, in which costumes and make-up played an integral role. Sherman studied photography at the State University College at Buffalo (1972–76) and soon after graduating moved to New York, where she developed her famous black-and-white series of *Untitled film stills* 1977–80, featuring various incarnations of female roles from B-grade movies. Sherman models for her own photographs, incorporating various *mise-en-scènes*, costumes and make-up. She uses these pop-cultural disguises to explore the instability and artifice of gender construction. Sherman's work from the early 1980s is characterised by grotesque photographs that include dolls and prosthetics, as well as vomit, waste and decaying substances, reflecting her love of horror. In the late 1980s her style shifted to appropriated scenes and characters derived from famous historical paintings. She made her directorial debut with the film *Office killer* of 1997, while her photographs since 2000 include portraits of clowns and aging socialites. Sherman featured in the survey exhibition *The pictures generation*, organised by the Metropolitan Museum of Art, New York (2009), and a major touring retrospective of her work was organised by the Museum of Modern Art, New York (2012).

Wayne Thiebaud
USA 1920–

Wayne Thiebaud worked at the Walt Disney Studios in Los Angeles in 1936, while still in high school, before studying commercial art at the Frank Wiggins Trade School in Los Angeles in 1937. He subsequently worked as a cartoonist in Long Beach and as an artist in the United States Army Air Force (1942–45). He also studied at San Jose State College and California State College at Sacramento (1949–53). During a period of teaching at Sacramento Junior College from 1951 to 1960, he visited New York, befriending Willem de Kooning and deriving inspiration from Robert Rauschenberg and Jasper Johns. As a result, abstract expressionism and art addressing everyday life were key influences on Thiebaud's paintings of the 1950s, which are dominated by thick, gestural brushstrokes on orderly compositions of commercial and everyday subject matter, such as pinball machines and cosmetics. After his appointment at the University of California at Davis in 1960, Thiebaud began his best-known series of pastel-toned still lifes depicting pies, ice-creams and cakes. In 1962 Thiebaud was included in the landmark pop exhibitions *New realists* at the Sidney Janis Gallery, New York, and *New painting of common objects* at the Pasadena Art Museum, alongside artists such as Andy Warhol, Ed Ruscha and Enrico Baj. From the mid 1960s Thiebaud predominantly painted rural and urban landscapes. In 2010 he was inducted into the California Hall of Fame.

Imants Tillers
Australia, 1950–

Imants Tillers studied architecture at the University of Sydney from 1969 to 1972. During this period he developed a conceptualist art practice, which rapidly gained momentum in the years following his graduation. In the mid 1970s he began

exploring ideas of appropriation and repetition by reworking image fragments drawn from art historical and literary sources. In 1981 Tillers commenced his system of working with amateur painters' canvas boards to create complex, layered compositions of quoted imagery and text arranged in grid formations, with each panel numbered sequentially to form part of an ever-expanding whole. In 1982 Tillers was included in the exhibition *Popism* at the National Gallery of Victoria, Melbourne, and throughout the decade was a major contributor to discourses on provincialism, postmodernism and originality in the Australian context. The son of Latvian immigrants, in the 1990s Tillers' explorations of locality and identity were more deeply engaged with his diasporic heritage. After relocating from Sydney to the Snowy Mountains region of New South Wales in 1997, the landscape became increasingly central to his practice. Major survey exhibitions of Tillers' work have been organised by the Institute of Contemporary Arts, London (1988); the National Art Gallery, Wellington (1989); the Museum of Contemporary Art in Monterrey, Mexico (1999); and the National Gallery of Australia, Canberra (2006). Tillers was a trustee of the Art Gallery of New South Wales from 2001 to 2009.

Joe Tilson
England 1928–

In the 1940s Joe Tilson worked as a carpenter and joiner and served in the Royal Air Force, before studying in London at St Martin's School of Art (1949–52) and the Royal College of Art (1952–55), ahead of fellow students Peter Blake and Richard Smith. His early abstract paintings were influenced by the abstract expressionist works he had seen at a 1956 exhibition of American art at the Tate Gallery, but by the early 1960s he was making colourful, geometric wooden reliefs that responded to the emergent pop art of his peers. These schematically juxtaposed images and text in a tautological fashion, and alluded in their construction to children's toys. In the late 1960s he introduced screenprinted elements, often featuring contemporary events and subjects derived from newspapers and other printed materials. From the mid 1960s he also produced screenprints and multiples that made creative use of technology. Tilson's first solo exhibition was held at the Marlborough Gallery, London, in 1962. In 1972 he and his family withdrew from urban life for a simpler rural existence in Wiltshire, where he returned to more traditional craftsmanship. In the 1980s the subject matter of his paintings and prints was predominantly mythological. A survey exhibition of Tilson's prints was held at the Vancouver Art Gallery (1979); retrospectives have been organised by the Arnolfini Gallery, Bristol (1984), and Royal Academy of Arts, London (2002).

Tony Tuckson
Australia 1921–73

Tony Tuckson spent his childhood in Egypt and England, where he studied painting full time in 1937–38 at the Hornsey School of Art, London. During the war he served in the Royal Air Force (1940–46) and was posted to Australia in 1942. He continued studying art at

the National Art School, East Sydney, from late 1946 to 1949, and exhibited with the Society of Artists and the Contemporary Art Society of Australia. His early paintings were most frequently figurative, domestic scenes drawn from everyday life, which show the influence of Pablo Picasso and Henri Matisse amongst others, but in the early 1960s Tuckson incorporated collaged found materials, such as newspapers and clothing items, into highly worked surfaces that recall Robert Rauschenberg's combines. In 1950 he worked as an attendant at the Art Gallery of New South Wales, Sydney, and was subsequently appointed assistant to the director. In 1957 his position continued under the title deputy director, until his death. Renowned for enhancing the gallery's Aboriginal and Melanesian collection, his later works register his appreciation of non-western forms of gestural painting as well as American abstract expressionism. Due to his institutional role, Tuckson held only two solo exhibitions of his work, in 1970 and 1973, both at the Watters Gallery in Sydney. The Art Gallery of New South Wales held a memorial retrospective for Tuckson in 1976, and in 2000 the National Gallery of Australia presented and toured the exhibition *Painting forever: Tony Tuckson*.

Peter Tyndall
Australia 1951–

Peter Tyndall pursued a career in art after studying architecture at the University of Melbourne (1971) and at the Royal Melbourne Institute of Technology (1972). Embracing the dominance of conceptual art in the 1970s, Tyndall's paintings examined propositions about art itself, especially the way in which 'looking' determines the experience of art. Since 1974 he has expressed these concerns through his ideogram of a square with two lines, symbolising a painting hanging from support wires. Since the mid 1970s Tyndall has prefaced each of his work titles with: *detail: A person looks at a work of art/someone looks at something ...* Although he used text, like the Art & Language group, his conceptual practice adopted a humorous pop aesthetic in the 1980s with the use of advertising, press material, children's books and comics. He was included in the exhibitions *Popism* (1982) and *Vox pop: into the eighties* (1983) at the National Gallery of Victoria, Melbourne, and the Biennale of Sydney in 1982, 1986 and 1990. Melbourne's Australian Centre of Contemporary Art organised a touring survey of his work in 1987, with a more recent survey taking place at the Anna Schwartz Gallery, Sydney, in 2012. Tyndall was also represented in *Mix tape 1980s: appropriation, subculture, critical style* and *Melbourne now* at the National Gallery of Victoria in 2013. He continues to engage with pop culture and the mass media through his blog bLOGOS/HA HA.

Andy Warhol
USA 1928–87

Born Andrew Warhola in Pittsburgh, Andy Warhol studied at the Carnegie Institute of Technology before moving to New York in 1949, where he established a successful career as a commercial illustrator. Motivated by a desire for serious artistic recognition, and inspired by Robert Rauschenberg, Warhol subverted abstract expressionist painting using advertising and comic strips. He eventually removed his presence from the artistic process further by using mechanical devices, such as stencils and rubber stamps. By 1962 Warhol used screen-printing exclusively and outsourced mechanical (re)production to assistants at his studio, better known as The Factory. Warhol chose subjects that mirrored contemporary American visual culture, from Hollywood film stars and mass-produced commodities, to press images of tragedy and violence. His entourage at this time included musicians, drug addicts and transvestites, and parties at The Factory often featured members of New York's high society. Warhol announced his complete devotion to film in 1965 (though he continued to produce works in other mediums). The absence of plots, editing and characters in films such as *Sleep* (1963) and *Empire* (1964) consistently challenged traditional film-making. In 1968 Warhol was shot and nearly died, prompting significant changes in his life and art. In 1969 he established *Interview* magazine, while the 1970s and 1980s saw him concentrate on private portrait commissions and print projects. Warhol's collaboration with Jean-Michel Basquiat in the mid 1980s encouraged the pop artist's return to painting. Warhol died in 1987 as a result of complications following a routine operation.

Dick Watkins
Australia 1937–

Dick Watkins came to prominence in the 1960s as a stylistically diverse abstract painter. While largely self-taught, Watkins occasionally attended classes at the Julian Ashton School, Sydney (1955–58), and studied for a year at the National Art School, East Sydney (1958). He subsequently travelled in England, Europe and the United States of America (1959–61). This was an important formative experience, as Watkins saw firsthand the diverse styles of contemporary art. He held his first exhibition at Barry Stern Galleries, Sydney (1963), and in the late 1960s was closely associated with the Central Street Gallery in Sydney. In 1968 Watkins was included in the hard-edge and colour field abstraction exhibition *The field*, at the National Gallery of Victoria and Art Gallery of New South Wales. Watkins subsequently adopted a shifting personal style that referenced a variety of forms, such as pop, figuration and gestural abstraction. Manipulating the styles of artists such as Jackson Pollock, Fernand Léger and Pablo Picasso amongst others, Watkins became an example to a younger generation of artists engaged in post-modern techniques of appropriation and pastiche. In 1985 Watkins represented Australia at the XVIII São Paulo Biennial. The National Gallery of Australia mounted the survey *Dick Watkins in context: an exhibition from the collection of the National Gallery* in 1993, and in 2012–13 featured Watkins in the exhibition *Abstract expressionism*.

Jenny Watson
Australia 1951–

Jenny Watson grew up in suburban Melbourne and the foothills of the Dandenong Ranges, an experience that informed her subject matter in the 1970s and 1980s. She completed a Diploma of Painting at the National Gallery of Victoria Art School in 1972 and a Diploma of Education at the State College of Victoria in 1973. Her first solo show, at Melbourne's Chapman Powell Street Gallery in 1973, featured paintings of figures and animals derived from the mass media. She was exposed to feminism and conceptual art through theorist Lucy Lippard and undertook extended periods of travel to London, Paris and New York between 1976 and 1979. During this time she sparked friendships with artists Howard Arkley and Elizabeth Gower, engaged with Melbourne's punk music scene and painted her famous series of childhood suburban homes. She was also a partner in the experimental Art Projects gallery (1979–84). In the 1980s Watson increasingly used text and materials drawn from her immediate environment in an exploration of diaristic themes and dream-like narratives. She was included in the exhibitions *Aspects of new realism* (1981), *Popism* (1982) and *Vox pop: into the eighties* (1983), all at the National Gallery of Victoria, Melbourne. Watson participated in the Biennale of Sydney in 1982 and 1984; in 1993 represented Australia at the Venice Biennale; and had a survey exhibition at the Ian Potter Museum of Art at the University of Melbourne in 2012. Her artwork is exhibited internationally and she currently divides her time between Australia and Europe.

Tom Wesselmann
USA 1931–2004

An innovator of American pop art in the 1960s Tom Wesselmann graduated with a psychology degree from the University of Cincinnati in 1956, before studying first as a cartoonist and then as a painter at the Cooper Union in New York from 1956 to 1959. His early works were influenced by abstract expressionism, particularly the gestural paintings of Willem de Kooning. By 1961, however, Wesselmann had embarked on his series *Great American nude* – bright, decorative compositions incorporating domestic ephemera and collaged advertising material. The following year he was invited to take part in the groundbreaking *New realists* exhibition at the Sidney Janis Gallery, alongside artists such as Andy Warhol, Wayne Thiebaud and Claes Oldenburg. In 1963 he married fellow student and model for his works, Claire Selley. His paintings of the late 1960s were increasingly erotic and featured vibrant, flat, formal compositions. During the 1970s Wesselmann worked at a monumental scale and experimented with a series of freestanding sculptural works of sheet metal. In the 1980s he created hand-cut aluminium wall works and pioneered the artistic use of laser-cut steel. Also a prolific printmaker, Wesselmann translated his imagery into lithographs, screenprints and aquatints. A significant retrospective of his work was organised by the Montreal Museum of Fine Arts in 2012, which toured to the Virginia Museum of Fine Arts in 2013 and the Denver and Cincinnati art museums in 2014.

Brett Whiteley
Australia 1939–92

Brett Whiteley occasionally attended John Santry's sketch club and life drawing classes at the Sydney Art School (now called the Julian Ashton Art School), from 1956 to 1959, while also working at Lintas Advertising Agency in the layout and commercial art department. Having won the Italian Government Travelling Art Scholarship in 1959, Whiteley toured Italy in 1960 before settling in London, where his inclusion in the 1961 exhibition *Recent Australian painting* at the Whitechapel Art Gallery earned him international recognition. The following year he married Wendy Julius, the subject and muse for many of his paintings. Returning to Sydney in 1965 Whiteley's mixed-media sculptures and figurative paintings of Australian beaches and the landscape took on a more pop aesthetic with the inclusion of collaged elements. In 1967 he was awarded a Harkness Foundation Scholarship and moved his family into the Chelsea Hotel, a cultural hub in New York; there he gained direct exposure to American art. After a failed attempt to relocate to Fiji in 1969, the Whiteley family returned to Sydney and moved to Lavender Bay. Whiteley participated in the Yellow House artist's collective in 1970–72, and in the 1970s twice won the Archibald, Wynne and Sulman prizes, including all three in 1978. In 1985 Whiteley transformed a Surry Hills factory into a studio, which is now administered as a studio museum by the Art Gallery of New South Wales. In 1991 Whiteley was awarded the Order of Australia.

All dimensions are in centimetres, height x width, or height x width x depth or (diam) for three-dimensional objects.

Valerio Adami

F Lensky all'International Dance Studio (F Lensky at the International Dance Studio) 1968
enamel paint on canvas
101.5 x 82.5 cm
JW Power Collection, University of Sydney, managed by Museum of Contemporary Art, purchased 1968

Howard Arkley

Primitive gold 1982
synthetic polymer paint on canvas
210 x 209.8 cm
National Gallery of Victoria, Melbourne. Michell Endowment 1982

Triple fronted 1987
synthetic polymer paint on canvas
166.4 x 238.4 cm
Art Gallery of New South Wales, Sydney. Mollie and Jim Gowing Bequest Fund 2014

Evelyne Axell

Le retour de Tarzan 1972
enamel on plexiglas
196 x 132 cm
Centre Pompidou, National Museum of Modern Art Collection. Don M Jean Antoine 2009
[not exhibited]

Enrico Baj

General 1961
oil with collage of sisal, silk, wool, glass, cotton, enamel, wood and various metals
146 x 110.1 cm
National Gallery of Australia, Canberra, purchased 1978

Le Baron Robert Olive de Plassey, Gouverneur de Bengale (The Baron Robert Olive de Plassey, Governor of Bengal) 1966
collage with felt, braid, brocade and badges on canvas
146.4 x 114.6 cm
JW Power Collection, University of Sydney, managed by Museum of Contemporary Art, purchased 1968

Jean-Michel Basquiat, Andy Warhol

Collaboration 1984–85
acrylic and oil stick on linen
193 x 264.5 cm
The Andy Warhol Museum, Pittsburgh. Founding Collection, Contribution The Andy Warhol Foundation for the Visual Arts Inc

Ten punching bags (Last Supper) 1985–86
acrylic and oil stick on punching bags
106.7 x 35.6 x 35.6 cm (diam, each)
The Andy Warhol Museum, Pittsburgh. Founding Collection, Contribution The Andy Warhol Foundation for the Visual Arts Inc

Vivienne Binns

Phallic monument 1966
synthetic polymer paint on composition board
91.5 x 106 cm (irreg)
National Gallery of Australia, Canberra, purchased 1993

Suggon 1966
enamel on composition board, electric motor, synthetic polymer mesh and steel
122.2 x 92 cm
National Gallery of Australia, Canberra, purchased 1977

Vag dens 1967
synthetic polymer paint and enamel on composition board
122 x 91.5 cm
National Gallery of Australia, Canberra, purchased 1978

Sir Peter Blake

The first real target 1961
enamel on canvas and paper on board
53.7 x 49.3 cm
Tate, purchased 1982

Self-portrait with badges 1961
oil paint on board
174.3 x 121.9 cm
Tate. Presented by the Moores Family Charitable Foundation to celebrate the John Moores Liverpool Exhibition 1979

Derek Boshier

Drinka pinta milka 1962
oil on canvas
152.5 x 121 cm
Royal College of Art, London

Robert Boynes

Premonition 1969
synthetic polymer paint on canvas
183 x 182.2 cm
National Gallery of Victoria, Melbourne, purchased 1980

Playboy club news 1974
synthetic polymer paint on canvas
152 x 152 cm
Art Gallery of New South Wales, Sydney, purchased 1983

Mike Brown, Ross Crothall

Sailing to Byzantium 1961
enamel, pencil and oil crayon on composition board
98 x 151.3 cm
National Gallery of Australia, Canberra, purchased 1981

Mike Brown, Ross Crothall, Colin Lanceley

Byzantium 1961–62
oil, synthetic polymer paint and collage of found objects on plywood
183 x 122 cm
National Gallery of Australia, Canberra, purchased 1988

Mike Brown

Arbitrary trisection with figtrees and later enthusiastic additions
c1964–65
synthetic polymer paint on masonite
122 x 122 cm
Collection of Noel Hutchison

Big mess 1964–c1970
synthetic polymer paint and collage on plywood
183 x 91 cm
Private collection, courtesy Charles Nodrum Gallery

Hallelujah! 1965
synthetic polymer paint and collage on cotton duck
93.4 x 139.1 cm
Collection of Noel Hutchison

Tom 1965
synthetic polymer paint on hardboard
92 x 137.5 cm
Art Gallery of New South Wales, Sydney, purchased with funds provided by an anonymous purchase fund for contemporary Australian art 1970
[not illustrated]

Patrick Caulfield

Dining recess 1972
oil on canvas
274.5 x 213.5 cm
Arts Council Collection, Southbank Centre, London

Juan Davila

Miss Sigmund 1981
synthetic polymer paint on photographic mural paper on canvas
200 x 260.5 cm
Queensland Art Gallery, Brisbane, purchased 1991 with funds from the 1990 International Exhibitions Program

Neo-pop 1983–85
oil on canvas
4 panels: 273.9 x 547.7 cm (overall)
Art Gallery of New South Wales, Sydney, purchased 2003

Jim Dine

An animal 1961
oil and pelt on canvas
183 x 153 cm
National Gallery of Australia, Canberra, purchased 1980

Rosalyn Drexler

Home movies 1963
oil and synthetic polymer with photo-mechanical reproductions on canvas
122.1 x 244.2 cm
Hirshhorn Museum and Sculpture Garden, Smithsonian Institution, Washington, DC. Gift of Joseph H Hirshhorn, 1966

Race for time 1964
acrylic and photomechanical reproduction on canvas
152.7 x 127.6 cm
Hirshhorn Museum and Sculpture Garden, Smithsonian Institution, Washington, DC. Gift of Joseph H Hirshhorn, 1966

Richard Dunn

Relief picture and figure 10
1981/2010
oil and acrylic on canvas, diptych
170.2 x 460.8 cm
Private collection

Erró

Pop's history 1967
glycerophtalic paint on canvas
145 x 205.2 cm
Reykjavík Art Museum

Öyvind Fahlström

ESSO-LSD 1967
plastic in three colours, two pieces
88 x 119.5 x 7 cm (each)
IVAM Valencian Institute of
Modern Art, Generalitat

Gilbert & George

Friendship 1982
photo-piece: screenprint on
black-and-white and colour
photographs, and synthetic polymer
paint on metal frames
427 x 455 cm
JW Power Collection, University of
Sydney, managed by Museum of
Contemporary Art, purchased 1986

Grafik des Kapitalistischen Realismus (Graphics of Capitalist Realism)

print portfolio
published by Stolpeverlag, Berlin, 1968
Art Gallery of New South Wales,
purchased 1991

KP Brehmer
The sensuality between fingertips 1968
offset colour photo lithograph,
four seed packets on
cloth-covered cardboard
69.5 x 49.8 cm (image/sheet)

KH Hödicke
Magic window cleaner II 1967
colour screenprint on transparent
synthetic polymer resin (plexiglas)
82.9 x 58.6 cm (image/sheet)

Konrad Lueg
Babies 1967
offset lithograph in duotone
59.6 x 84 cm (image/sheet)

Sigmar Polke
Weekend-home 1967
colour screenprint
52.2 x 84 cm (image, irreg);
59.6 x 84 cm (sheet)

Gerhard Richter
Hotel Diana 1967
colour photo lithograph
29.5 x 40.2 cm (image);
59.6 x 84 cm (sheet)

Wolf Vostell
Starfighter 1967
photo screenprint, glitter
53.5 x 81.8 cm (image/sheet)

Richard Hamilton

Carapace 1954
oil on canvas
41 x 76.5 cm
Queensland Art Gallery, Brisbane.
Gift of Phyllis Whiteman and Josephine
Whiteman through the Queensland
Art Gallery Foundation 2004. Donated
through the Australian Government's
Cultural Gifts Program

Adonis in Y fronts 1963
screenprint
69.2 x 84.8 cm
National Gallery of Australia, Canberra,
purchased 1982

My Marilyn 1965
screenprint
51.7 x 63.2 cm (image);
69 x 84.3 cm (sheet)
National Gallery of Australia, Canberra,
purchased 1974

Toaster 1967
lithograph, screenprint,
with collage of metalised polyester
58.4 x 58.4 cm (image);
88.8 x 63.4 cm (sheet)
National Gallery of Australia, Canberra,
purchased 1982
[not illustrated]

Swingeing London '67 – etching 1968
etching, aquatint, embossing,
die stamp and collage
56.8 x 72.6 cm (sheet)
National Gallery of Australia, Canberra,
purchased 1982

Swingeing London 67 – sketch 1968
pencil, pastel, watercolour and
metalised acetate on paper
33 x 48 cm
Arts Council Collection, Southbank
Centre, London

Fashion-plate 1969–70
photo-offset lithograph, collage,
screenprint and pochoir, retouched
with cosmetics on wove paper
75 x 60.3 cm (image);
99.3 x 69 cm (sheet)
Queensland Art Gallery, Brisbane,
purchased 1985
[not illustrated]

Kent State 1970
colour photo screenprint
67.1 x 87.1 cm (image);
73 x 102 cm (sheet)
Art Gallery of New South Wales,
Sydney, purchased 1971

Just what was it that made yesterday's homes so different, so appealing? Upgrade 2004
Piezo pigment inkjet print
26 x 24.8 cm (image);
41.9 x 29.8 cm (sheet)
The Metropolitan Museum of Art,
New York. Gift of the artist 2004

Duane Hanson

Woman with a laundry basket 1974
surface paint oil, cardboard, resin,
talc, fibreglass, fabric, plastic,
cardboard packaging
165 x 84 x 70 cm (irreg)
Art Gallery of South Australia,
Adelaide. South Australian
Government Grant 1975

Keith Haring

Untitled 1982
synthetic polymer paint on vinyl
tarpaulin with aluminium eyelets
213.5 x 220 cm
JW Power Collection, University of
Sydney, managed by Museum of
Contemporary Art, purchased 1982

David Hockney

We two boys together clinging 1961
oil on board
121.9 x 152.4 cm
Arts Council Collection, Southbank
Centre, London

The second marriage 1963
oil, gouache and collage of torn
wallpaper on canvas
197.8 x 228.7 cm (irreg)
National Gallery of Victoria, Melbourne.
Presented by the Contemporary Art
Society of London, 1965

Man in shower in Beverly Hills 1964
acrylic paint on canvas
167.3 x 167 cm
Tate, purchased 1980

Portrait of an artist 1972
synthetic polymer paint on canvas
213.3 x 304.8 cm
The Lewis Collection

Robert Indiana

The Demuth American dream no 5 1963
oil on canvas
5 panels: 121.9 x 121.9 cm (each)
Art Gallery of Ontario, Toronto. Gift from
the Women's Committee Fund 1964

Love cross 1968
oil on canvas, five panels
457.2 x 457.2 cm (irreg)
The Menil Collection, Houston

Alain Jacquet

Déjeuner sur l'herbe (diptych) 1964
photo screenprint on canvas,
two panels
173 x 96.5 cm (each)
National Gallery of Australia, Canberra,
purchased 1983

Portrait d'homme (Portrait of a man) 1964
screenprint on canvas
163 x 115 cm
JW Power Collection, University of
Sydney, managed by Museum of
Contemporary Art, purchased 1968

Jasper Johns

White numbers 1957
encaustic on canvas
86.5 x 71.3 cm
The Museum of Modern Art,
New York. Elizabeth Bliss
Parkinson Fund 1958

Allen Jones

Reflected man 1963
oil on canvas
152.4 x 182.9 cm
Arts Council Collection, Southbank
Centre, London

Come in 1967
synthetic polymer paint on canvas,
synthetic polymer sheet on aluminium
and iron
231 x 152.5 x 46 cm
JW Power Collection, University of
Sydney, managed by Museum of
Contemporary Art, purchased 1967

Secretary 1972
fibreglass, aluminum and leather
105 x 45 cm
State Art Collection, Art Gallery of
Western Australia, purchased 1973

Edward Kienholz

Sawdy 1971
steel, rubber, chrome, aluminium,
vinyl, synthetic polymer paint, synthetic
polymer resin, mirror film, glass and
screenprint on paper, flourescent tube
and unit
100 x 94 x 18.5 cm (irreg)
JW Power Collection, University of
Sydney, managed by Museum of
Contemporary Art, purchased 1972

Peter Kingston

The checkout chicks 1976
wood, enamel, felt
28 x 90 x 60 cm (variable)
National Gallery of Australia, Canberra.
Gift of the Philip Morris Arts Grant 1982

RB Kitaj

Walter Lippmann 1966
oil on canvas
182.9 x 213.4 cm
Collection Albright-Knox Art Gallery,
Buffalo, New York. Gift of Seymour
H Knox, Jr 1967

Jeff Koons

New Hoover Convertibles 1984
two Hoover Convertibles,
plexiglas, fluorescent lights
147.3 x 104.1 x 71.1 cm
Courtesy Murderme

Three ball 50/50 tank (Spalding Dr JK Silver series) 1985
glass, steel, distilled water, three basketballs
153.7 x 123.8 x 33.7 cm
Courtesy Murderme

Vase of flowers 1988
from the series **Banality**
mirror
184.2 x 134.6 x 2.5 cm
Art Gallery of New South Wales,
Sydney. John Kaldor Family Collection

Maria Kozic

MASTERPIECES (Warhol) 1986
synthetic polymer paint on wood
182 x 122 cm
JW Power Collection, University of
Sydney, managed by Museum of
Contemporary Art, purchased 1987

Barbara Kruger

Untitled (You can't drag your money into the grave with you) 1990
photographic silkscreen on vinyl
276.9 x 377.5 cm
The Seavest Collection

Colin Lanceley

Love me stripper 1963
oil and collage of miscellaneous
objects on plywood
188.3 x 122 cm
National Gallery of Australia, Canberra,
purchased 1973

Richard Larter

Dithyrambic painting no 6 1965
synthetic polymer paint on hardboard
121.8 x 182.8 cm
Art Gallery of New South Wales,
Sydney. Gift of Mrs MA McGrath 1972

collages c1965
collage of magazine illustrations
and printed text
National Gallery of Australia, Canberra,
purchased 1993

Being dead
49.5 x 37 cm (image);
50.8 x 38.2 cm (sheet)

Quick whirl round the puppet gallery
49.8 x 37.2 cm (image);
50.6 x 38 cm (sheet)

The deadheart of illusions
50 x 37.8 cm (image);
50.8 x 38 cm (sheet)

Untitled [figures and bomb]
49.2 x 37.8 cm (image);
51 x 38 cm (sheet)

Untitled [figures and factory]
48.6 x 36 cm (image);
50.8 x 38.2 cm (sheet)

Untitled [figures and shark]
49 x 36.8 cm (image);
50.8 x 38.2 cm (sheet)

Big time easy mix 1969
synthetic polymer paint and pencil
on composition board
122.2 x 183.3 cm
National Gallery of Australia,
Canberra. Gift of the Philip Morris
Arts Grant 1982

The hairdresser 1969
synthetic polymer paint
on composition board
133 x 122 cm
Collection of Helen Eager
and Christopher Hodges

**Prompt Careb and
how we never learn** 1975
synthetic polymer paint on canvas
183.2 x 133 cm
Art Gallery of New South Wales,
Sydney. Visual Arts Board Australia
Council Contemporary Art Purchase
Grant 1975

Roy Lichtenstein

Look Mickey 1961
oil on canvas
121.9 x 175.3 cm
National Gallery of Art, Washington,
DC. Gift of Roy and Dorothy
Lichtenstein in Honour of the
50th Anniversary of the National
Gallery of Art, 1990.41.1

Kitchen range 1961–62
oil on canvas
173 x 173 cm
National Gallery of Australia,
Canberra, purchased 1978

Peanut butter cup 1962
oil on canvas
35.6 x 35.6 cm
Private collection, Australia
[not illustrated]

In the car 1963
oil and magna on canvas
172 x 203.5 cm
Scottish National Gallery of
Modern Art, Edinburgh

Woman in bath 1963
oil and magna on canvas
173.3 x 173.3 cm
Museo Thyssen-Bornemisza,
Madrid

Bull I–VI 1973
from the series **Bull profile**
lithograph, screenprint and line-cut
68.6 x 88.9 cm (sheet)
Art Gallery of New South Wales,
purchased with funds provided
by Hamish Parker 2013

Konrad Lueg

Football players 1963
tempera on canvas
135 x 170 cm
Deutsche Bank Collection at the
Städel Museum, Städel Museum,
Frankfurt am Main

Bridgid McLean

Untitled 1969
synthetic polymer paint
on canvas
152.5 x 122.1 cm
Art Gallery of New South Wales,
Sydney. Patrick White Bequest 2013

Stop 1970
synthetic polymer paint
on canvas
152.4 x 122.2 cm
Art Gallery of New South Wales,
Sydney. Patrick White Bequest 2013

Marisol

John Wayne 1963
wood, mixed media
264.2 x 243.8 x 38.1 cm
Colorado Springs Fine Art Center.
Julianne Kemper Purchase Fund,
Debutante Ball Purchase Fund

Claes Oldenburg

Leopard chair 1963
vinyl, wood, foam rubber and metal
83.9 x 177 x 93.7 cm
National Gallery of Australia, Canberra,
purchased 1978

Giant soft fan – ghost version 1967
canvas, wood and polyurethane foam
304.8 x 149.9 x 162.6 cm
The Museum of Fine Arts, Houston.
Gift of D and J de Menil

Giant 3-way plug scale B 1970
wood
147.3 x 99.1 x 74.9 cm
Tate, purchased 1971

Alan Oldfield

Cliché c1968
synthetic polymer paint on canvas
183 x 152.5 cm
National Gallery of Australia, Canberra,
purchased 1969

Sir Eduardo Paolozzi

I was a rich man's plaything 1947
collage mounted on card
35.9 x 23.8 cm (support)
Tate. Presented by the artist 1971

Lessons of last time 1947
collage mounted on card
22.9 x 31.1 cm (support)
Tate. Presented by the artist 1971

**It's a psychological fact pleasure
helps your disposition** 1948
collage mounted on card
36.2 x 24.4 cm (support)
Tate. Presented by the artist 1971

Meet the people 1948
collage mounted on card
35.9 x 24.1 cm (support)
Tate. Presented by the artist 1971

Sack-o-sauce 1948
collage mounted on card
35.6 x 26.4 cm (support)
Tate. Presented by the artist 1971

**You'll soon be congratulating
yourself** 1949
collage
30.5 x 23 cm
Victoria and Albert Collection.
Given by the artist

**Hazards include dust, hailstones
and bullets; Survival** 1950
collage
24.8 x 18.6 cm (each)
Victoria and Albert Collection.
Given by the artist

Man holds the key 1950
collage
36.4 x 25.4 cm
Victoria and Albert Collection.
Given by the artist

Real gold 1950
collage mounted on card
35.6 x 23.5 cm (support)
Tate. Presented by the artist 1971

Windtunnel test 1950
collage mounted on card
24.8 x 36.5 cm (support)
Tate. Presented by the artist 1971

Headlines from horrors ville 1951
collage
25.3 x 39 cm
Victoria and Albert Collection.
Given by the artist

You can't beat the real thing 1951
collage
35.7 x 24 cm
Victoria and Albert Collection.
Given by the artist

Yours till the boys come home
1951
collage mounted on card
36.2 x 24.8 cm (support)
Tate. Presented by the artist 1971

Bunk! Evadne in green dimension
1952
collage, paper glue and string
56.7 x 41.5 cm
Victoria and Albert Collection.
Given by the Artist Copyright Trustees
of the Paolozzi Foundation

Merry Xmas with T-1 space suits 1952
collage
38.2 x 28.5 cm
Victoria and Albert Collection.
Given by the artist

No one's sure how good it is 1952
collage
30.5 x 16.1 cm
Victoria and Albert Collection.
Given by the artist

The ultimate planet 1952
collage mounted on card
25.1 x 38.1 cm (support)
Tate. Presented by the artist 1971

**Was this metal monster master
– or slave?** 1952
collage mounted on card
36.2 x 24.8 cm (support)
Tate. Presented by the artist 1971

Will man outgrow the Earth 1952
collage
36.3 x 25.7 cm
Victoria and Albert Collection.
Given by the artist

Markoni capital 1962
gunmetal and brass
226.7 x 98.5 x 67.3 cm
Art Gallery of New South Wales,
Sydney. Gift of Gabrielle Keiller 1985

Peter Phillips

Motorpsycho / Tiger 1961–62
oil on canvas with
lacquered wood panels
205.5 x 150.5 cm
Private collection

Sigmar Polke

Untitled (Vase II) 1965
oil on beaver bed sheet
89 x 75.5 cm
Stiftung Museum Kunstpalast,
Düsseldorf

Peter Powditch

The big towel 1969
oil on composition board
183.6 x 122.4 cm
National Gallery of Victoria, Melbourne.
Samuel E Wills Bequest 1979

Seascape II 1969
oil on plywood
244 x 244 cm
Art Gallery of New South Wales, Sydney.
Purchased with funds provided by
an anonymous purchase fund for
contemporary Australian art 1970

Richard Prince

Untitled (cowboy) 1980–89
Ektacolor photograph
181.5 x 271.5 cm (sight)
Art Gallery of New South Wales,
Sydney. John Kaldor Family Collection

Robert Rauschenberg

Dylaby 1962
oil on rubber tyre and packing case
timber with iron nails
62.2 x 55.9 x 33 cm
Art Gallery of New South Wales,
Sydney. John Kaldor Family Collection

Dylaby 1962
oil, metal objects, metal spring,
metal Coca-Cola sign, ironing board,
and twine on unstretched canvas tarp
on wood support
278.1 x 221 x 38.1 cm
Robert Rauschenberg Foundation

Quote 1964
oil and silkscreen ink on canvas
243.8 x 182.9 cm
Kunstsammlung Nordrhein-Westfalen,
Düsseldorf

Martial Raysse

Rear view mirror 1962
photomechanical reproduction and
paint on paper mounted on fiberboard
76.5 x 152 cm
Hirshhorn Museum and Sculpture
Garden, Smithsonian Institution,
Washington, DC. The Joseph H
Hirshhorn Bequest 1981

Ken Reinhard

Ticket box 1966
pencil, decal lettering, charcoal, oil and
synthetic polymer paint on wood and
composition board
126.8 x 184.6 x 17.6 cm
National Gallery of Victoria, Melbourne.
Gift of Dr Bronte Douglass 1988

EK 1972
wall construction: synthetic polymer
paint, brass, copper, plastic and
photograph on hardboard
186.7 x 186.6 x 32.3 cm
Art Gallery of New South Wales,
Sydney, purchased 1974

Gerhard Richter

Helga Matura with her fiancé 1966
oil on canvas
199.5 x 99 cm
Stiftung Museum Kunstpalast,
Düsseldorf

Robert Rooney

Superknit 1 1969
synthetic polymer paint on canvas
133.4 x 243.9 cm
National Gallery of Victoria, Melbourne,
purchased 1981

The setting sun 1984
synthetic polymer paint on canvas
121.8 x 198.2 cm
National Gallery of Victoria, Melbourne,
purchased from Admission Funds, 1987

Tumult in the clouds 1985
synthetic polymer paint on canvas
122.2 x 183 cm
Art Gallery of New South Wales,
Sydney. Gift of Terry and Tina Smith
2013, donated through the Australian
Government's Cultural Gifts Program

James Rosenquist

Silver skies 1962
oil on canvas
199.4 x 502.9 cm
Chrysler Museum of Art, Norfolk.
Gift of Walter P Chrysler, Jr, 1971

F-111 1974
lithograph and screenprint
4 sheets: 91.4 x 191 cm (each);
91.4 x 764 cm (overall)
National Gallery of Australia, Canberra,
purchased 1976

Martha Rosler

from the series
**House beautiful:
bringing the war home** 1967–72
photomontage
Courtesy of the artist and
Mitchell-Innes & Nash, New York

Balloons
61 x 50.8 cm

Beauty rest
61 x 50.8 cm

Booby trap
61 x 50.8 cm

Boy's room
61 x 50.8 cm

Cleaning the drapes
50.8 x 61 cm

Empty boys
61 x 50.8 cm

First Lady (Pat Nixon)
50.8 x 61 cm

Honors (striped burial)
50.8 x 61 cm

House beautiful, Giacometti
61 x 50.8 cm

Makeup/Hands up
61 x 50.8 cm

Patio view
61 x 50.8 cm

Playboy (on view)
61 x 50.8 cm

Red stripe kitchen
61 x 50.8 cm

Roadside ambush
50.8 x 61 cm

Runway
50.8 x 61 cm

Scatter
50.8 x 61 cm

Tract house soldier
50.8 x 61 cm

Tron (amputee)
61 x 50.8 cm

Vacation getaway
50.8 x 60 cm

Woman with cannon (dots)
61 x 50.8 cm

Edward Ruscha

**Noise, pencil, broken pencil,
cheap Western** 1963
oil and wax on canvas
180.3 x 170.2 cm
Virginia Museum of Fine Arts,
Richmond. Gift of Sydney and
Frances Lewis

Twentysix gasoline stations 1963
(printed 1969)
48 pages, 26 black-and-white
photographic illustrations; glassine
dust jacket
17.9 x 14.1 cm (book closed)
Art Gallery of New South Wales,
Sydney, purchased with funds
provided by the Photography
Collection Benefactors Program 2008

**Every building on the
Sunset Strip** 1966
54 pages (folded), black-and-white
photographic illustrations; accordion
fold; original slipcase, silver paper over
boards; white paper belly band
18 x 14.2 cm (book closed);
18 x 750 cm (book open, pages
extended)
Art Gallery of New South Wales,
Sydney, purchased with funds
provided by the Photography
Collection Benefactors Program 2008

**Nine swimming pools
and a broken glass** 1968
(printed 1976)
62 pages, 10 colour photographic
illustrations
17.7 x 14.1 cm (book closed)
Art Gallery of New South Wales,
Sydney. Purchased with funds
provided by the Photography
Collection Benefactors Program 2008

Gospel 1972
synthetic polymer paint and aluminium
on raw canvas
137.2 x 152.4 cm
Art Gallery of New South Wales,
Sydney. Gift of the Art Gallery Society
of New South Wales and Ed and
Danna Ruscha with the support of
Gagosian Gallery 2013

Niki de Saint Phalle

Black beauty 1968
from the series **Nana**
resins with synthetic polymer paint
237.4 x 145 x 60 cm
State Art Collection, Art Gallery of
Western Australia, purchased 1982

Gareth Sansom

The great democracy 1968
oil, enamel, synthetic polymer paint,
collage and pencil on composition board
180 x 180 cm
National Gallery of Australia, Canberra.
Gift of Emmanuel Hirsh in memory
of Etta Hirsh 2007

Martin Sharp

**Legalise cannabis: the putting
together of the heads** 1967
colour screenprint on
gold foil laminated paper
73.4 x 48.2 cm (image);
76 x 50.7 cm (sheet)
Art Gallery of New South Wales,
Sydney, purchased 2014

Live give love 1967
screenprint on silver foil laminated paper
50 x 75 cm (image); 76 x 99 cm (sheet)
Art Gallery of New South Wales,
Sydney. Purchased 2014

Mister Tambourine Man 1967
colour screenprint on gold foil
laminated paper
75.4 x 49.8 cm (image/sheet)
Art Gallery of New South Wales, Sydney.
Thea Proctor Memorial Fund 1970

Sex 1967
colour screenprint on silver foil
laminated paper
72.3 x 48.8 cm (image);
75.9 x 50.5 cm (sheet)
Art Gallery of New South Wales,
Sydney, purchased 2014

Sunshine Superman 1967
colour screenprint on silver foil
reflective paper
74.1 x 49.6 cm (image);
76 x 59 cm (sheet)
Art Gallery of New South Wales,
Sydney. Gift of Lucy Swanton 1978
[not illustrated]

Jimi Hendrix c1971
enamel on synthetic polymer film
between two sheets of perspex
101 x 115 cm
National Gallery of Australia, Canberra.
Gift of Jim Sharman 1984

Martin Sharp, Tim Lewis

Still life 1973
synthetic polymer paint on canvas
117 x 91.5 cm (sight)
National Gallery of Australia,
Canberra, purchased 1973

**The unexpected answer
(Yellow House)** 1973
synthetic polymer paint on
composition board
182.8 x 116.8 cm
National Gallery of Australia,
Canberra. Gift of the Philip Morris
Arts Grant 1982

Michael Allen Shaw

Lawrence diptych 1965
synthetic polymer paint on board
and canvas
117.5 x 233.5 cm
Private collection

Garry Shead

Bondi 1968, 1998 (re-worked)
synthetic polymer paint and collage
on board
216.5 x 137.5 cm
Art Gallery of New South Wales,
Sydney. DG Wilson Bequest Fund 1999

Cindy Sherman

Untitled film still #3 1977
gelatin silver photograph
16.1 x 24 cm (image);
30.4 x 35.4 cm (sheet)
National Gallery of Australia,
Canberra, purchased 1983

Untitled film still #35 1979
gelatin silver photograph
23.3 x 16.2 cm (image);
25.3 x 20.3 cm (sheet)
Art Gallery of New South Wales,
Sydney. Mervyn Horton Bequest
Fund 1986

Untitled film still #46 1979
gelatin silver photograph
17 x 23.2 cm (image);
20.3 x 25.3 cm (sheet)
Art Gallery of New South Wales,
Sydney. Mervyn Horton Bequest
Fund 1986

Untitled film still #50 1979
gelatin silver photograph
16.4 x 24 cm (image);
30.4 x 35.4 cm (sheet)
National Gallery of Australia,
Canberra, purchased 1983

Untitled film still #52 1979
gelatin silver photograph
16.1 x 24 cm (image)
National Gallery of Australia,
Canberra, purchased 1983

Untitled #92 1981
type C colour photograph
61.5 x 123.4 cm (image)

Untitled #93 1981
type C colour photograph
61.5 x 123 cm (image)
National Gallery of Australia,
Canberra, purchased 1983
[not illustrated]

National Gallery of Australia,
Canberra, purchased 1983
[not illustrated]

Untitled #113 1982
type C photograph
114.3 x 75 cm (sight)
Art Gallery of New South Wales, Sydney.
Mervyn Horton Bequest Fund 1986

Untitled 1982
chromogenic colour print
50.8 x 40.6 cm (image)
Courtesy of the artist and Metro
Pictures, New York

Wayne Thiebaud

Delicatessen counter 1962
oil on canvas
76.8 x 92.1 cm
The Menil Collection, Houston

Imants Tillers

White Aborigines 1983
oil stick and synthetic polymer paint
on canvas
254 x 381 cm
Museum of Contemporary Art.
Gift of Loti Smorgon AO and
Victor Smorgon AC, 1995

Joe Tilson

Nine elements 1963
mixed media on wood relief
259 x 182.8 cm
Scottish National Gallery of Modern
Art, Edinburgh

Tony Tuckson

Pyjamas and Herald 1963
synthetic polymer paint, tempera,
and collage of newsprint, hessian
and cotton on composition board
121.9 x 182.8 cm
National Gallery of Australia,
Canberra, purchased 1979

Peter Tyndall

Title	detail
	**A Person Looks
At A Work Of Art/**	
	**someone looks at
something...**	
	LOGOS/ HA HA
Medium	**A Person Looks
At A Work of Art/**	
	**someone looks at
something...**	
	**CULTURAL
CONSUMPTION	
PRODUCTION**	
Date	- 1985–87 -
Artist	Peter Tyndall

synthetic polymer paint on canvas,
wood frame, plastic coated wire
340.4 x 243.4 cm (installed)
National Gallery of Victoria, Melbourne,
purchased from Admission Funds, 1988

Andy Warhol

Silver Liz [Studio type] 1963
silkscreen ink and silver spray paint
on linen canvas
101.6 x 101.6 cm
The Eyles Family Collection

Triple Elvis 1963
screenprint ink, silver paint and
spray paint on linen
208.3 x 180.3 cm
Virginia Museum of Fine Arts,
Richmond. Gift of Sydney and
Frances Lewis

Heinz Tomato Ketchup boxes
1964
silkscreen ink and house paint
on plywood
5 units: 21.6 x 39.4 x 26.7 cm (each)
The Andy Warhol Museum,
Pittsburgh. Founding Collection,
Contribution The Andy Warhol
Foundation for the Visual Arts Inc
Acc 1998.1.728, 731, 733, 740, 745

Jackie 1964
acrylic and silkscreen ink on linen
4 panels: 50.8 x 40.6 cm (each)
The Andy Warhol Museum,
Pittsburgh. Founding Collection,
Contribution The Andy Warhol
Foundation for the Visual Arts Inc
Acc 1998.1.84, 91, 119, 132

Screen tests 1965–66
16 mm film transferred to digital file
black-and-white, silent
The Andy Warhol Museum,
Pittsburgh. Contribution The Andy
Warhol Foundation for the
Visual Arts Inc

> **Screen test:**
> **Edie Sedgwick** ST308 1965
> 4:36 min at 16 frames per sec

> **Screen test:**
> **Bob Dylan** ST82 1966
> 4:36 min at 16 frames per sec

> **Screen test:**
> **Lou Reed** ST263 1966
> 4:18 min at 16 frames per sec

> **Screen test:**
> **Marcel Duchamp** ST80 1966
> 4:24 min at 16 frames per sec

Electric chair 1967
synthetic polymer paint
screenprinted on canvas
137.2 x 185.1 cm
National Gallery of Australia,
Canberra, purchased 1977

Marilyn Monroe 1967
silkscreen on paper
suite of 10: 91.5 x 91.5 cm (each)
Frederick R Weisman Art Foundation,
Los Angeles

Campbell's soup 1 1968
portfolio of 10 screenprints on paper
published by Factory Additions,
New York
88.9 x 58.4 cm (each)
Kerry Stokes Collection, Perth

Mao 1973
acrylic and silkscreen ink on linen
101.6 x 86.4 cm
The Andy Warhol Museum,
Pittsburgh. Founding Collection,
Contribution The Andy Warhol
Foundation for the Visual Arts Inc

Mona Lisa c1979
acrylic and silkscreen ink
on canvas
203.2 x 254 cm
The Andy Warhol Museum,
Pittsburgh. Founding Collection,
Contribution The Andy Warhol
Foundation for the Visual Arts Inc

Self-portrait no 9 1986
synthetic polymer paint and
screenprint on canvas
203.5 x 203.7 cm
National Gallery of Victoria,
Melbourne, purchased through
The Art Foundation of Victoria
with the assistance of the National
Gallery Women's Association,
Governor, 1987

Dick Watkins

The fall no 1 1968
synthetic polymer paint on canvas
183 x 152 cm
Private collection

The fall no 2 1968
synthetic polymer paint on canvas
183 x 156.5 cm
Private collection

Jenny Watson

A painted page 1:
Twiggy by Richard Avedon 1979
oil on canvas
105 x 153 cm
National Gallery of Victoria,
Melbourne. Michell Endowment 1982

A painted page: pages 52 and 53
of "In the gutter" (The ears) 1979
oil on canvas
162.5 x 178 cm
Collection of The University of
Queensland, purchased with the
assistance of the Visual Arts Board
of the Australia Council, 1981

A painted page:
the Herald 21/11/79 1979–80
oil on cotton duck
60 x 76 cm
Courtesy of the artist and
Anna Schwartz Gallery

Tom Wesselmann

Still life #29 1963
oil and collage on canvas
264.2 x 365.8 cm
Claire Wesselmann

Smoker #11 1973
oil on canvas
224.8 x 216 cm
Claire Wesselmann

Brett Whiteley

The American Dream 1968–69
18 panels, mixed media on plywood
244.3 x 122.2 cm (a–n);
243 x 122 cm (o); 221 x 122 cm (p);
188 x 122 cm (q–r)
State Art Collection, Art Gallery of
Western Australia, purchased 1978

BUT WHY SHOULD I BE ORIGINAL? WHY CAN'T I BE NON-ORIGINAL?

ANDY WARHOL, 1963

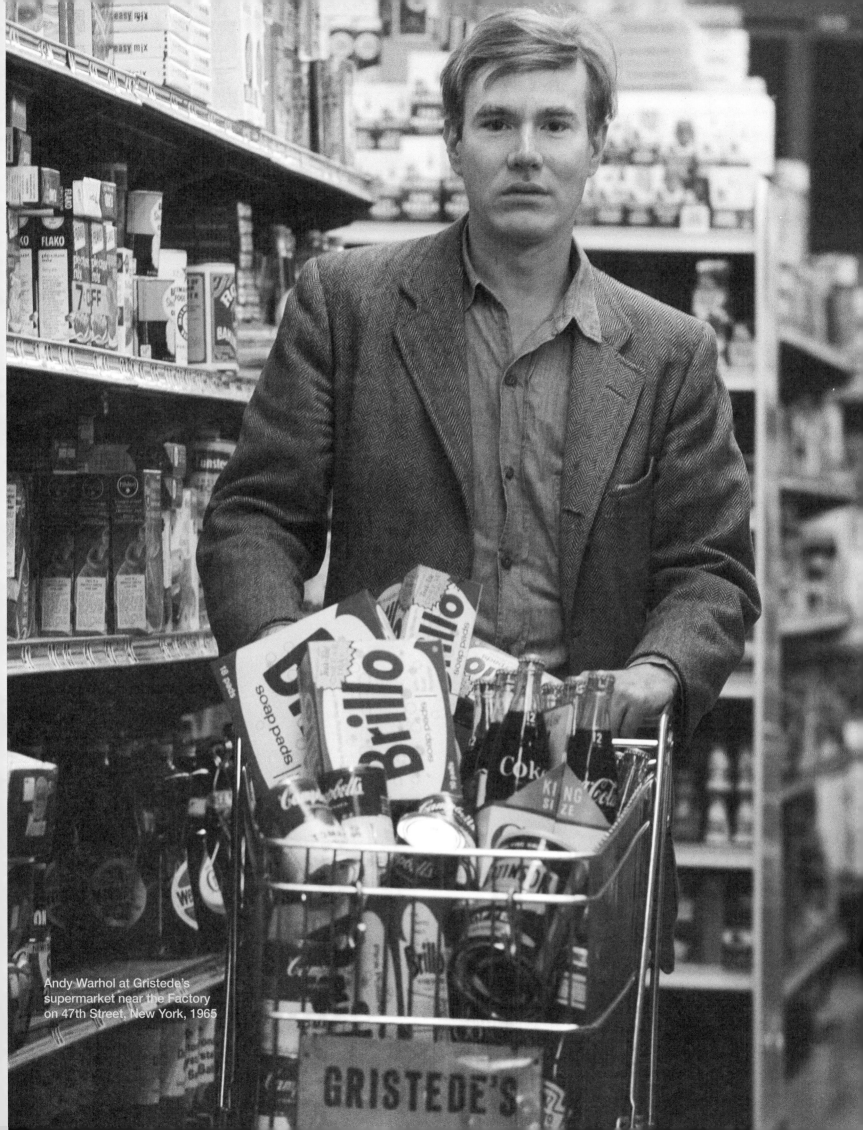

Andy Warhol at Gristede's
supermarket near the Factory
on 47th Street, New York, 1965

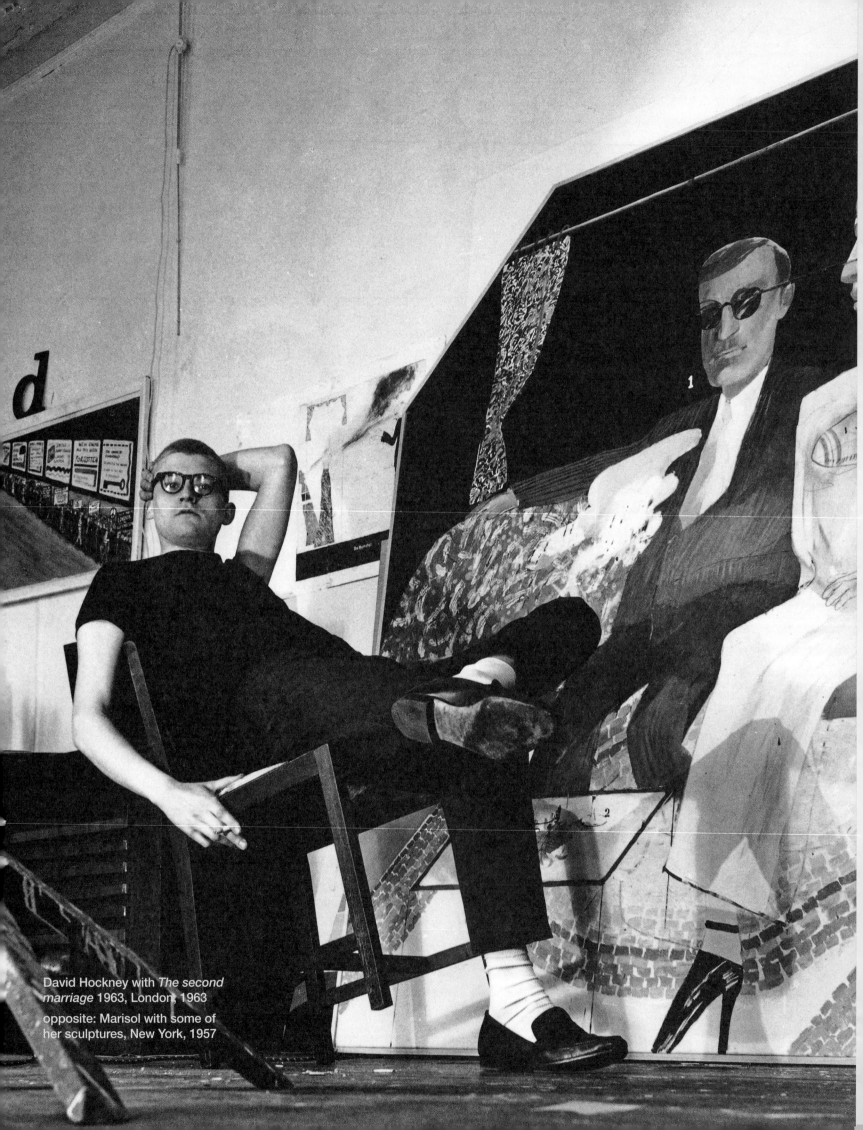

David Hockney with *The second marriage* 1963, London, 1963

opposite: Marisol with some of her sculptures, New York, 1957

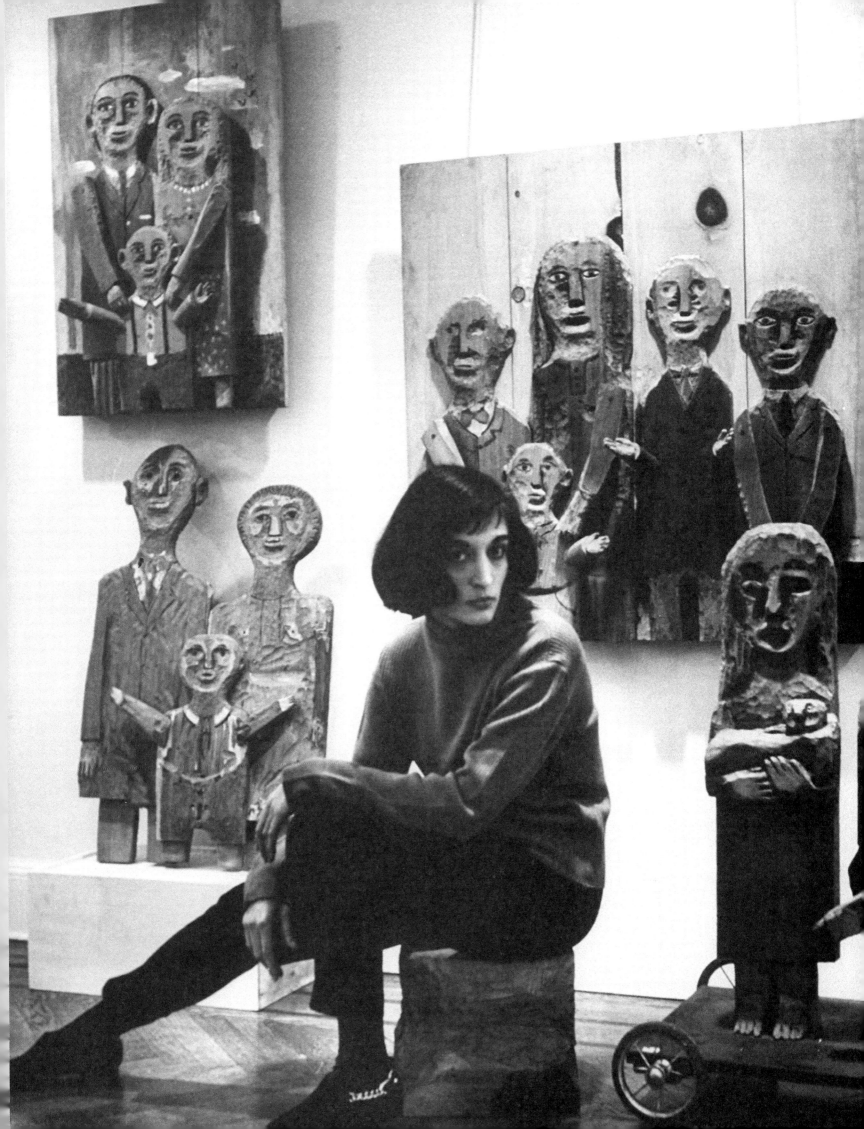

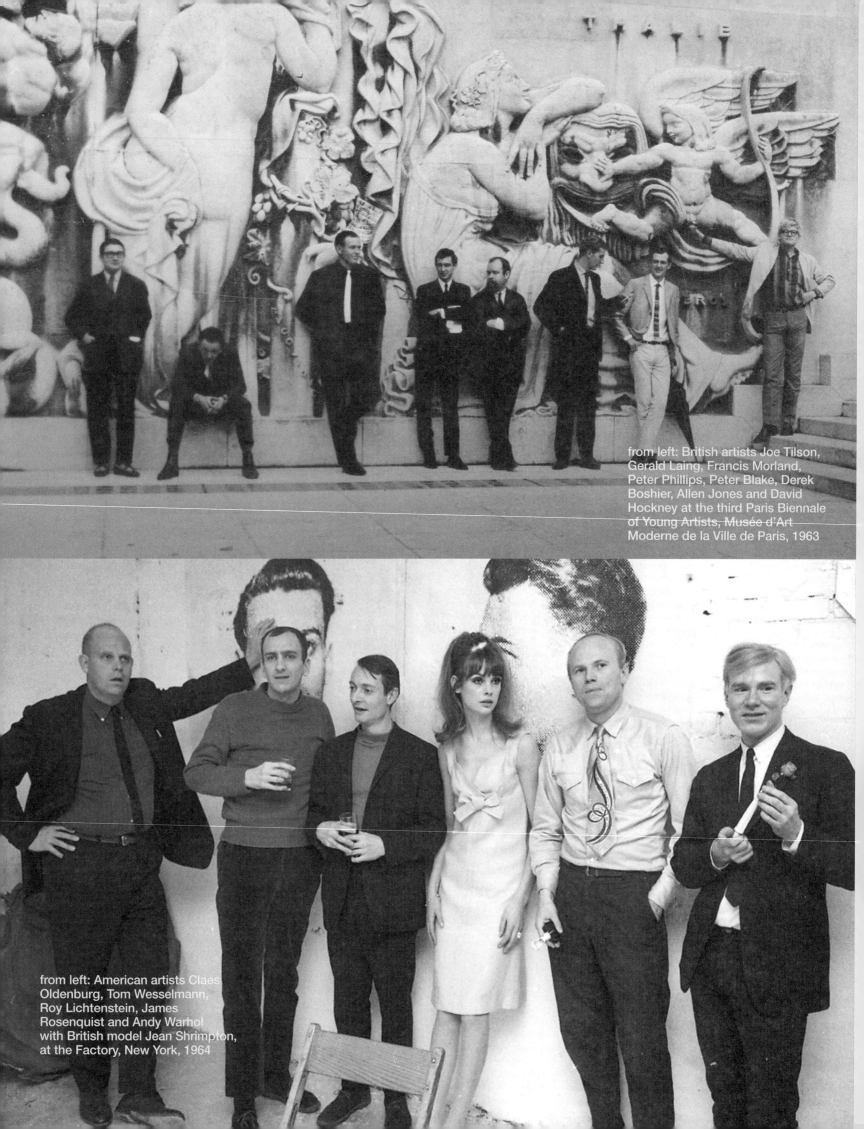

from left: British artists Joe Tilson, Gerald Laing, Francis Morland, Peter Phillips, Peter Blake, Derek Boshier, Allen Jones and David Hockney at the third Paris Biennale of Young Artists, Musée d'Art Moderne de la Ville de Paris, 1963

from left: American artists Claes Oldenburg, Tom Wesselmann, Roy Lichtenstein, James Rosenquist and Andy Warhol with British model Jean Shrimpton, at the Factory, New York, 1964

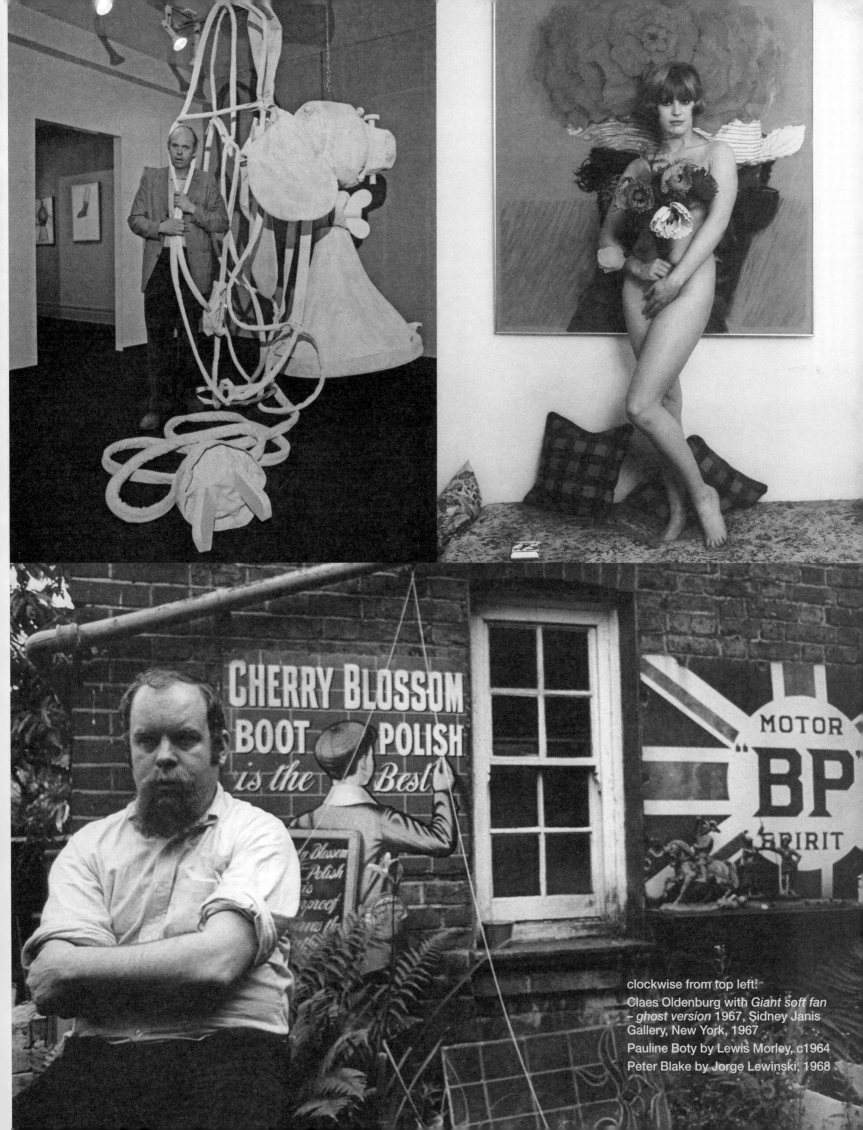

clockwise from top left:
Claes Oldenburg with *Giant soft fan – ghost version* 1967, Sidney Janis Gallery, New York, 1967
Pauline Boty by Lewis Morley, c1964
Peter Blake by Jorge Lewinski, 1968

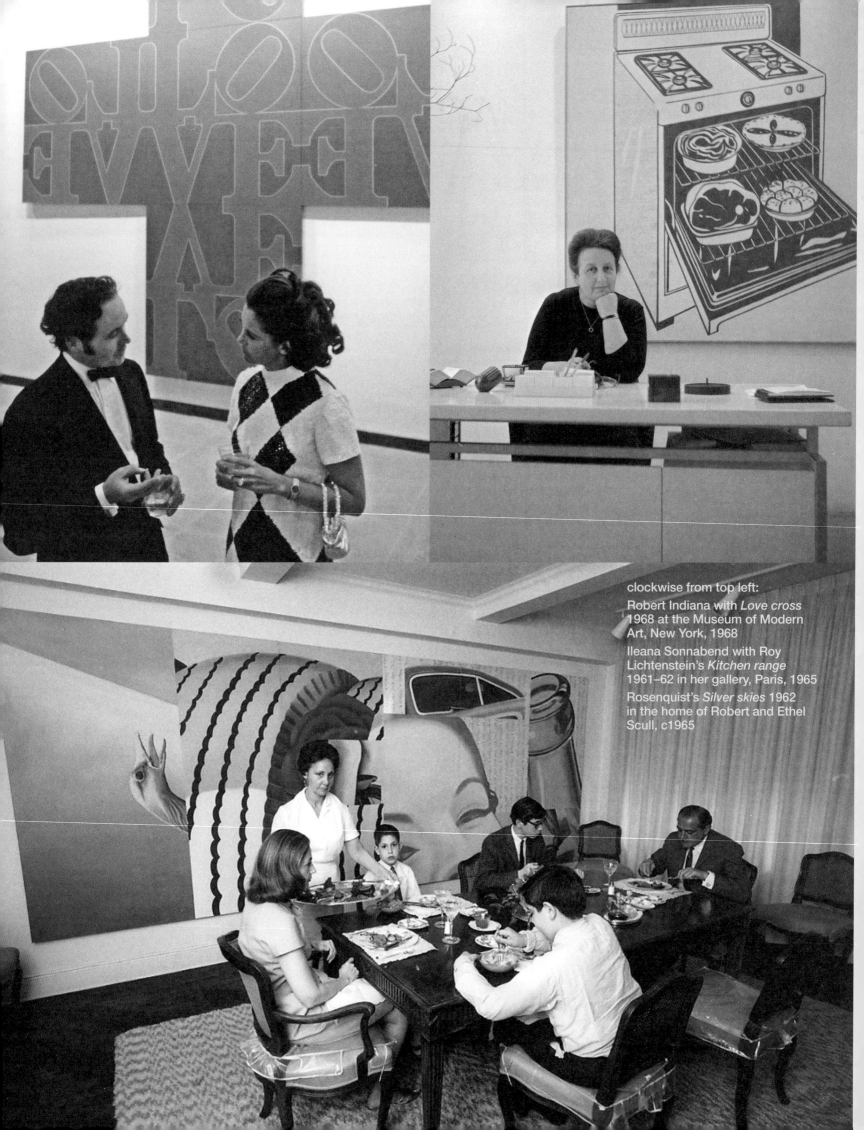

clockwise from top left:

Robert Indiana with *Love cross* 1968 at the Museum of Modern Art, New York, 1968

Ileana Sonnabend with Roy Lichtenstein's *Kitchen range* 1961–62 in her gallery, Paris, 1965

Rosenquist's *Silver skies* 1962 in the home of Robert and Ethel Scull, c1965

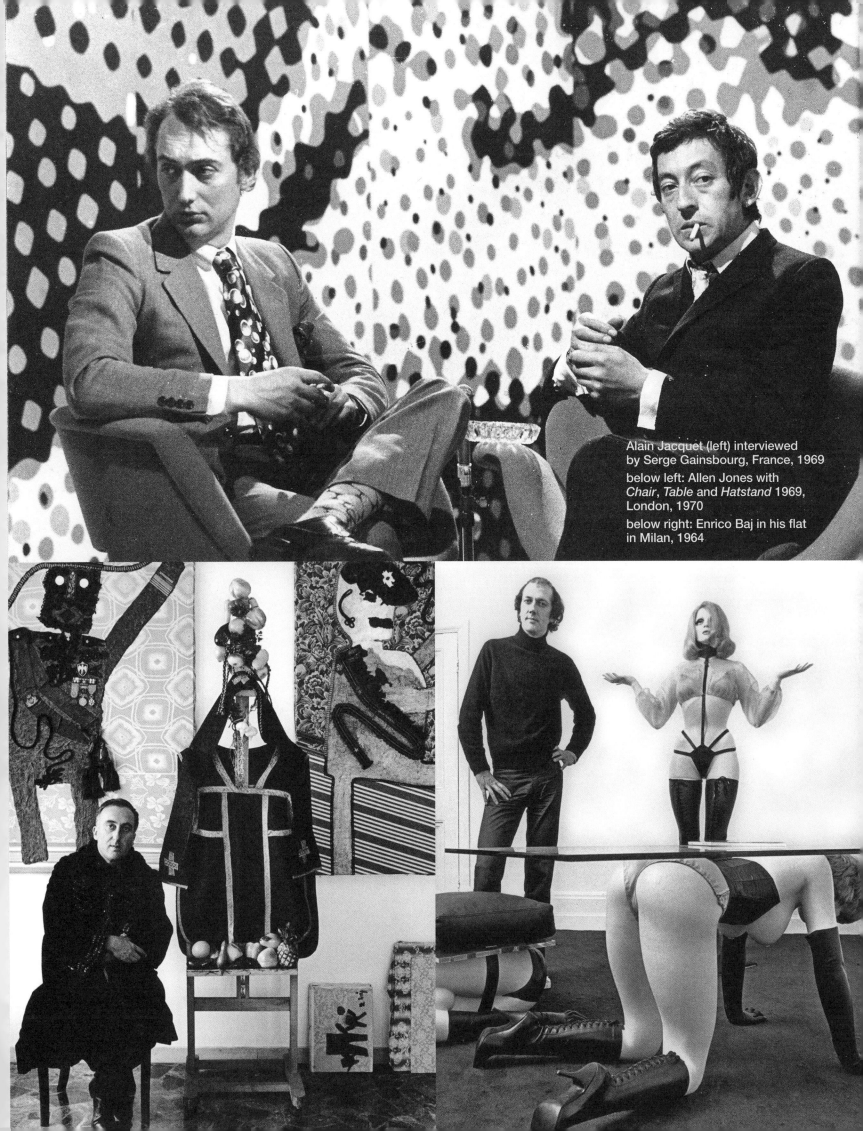

Alain Jacquet (left) interviewed
by Serge Gainsbourg, France, 1969

below left: Allen Jones with
Chair, *Table* and *Hatstand* 1969,
London, 1970

below right: Enrico Baj in his flat
in Milan, 1964

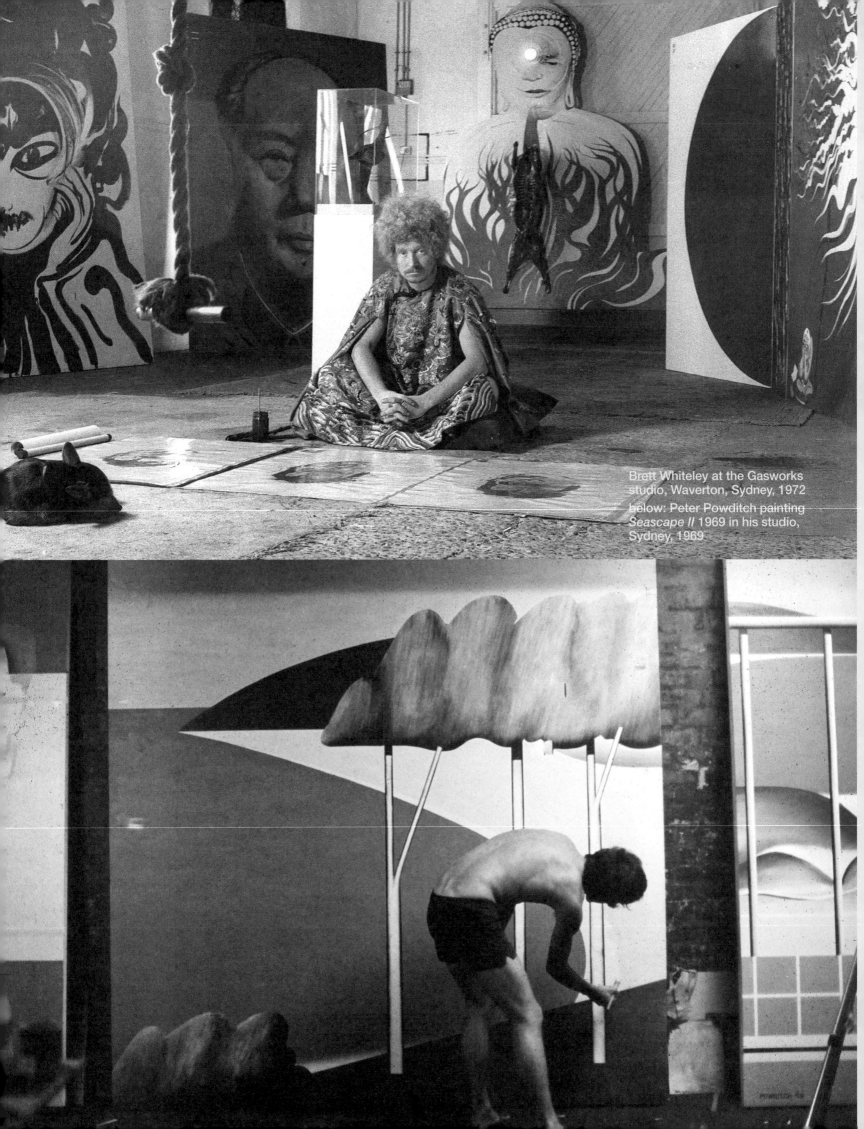

Brett Whiteley at the Gasworks
studio, Waverton, Sydney, 1972
below: Peter Powditch painting
Seascape II 1969 in his studio,
Sydney, 1969

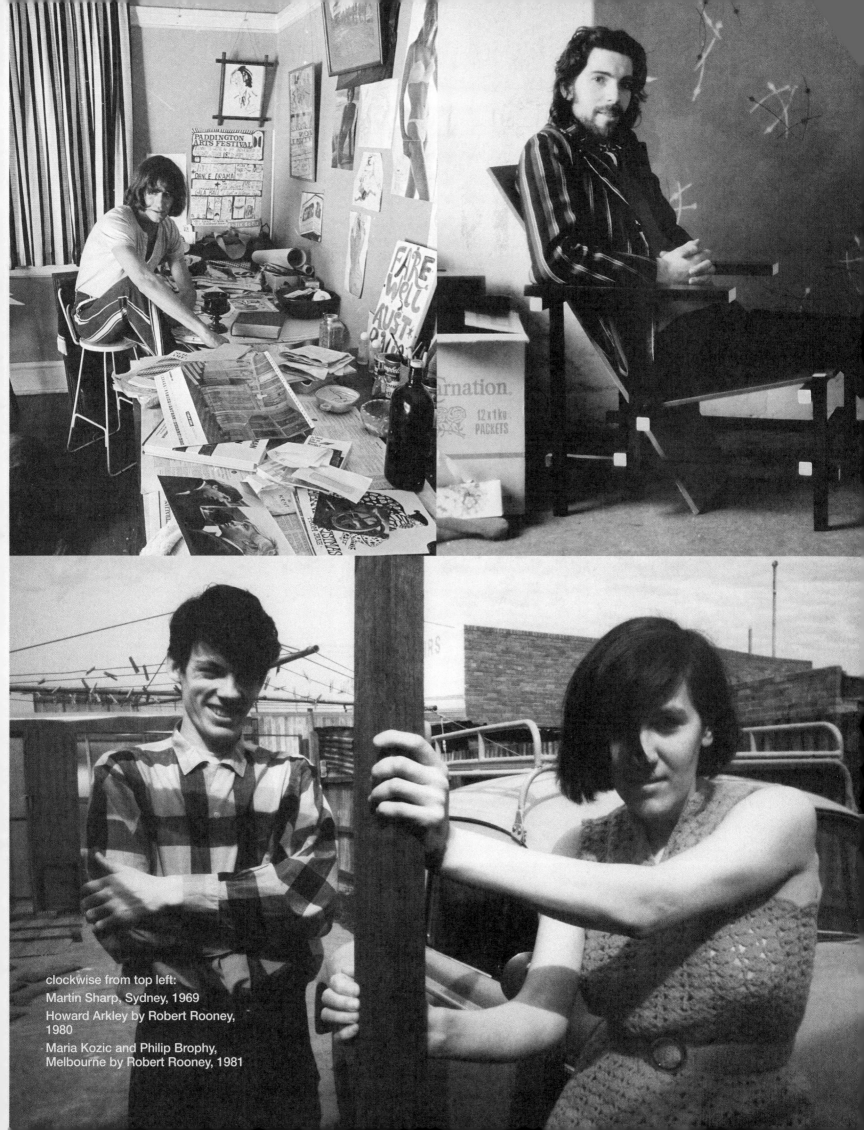

clockwise from top left:

Martin Sharp, Sydney, 1969

Howard Arkley by Robert Rooney, 1980

Maria Kozic and Philip Brophy, Melbourne by Robert Rooney, 1981

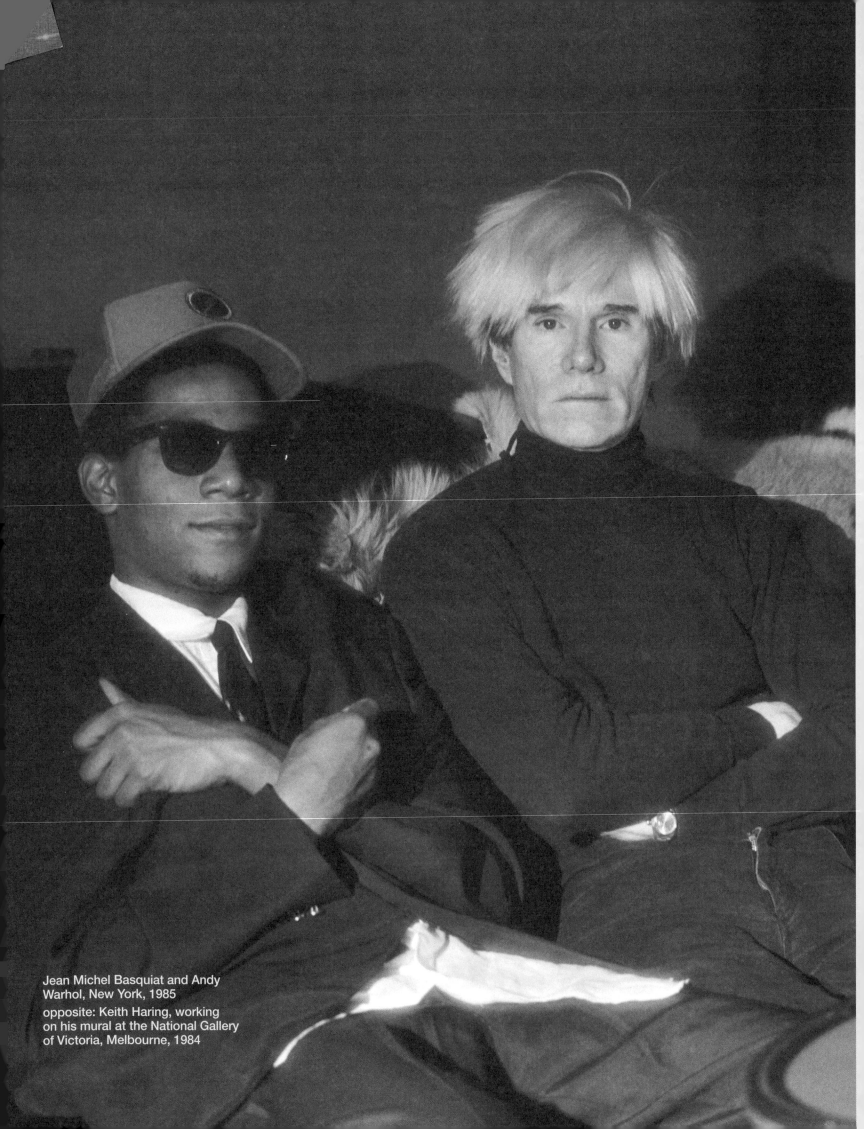

Jean Michel Basquiat and Andy
Warhol, New York, 1985

opposite: Keith Haring, working
on his mural at the National Gallery
of Victoria, Melbourne, 1984

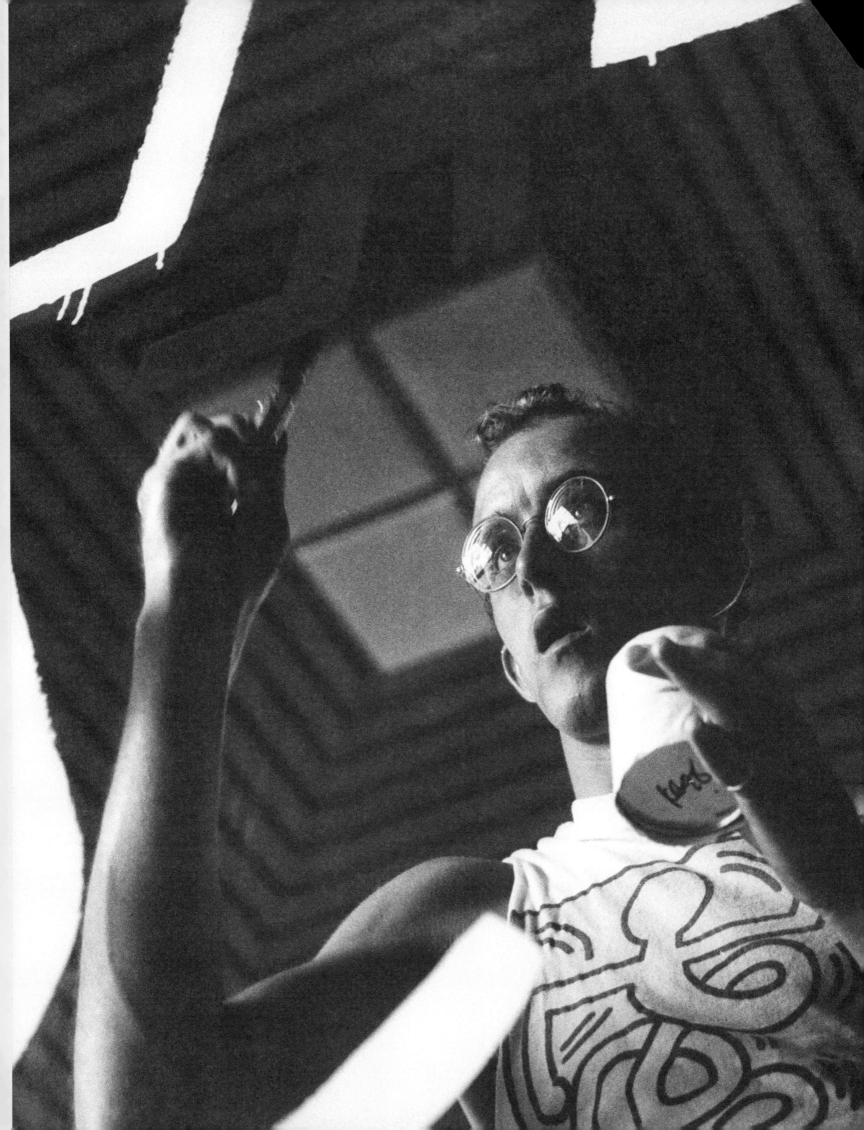

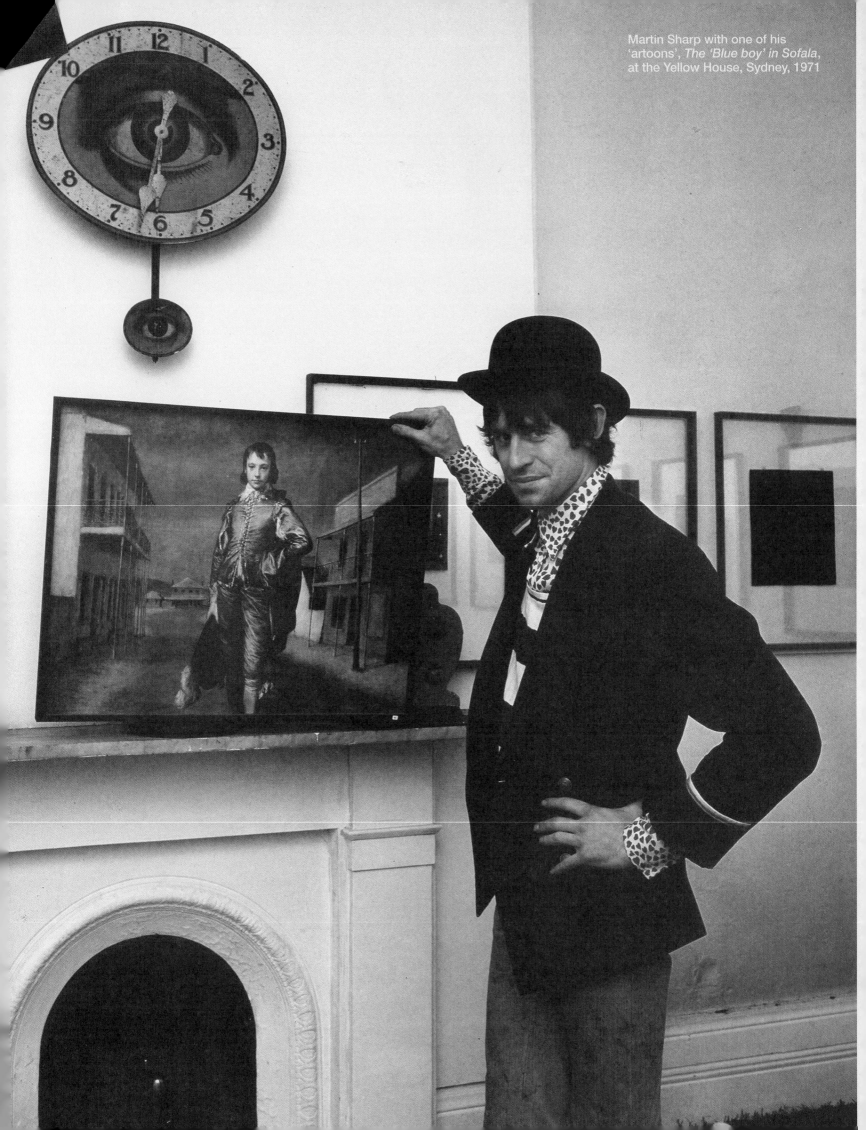